California
Impressionism

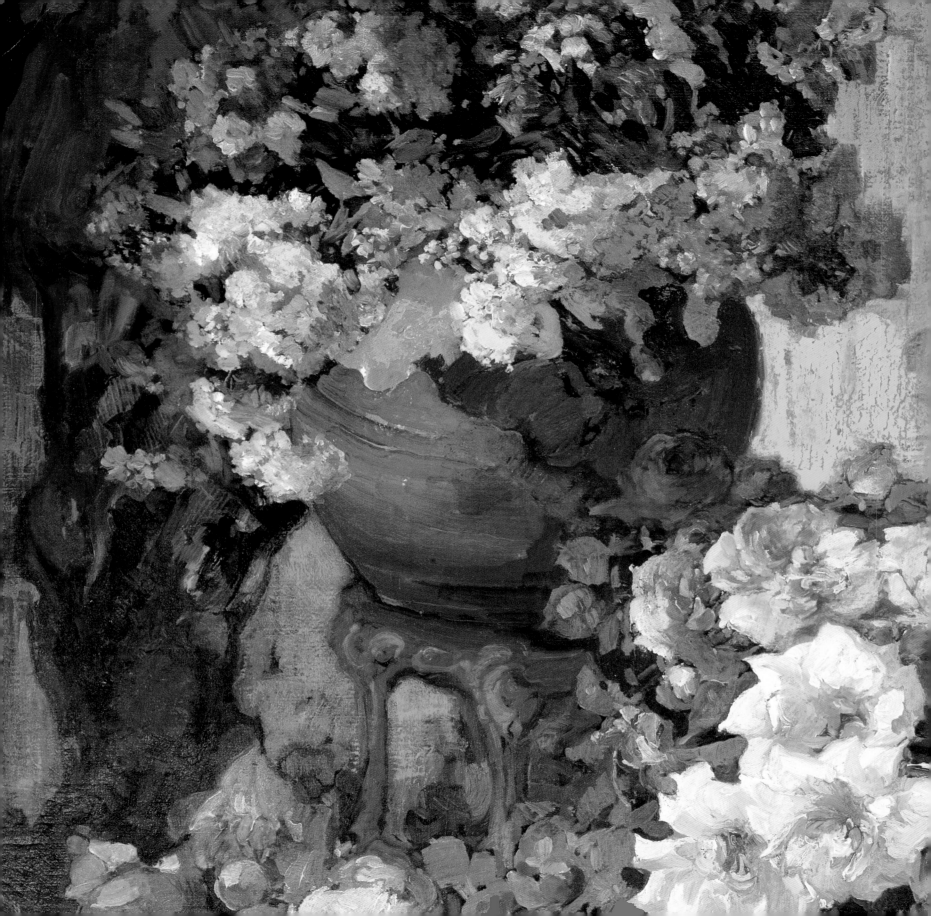

California
Impressionism

WILLIAM H. GERDTS
WILL SOUTH

ABBEVILLE PRESS
PUBLISHERS

NEW YORK

LONDON

PARIS

The authors would like to dedicate their essays to Dr. A. Jess Shenson and his brother, the late Dr. Ben Shenson (1915–1995), for their years of support of scholarship in American art and the arts in California especially, and for their enduring friendship and generosity.

Abbeville Press gratefully acknowledges the generous and enthusiastic support of Mort and Donna Fleischer and the Fleischer Museum.

EDITORS: Mary Christian and Nancy Grubb
DESIGNER: Celia Fuller
PRODUCTION EDITOR: Abigail Asher
PICTURE EDITOR: Elizabeth Boyle
PRODUCTION MANAGER: Lou Bilka

FIRST EDITION
10 9 8 7 6 5 4 3 2

Library of Congress Cataloging-in-Publication Data
Gerdts, William H.
 California Impressionism / William H. Gerdts, Will South.
 p. cm.
 Includes bibliographical references and index.
 ISBN 0-7892-0176-3
 1. Impressionism (Art) — California. 2. Painting, American — California.
 3. Painting, Modern — 20th century — California.
 I. South, Will. II. Title.
 ND230.C3G47 1998
 759.194'09'04 — dc21 97-32267

FRONT COVER
Detail of Donna Schuster, *In the Garden*, 1917. See plate 168.

BACK COVER
Detail of Guy Rose, *Mist over Point Lobos*, c. 1918. See plate 189.

FRONTISPIECE
Detail of Franz Bischoff, *Roses*, n.d. See plate 140.

Contents

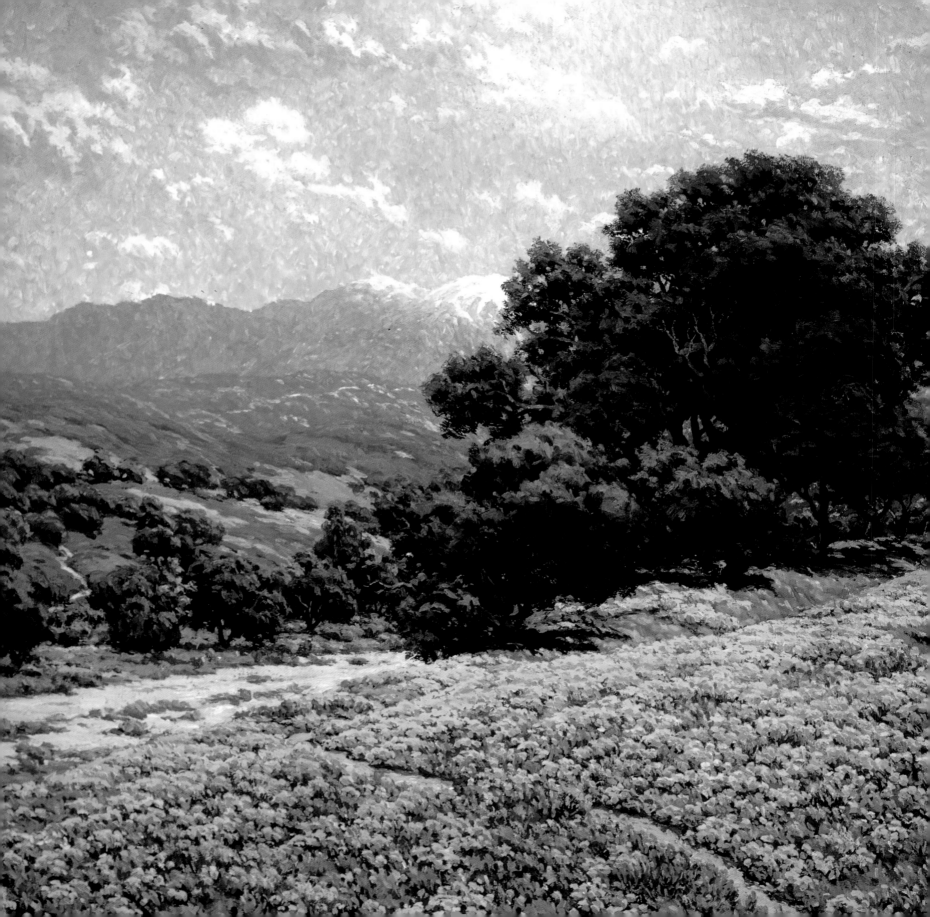

California Impressionism in Context

William H. Gerdts

There has been an ever-growing interest in regional manifestations of American Impressionism in recent years. Attention has been drawn to Connecticut Impressionism, the Indiana ("Hoosier") Impressionists, southern Impressionist painters, and even Ohio and Minnesota Impressionists, but no regional Impressionism in the United States has stimulated such far-reaching excitement as that of California. This subject has yielded numerous exhibitions—often with substantial catalogs—as well as a number of books. Many private collectors and institutions have concentrated on acquiring the work of artists whose paintings fall under the rubric "California Impressionism"; a few of these collections have been substantially cataloged, in book-length publications.

Interest in California Impressionism is truly national. These collectors are not exclusively residents of California, unlike the specialists in the Hoosier Group, who appear to be based totally in Indiana, or collectors of southern Impressionism, who are themselves southerners. A number of major collectors of California Impressionism reside in New York and New Jersey, while the patrons of this volume, Mort and Donna Fleischer, live in Scottsdale, Arizona, where they maintain a museum devoted to California Impressionism.[1]

All of these collectors, of course, were encouraged and aided by growing numbers of commercial galleries and dealers who specialize, in whole or in part, in work by the California

1. Granville Redmond. Detail of
 A *Foothill Trail*, c. 1919.
 See plate 11.

Impressionists. This activity has not been lost upon the mainstream art establishment. The major museums in the Northeast devoted generally to American art may not have had the foresight yet to begin collecting the work of the California Impressionists, but some northeastern institutions—such as the Montclair (New Jersey) Art Museum and the National Academy Museum in New York—have at least begun to mount exhibitions of their paintings. The New York art market has seen increasing sales of work by these California artists, which has been appearing more frequently in major auctions at Christie's and Sotheby's, bringing substantial prices.

American collectors have been interested in French Impressionism since early in its history. They became acquainted with the French painters through a great exhibition of their work in New York in 1886 and quickly began to collect it, especially canvases by Claude Monet. Also in that decade, hundreds of young Paris- or Munich-trained American artists were captivated by the new aesthetic and transmitted the style to other artists and collectors at home. The vastly popular mode of painting remained strong in America for almost thirty years. But tastes shift. By the second decade of the twentieth century, at least on the East Coast, the acceleration of changes in all aspects of life, the increasing awareness in urban centers of social ills, and the exposure to more modernist aesthetics led many artists and collectors to the concomitant perception that Impressionist painting had become socially irrelevant and somewhat clichéd. American Impressionism fell from favor among collectors, dealers, critics, and scholars in the East for some forty years. When interest resurfaced, it was concentrated on a relatively limited group of painters—generally those who had enjoyed prolonged residence in France and who had at least nominal interaction with the great French Impressionists, or those who had centered their careers in New York City, the community that had been most immediately receptive to new aesthetic directions in the late nineteenth century.

It was only in 1980 that scholars began to recognize that the Impressionist impulse had spread to selected areas beyond New York. That year was marked by a definite change in the perception of Impressionism in America, from an emphasis on the concordances and discrepancies between American and French Impressionism to both the incorporation of regional manifestations within the overall history of American Impressionism and the beginning of the study of those manifestations themselves.[2] California was not far behind. The first major show devoted to California Impressionism was presented at the Oakland Museum in 1981,[3] and a wealth of California Impressionist–related exhibitions and publications followed in its wake.

The most significant reason for the growing interest in regional American Impressionist paintings is the elusive matter of quality—not only in terms of the sheer technical skill of the

2. Benjamin Brown (1865–1942).
 The Joyous Garden, n.d.
 Oil on canvas, 30 x 40 in.
 (76.2 x 101.6 cm). Joan Irvine
 Smith Fine Arts, Newport
 Beach, California.

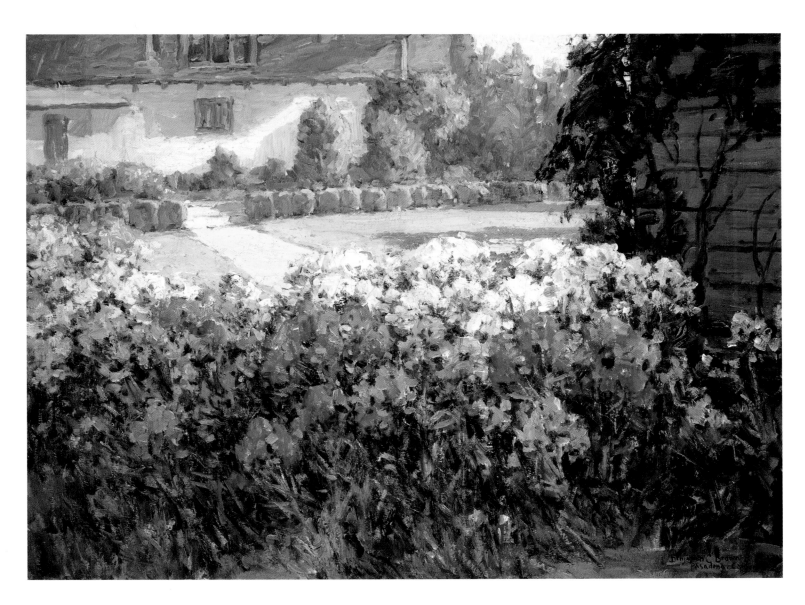

painters but also the caliber of their imagination and originality. At their finest, regional works of art offer aesthetic satisfactions fully as rich as those by artists of national and international reputation, as the works in this volume certainly make clear. The finest work by the Californian Guy Rose, for instance, transcends a routine painting by the more famous Childe Hassam, just as Hassam's finest pictures outshine a commonplace Monet, regardless of their market value. But there are different degrees of quality and originality within regional Impressionism. Among the eastern Impressionists, John Henry Twachtman devoted almost all his paintings created in the 1890s to the landscape of his several-acre estate in Greenwich, Connecticut; no two of these intimate glimpses of nature look alike, and each offers a special spiritual experience for the viewer. But one Sierra Nevada scene by the California Impressionist Edgar Payne, however majestic, can seem very much like another. We have taken such repetition into account in selecting the artists and in determining the number and range of their illustrations in this volume.

The motivations for the renewed interest in collecting and studying the California Impressionists have been varied. Generally, the explosion of interest in the art discussed and illustrated in this volume has grown out of the perpetual fascination with all manifestations of Impressionism throughout the world. At another level, economics may have been a factor, since examples deemed regional are still far more affordable than works by some of the most noted American Impressionists—Mary Cassatt, Childe Hassam, and Twachtman, for example—just as, initially, paintings by Hassam and Twachtman were less expensive than those by Monet and Edgar Degas. A more important, because more enduring, incentive than economics has been regional pride. This is especially the case in Southern California, where some of the earliest significant artistic developments were within the Impressionist mode. This meant that enough Impressionist paintings were produced, and subsequently rediscovered, to sustain continued interest in California Impressionism, with many new finds now surpassing those exhibited and published over the last fifteen years.

The definition of Impressionism is elusive and is further complicated by the diverse international and American manifestations of the style. In formal terms, historians, critics, and collectors tend to identify as Impressionist work that features a wide-ranging chromaticism; an absence of black and related neutral tones; a use of colored shadows, with emphasis perhaps on shades of purple and violet;[4] and the exploration of light and atmosphere, using colors that seem to glow on the canvas. Separate hues are often laid side by side in broken brush strokes—sometimes small and comma-shaped, as in some of Hassam's, and sometimes long and quill-shaped,

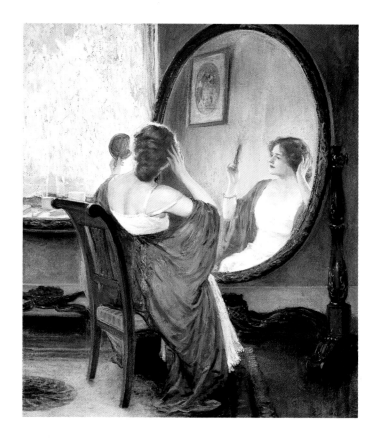

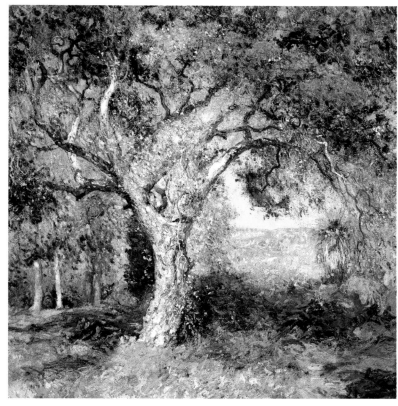

as in paintings by John Singer Sargent.[5] Because the artists eschewed the traditional smooth finish of academic work, the surfaces are often rough and scumbled; this was an approach heretofore identified with field sketches rather than with paintings meant to be considered as completed works. Indeed, in the United States, a heated critical controversy developed in the late 1870s concerning the concept of "finish" and the propriety of exhibiting sketches.[6] The combination of these strategies led to images that were indistinct and lacking conventional detail.

Conceptually, Impressionist painting has been identified as a development of Realism, an art concerned with the painting of modern life and the rejection of traditional academic subjects. Many Impressionists were devoted to painting landscapes and figures outdoors—subjects well suited to the artists' concern for light, color, and atmosphere. Such pictures concentrated on everyday activity, usually leisure pursuits rather than momentous events; they might even reflect the lives and activities of the artists and their associates. Such commonplace subject matter

5. Joseph Kleitsch (1882–1931).
Enchantment, c. 1922.
Oil on canvas, 22 x 18¼ in.
(55.8 x 46.3 cm). The Joan
Irvine Smith Collection.

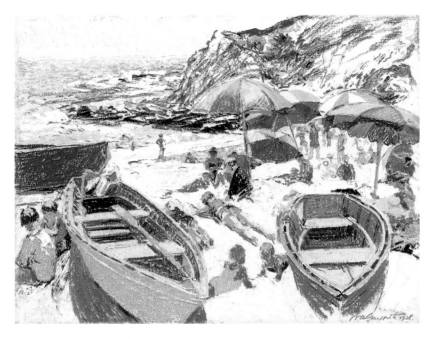

6. William Griffith
(1866–1940).
Diver's Cove, 1928.
Pastel on linen, 16 x 20 in.
(40.6 x 50.8 cm).
Wilson Burrows.

7. Clarence Hinkle
(1880–1960).
Santa Barbara Harbor, n.d.
Oil on canvas, 20 x 24 in.
(50.8 x 60.9 cm). Paul
Bagley Collection.

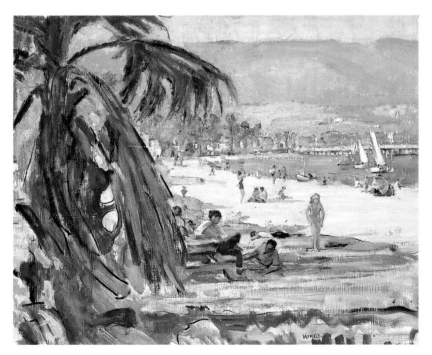

meant that viewers and patrons were expected to be attracted to the paintings' intrinsic beauty and dynamic technique more than to their subjects. Indeed, in America, the contemporaneous criticism by opponents of Impressionism attacked its lack of spirituality as much as its nontraditional methodology.[7] These paintings have only recently been analyzed as Realist images that do, in fact, embody psychological, symbolic, or spiritual concerns and values.

The designation of a painting as Impressionist is even more complex than these formal and conceptual parameters might convey. Impressionist styles evolved over the years from French Impressionism's beginnings in the early 1870s to the arrival of the first American colonists in Giverny some fifteen years later. Even among the pictures produced by the Americans active in Giverny, there are tremendous differences between those by the earliest colonists, such as Theodore Robinson (active there from 1887 to 1892), and those by the subsequent generation, associated with Frederick Frieseke from about 1908 on. The earlier men and women concentrated on the local landscape and aspects of peasant life, harking back to Jean-François Millet and the Barbizon school's figural traditions. The later artists painted mostly more intimate figural works, posing family and friends or models within the boundaries of their own dwellings. And the aesthetics changed: the color range favored by Frieseke's generation is heightened far beyond that of their predecessors, to such a degree that, although Frieseke himself stated that his primary aim was to paint sunlight, the results of his exploration of light and color tend to be overtly synthetic and nonnaturalistic.[8] For all their identification as Impressionist, these works seem to fall just as comfortably into the realm of Post-Impressionism; indeed, when the paintings of this group were exhibited, to great applause, in New York in 1910, some critics sought alternative designations, such as "Luminists" and the "Giverny Group."[9]

One member of this "Giverny Group" of American painters was Guy Rose, who is one of the outstanding and, today, perhaps the best known and most sought after of all the California painters identified as Impressionist. Rose was in Giverny in 1890 and 1891 (early in the history of the colony), returned for three months in 1894, was back again in 1899, and lived there from 1904 to 1912, becoming one of the artists to respond to the new aesthetic that appears to have been introduced by Frieseke around 1908.[10] Few of Rose's Giverny pictures from his relatively brief visits during the 1890s have come to light, but a work such as *Giverny Hillside* (c. 1891; Terra Museum of American Art, Chicago) is evidence that they were more Naturalist and distinct from his later, twentieth-century production (though unlike most of his colleagues of that period, Rose concentrated more on pure scenery than on figures). Rose took this heightened colorism back to California in 1914, when he settled in Pasadena and began to produce images

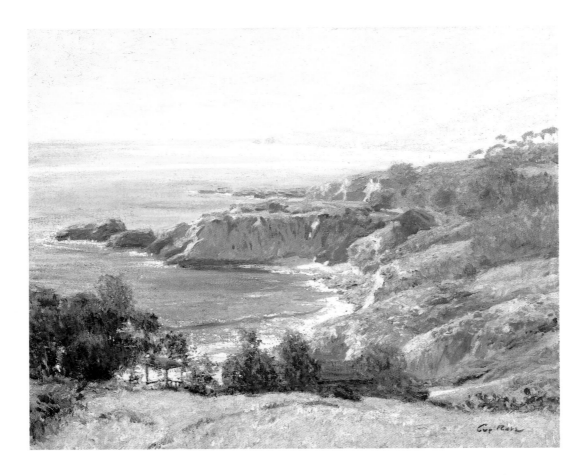

8. Guy Rose (1867–1925).
Laguna Coast, c. 1916.
Oil on canvas, 24 x 29 in.
(60.9 x 73.6 cm). Rose
Family Collection.

of the region's spectacular landscape, concentrating on those scenes that became the mainstay of California Impressionism—the southern coasts at Laguna Beach and La Jolla, the dunes and rocky shores of Carmel and Monterey farther north, and the towering Sierra Nevada.

Some of the themes associated with American Impressionism appear ubiquitous, and the subjects of some of the California painters are fairly indistinguishable from those of their eastern counterparts. Whether in the northeastern United States or in California, one finds an abundance of colorful garden scenes, with or without figures; sylvan landscapes; and paintings of women (often gowned in kimonos) absorbed in reading, daydreaming, or conversations at teatime. There are, of course, certain themes painted by eastern Impressionists that were seldom undertaken in California—scenes of modern urban life, for example. Childe Hassam and Colin Campbell Cooper repeatedly painted such subjects, especially set in New York City. But

OPPOSITE
9. Colin Campbell Cooper
(1856–1937).
Summer, 1918.
Oil on canvas, 50 x 60 in. (127 x
152.4 cm). John H. Surovek
Gallery, Palm Beach, Florida.

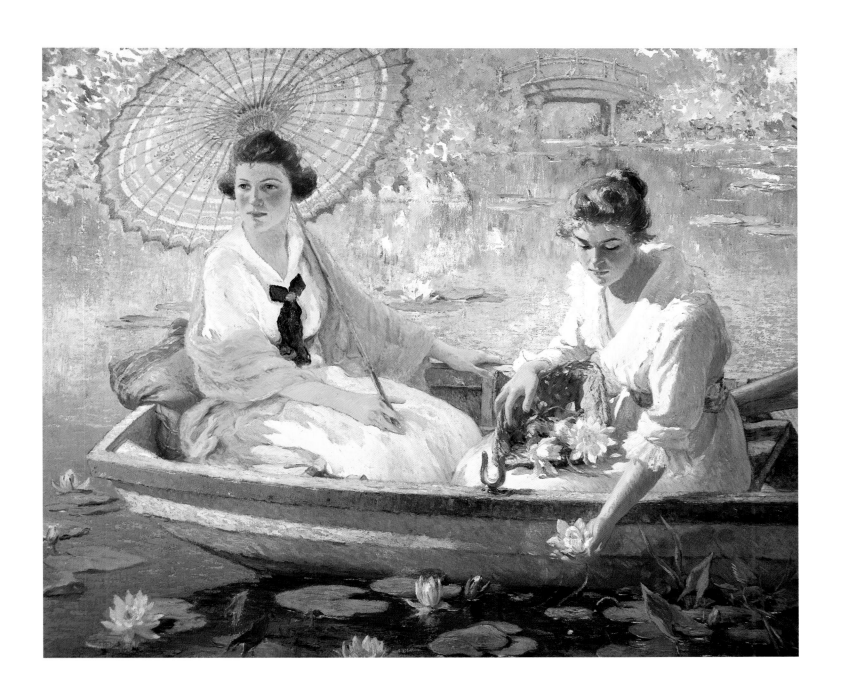

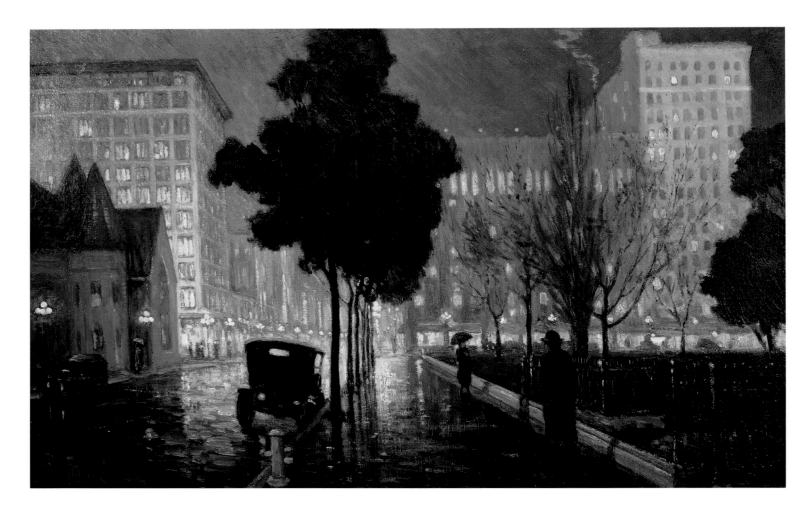

in Southern California, Frank Coburn stands nearly alone in his devotion to the cityscape in works such as *Rainy Night* (plate 10).

On the other hand, some themes painted by California Impressionists were rarely undertaken by the eastern Impressionists. Few painters in communities along the Atlantic explored the coastal terrain, which was a favorite subject of California painters at Laguna Beach, La Jolla, and Monterey. Mountain grandeur became the focus of such California painters as Paul Lauritz, Edgar Payne, Hanson Puthuff, and William Wendt, whereas most of the better-known eastern Impressionists (with the principal exception of Willard Metcalf) shunned those painting grounds revered by earlier generations of American landscapists—the Catskills, the Adirondacks, and

10. Frank Coburn (1862–1938). *Rainy Night*, 1917. Oil on canvas, 23 x 36 in. (58.4 x 91.4 cm). Los Angeles Athletic Club.

the White Mountains. Great carpets of wildflowers—above all, the golden California poppies—became the specialty of many California painters, such as John Gamble, William Jackson, Granville Redmond, and others (and almost all their colleagues painted this subject at least occasionally), but wildflower fields were absent from the repertoires of eastern artists.[11] A number of the California artists also used Impressionist strategies to interpret the desert landscape—a terrain unavailable to their eastern counterparts. And, of course, the old missions that the California Impressionists investigated with such enthusiasm—as had their predecessors Edwin Deakin and Henry Chapman Ford—found no equivalent in the East.[12]

11. Granville Redmond
(1871–1935).
A Foothill Trail, c. 1919.
Oil on canvas, 40 x 60 in.
(101.6 x 152.4 cm).
Private collection.

In formal terms, work by some of the California Impressionists might be taken for that of their eastern colleagues. This is true, certainly, of much of the painting by the Oakland artist William Clapp, whose finest works were painted in France, Spain, Cuba, or his native Canada before he settled in California. Likewise, were it not for his desert subjects and cottonwood trees, John Frost's paintings might well be identified with those by many eastern Impressionist painters. Several California artists also painted in the East, sometimes within Impressionist colonies there, as represented by Alson Clark's *The Old Mill, Old Lyme* (plate 14). In addition, some of the California Impressionists occasionally worked in a more Tonalist manner—see, for example, Maurice Braun's *Moonrise over San Diego Bay* (plate 15)—as did New England artists such as Metcalf; especially in their night scenes a single hue would replace the varied chromaticism of most Impressionist painting.

12. William Clapp (1879–1954).
 La Moisson, c. 1905.
 Oil on canvas, 29 x 37 in.
 (73.8 x 94.2 cm). Musée du
 Québec, Canada.

ABOVE, LEFT

13. John Frost (1890–1937).
 Cottonwoods, 1927.
 Oil on canvas, 40 x 50 in.
 (101.6 x 127 cm). Daniel
 Hansman and Marcel Vinh.

ABOVE, RIGHT

14. Alson Clark (1876–1949).
 The Old Mill, Old Lyme, n.d.
 Oil on canvas, 30 x 36 in.
 (76.2 x 91.4 cm). Maxwell
 Galleries, San Francisco.

As this study amply demonstrates, California Impressionists did not remain committed to a single aesthetic and some veered away from traditional Impressionist practice, though many of them reiterated certain landscape and figurative themes. In Rose's work, for example, his response to nature at Carmel and Monterey differed from his reaction to the brilliant sunshine of La Jolla, though such imagery can all be encompassed within a relatively elastic definition of Impressionism. Basically, two stylistic variations can be identified within the body of work defined as California Impressionism, each flavored by individual artists' idiosyncratic aesthetic choices. First, there is the adoption of vigorous, even blocky brushwork, a strategy that had no counterpart back east. Though some artists utilized this approach in their more pastoral landscapes, it is seen especially in Wendt's mountain paintings—particularly in his most renowned work, *Where Nature's God Hath Wrought* (plate 215)—as well as in work by his colleagues, to varying degrees. One might even interpret as Cézannesque such an artistic emphasis upon solid form achieved through slabs of color, reinforcing the grandeur of the sublime mountain subject (plate 16).

The second approach, practiced by many of these painters during some or all of their careers, overlaid their basic Impressionist manner with elements derived from Post-Impressionism and even later movements—Pointillist brushwork, heightened colorism, simplification, decorative patterning. The outstanding example of this can be found in the work of Joseph Raphael, one of

15. Maurice Braun (1877–1941).
 Moonrise over San Diego Bay, 1915.
 Oil on canvas, 22 x 28 in. (55.8 x 71.1 cm).
 Private collection.

16. William Wendt (1865–1946).
 I Lifted Mine Eyes to the Hills, 1912.
 Oil on canvas, 36 x 50 in. (91.4 x 127 cm). Fleischer Museum, Scottsdale, Arizona.

Northern California's greatest artists, whose patterned gardens and fields of flowers painted in Holland during the first half of the 1910s—such as *The Garden* (plate 155), *Fields and Flowering Trees (Noordwijk, Holland)* (plate 19), and *Rhododendron Field* (plate 17)—reflect, to some degree, the work of the French Divisionists Georges Seurat and Paul Signac. In turn, Raphael's still lifes, such as *Still Life with Bowl of Fruit, Blue Milk Jug, and Coffee Pot* (plate 18), are often extremely Cézannesque. Then, beginning around 1916, Raphael moved toward expressionism, as can be seen in *The New Blue Door* (plate 159)—a move that may be associated with the work of Vincent van Gogh, as Will South indicates (see chapter 5). Johanna Sibbett, Raphael's daughter, recalls her father poring over a book on van Gogh as carefully and intensely as a Bible.[13]

17. Joseph Raphael (1869–1950). *Rhododendron Field*, n.d. Oil on canvas, 30 x 40 in. (76.2 x 101.6 cm). Oakland Museum of California; Gift of Dr. William S. Porter.

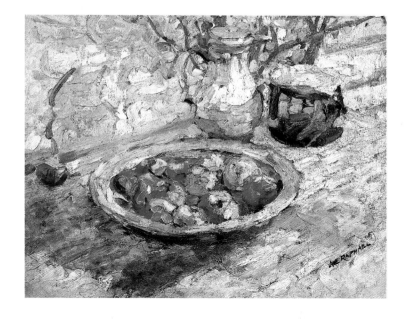

18. Joseph Raphael (1869–1950).
*Still Life with Bowl of Fruit,
Blue Milk Jug, and Coffee
Pot,* n.d.
Oil on canvas, 26½ x 31½ in.
(67.3 x 80 cm). Oscar and
Trudy Lemer.

19. Joseph Raphael (1869–1950).
*Fields and Flowering Trees
(Noordwijk, Holland),* c. 1912.
Oil on canvas, 27½ x 30 in.
(69.8 x 76.2 cm). Fleischer
Museum, Scottsdale, Arizona.

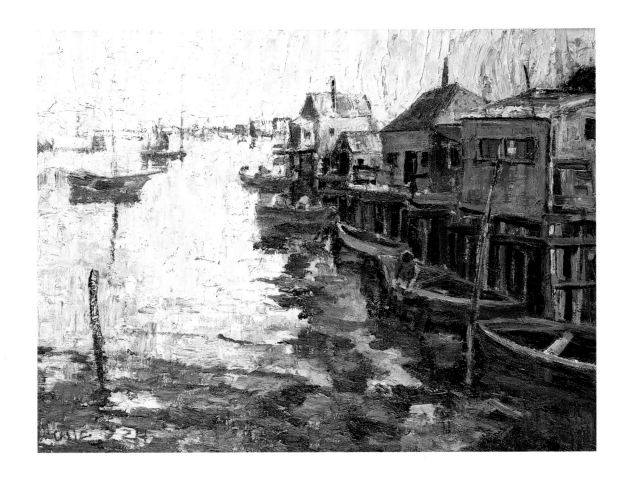

20. Selden Gile (1877–1947).
*Tiburon Waterfront
(Olga's Dock)*, n.d.
Oil on board, 24 x 30 in.
(60.9 x 76.2 cm). Fleischer
Museum, Scottsdale, Arizona.

There were frequent shifts in style. Some of the Bay Area's Society of Six—including Seldon Gile and his contemporaries August Gay and Maurice Logan—began painting in an Impressionist mode but soon took up the vivid brushwork, simplified form, and heightened colorism associated with French Fauvism; these influences may have been imparted by their association with Euphemia Charlton Fortune in Monterey. Among the Impressionists of Southern California, Franz Bischoff adopted strong, expressionist brushwork in *Monterey Cypress* (plate 21), as San Diego's Charles Reiffel did in most of his paintings—for example, *The Apple Tree* (plate 22). Donna Schuster painted pictures using traditional Impressionist strategies, such as *Morning Sunshine* (plate 201), at the same time as those with a nonnaturalistic, strident color range and stylized form, like *In the Garden* (plate 168); both are from 1917.

21. Franz Bischoff (1864–1929).
Monterey Cypress, n.d.
Oil on canvas, 24 x 30 in.
(60.9 x 76.2 cm). Paul Bagley
Collection.

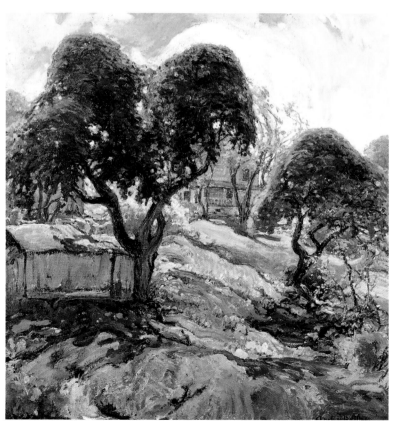

22. Charles Reiffel (1862–1942).
The Apple Tree, n.d.
Oil on canvas, 37 x 34 in.
(93.9 x 86.3 cm). Paul Bagley
Collection.

In the 1890s a few California painters had limited contact in France with some of the Impressionist masters. The most obvious site was Giverny, which Eric Pape had been the first Californian to visit, in September 1889.[14] The English-born Mary Brady appears to have been the first California woman to work in Giverny. She was there for over two months, beginning September 23, 1889, overlapping with the Californian Ernest Peixotto's first stay (both resided at the Hôtel Baudy); and she returned in May 1890 and again in October 1892. Brady was the model for the figure in Theodore Robinson's haunting *November* (plate 23), the last picture Robinson ever painted in the village.[15]

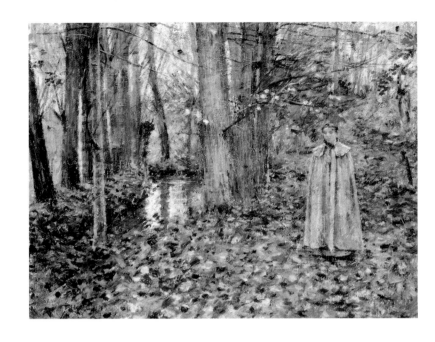

Peixotto probably induced Guy Rose and his companion, the artist Evelyn McCormick (the second California woman artist in the colony), to visit in 1890 and 1891. McCormick's *Garden in Giverny* (plate 95) testifies to her presence there and her application of Impressionist strategies to the theme of the vegetable garden, a theme (as opposed to Monet's legendary interest in the flower garden) that was in keeping with the concerns of Robinson and most of the other early artist-colonists in Giverny.[16] Although Rose knew Monet socially and wrote about him,[17] there is no documentation of familiarity between Monet and any other Californian; in fact, only a few American artists developed any kind of collegiality with Monet over the many decades of the colony's existence.

Somewhat more intriguing, though far less well documented, is the friendship between California's Lucy Bacon and Camille Pissarro (who lived in nearby Eragny around 1894), as well as her contact with Mary Cassatt. Although Bacon's *Garden Landscape* (plate 101) certainly reflects Impressionist strategies, her artistic persona is still too little known and studied to determine the possible extent of Pissarro's or Cassatt's influence on her—or hers, in turn, on other California painters after she returned to San Jose around 1898.[18] Bacon, back from her Parisian studies, was exhibiting works such as *A San Jose Garden* at the San Francisco Art Association in 1898. (Her niece Ruth married Robert K. Vickery, the son of William Kingston Vickery, an art impresario who in 1891 and 1893 was responsible for organizing the first Impressionist exhibitions in San Francisco.)

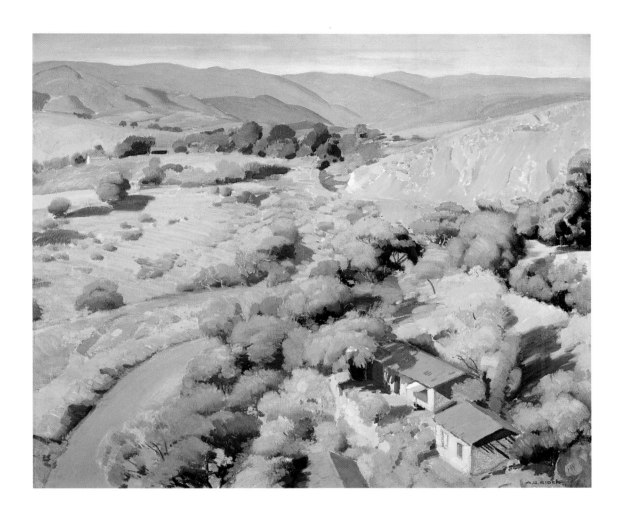

24. Arthur Rider (1886–1975).
Ortega Highway, c. 1928.
Oil on canvas, 30 x 35 in.
(76.2 x 88.9 cm). Joan Irvine
Smith Fine Arts, Newport
Beach, California.

Giverny was not the only European training ground for California Impressionists. More than half the California painters in this volume studied abroad—primarily in France but also in Germany and England. Much later, in the late 1910s, the Chicago-born, French-trained painter Arthur Rider worked in Spain with the great Spanish Impressionist Joaquín Sorolla after the latter had exhibited at the Art Institute of Chicago and taught classes there. Rider had already been familiar with Sorolla's painting, but it was this contact that began their long association, wherein Sorolla "breathed sunlight" into Rider's work.[19] Rider settled in Los Angeles in 1924; pictures such as his *Spanish Boats* (plate 212) reflect *Sorollismo* in both manner and theme.[20]

French Impressionist painting first appeared on public exhibition in California in March 1891, when Mrs. William H. Crocker lent Monet's *Sunlight Effect on the Riviera*, Eugène Boudin's *Scene in Holland*, and Pissarro's pastel of a woodland scene to the *Art Loan Exhibition of Foreign Masters*, organized by William Kingston Vickery for the Maria Kip Orphanage and the West Oakland Home for Destitute Children. Monet and Boudin were both specifically identified in the catalog as Impressionists. The same pictures by Monet and Pissarro were exhibited in March 1893 in another loan show arranged by Vickery, for the benefit of the Children's Free Ward and Building Fund of the Hahnemann Hospital in San Francisco. A slightly more substantial group of French Impressionist work was shown in San Francisco at the California Midwinter International Exposition of 1894, which included one work each by Pissarro, Pierre-Auguste Renoir, and Alfred Sisley, along with two Monets and three Boudins. The critics responded not unfavorably to these pictures, recognizing their aesthetic as more radical than that prevailing in contemporary California art, which was more Barbizon and Tonalist in nature.[21] And in January 1895, Mrs. Crocker once again lent French Impressionist works to Vickery's benefit exhibition for the orphanage; now her loans were much more impressive, including four paintings by Degas (two Dancers, two Bathers); two by Monet (A *Haystack* and *The Poplars*); and landscapes by Pissarro and Renoir. There is no indication, however, that these exhibitions of French Impressionist paintings had any immediate or enduring influence on the local art community.

The earliest *American* Impressionist pictures seen in the state were probably by California artists who had returned from Giverny. Several small landscapes that Rose exhibited in October 1891 at Sanborn, Vail and Company on his return to Los Angeles from Giverny that year reflected some degree of an Impressionist mode, including *Giverny Hillside* (c. 1891; Terra Museum of American Art, Chicago) and a view of a church, possibly Giverny's Sainte-Radegonde. Though Rose left for New York the following year, he exhibited works in the spring 1892 exhibition of the San Francisco Art Association. Two of these, *October* and *November*, may have been Impressionist landscapes, perhaps painted in Giverny in the autumn of 1890. (A decade later, in 1902, his very Impressionist *July Afternoon* [1897; Rose Family Collection], painted in Sullivan County, New York, was exhibited at the association's spring annual.)

McCormick, who by 1892 had returned to California and resided in San Francisco, also showed Giverny work in the association's spring 1892 exhibition. Presumably these were pictures painted in an Impressionist idiom, such as her large *Garden in Giverny* (plate 95), which had been shown at the Paris Salon in 1891 along with her *Garden in Normandy, Cottage at*

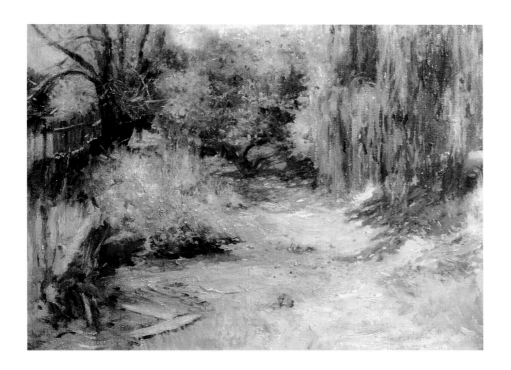

Giverny, and *Wheat Field at Giverny*. Indeed, McCormick may have been one of the first artists to apply Impressionist strategies to the California landscape, for she also exhibited *Morning at Pacific Grove* in the association's 1892 exhibition. In January 1893 she exhibited *Afternoon at Ginerney [sic], France* (unlocated) in the art section of the Twenty-seventh Industrial Exhibition of the Mechanics' Institute in San Francisco (it was noted in the catalog that the picture had been shown in 1891 in the "Berlin Exhibition").[22] McCormick was to exhibit one more Giverny picture at the San Francisco Art Association in 1894, but her appearances there were infrequent for the rest of the decade, and by 1900 her scenes of Giverny had given way to those of Monterey, where she moved after the devastating San

25. Ernest Peixotto (1869–1940). *Clearing by a Willow, San Rafael*, 1893. Oil on canvas, 14 x 18 in. (35.5 x 45.7 cm). The Schwarz Gallery, Philadelphia.

Francisco earthquake and fire of April 1906.[23]

Peixotto, too, had returned from Giverny for a two-year stay in San Francisco, and in 1892 he exhibited Giverny pictures at the Art Association, including *Cemetery in Giverny* (unlocated). Several of his works (which were probably Giverny scenes) appeared in the 1893 Mechanics' Institute exhibition. Unfortunately, Peixotto's development remains unclear, since there are so few located paintings to demonstrate how much Impressionism affected him at the time. An exception is his *Clearing by a Willow, San Rafael* (plate 25), which suggests that Peixotto had indeed absorbed the principles of Impressionism during his five stays in Giverny from 1889 to 1891. Conjectures about his Impressionist style are bolstered by his recollection that in Giverny, painters "called me 'Pinkey Green' because I was strongly impressed by the impressionist method of which this was the era and many a battle did I wage in favor of it as a young man!"[24] McCormick and Peixotto were the only Californians with Giverny connections included in the 1894 California Midwinter International Exposition in San Francisco (Mrs. R. J. Taussig lent an otherwise unidentified study by William Merritt Chase to the 1895 loan show in San Francisco).[25]

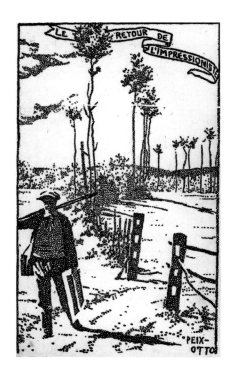

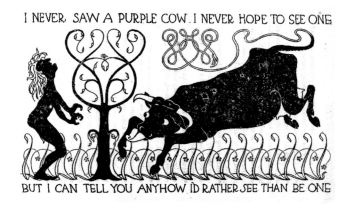

Peixotto, who returned to Giverny on several occasions in 1894, was back in San Francisco by September 1895, when he produced a cover design for the new avant-garde magazine the *Lark*. *Le Retour de l'impressioniste* (plate 26), which appeared on the October issue, depicts a painter, with his equipment, passing through a field. It was based on a drawing in which instead of outlines and shading, Peixotto used only tiny circles, presumably meant to simulate the Impressionist technique in the graphic medium. In the first issue of the *Lark* (May 1895), its artist-editor, Gelett Burgess, had produced an almost Art Nouveau design to accompany his famous poem "I never saw a purple cow / I never hope to see one / But I can tell you anyhow / I'd rather see than be one" (plate 27). Given the publication of this poem so soon after the appearances of French and American Impressionist paintings in San Francisco exhibitions, and especially given Burgess's reference to the purple color that was so closely associated with Impressionism, this little verse must be viewed as a witty satire on that movement.[26] In 1896 Peixotto showed several Giverny paintings in an exhibition held by the Guild of Arts and Crafts in San Francisco, and the following year—although he was living in New York at the time—some of his Giverny scenes were hung at the Bohemian Club in San Francisco.

In the years after the 1906 earthquake, Impressionism took hold in small art colonies outside the Bay Area, especially in Monterey, about a hundred miles down the coast, where McCormick and her fellow Giverny alumna Mary Brady (known especially as a colorist) were identified in 1908 as "the pioneers of the present settlement of Monterey as a mecca of art."[27] Brady had begun painting scenes in Monterey as early as 1896, when she exhibited one in New York at the Society of American Artists (while listing a Broadway address). By 1898 she was back in her native San Jose, showing *Sand Dunes* (unlocated) at the spring annual of the San Francisco Art Association (perhaps the same picture she had displayed in New York two years earlier).[28] To at least some degree, the Carmel-Monterey colony of artists (like the one that developed in Pasadena) might be aligned in their exploration of Impressionist strategies to the

28. Clark Hobart (1868–1948). *Between Showers, Monterey*, n.d. Oil on canvas, 24 x 30 in. (60.9 x 76.2 cm). Fleischer Museum, Scottsdale, Arizona.

PAGES 32–33

29, 30. Evelyn McCormick (1869–1948). *Carmel Valley, Pumpkins* (and detail), n.d. Oil on canvas, 32 x 39 in. (81.3 x 99.1 cm), framed. Los Angeles County Museum of Art; Purchased with funds provided by Robert and Kelly Day.

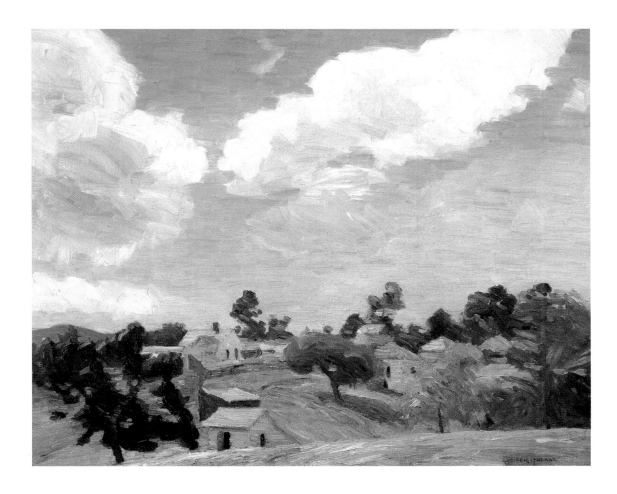

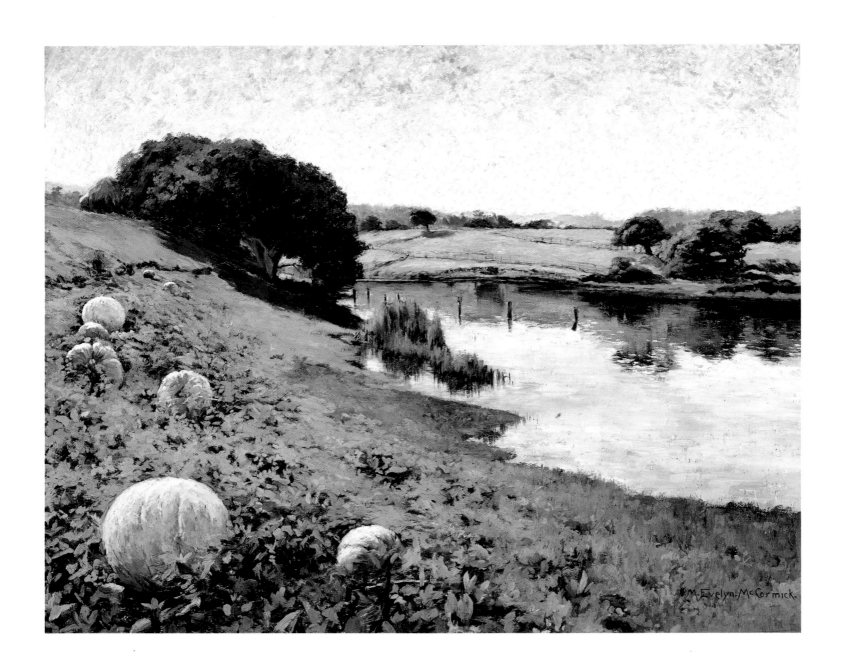

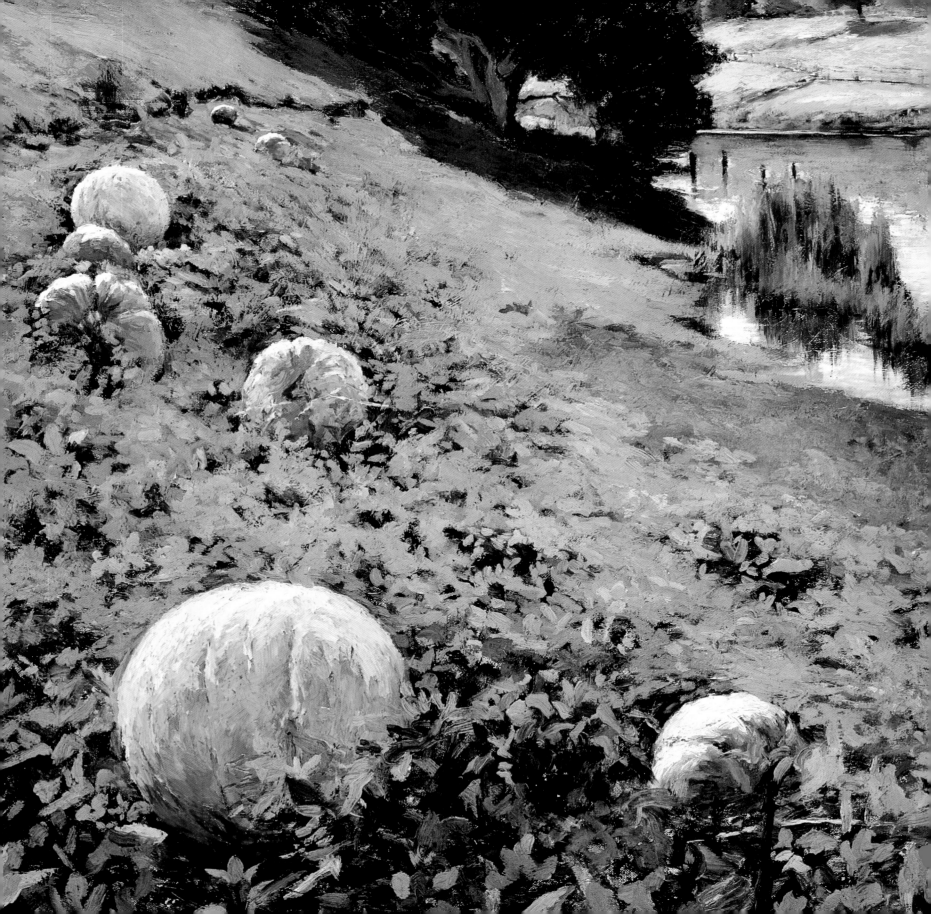

community that first developed in Giverny in the late 1890s, especially after Guy Rose began to paint extensively in Carmel and Monterey, starting in the summer of 1918.

Despite the arrival of Impressionism in Northern California with the display of French Impressionist works in San Francisco and the showing of Giverny scenes by California painters in the early 1890s, and despite the strengthening presence of California Impressionism in nearby art colonies during the first decades of the century, Impressionism seems to have had little impact on the San Francisco art community. This was almost surely due to the dominance of late Barbizon and Tonalist aesthetics embodied in the powerfully influential works of William Keith and Arthur Mathews. However, it was noted in the 1896 annual of the San Francisco Art Association that *Blue Gums and Poppies* by Samuel H. McCrea was "a rather clever imitation of Monet," though at the same time, "the purple mountains and trees and vivid green grass have a touch of truthfulness to California scenery in early spring time."[29] In any case, McCrea, who gave his address as both Los Gatos, California, and Chicago, may have been only a visitor to Northern California, and he seems to have immediately vanished from the scene.

By the early twentieth century, the major development of Impressionism in California had effectively shifted to the south. Nancy Moure has identified the 1889 painting *Santa Catalina Island*—a Southern California subject—by San Franciscan Ernest Narjot (plate 31) as the earliest California Impressionist picture. However, it seems doubtful that he was consciously exploring this then-radical aesthetic—the picture seems to be a quickly sketched equivalent of similar shore themes painted by such eastern artists as Alfred Bricher.[30] Noting the increased teaching of landscape classes from nature during the 1890s, Moure has also identified a group of works by Los Angeles–area artists of the period—Benjamin Brown, Fannie Duvall, John Bond Francisco, William Lees Judson, Gardner Symons, and Thaddeus Welch—as reflecting some tenets of Impressionism.[31] But even though all of these artists painted pictures that in some way share Impressionism's greater painterliness, brighter sunlight, or more intense coloration, none seems to me to be truly informed by the spirit of Impressionism. Moure has also suggested that Brown and Granville Redmond might be claimed as the area's first important resident Impressionists, but she concedes that their early work—"tight, uniform, conservative and academic" in brushwork, and with color "subdued and low-key"—would not appear Impressionist to us today.[32]

Admittedly, contemporary writers would very occasionally identify some of these pictures— including several that Judson exhibited at the art gallery at the Los Angeles Chamber of Commerce in 1894—as "impressionist," but their terminology may have been extremely flexible.[33]

31. Ernest Narjot (1826–1898). *Santa Catalina Island*, 1889. Oil on canvas, 9½ x 14½ in. (24.1 x 36.8 cm). Oscar and Trudy Lemer.

Judson's "Impressionism" is especially suspect, given that three years later he published an amusing satire called "How I Became an Impressionist." In it he recounted that a number of his early works had achieved acclaim as modern after they were damaged by rain from a leaky roof, while a new personal vision resulted from his wearing old-fashioned "chromatic glasses" that conditioned a pair of "impressionist eyes"—blue on one side, orange on the other, and the result a blurred purple haze.[34]

Yet by the closing years of the first decade of the twentieth century, and possibly even earlier, there may have been a number of landscape painters who had visited or settled in Southern California and begun to adopt the strategies of Impressionism. Moure has proposed Redmond, Elmer Wachtel, and William Wendt as the leading landscape painters in Los Angeles during that decade, each working "in his own particular variation of the Impressionist style."[35] However, few of Wachtel's paintings from these years have been located, and Redmond's pictures from the first decade of the century appear overwhelmingly Tonalist, with little chromatic vibrancy, although he may have worked with more vivid colors between 1903 and 1905.[36] Moure's observations do, however, appear true of Wendt. His *Poppy Field, California*, exhibited at the

33. William Wendt (1865–1946). *Summer Hillside*, c. 1906. Oil on canvas, 24 x 36 in. (60.9 x 91.4 cm). The Irvine Museum, Irvine, California.

Art Institute of Chicago in 1897 (then owned by Dr. A. J. Ochsner), would almost surely have been an Impressionist picture; it was probably similar to *The Scarlet Robe* (unlocated), reproduced in 1900 in one of the earliest articles on Wendt and described in very Impressionist terms (and almost identical to *Red Poppies*, plate 32).[37] But by and large, the work of Redmond and Wachtel seems difficult to identify with Impressionism until after 1910.

Meanwhile, Impressionists from elsewhere in the United States had begun to visit and paint in California at the beginning of the twentieth century. One of the earliest of these was Theodore Steele, the leading figure among the association of painters that the writer Hamlin Garland had defined in 1894 as the "Hoosier Group."[38] Trained in Munich, Steele had gradually traded the dark, Tonalist manner he learned there for the strategies of Impressionism. He practiced the new style conservatively at first, but by the time he traveled west in 1902 to visit family members (following the death of his first wife in 1899), he was fully committed to its tenets. He painted Impressionist pictures around Puget Sound in Washington, along the Oregon coast at Newport, and on Nye Creek Beaches in Oregon. Steele then traveled through

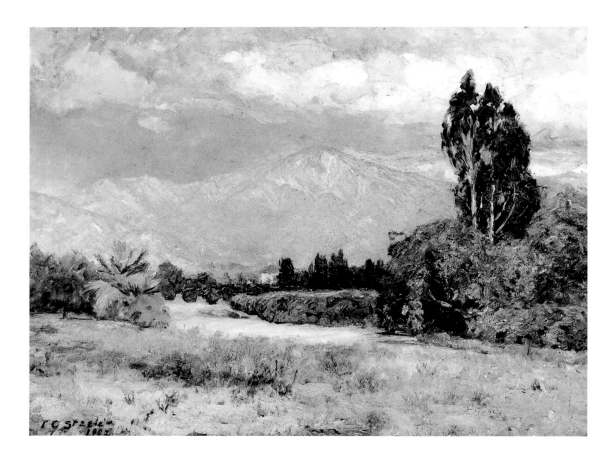

34. Theodore Steele (1847–1926). *Redlands*, 1902. Oil on canvas, 22 x 29 in. (55.8 x 73.6 cm). Private collection.

San Francisco, where he met William Keith, and continued on down to Redlands (near San Bernardino) in September—no doubt to meet his son, Shirley, who had moved there in 1900. He remained in Redlands until mid-November, painting a series of colorful mountain and forest landscapes as well as views of the town (plate 34). In California, Steele found

> the local color strong and vivid . . . the wonderful color effects of the landscape is [*sic*] due far more to the atmosphere than anything else. . . . The air seems to vibrate with flashes of colored light, rose and violet red and blue and orange, and this with a vividness and intensity I have never seen before. So brilliant does this become at times, at sunset and twilight, that it has often made me think of aniline dyes, and by this I do not mean to disparage the color effect at all, but to express the brilliant color quality as compared with the softer duller color of our ochres and vegetable colors

like the madders. . . . In the air there was nearly always a slight haze, but a haze that did not obscure so much as with us, nor pass into gray as it thickened as ours is apt to do.[39]

Steele may have been the first fully committed Impressionist, other than Wendt, to paint the Southern California landscape. Except for his visit with Keith, we have no record of any relationship between Steele and the California art community nor of any exposure of or reaction to his art.[40] Yet Steele was exceptionally perceptive concerning the pictorial future of the California landscape. By 1902 Keith had been working for some time firmly in the Barbizon mode and, according to Steele, Keith found the grandeur of the California landscape no longer paintable. But Steele disagreed:

> I do not think his conclusions that these subjects are unpaintable is correct, but they will be painted by artists of the Monet type, for one can see Monets everywhere. The same color charged air, the same scintillating radiance that Monet finds in the south of France, though with nobler forms and greater compositions than one usually finds in his pictures. I have no shadow of a doubt that some day there will develop a school of painters on this western coast, that can fully interpret these great subjects, and give to the world a new and powerful school of art.[41]

Steele, who had already developed his own Impressionist style of painting within the flat, uniform scenery of Indiana—and established himself as the leader of that region's Impressionist group—clearly saw the potential of the opulent California landscape for inspiring "nobler forms and greater compositions." His words, pronounced in 1903 after a second trip to California, may be the most prescient observation concerning the direction that art in California would take in the early twentieth century.[42]

Steele presumably did not see any paintings by Wendt or other Southern California painters while visiting inland, at Redlands, in 1902 and 1903. Nonetheless, he almost certainly would have been familiar with Wendt's work by then, for Steele was active in the exhibitions of the Society of Western Artists, which traveled throughout the Midwest, beginning with its first annual exhibition in 1897. Wendt himself had been a Chicago artist prior to settling in Los Angeles in 1906; he had visited and painted in California on numerous occasions, and some of those pictures had been shown at the society's annuals.[43] Steele would have been aware of Wendt's Impressionist pictures of California if he had visited the Art Institute of Chicago for an Annual Exhibition of Works by Artists of Chicago and Vicinity, a series that was also instituted

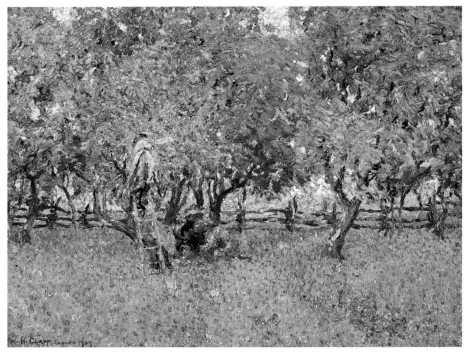

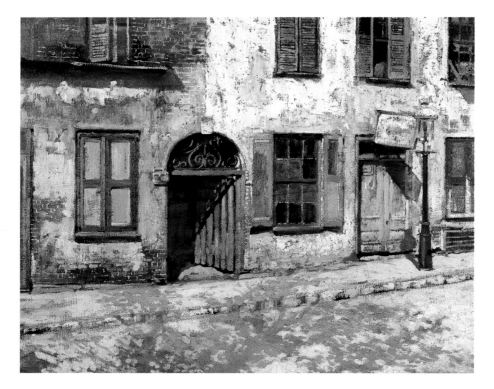

35. William Clapp (1879–1954).
Untitled (Reclining Nude), n.d.
Oil on Masonite, 24¼ x
32½ in. (61.5 x 82.5 cm).
The Buck Collection.

36. William Clapp (1879–1954).
In the Orchard, Quebec, 1909.
Oil on canvas, 29 x 36 in.
(73.9 x 92.2 cm). Art Gallery of
Hamilton, Hamilton, Canada;
Gift of W. R. Watson, 1956.

37. Alson Clark (1876–1949).
Old Houses, Charleston, 1919.
Oil on canvas, 28 x 32 in.
(71.1 x 81.2 cm). Paul Bagley
Collection.

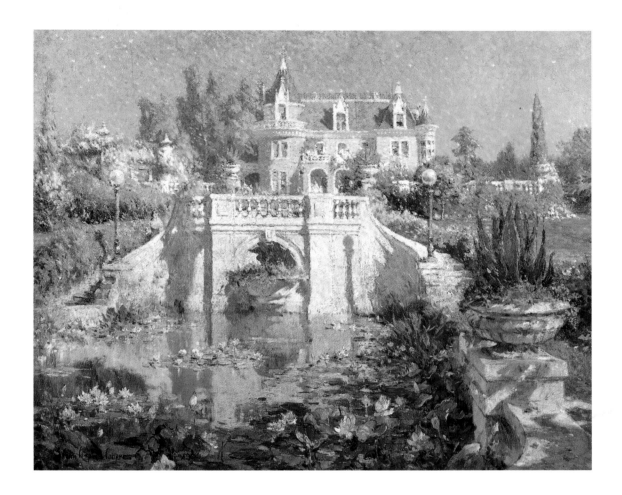

38. Colin Campbell Cooper
(1856–1937).
Kimberly Crest, n.d.
Oil on canvas, 29½ x 36½ in.
(74.9 x 92.7 cm). Fleischer
Museum, Scottsdale, Arizona.

in 1897. Or Steele might have seen what amounted to Wendt's one-artist invitational show of forty-seven works there in 1899—part of the museum's Annual Exhibition of American Paintings and Sculpture, where Steele himself had two works on view.

Other painters—among them William Clapp, Alson Clark, Colin Campbell Cooper, and possibly John Frost—adopted the Impressionist aesthetic in the first decade of the century, but none of them settled in California until years later—Clapp in 1917, Frost and Clark in 1919, and Cooper in 1921. Guy Rose returned to Southern California in 1914. Maurice Braun, originally working somewhat independently in San Diego, where he had settled in 1909, may be another of the California artists to have adopted the strategies of Impressionism early on. Yet as early as the beginning of the second decade of the century there was a body of painters in

Southern California clearly identified as Impressionist. Antony Anderson, the very perceptive art critic for the *Los Angeles Times* and unquestionably the major critical force in the region (a man who would champion the local Impressionist faction until his retirement in the mid-1920s), declared in December 1911: "By now we are getting accustomed to impressionism in Los Angeles. Few of us dare laugh at it, for fear that we may become the butt of our own jokes. We are beginning to take it seriously, to study it, to enjoy it. We've had [Jack Gage] Stark, [Detlef] Sammann, Helena Dunlap, [Ernest] Browning Smith."[44] What is remarkable is the fact that Anderson identified the movement in Los Angeles with four painters who today remain almost entirely unknown. Not one of them has even appeared in the previous studies and exhibitions of California Impressionism since the 1980s, and few of these artists' works are even located today. Certainly, then, there is still much to discover about the origins of California Impressionism.

The perception of the increasing appearance of Impressionism among Southern California painters essentially can be pinpointed to the year 1911. One revealing clue lies in the activities and membership of artists' organizations in Los Angeles. Reviews of the exhibitions held by the all-male Painters' Club, which had been formed in 1906, reveal that Impressionism was not yet recognized as a critical issue in the group's shows—whether the monthly display of pictures hung randomly by the members or their two more prestigious annuals of October 1908 and November 1909 (the year the club disbanded). Relatively few of the participants went on to become identified with the movement (the exceptions being Franz Bischoff, Carl Oscar Borg, Frank Coburn, Hanson Puthuff, and Wendt). Most of the pictures in the Painters' Club shows were acknowledged as promoting the scenery of California, but the club's aesthetics were never perceived as avant-garde.[45] However, by 1911 the term *Impressionism* appeared with increasing frequency in reviews of the early exhibitions of the California Art Club, which had been established in Los Angeles in 1909 as a successor to the Painters' Club. The new group held its first exhibition in the ballroom of the just-constructed Hotel Ivins in January 1911. One-artist shows by some of the members, including Dunlap, Sammann, Smith, and Stark—the artists Anderson identified in his column—were especially linked to the style.

Stark may have been the first artist exhibiting in Southern California to be recognized as an Impressionist. Midwestern critics had already identified him with Impressionism in 1908, when he held an exhibition of sixteen canvases at the Findlay Art Gallery in Kansas City that September.[46] In March 1909 he settled in Silver City, New Mexico, after studying in Paris.[47] In Los Angeles, Anderson titled his review of a small show of Stark's pictures mounted at the

39. Jack Gage Stark (1882–1950). *California Landscape*, c. 1910. Oil on canvas, 21¼ x 25½ in. (53.9 x 64.7 cm). Fleischer Museum, Scottsdale, Arizona.

Blanchard Music and Art Building in November 1909 "Pictures by an Impressionist" and noted, "Our young impressionist has used pure color, purples and greens, all through his beautiful 'Sur la Marne.'"[48] That winter Stark painted at La Jolla.[49] In early November 1911, a review of Stark's exhibition at the Steckel Gallery was subtitled "Stark's Impressions" and noted:

> In the eight pictures and ten sketches from the brush of Jack Gage Stark we have the last word of this brilliant young impressionist. Educated in Paris, surrounded by the mad artistic iconoclasm of the twentieth century, the talented American still kept a level head, and though his art is "new" it is not a wild and fantastic revolt against all tradition, but a vigorous grafting of the impressionist expression of Manet and Monet. Like them, his search is for more light and atmospheric vibration. He is the most modern of moderns in technique, and belongs to the school which is known as the Luminarists.[50]

In Silver City, New Mexico, Stark held an exhibition in November 1911 of twenty pictures, which critics again identified as Impressionist,[51] and the following summer he built a large and noteworthy studio there. Stark regularly visited and exhibited in Southern California until early 1913, by which time he had moved permanently to the state, first living in Los Angeles and/or Santa Monica and eventually settling in Santa Barbara.[52]

Detlef Sammann, a painter from Schleswig in Germany, had gained fame as a decorator, first for the court in Dresden and then in New York City, after he immigrated to the United States in 1881. He was even awarded commissions from the White House during the presidency of Benjamin Harrison. Sammann continued his decorating practice after he moved to California in 1898, settling in Pasadena for his health in 1900. Toward the end of 1910 he turned to outdoor landscape painting (again, partly for his health), utilizing Impressionist strategies (plate 40). He then completely renounced his former decorative work, which had culminated in his 1910 murals painted for the Indian Room of the Edward L. Doheny house in Los Angeles.[53]

Anderson noted that, beginning with the work shown previously at Sammann's exhibition at the Blanchard Building in March 1911, his art had "changed radically, for he has swung over from the camp of the conservatives to the gay picnic grounds of the impressionists. And I think he has burnt all his ships behind him."[54] Sammann told Anderson that "he now wonders how he could possibly have painted in the old way . . . and, in fact, declar[es] that he would be quite content to paint a haystack through the variations of days and seasons."[55] In that same review, Anderson made the claim that "within the last few years Mr. Sammann has enrolled

himself among the ranks of the impressionists. . . . He has become a faithful follower of Manet and Monet and their school." Anderson's second review of the same Blanchard show was subtitled "Pictures by an Impressionist."[56] And Anderson's December 31, 1911, pronouncement on the emergence of California Impressionism followed a review of a show featuring Sammann that opened the following day at the new Daniell Gallery on South Broadway in Los Angeles.

In Ernest Browning Smith's first one-artist show, held at the Blanchard Building in May 1909, there was no suggestion of Impressionist affiliation; however, in a March 1911 critique of an exhibition of his work there, Smith was identified as "an impressionist in his technical methods."[57] The critics' identification of Helena Dunlap with Impressionism began in October 1911, when *The Open Door* (unlocated) appeared in her first one-artist show at the Steckel Gallery. It elicited Anderson's enthusiastic description of the picture as "a beautiful bit of impressionism."[58]

40. Detlef Sammann painting outdoors.

This group of four Southern California painters appears to have remained the central corps of California Impressionism for several years. In 1913 Everett C. Maxwell, in reviewing the California Art Club's third annual exhibition at the Blanchard Building, wrote specifically of "the modern impressionism of Helena Dunlap and Jack Gage Stark."[59] Yet at least some of this first contingent of Southern California Impressionists may have moved away rather quickly from their early involvement with Impressionism. Maxwell also mentioned in 1913 that Dunlap was developing "strongly in the direction of the post-impressionistic movement" and went on to remark in the same paragraph that "Detlef Sammann showed great improvement in his latest works over his spotty method of applying paint a year ago."

Sammann may have carried his brand of Impressionism to Northern California after moving to Pebble Beach, near Monterey, in 1912. There he became renowned for his coastal scenes, which remain his most famous paintings. That April he began exhibiting with the San Francisco Art Association, where his work was well received; one San Francisco critic subtitled his review of the show "Portraits by Wares [*sic*] and Landscape by Sammann among the Most Notable."[60] That same year Sammann also showed locally with the Hotel del Monte Art Gallery in Monterey, where Smith had been exhibiting since 1909. In 1915 Sammann was a contributor to the First Exhibition of Painting and Sculpture by California Artists, held at the Golden Gate Park Memorial Museum in San Francisco, but by then he appears to have adopted a stronger, more naturalistic approach, with a deeper, less colorful palette—as evident in *Monterey Cypress, Pebble Beach* (plate 126). Sammann may have felt these features to be more appropriate to the drama of the Northern California coast.

41. Helena Dunlap (1876–1955).
Paris Studio, prior to 1911.
Oil on canvas, 22 x 18 in.
(55.8 x 45.7 cm). Anita
Dunlap.

The activities of the California Art Club became increasingly associated with Impressionist painting in Southern California. The club's second annual show, mounted at the Blanchard Building in November 1911, seems to have been dominated by the artists already identified with Impressionism, such as Sammann, Stark, Dunlap, and Wendt, as well as by many who would soon be among its leading practitioners—Franz Bischoff, Benjamin Brown, Jean Mannheim, Hanson Puthuff, William Ritschel, Jack Wilkinson Smith, and Gardner Symons. Over the next decade, almost all the remaining artists to be associated with Southern California Impressionism would exhibit with the California Art Club—Borg, Braun, Frank Cuprien, and Karl Yens in 1912; Anna Hills in 1913; Fernand Lungren, John Rich, William Silva, and Jack Wilkinson

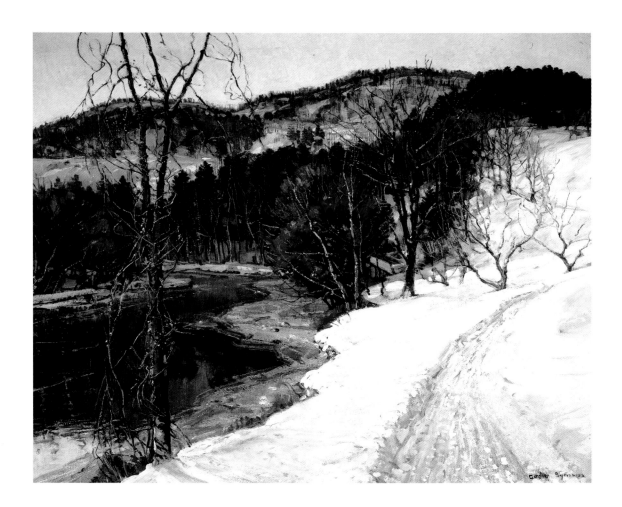

42. Gardner Symons (1862–1930).
The Mountain Road, c. 1920.
Oil on canvas, 52 x 62 in.
(132 x 157.4 cm). Private
collection.

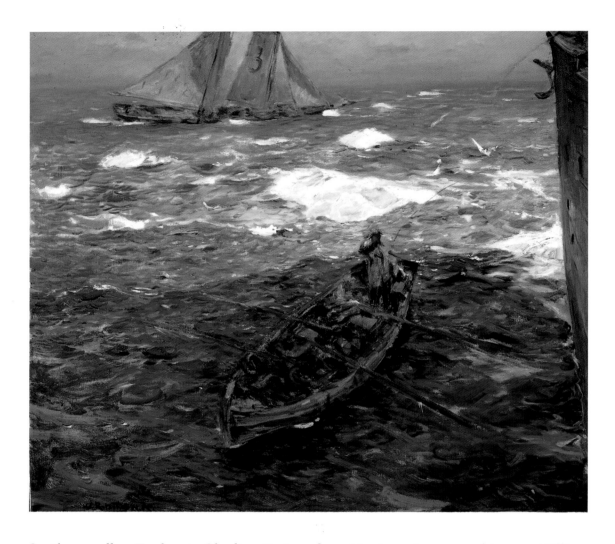

43. William Ritschel (1864–1949).
Pilot on Board, n.d.
Oil on canvas, 36 x 40 in.
(91.4 x 101.6 cm). Private
collection.

Smith, as well as Euphemia Charlton Fortune from Monterey, in 1914; and in 1915, William
Cahill, Meta Cressey, Guy Rose, Donna Schuster, and C. P. Townsley, as well as San Fran-
cisco's Anne Bremer. After Richard Miller and Dana Bartlett began to exhibit in 1916, Edgar
Payne and Orrin White in 1917, Clarence Hinkle and Christian von Schneidau in 1918, and
Alson Clark, John Frost, Sam Hyde Harris, and Paul Lauritz in 1920, the resident Southern
California Impressionists were almost all active members of the California Art Club.[61]

Discussions of California Impressionism have traditionally begun with the significant ex-
hibition of Impressionist art at the Panama-Pacific International Exposition in San Francisco in

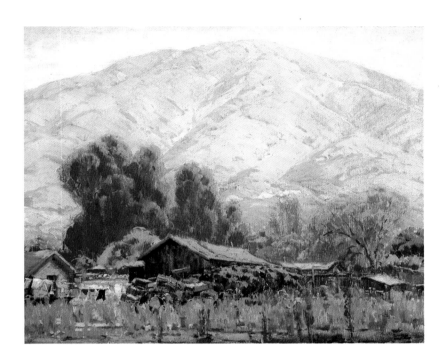

44. Sam Hyde Harris (1889–1977). *Morning Glory*, n.d. Oil on canvas, 30 x 36 in. (76.2 x 91.4 cm). Paul Bagley Collection.

1915, and the following fifteen years certainly constitute the flowering of the movement. But, as we have seen, Impressionism at the exposition did not emerge unheralded. The first fifteen years of the century witnessed the movement's origination, with interest accelerating during the years immediately before the great fair. This interest was further stimulated by the appearance in California of paintings by acclaimed Impressionist masters and, in some cases, by the presence of the nationally known painters themselves. The extent of their interaction with, and their impact upon, the local artists is difficult to determine, especially since the contacts between established Impressionists and California artists have not yet been investigated.

Frederick Frieseke's time in California, for example, and the exposure of his art there have been little explored. After his parents moved to the state, the painter and his wife left the artists' colony in Giverny late in 1911 to visit them, going first to New York City and then to Los Angeles. The Paris-trained Frieseke had been exhibiting in the United States since 1901, but he appears to have evolved his distinctive and highly influential mode of sparkling, light-filled Impressionist figure painting only about 1908, and his participation in the breakthrough exhibition of the Giverny "Luminists" had just occurred at the Madison Art Galleries in New York in December 1910. By 1911 Frieseke had formed an association with the prestigious Macbeth Galleries in New York, and surely one of the primary motivations for his trip to the United States was to firm up what would be a successful commercial affiliation for many decades.

Frieseke arrived in Los Angeles in December. Although it was an excursion made for personal rather than professional reasons, his trip nevertheless brought to the city a new star on the Impressionist horizon. There has not yet been any documentation of his interaction with local artists, nor did he exhibit his paintings publicly in Los Angeles, but while in the city Frieseke did paint a group of pictures in his relatively new and celebrated mode. None of his California paintings have yet been identified, but these canvases were likely akin to his *Pink Parasol* (plate 45), which was probably produced in Giverny. Antony Anderson saw Frieseke's

California pictures while they were being framed at one of the city's most important art emporiums, the Kanst Art Galleries, which had just been established out of the older firm of McClellan-Kanst. Anderson reported that he

> had stepped into the Kanst studio, to find five wonderful paintings of gardens under sunlight by Frederick C. Frieseke, who had run out from New York to visit his parents here, and who painted these five impressions of gardens with figures on his brief stay. One of them is a splendid portrait of Frieseke's wife, who sits under a blue sunshade near red geraniums that lift their flamboyant blossoms over her head. All are stunning things, but sad to say the artist is under contract not to show them anywhere but in New York. They were being framed at Kanst's. They would be eye-openers to our Los Angeles public-educational skyrockets. Yet, Frieseke was a perfectly proper and academic painter a year or two ago, just as Sammann was.[62]

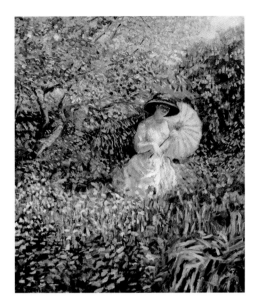

45. Frederick Frieseke
 (1874–1939).
 Pink Parasol, c. 1913.
 Oil on canvas, 32⅛ x 25½ in.
 (81.5 x 64.7 cm). Private
 collection.

The equating of Frieseke and Sammann is all the more intriguing given the latter's total obscurity today. One wonders, too, if any local artists might also have wandered into Kanst's gallery while the paintings were there.[63]

Frieseke was inspired by California—by the mild climate and brilliant light that supported the development of Impressionism around Los Angeles. He wrote to William Macbeth: "This is a perfectly wonderful climate—brilliant sun every day and nearly summer heat without the discomfort. We have a friend in Pasadena who has a beautiful garden and I have been able to do several canvases which I believe are good." Frieseke went on to inform Macbeth that several dealers—presumably Kanst and others—had seen the paintings and believed they could sell them, but the artist had informed them that they would have to arrange this with Macbeth.[64]

Whether Macbeth agreed to allow any of the canvases to remain in California is not known. It is possible they stayed, since none of the fifteen paintings in Macbeth's first exhibition of Frieseke's works (in January 1912) was specifically described as a California scene, nor did the New York critics so identify any of these works. Frieseke seems to have been admired in Los Angeles, for he was represented by his painting *Fox Gloves* (sold Sotheby's, New York, May 25, 1988) at the loan exhibition that opened the Fine Arts Gallery of the new Los Angeles Museum of History, Science and Art in November 1913.

The Los Angeles Museum show brought together works by emerging local Impressionists such as Franz Bischoff, Maurice Braun, Benjamin Brown, Frank Cuprien, Helena Dunlap, John

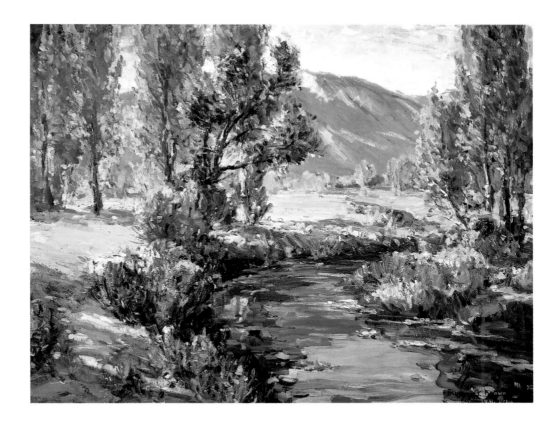

46. Benjamin Brown (1865–1942).
Autumn Glory, Bishop,
California, n.d.
Oil on canvas, 28 x 36 in.
(71.1 x 91.4 cm). The Irvine
Museum, Irvine, California.

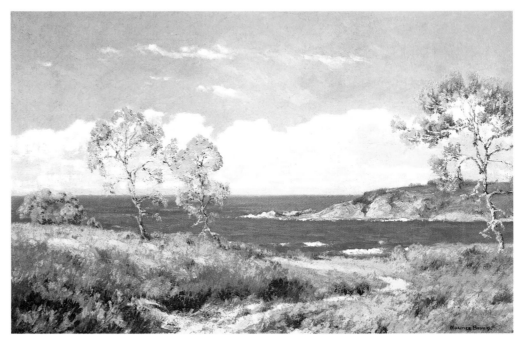

47. Maurice Braun (1877–1941).
The Path along the Shore, n.d.
Oil on canvas, 16 x 24 in.
(40.6 x 60.9 cm). The Redfern
Gallery, Laguna Beach,
California.

48. Jean Mannheim (1862–1945).
Ironing Day, 1910.
Oil on canvas, 39 x 34 in.
(99 x 86.3 cm). Peter and
Gail Ochs.

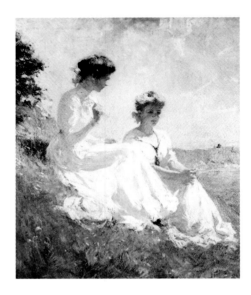

49. Frank Benson (1862–1951).
In Summer, c. 1909.
Oil on canvas, 32 x 25 in.
(81.2 x 63.5 cm). Private
collection.

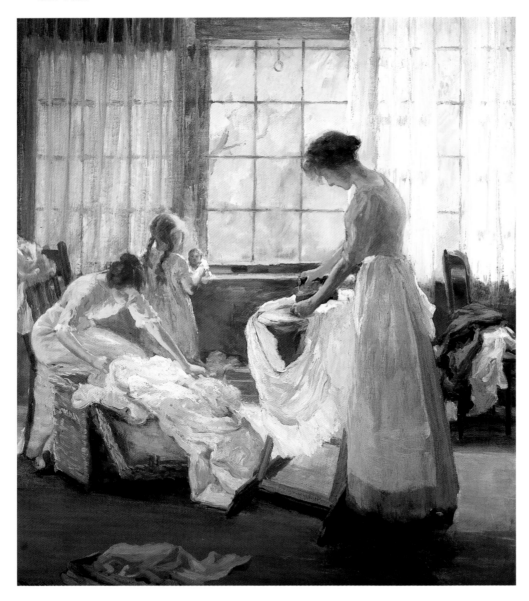

Gamble, Joseph Greenbaum, Anna Hills, Clark Hobart, Fernand Lungren, Jean Mannheim, Granville Redmond, William Ritschel, Detlef Sammann, William Silva, Gardner Symons, Elmer Wachtel, and Karl Yens. There were also twenty-six paintings by eastern artists that had been selected by Symons.[65] These included a number of well-known Impressionists: not only Frieseke and Richard Miller, both associated with the Giverny art colony, but also Edward Redfield and Daniel Garber, leaders of the Pennsylvania Impressionists; Maurice Prendergast; and some members of the Ten American Painters (the Impressionist-dominated exhibition group, known as the Ten, that had been formed in New York City late in 1897 and had shown there and in Boston annually)—Frank W. Benson, Joseph DeCamp, Childe Hassam, and Willard Metcalf.

Work by some of the leading eastern Impressionists could also be seen in San Francisco in November–December 1913 in *Collection of Paintings by American Artists*, a show circulated by the American Federation of Arts to the San Francisco Art Association; it then went to the Los Angeles Museum of History, Science and Art. This exhibition included pictures by Benson, Hassam, Redfield, and J. Alden Weir. Benson's painting *The Hillside*—probably the canvas now known as *In Summer* (plate 49), featuring two of his daughters dressed in white in bright sunshine[66]—and an Appledore Island landscape by Hassam may have been especially pertinent to the aesthetic directions developing in California at the time.

An even more substantial number of works by nationally known Impressionists were on view in California in 1914. Hassam, Robert Reid, and Edward Simmons—three of the painters renowned as the Ten—were among the ten artists involved with painting murals for the Panama-Pacific International Exposition.[67] They had been asked to submit easel paintings for the show far in advance, so that they could first be shown together in an exhibition held at San Francisco's Palace Hotel in March. In June this group of the muralists' ninety canvases traveled to the Los Angeles County Museum of History, Science and Art.[68]

Hassam, Reid, and Simmons were in San Francisco in order to apply the finishing touches to their murals (which were actually painted in their New York studios) and to attend the opening of the show at the Palace Hotel. Both Hassam and Simmons, at least, remained long enough to paint landscapes in Northern California. It seems, in fact, that they worked together, for Hassam's *Hill of the Sun, San Anselmo, California* (plate 51) and Simmons's *Bosom of the Land, San Anselmo, California* (plate 50) depict the identical landscape from the same vantage point—though Hassam carried his Impressionism almost to the point of expressionism in the long, patterned brush strokes and simplified, contrasting, even discordant tones of yellow and green.[69]

FAR LEFT

50. Edward Emerson Simmons (1852–1931).
The Bosom of the Land, San Anselmo, California, 1914.
Oil on canvas, 24 x 24 in. (60.9 x 60.9 cm). Garzoli Gallery, San Rafael, California.

These eastern Impressionists were responding to the rugged California landscape as enthusiastically as the Hoosier Impressionist Theodore Steele had twelve years earlier. Neither Hassam nor Simmons had previously explored such mountain scenery to any great extent—in fact, this was a subject rarely treated at all by eastern Impressionists. But almost all of Hassam's known California scenes—some ten to twelve in total—depict such majestic subjects. The exceptions are several pictures of eucalyptus trees (which, though unlocated, are presumably somewhat pastoral landscapes) and *Point Lobos, Carmel* (plate 52), in which Hassam depicted the rocky shore at Carmel and even the specific site at Point Lobos there that would become a standard subject for a number of California Impressionists, such as Guy Rose, over the next decade.[70]

Hassam's California paintings, including the two illustrated here, were exhibited as a group in a show at the Montross Gallery in New York in November–December 1915. One critic admired the "quite remarkable effects of filtered sunlight" in several of the paintings and characterized as "Turneresque" *The Silver Veil and the Golden Gate* (Valparaiso University Museum of Art, Valparaiso, Indiana).[71] One of Hassam's California pictures, *California Hills in Spring* (American Academy of Arts and Letters, New York), was among the thirty-eight works he showed at the Panama-Pacific International Exposition.[72] That work, *Telegraph Hill* (White House, Washington, D.C.), and *Spring Morning in California* (unlocated) were later shown in the *Post-Exposition Exhibition,* held in San Francisco in 1916.

ABOVE, RIGHT

51. Childe Hassam (1859–1935).
Hill of the Sun, San Anselmo, California, 1914.
Oil on canvas, 24 x 24 in. (60.9 x 60.9 cm). Oakland Museum of California; Gift of the Women's Board in honor of George W. Neubert.

OPPOSITE

52. Childe Hassam (1859–1935).
Point Lobos, Carmel, 1914.
Oil on canvas, 28½ x 36 3/16 in. (64.7 x 91.9 cm). Los Angeles County Museum of Art; Mr. and Mrs. William Preston Harrison Collection.

The few landscapes that Simmons is known to have painted during his California stay in 1914, such as *The Bosom of the Land, San Anselmo, California*, are among the most Impressionist pictures of his career—much more so than the paintings he exhibited in the group show of the muralists held in San Francisco and Los Angeles. However, Simmons was one of the few muralists who exhibited no easel work the following year at the exposition itself. The fact that 1914 was the high point of his involvement with Impressionism is not surprising. His inclusion in the Ten American Painters was something of an anomaly, since much of his painting activity during the Ten's two decades of existence was devoted to quite academic murals. As Kathleen M. Burnside has written, "When American Impressionists did accept commissions for mural work they generally endorsed the traditional expectations and conventions for decorative painting."[73]

Simmons's two forty-six-foot (14.06-meter) murals in San Francisco do feature orthodox allegorical personifications (representing the march of Anglo-Saxon civilization from the Atlantic to the Pacific), but he decided to experiment formally, utilizing brilliant Impressionist color and broken brushwork. As he later recorded, this was

> an idea that I had been mulling over for years—namely, that of doing a large panel with only three pots of color—red, yellow, and blue—and three brushes. Somehow, I felt that this would simplify my work, and I think I was right. The canvases, forty-six feet long, were to be placed high in the open air, and needed a certain boldness of treatment which I meant to acquire, so I made a flesh-color sky, white drapery, pink roses, black hair, etc., all with three colors, crisscross, using red, white, and blue stripes about as wide as my finger, for the entire composition. . . . There is not a single outline in the two panels.[74]

The results were probably the most Impressionist public murals painted anywhere in the United States during the first several decades of the century, an experiment that expanded the pictorial range of Impressionism and served as a monumental example of the modern aesthetic for artists and laymen visiting the fair.[75]

During their 1914 visit Hassam, Simmons, and presumably Reid stayed at the Bohemian Club in San Francisco for some months, a privilege allowed them through their membership in the Lambs' Club in New York. They traveled to Bohemian Grove, in the redwood forests, to enjoy the annual play produced by the club. Hassam was delighted with San Francisco, and Simmons enjoyed his stay so much that he contemplated remaining in California but

53. Photograph of William Merritt
Chase leading sketching class,
Carmel, California, 1914.

realized it would be impossible for him to make a living there.[76] The impact of these eastern Impressionists on San Francisco, personally and through their paintings exhibited at the Palace Hotel, may have been slight. It appears that Hassam and probably Simmons consorted with two of the leaders of the prevailing Tonalist movement, Francis McComas and Arthur Mathews,[77] and that aesthetic continued to dominate work by the leading San Francisco artists.

It may have been a very different story, however, when the Palace Hotel show appeared in Los Angeles, nourishing the Impressionist tendencies growing in the artistic community there. Specific documentation is lacking, but it is known that the exhibition led Everett C. Maxwell to claim, "For the first time in the history of local art endeavor, Los Angeles is for the moment one of the great art centers of the world, and the gallery of fine arts, museum of history, science, and art is demonstrating its real worth as an educational force in the community."[78] In a subsequent review he declared that among the ten exhibiting artists "Hassam, known to many as the pioneer of the broken color treatment in American art, is unquestionably the 'headliner' of the present showing. . . . His group of eleven canvases, both landscapes and figure studies, should be seen by all students and lovers of art in and about Los Angeles."[79] Anderson's reviews of the exhibition were more equivocal, for he believed that in some cases the artists had not bothered to send their finest work westward, but he, too, offered extensive praise for most of Hassam's efforts, concluding: "He is an original painter. Moreover, he has something to say about light and air and outdoor vibration, and more often than not he says it exquisitely."[80]

Perhaps a stronger eastern Impressionist influence was exerted in Northern California when William Merritt Chase, another member of the Ten American Painters, arrived in Carmel that summer of 1914 to teach a class in outdoor painting (plates 53 and 57), which ran from June to the end of September, sponsored by the local Arts and Crafts Club. Euphemia Charlton Fortune claimed credit for Chase's presence in Carmel. She had attended his lectures in New York in the late 1900s and had subsequently settled first in Carmel, then Monterey; by 1914 she was the most avant-garde painter working in Northern California.[81]

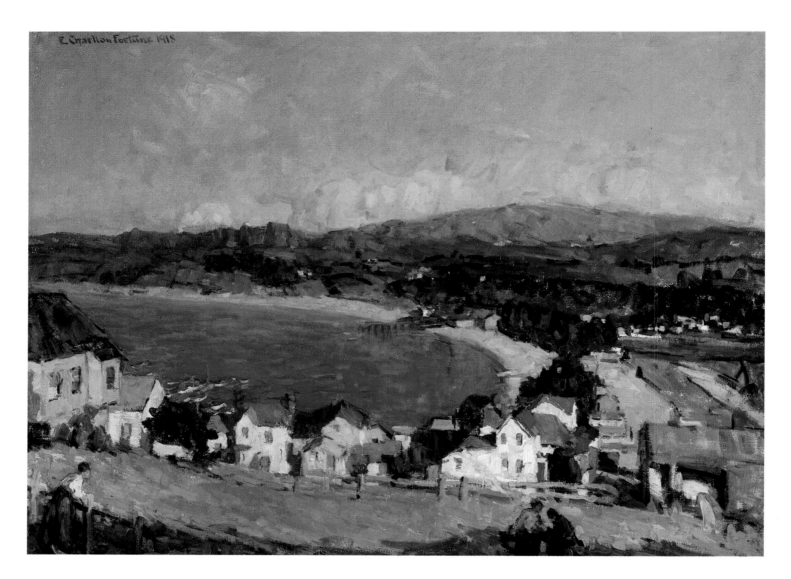

ABOVE

54. Euphemia Charlton Fortune
(1885–1969).
Above the Bay (also known as
Monterey Bay), 1918.
Oil on canvas, 30 x 40 in.
(76.2 x 101.6 cm). Stephen
and Suzanne Diamond.

OPPOSITE

55. Euphemia Charlton Fortune
(1885–1969).
Cabbage Patch, c. 1914.
Oil on canvas, 20 x 24 in.
(50.8 x 60.9 cm). John and
Patricia Dilks.

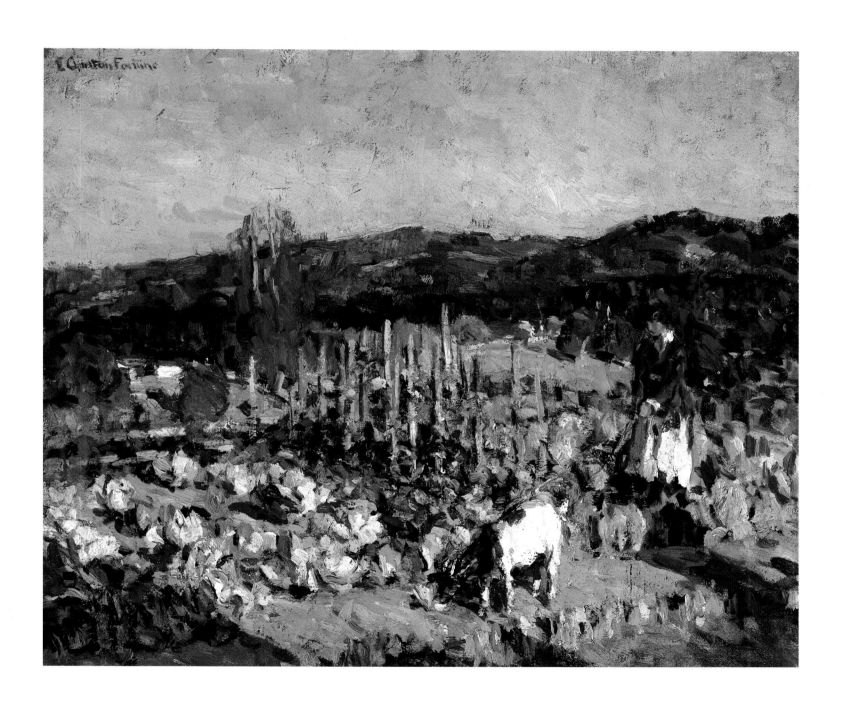

Chase gave his first critiques to his classes on July 6; the Monday morning critiques were also open to the public for a fee. He had successfully conducted such summer classes since 1891, when he had instituted the Shinnecock Summer School of Art on Long Island, New York. After the school closed in 1902, Chase continued to offer summer sessions in various countries abroad; the Carmel season would be his last. Chase's former student at the Chase School of Art, C. P. Townsley, who had managed the Shinnecock Summer School and helped organize the classes abroad, was director of the Carmel Summer School; Townsley had just settled in Pasadena, where he had held his first exhibition that May. Chase stayed at the Hotel del Monte in Monterey, the center of the local art colony. His school had an excellent enrollment—about 150 students— and Chase was able to paint a number of fish pictures; portraits (including one of Townsley); some monotypes; and a few landscapes, such as *Monterey* (plate 151).[82] He also painted five demonstration pictures, illustrating his methods of handling various subjects. Four of these paintings—a portrait, a landscape, a fish study, and a still life— were given as prizes to the best students.[83]

56. Louise Crow (1891–1968). *Untitled (Eucalyptus Trees)*, c. 1914–15. Oil on canvas, 22 x 19¾ in. (55.8 x 50.1 cm). Private collection; Courtesy of Martin-Zambito Fine Art, Seattle.

Chase's summer students came from as far away as Philadelphia, and his classes were constituted primarily, but not exclusively, of women. One first-prize winner was John Butler of Seattle. Butler and Louise Crow, also from Seattle, were two of the students who went on to establish impressive reputations—Butler in Seattle, and Crow, ultimately, in Santa Fe. Prior to her move there, Crow continued in the mid-1910s to work in California as well as in Washington, and her *Untitled (Eucalyptus Trees)* (plate 56) is a California subject very likely painted about the time she was studying with Chase.[84]

Among Chase's students from California who went on to pursue professional careers was the Monterey youth Myron Oliver, son of the owner of the local art store, the Custom House Art Emporium; Chase painted a portrait of Oliver (sold, Butterfield's, San Francisco, June 15, 1995), who also served as the visiting master's chauffeur. Mary Amanda Lewis, active in Sacramento as a painter as well as a cellist and music teacher, also attended Chase's classes, along with her cousin the art teacher Fannie Edgerton; Lewis documented the activities in a series of photographs (plates 53 and 57). Lewis had been professionally active as a painter before her experience with Chase, exhibiting a large number of works, primarily scenes in and around Monterey, in a show at the Hotel Sacramento in November 1911. Her *Sketching* (formerly *The Sketch Class*, plate 58) has been thought to be the artist's own depiction of the summer pro-

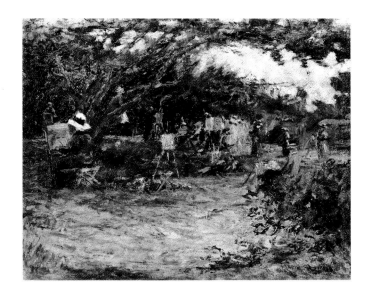

gram in Carmel, and though the picture was not exhibited until 1932, the dress of the students does appear to be consistent with a 1914 date.[85] The best known of Chase's California students was Donna Schuster, who had already participated in a summer class that Chase had offered in Belgium in 1912; she settled in California within a year after she returned to his summer tutelage in Carmel.[86]

Chase helped his summer students take advantage of the Carmel-Monterey region. He took them to the wharves at Monterey to paint motifs in that area, and he and his students also mixed with the local art community. They were invited by William Ritschel to see his latest work in his studio, five miles down the coast from Carmel.[87] And they would have seen the summer show at the Hotel del Monte Art Gallery, which that year probably contained work not only by Fortune, Ritschel, Sammann, and the Bay Area Tonalists but also by such Southern California avant-garde artists as Borg, Braun, Brown, Mannheim, Puthuff, and Wendt, all painters with whose works Chase would probably have been sympathetic.[88] Whatever impact Chase had on the California art community, Townsley was propelled further into art education. He reorganized the Stickney Memorial School of Art in Pasadena the following September, continued to direct the Carmel Summer School in 1915 and 1916, and became director of the newly formed Otis Art Institute in Los Angeles in 1918.[89]

We have already seen that 1914 was a tremendously significant year for the development of Impressionism in California. It was also the year that Guy Rose, who enjoyed a considerable

reputation in America and abroad, returned to live in Pasadena, having left Giverny in 1912 for two years in New York and Rhode Island. Rose brought to California a more "orthodox" version of Impressionism than was already being practiced there by Wendt and his colleagues—orthodox on several counts, since Rose's landscape painting, in particular, reflected its French antecedents in the painting of Claude Monet while also exemplifying the new, intense chromaticism and more decorative quality that benefited from his association with Frieseke. Rose quickly settled into the art community of Southern California, but even though he painted themes already established in the California repertory, he offered an alternative approach to

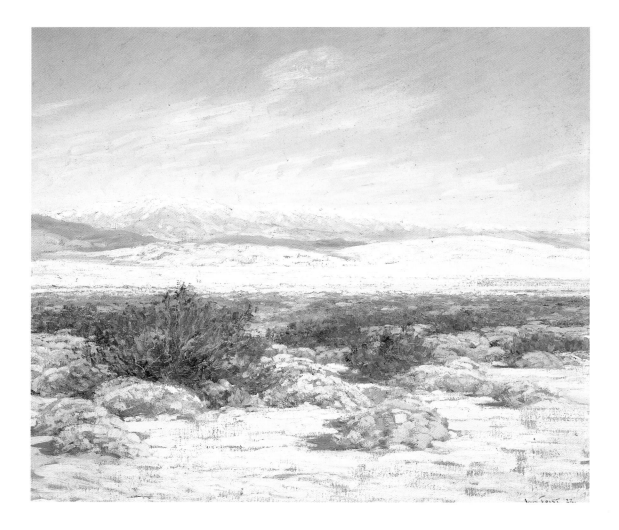

59. John Frost (1890–1937). *Devil's Playground*, 1922. Oil on canvas, 26 x 30 in. (66 x 76.2 cm). Joan Irvine Smith Fine Arts, Newport Beach, California.

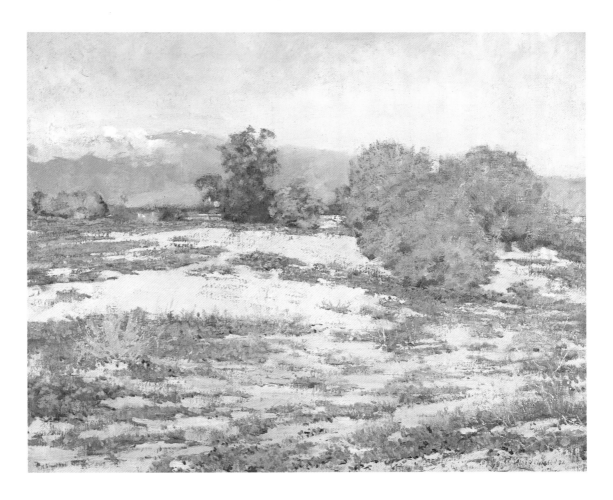

60. Alson Clark (1876–1949).
Desert Verbena, Palm Springs, 1926.
Oil on canvas, 26 x 32 in.
(66 x 81.2 cm). Paul Bagley
Collection.

the Impressionist plein air painting represented by Puthuff, Wendt, and some of their colleagues. Given that a number of the local artists—such as Sammann, Stark, and their associates—had already been identified repeatedly by critics with Manet and Monet, and their art cited as incorporating the vibratory chromatics of purples and greens, research should be done regarding the possibility of influence and interaction after 1914 between Rose and the dominant art community centered on Wendt.

The last years of the decade might be particularly intriguing to investigate, since Rose enriched the local art establishment by attracting his former Giverny associates to the area. Pasadena benefited from the relatively brief but productive and influential residence there of Richard Miller in 1916–17, John Frost's move to the region in 1919, and also Alson Clark's, who

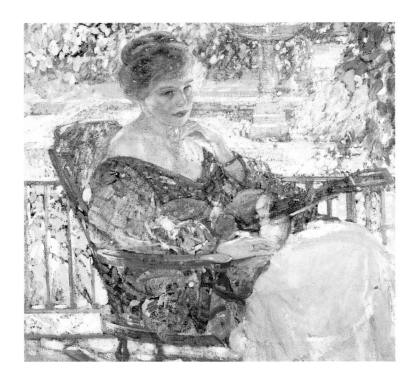

61. Richard Miller (1875–1943).
Daydreams, n.d.
Oil on canvas, 34 x 36 in.
(86.3 x 91.4 cm). Sheldon
Memorial Art Gallery,
University of Nebraska,
Lincoln; Bequest of Mr. and
Mrs. F. M. Hall.

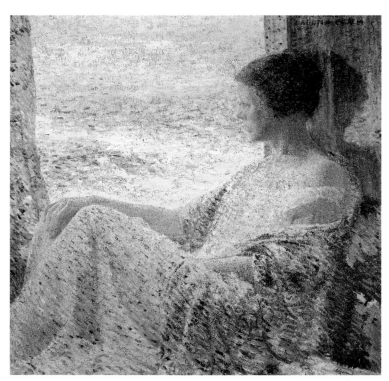

62. William Cahill (1878–1924).
Thoughts of the Sea, 1919.
Oil on canvas, 40 x 39⅝ in.
(101.6 x 100.5 cm). Mr. and
Mrs. Gerald D. Gallop.

settled there permanently in 1919. Miller was one of many American artists who returned to the United States in 1914 after World War I began in Europe. The influence of Miller's Giverny aesthetic can be seen in the painting of William Cahill, who settled in Los Angeles in 1914, and perhaps also in the work of Christian von Schneidau, who arrived in 1917 and three years later studied in Provincetown, Massachusetts, with Miller (who had settled in the Cape Cod village after leaving California). Indeed, the war years proved to be an artistic boon to Southern California (as they were to a number of other communities in the country, such as Charleston, South Carolina) because the region served as an alternative destination for vacationing painters—Chicago's Charles Francis Browne and Oliver Dennett Grover, for example—who no longer could travel abroad.

In 1915 the Panama-Pacific International Exposition brought the achievements of American Impressionism, east and west, into sharp focus. There was overwhelming proof of the dominance of the aesthetic in America: the rooms devoted to one-artist displays of work by Impressionist painters including Chase, Hassam, Redfield, Robinson, Edmund C. Tarbell, and Twachtman (most of them members of the Ten); the number of medals awarded to California and eastern Impressionists; and the award of the grand prize to Frieseke. All this could only enhance Impressionism's attraction for younger California artists. That year, the California painter Joseph Greenbaum defined the local landscape in Impressionist terms, and its interpreters as the standard-bearers of modernism:

> Most artists on coming here see too much local brown, which although it exists does not exist in the paint. This is really a country of blue and gold. The fields and hills are yellow and orange in tone, thus making the shadows blue. Shadows are naturally colder than sunlit parts, and by force of circumstances must be either blue or purple. . . . The general public looks too much to subject in landscape whereas with the modern movement subject means nothing—line, color and composition everything. Such artists as Helena Dunlap, Jack Stark and Bruce Nelson apply this method in their work. This country is ideal for the modernist. Things are so vibrating that under certain conditions one can fairly see the color dance and almost observe the particles of the spectrum.[90]

And by 1916 Antony Anderson could announce: "Light and air. To us of today these are the Alpha and Omega of painting."[91]

Though lauded by critics in their own state and presumably well patronized (at least until the Depression years of the 1930s), the work of the California Impressionists was surprisingly

63. Bruce Nelson (1888–1952).
Pacific Grove Shoreline, c. 1915.
Oil on canvas, 25 x 30 in.
(63.5 x 76.2 cm). John and
Patricia Dilks.

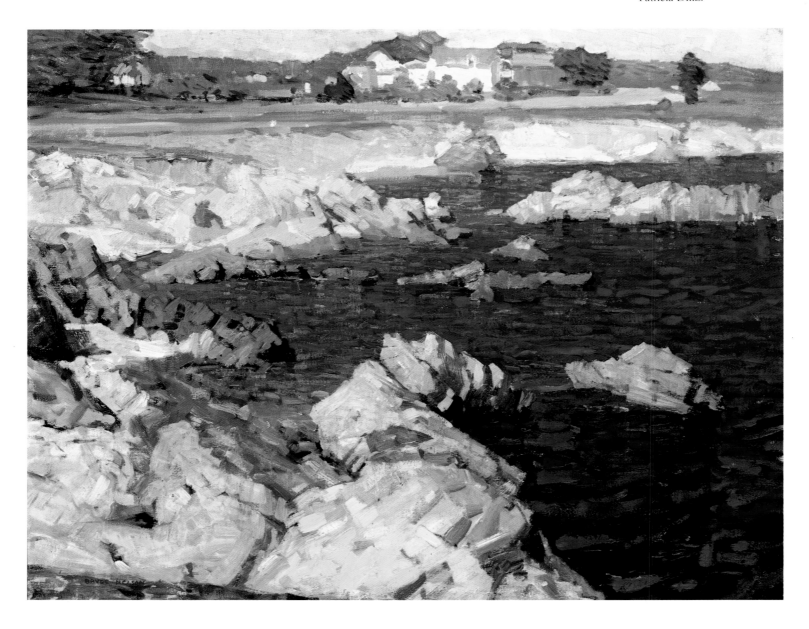

64. Joseph Kleitsch (1882–1931). *The Oriental Shop*, 1925. Oil on canvas, 32 x 26 in. (81.2 x 66 cm). Joan Irvine Smith Fine Arts, Newport Beach, California.

little known elsewhere. There were exceptions, of course. A number of the California Impressionists—Alson Clark, Joseph Kleitsch, Edgar Payne, Hanson Puthuff, Arthur Rider, Christian von Schneidau, and especially William Wendt—either came from Chicago or had lived and worked there for a number of years. Their pictures were often shown at the Art Institute of Chicago, sometimes in one- or two-artist shows. (In the case of Rider and von Schneidau, the artists did not exhibit in Chicago after they moved to California.) Much has been made in past scholarship of the affiliations of a number of California artists with New York dealers—especially William Macbeth, who exhibited the work of Guy Rose through the 1910s and Maynard Dixon in the '20s; the Grand Central Galleries, which showed the paintings of Alson Clark; the Milch and Babcock Gallery exhibitions of pictures by Maurice Braun; and Anne Bremer's

show at the Arlington Galleries in 1917. However, these were exceptional commercial connections for the California Impressionists. It would be interesting to determine the degree of success these artists had in New York and who acquired their paintings.

The relatively few California Impressionists whose works were well known in New York were primarily those who kept a New York studio and used a New York address, such as William Ritschel and Gardner Symons. These artists, both of whom, along with Wendt, also had one-artist shows at the Pratt Institute in Brooklyn, were among the few California members of the National Arts Club in New York (Wendt gave the club as his address when exhibiting in the city). The only California Impressionists who were members of the prestigious National Academy of Design were Colin Campbell Cooper, Arthur Hill Gilbert, Armin Hansen, Maurice Logan (who did not qualify until the 1950s!), Ritschel, Symons, and Wendt, and the influential visitors to California, Childe Hassam and Richard Miller. Many California Impressionists—among them Hansen, Payne, Puthuff, Charles Reiffel, William Silva, and Symons—were members of the low-key, conservative Salmagundi Club.

Otherwise, what is surprising is not only that a substantial number of significant California Impressionists never exhibited outside the state, but that the majority of those who did often showed only once or twice. Some artists exhibited in Chicago, but not on a regular basis.[92] The same was true in New York, where even fewer California Impressionists exhibited at the annuals of the National Academy of Design and usually not a second time.[93] The one major New York exhibition in which California artists were represented in any strength was the first annual exhibition of the Society of Independent Artists, held in 1917. There, Bremer, Dixon, Reiffel, Detlef Sammann, Donna Schuster, and Symons all displayed their paintings, but in an exhibition of 2,125 works of art, the California contingent hardly made a ripple.[94]

It is quite possible, of course, that some of the California Impressionists did submit paintings more often to the major exhibitions in Chicago and New York, only to be rejected by the juries, but it seems more likely that they simply declined to enter. The artists may have found that it was either unrewarding or too much of a bother, compared to the acclaim they received so easily at home. In any case, the insularity of the California Impressionists during the period from around 1910 to 1930 suggests an astonishing degree of contentment with their situation, especially when compared to the constant merchandising throughout the United States of the art of so successful an eastern Impressionist as Childe Hassam.

This is not to say that the Californians were unappreciative of eastern esteem and patronage. Detlef Sammann was so elated when his painting *The Old Warrior* was accepted for the

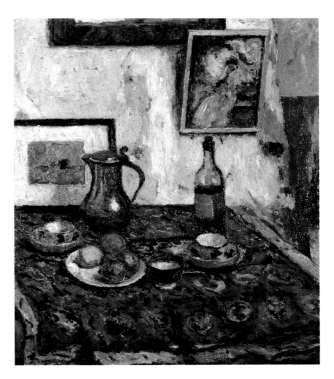

1915 National Academy of Design annual exhibition and sold the first day that he wrote from Pebble Beach to inform Antony Anderson, who promptly printed a notice of Sammann's success.[95] Yet it was in California that these Impressionists received the greatest praise—from such eminent writers as Anderson, Everett C. Maxwell, and Mabel Urmy Seares—for their individual and collective achievements in celebrating their native landscape.

Still needed is a study of the patronage of California Impressionism in its heyday. Did some collectors patronize one or two artists extensively and others buy works across the board? Did many collectors acquire a few pictures each? Did a few art lovers build up large collections of Impressionist paintings? And did their acquisitions follow regional patterns—concentrated on Northern or Southern California—or were there some collectors who sought works by painters from the entire state? With the burgeoning motion picture industry and the involvement of local artists (Arthur Rider, for example) in scenic design, did any of the California Impressionists enjoy the patronage of the increasingly wealthy movie moguls or performers?

Whatever undiscovered histories remain of these painters and their work, it is clear that the splendors of the Golden State offered them the finest possible subjects and inspiration.

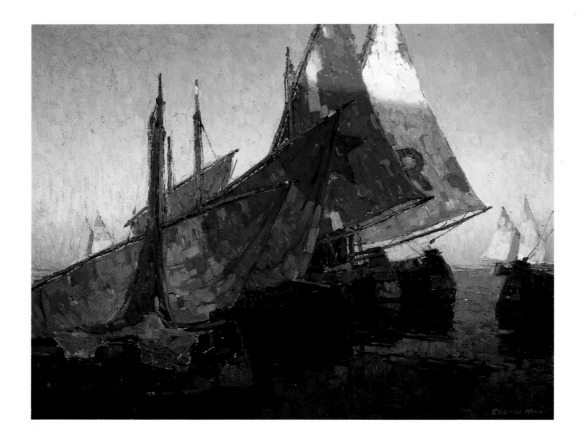

67. Edgar Payne (1883–1947).
Sundown, Boats at Chioggia, Italy, c. 1923.
Oil on canvas, 40 x 50 in.
(101.6 x 127 cm). Private
collection.

When Edgar Payne, perhaps the most peripatetic of their number, displayed some of the results of his European travels at the Stendahl Galleries in May 1926, the *Los Angeles Times* critic Fred Hogue voiced obvious approval and pride when noting: "In the exhibition are also California mountains which he painted before his European adventures; and I was glad to learn that he is preparing for a new pilgrimage to the High Sierras, that he will spend the summer painting in the mountains and, when winter comes, will turn his brush to reproduce on canvas the songs of our southern seas."[96] And a year later, reviewing another show at Stendahl's, Sonia Wolfson, in contrasting Payne's views of Alpine grandeur with his Sierra scenery, exhorted her readers to "breathe an unconscious prayer of thanksgiving for the beauties of our homeland and the artists who knowing the glories of other lands . . . still bring us to a realization of the beauties close to us."[97] These California beauties are what we document, describe, and savor in this volume.

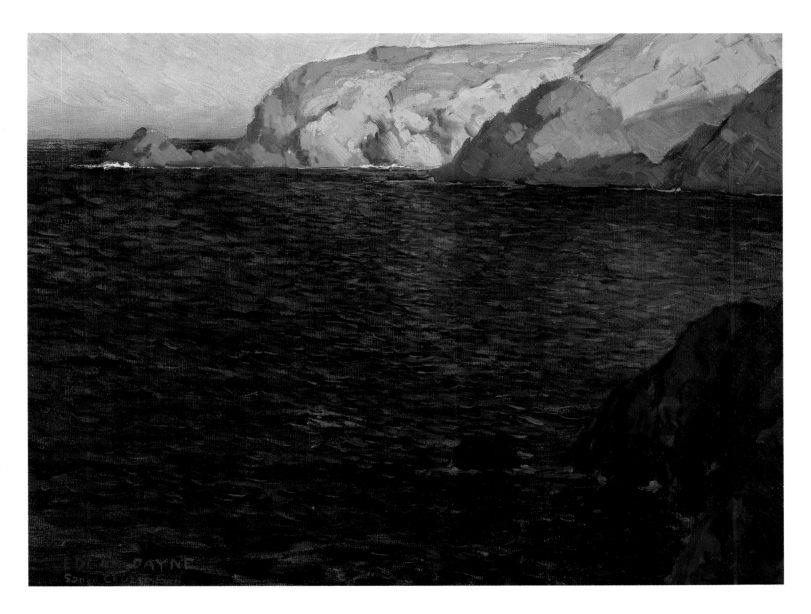

68. Edgar Payne (1883–1947).
Santa Cruz Island, c. 1915.
Oil on canvas, 18 x 24 in.
(45.7 x 60.9 cm). William A.
Karges Fine Art, Carmel,
California.

NOTES

1. For a fine overview of these recent developments in collecting, see Jean Stern, "The California Impressionist Style in Perspective," in Susan Landauer, *California Impressionists* (Athens, Ga.: Georgia Museum of Art; Irvine, Calif.: Irvine Museum, 1996), pp. 73–84.

2. See Harold Spencer, Susan G. Larkin, and Jeffery W. Anderson, *Connecticut and American Impressionism* (Storrs, Conn.: William Benton Museum of Art, University of Connecticut; Greenwich, Conn.: Greenwich Library; Old Lyme, Conn.: Lyme Historical Society, 1980); and William H. Gerdts, *American Impressionism* (Seattle: Henry Art Gallery, 1980).

3. Harvey L. Jones, John Caldwell, and Terry St. John, *Impressionism: The California View* (Oakland, Calif.: Oakland Museum, 1981).

4. See, for instance, Oscar Reutersvärd, "The 'Violettomania' of the Impressionists," *Journal of Aesthetics and Art Criticism* 9 (December 1951): 106–10.

5. Oscar Reutersvärd, "The Accentuated Brush Stroke of the Impressionists," *Journal of Aesthetics and Art Criticism* 10 (March 1952): 273–78.

6. William H. Gerdts, "The Oil Sketch in Nineteenth-Century American Painting," in Jan Driesbach, *American Views: Oil Sketches by Thomas Hill* (Sacramento, Calif.: Crocker Art Museum, 1997), especially pp. 101–5.

7. See, for instance, Alfred Trumble, "Impressionism and Impressions," *Collector* 4 (May 15, 1893): 213.

8. Clara MacChesney, "Frieseke Tells Some of the Secrets of His Art," *New York Sunday Times*, June 7, 1914, sec. 6, p. 7; Phyllis Derfner, "New York Letter," *Art International* 19 (February 20, 1975): 41.

9. "Luminism from Giverny," *New York Evening Post*, December 20, 1910, p. 9; Florence B. Ruthrauff, "Art Notes," *New York Morning Telegraph*, December 21, 1910, p. 4.

10. The definitive study is Will South, *Guy Rose: American Impressionist* (Oakland, Calif.: Oakland Museum; Irvine, Calif.: Irvine Museum, 1995).

11. Fields of wildflowers were celebrated in the regional literature as well. See, for instance, Charles F. Lummis, "The Carpet of God's Country," *Out West* 22 (May 1905): 306–17.

12. See Jean Stern, Gerald J. Miller, Pamela Hallan-Gibson, and Norman Neuerburg, *Romance of the Bells: The California Missions in Art* (Irvine, Calif.: Irvine Museum, 1995).

13. Mrs. Sibbett, interview with author, September 16, 1996. The book was Jacob Baart de la Faille's *Vincent van Gogh* (Paris: Hyperion, 1939), which is still in his daughter's possession. Mrs. Sibbett recalled that her father's devotion to van Gogh's art had begun far earlier.

14. Frederick (known as Eric) Pape from San Francisco was the earliest California artist in Giverny, visiting for the first time in May 1889. Pape, however, did not return to California, establishing himself in Boston in 1898. Peixotto was at the Hôtel Baudy for the first of many stays in September 1889. Rose and McCormick arrived on July 4, 1890, and stayed for the rest of the year, Rose returning in May 1891 and McCormick at the beginning of June; they both left on July 1, 1891. See Carol Lowrey, "Hôtel Baudy Guest Register," in William H. Gerdts, *Monet's Giverny: An Impressionist Colony* (New York: Abbeville Press, 1993), pp. 222–24.

15. See Theodore Robinson's "Diaries," entries for November 9, 10, and 16, 1892, Frick Art Reference Library, New York.

16. Rose painted a similar subject, *The Cabbage Patch* (Rose Family Collection), very possibly at the same time. See South, *Guy Rose*, pp. 27–28.

17. Guy Rose, "At Giverny," *Pratt Institute Monthly* 6 (December 1897): 81. Rose is said to have met Monet while painting out of doors during the summer of 1891. (C. F. Sloane, "Guy Rose's Work," *Los Angeles Herald*, October 4, 1891, p. 7.) Sloane went on to make the exaggerated claim that "Rose found himself as nearly a pupil to the great artist . . . as any student may hope to be." Rose renewed his acquaintance with Monet after 1904, when he and his wife, Ethel, settled back in Giverny, where they remained for eight years. Ethel stated that she, too, knew Monet socially: see Ethel Rose, letter to "Life and Art," *Laguna Life* 9 (October 27, 1922): 1.

18. See the copies of the letters between Bacon and Pissarro and Cassatt in the Bacon files at the Fine Arts Museums of San Francisco; our gratitude to Patti Junker for sharing this material with us and to Robert Vickery of Salt Lake City for additional family history.

19. Interview with George Gibson, March 10,

1993, from the researches of Phil Kovinick and Marian Yoshiki-Kovinick; courtesy of Donna H. Fleischer, executive director, Fleischer Museum, Scottsdale, Arizona.

20. See the discussion by Priscilla E. Muller, "Sorolla in America," in *The Painter Joaquín Sorolla*, ed. Edmund Peel (London: Philip Wilson Publishers, 1989), p. 63.

21. J. A. Stanton, for instance, noted: "Never since Corot's time has there been a man of so much prominence in art as Claude Monet," and described his work as "so full of atmosphere and color that it really dazzles you, and makes you catch your breath. The work may not be appreciated or understood by the masses. . . . Pizzarro [sic], Renoir, and Sisley, are pronounced impressionists, and their works can be carefully considered by those who are interested in the new school." (Stanton, "Impressions of the Art Display," *Overland Monthly* 23 [April 1894]: 404.) Even Arthur Mathews was at least equivocal about the paintings by Monet (whom he identified incorrectly as "Manet"), concluding, "For myself I feel that this particular phase of art sacrifices too much for a problem—the vibration of light and color; but I am not prepared to discuss the issue." (Mathews, "In the Fine-Arts Building," *Californian* 5 [March 1894]: 410.)

22. The Berlin showing might be questioned, since an inquiry to the Nationalgalerie in Berlin indicates there was no official exhibition held that year that would have included McCormick's painting.

23. In the autumn of 1894 McCormick also exhibited *Afternoon in Ginerney* [sic], *France* along with *Cactus Garden, California* (both unlocated) at the Annual Exhibition of American Paintings and Sculpture at the Art Institute of Chicago.

24. Peixotto, in De Witt Lockman, "Interview," March 27, 1926, typescript in the New-York Historical Society library.

25. The Taussig family still owned this work in 1909, when they lent it to the San Francisco Sketch Club exhibition that March.

26. Burgess was a minor poet and painter who exhibited Symbolist watercolors at Alfred Stieglitz's 291 Gallery in New York in November 1911. He is best known as the author of one of the first articles by an American to deal with avant-garde European modernism; his "The Wild Men of Paris" appeared in *Architectural Record* in May 1910.

27. Ellen Dwyer Donovan, "California Artists and Their Work," *Overland Monthly* 51 (January 1908): 33.

28. Brady was identified as a San Francisco artist when she exhibited in New York in 1896; see Van Dyck Brown, "The Spring Exhibition of New York: Pictures at the Academy and the Society of American Artists," *San Francisco Call*, May 17, 1896, p. 18; I thank Alfred Harrison Jr. of North Point Gallery for sharing this review with me.

29. "Spring Exhibit Opens," *San Francisco Call*, April 17, 1896, p. 10. Again, I thank Alfred Harrison Jr. for this review.

30. Nancy Dustin Wall Moure, *Loners, Mavericks and Dreamers* (Laguna Beach, Calif.: Laguna Art Museum, 1993), p. 64.

31. Ibid., pp. 65–67.

32. Nancy Dustin Wall Moure, "Impressionism, Post-Impressionism, and the Eucalyptus School in Southern California," in Ruth Westphal, *Plein Air Painters of California: The Southland* (Irvine, Calif.: Westphal Publishing, 1982), pp. 5–6.

33. "Professor W. L. Judson of the same institution [the Los Angeles School of Art and Design] shows some good work in water, in oil and in pastel, the two best examples being in water with a strong impressionist tendency, one of a Canadian lake, the other a breezy hillside, in both of which the coloring is most effectively treated." (E.M.C., "Comment on Art Progress," *Los Angeles Herald*, November 11, 1894, part 2, p. 15.)

34. William L. Judson, "How I Became an Impressionist," *Overland Monthly* 30 (November 1897): 417–22. Judson was eventually to succumb to some degree to the high-key coloring of Impres-

sionism, but it was subsequently noted that "in his later years he returned more and more to the smooth unloaded surface." ("Record of Lifetime in Judson Exhibit," *Los Angeles Times*, July 10, 1927, part 3, p. 32.)

35. Nancy Dustin Wall Moure, *Painting and Sculpture in Los Angeles, 1900–1945* (Los Angeles: Los Angeles County Museum of Art, 1980), p. 11.

36. See Mary Jean Haley (based on "Granville Redmond," n.d., unpublished, by Mildred Abronda), *Granville Redmond* (Oakland, Calif.: Oakland Museum), 1988; Mildred Abronda, "Granville Redmond: California Landscape Painter," *Art and Antiques* 5 (November–December 1982): 51. Subsequently, Antony Anderson, in reviewing Redmond's one-artist show at the Steckel Gallery in Los Angeles in July 1907, noted that his "color, however, is seldom rich and suave—often, indeed, it is rather thin and dry. His bent is very much toward tonal pictures, so called, by which is meant, it would seem, the partial negation of color. Some of these pictures are very pleasing, though they are seldom alive or vibrant." (Anderson, "Art and Artists," *Los Angeles Times*, July 7, 1907, part 6, p. 2.)

37. Charles Francis Browne, "Some Recent Landscapes by William Wendt," *Brush and Pencil* 6 (September 1900): 260.

38. Garland had invited this group of five Indiana painters to exhibit together at the Auditorium Building in Chicago in the winter of 1894. Garland, along with the sculptor Lorado Taft and the landscape painter Charles Francis Browne, participated in a discussion of the show, which was subsequently published: "The Critical Triumvirate," in *Five Hoosier Painters* (Chicago: Central Art Association, 1894).

39. Theodore Steele, "In the Far West," 1903, typescript of a lecture delivered at the Portfolio Club in Indianapolis, Theodore Steele Papers, Archives of American Art, Smithsonian Institution, Washington, D.C., pp. 13–14.

40. See especially Selma N. Steele, *Theodore L. Steele, and Wilbur D. Peat, The Life and Work of*

T. C. Steele: The House of the Singing Winds, rev. ed. (Indianapolis: Indiana Historical Society, 1989), p. 51. This is the principal study of Steele. See also Judith Vale Newton and William H. Gerdts, The Hoosier Group: Five American Painters (Indianapolis: Eckert Publications, 1985); and William H. Gerdts, Theodore Clement Steele: An American Master of Light (New York: Chameleon Books, 1995).

Steele's western trips of 1902 and 1903 merit further research. He exhibited three of his California landscapes—two views of Redlands and one of Mount San Bernardino—at the Seventh Annual Exhibition of the Society of Western Artists at the end of 1902. He exhibited a depiction of the Oregon coast and a view of the San Bernardino Valley in the society's eighth annual. He also showed Mount San Bernardino, Southern California again in October 1903 at the Annual Exhibition of American Paintings and Sculpture, held at the Art Institute of Chicago.

41. Steele, "In the Far West," p. 10.

42. Coincidentally, the brothers Stoughton, Alvin, and Ingram Fletcher, major early patrons of Steele, were all sons of Calvin Fletcher, who in 1873 laid out the city of Pasadena, which would become the center of the Impressionist art colony in Southern California. See Jacob Piatt Dunn, Memorial Record of Distinguished Men of Indianapolis and Indiana (Chicago and New York: Lewis Publishing Company, 1912), p. 166.

43. Wendt showed with the society again in 1901. Benjamin Brown was the one California artist to exhibit in the first several exhibitions of the Society of Western Artists, giving his address as Pasadena.

44. Antony Anderson, "Art and Artists," Los Angeles Times, December 31, 1911, part 3, p. 13. That these artists were not only recognized as Impressionists but also admired for working in that style was suggested the following year, in Anderson's review of an exhibition of the California Art Club: "What is more the modern impres-sionism of Helena Dunlap and Jack Gage Stark is not looked at askance." (Anderson, "Art and Artists," Los Angeles Times, November 24, 1912, part 3, p. 18.)

45. See the column by Antony Anderson, "Art and Artists," in the Los Angeles Times: December 9, 1906, part 6, p. 2; January 6, 1907, part 6, p. 2; October 11, 1908, part 3, p. 2; October 18, 1908, part 3, p. 2; November 7, 1909, part 3, p. 12; November 14, 1909, part 3, p. 15.

46. Kansas City Star, September 23, 1908, clipping in the Stark file, Nelson-Atkins Museum of Art, Kansas City, Missouri. I am greatly indebted to Margaret Conrads, curator of American art, for having supplied the authors with considerable material on this elusive artist.

47. "Jack Stark Stages One-Man Exhibit in California Art Show," Silver City Enterprise, January 29, 1937. Stark had been in Silver City earlier, at least during the summer of 1905, possibly originally as a miner.

48. Antony Anderson, "Art and Artists," Los Angeles Times, November 26, 1909, part 3, p. 15; Anderson amplified his consideration of Stark's Impressionism in a second review: Anderson, "Art and Artists," Los Angeles Times, November 28, 1909, part 3, p. 15. With her usual perspicuity, Nancy Moore appears to have been the one art historian who previously took notice of Stark's precedence in presenting Impressionism to the Los Angeles public at exhibitions held at the Blanchard Music and Art Building. See Moure, "Impressionism, Post-Impressionism, and the Eucalyptus School in Southern California," in Westphal, Southland, pp. 6, 7, 11.

Sandwiched between Anderson's more extensive treatment of Impressionist scenes of California by Stark and Sammann is a brief reference to paintings in a similar mode by Sydney Dale Shaw. Shaw was a New York artist who summered extensively in Pasadena and painted works in an Impressionist vein; his Plumy Trees (plate 69) was reproduced in C. P. Austin, "The California Art Club," Out West o.s. 19 (December 1911): 8. One wonders how many other early California Impressionists await rediscovery.

49. "San Francisco, Cal.," American Art News 8 (February 26, 1910): 2.

50. Anthony [sic] Anderson, "Art and Artists," Los Angeles Times, November 5, 1911, part 3, p. 19.

69. Sydney Dale Shaw. Plumy Trees, from C. P. Austin, "The California Art Club," Out West, o.s. 19 (December 1911): 8.

51. "A Coming Artist," *Silver City Enterprise,* November 10, 1911.

52. Stark is usually said to have settled in Southern California in 1916; however, Silver City obituaries in March 1913 for his mother-in-law Adessa B. Walton note that her daughter, Elizabeth, and her husband were residents of Los Angeles. See "Mrs. A. B. Walton," *Silver City Independent,* March 18, 1913; "Death of Mother of Senator Walton," *Silver City Enterprise,* March 14, 1913. Stark maintained a connection with Silver City at least through January 1931, in part through his aunt and uncle, who was the probate clerk of the city, and also through his first wife and her family. His second wife, Edith Glass, may also have been a Silver City native. I am extremely grateful to Susan Berry, director of the Silver City Museum, for these and many other articles on Stark and his connection with Silver City.

53. These murals received considerable attention in the press; see especially Everett C. Maxwell, "Art," *Graphic,* September 10, 1910, p. 8. The most complete study of Sammann is an unpublished manuscript by Dr. Karl Rendorff of Stanford University, written sometime during the 1920s (courtesy of Barbara Douglass).

54. Antony Anderson, "Art and Artists," December 31, 1911, part 3, p. 13. Sammann would shortly move to the north, settling in Pebble Beach; in 1921 he returned to Dresden.

55. Antony Anderson, "Art and Artists," *Los Angeles Times,* March 5, 1911, part 3, p. 19.

56. Antony Anderson, "Art and Artists," *Los Angeles Times,* March 5, 1911, part 3, p. 19; March 12, part 3, p. 18.

57. Rene T. de Quelin, "Art and Artists," *Graphic,* May 1, 1909, p. 9; Antony Anderson, "Art and Artists," *Los Angeles Times,* March 19, 1911, part 3, p. 17.

58. Antony Anderson, "Art and Artists," *Los Angeles Times,* October 22, 1911, part 3, p. 21.

59. Everett C. Maxwell, "Exhibition: California Art Club," *Fine Arts Journal* 28 (March 1913): 192.

60. *San Francisco Examiner,* April 5, 1912, clipping in Alice Chittenden Papers, Archives of American Art, Smithsonian Institution, Washington, D.C. Jack Gage Stark exhibited along with Sammann in this exhibition.

61. Among the major Southern California Impressionists, only Granville Redmond and the Wachtels (Elmer and Marion) did not show with the California Art Club. During much of this period Redmond was living in Northern California, although he continued to exhibit both at commercial galleries in Los Angeles and at the Los Angeles Museum of History, Science and Art.

62. Antony Anderson, "Art and Artists," *Los Angeles Times,* December 31, 1911, part 3, p. 13.

63. Frieseke did exhibit *A California Garden* at the annual exhibition of the Pennsylvania Academy of the Fine Arts the following year, 1912.

64. Frieseke to William Macbeth, December 16, 1911, Los Angeles, Macbeth Gallery Papers, Archives of American Art, Smithsonian Institution, Washington, D.C.

65. Winifred Haines Higgins, "Art Collecting in the Los Angeles Area, 1910–1960," Ph.D. diss. (University of California, Los Angeles, 1963), p. 9.

66. This was not the painting entitled *The Hillside* in the collection of the University Art Museum at the University of Minnesota, Minneapolis; the painting shown in Los Angeles was described as follows: "It depicts two young girls in white seated on the brow of a low hill." (Everett C. Maxwell, "Art," *Graphic,* n.d. [January], clipping in the Los Angeles Museum of History, Science and Art Scrapbooks, on file at Los Angeles County Museum of Natural History.)

67. Ten muralists were involved with the official decorations at the exposition. In addition to Jules Guerin, director of color and of the mural projects at the exposition, these were Milton Bancroft, Frank Brangwyn, William de Leftwich Dodge, Frank Vincent DuMond, Childe Hassam, Charles Holloway, Arthur Mathews, Robert Reid, and Edward Simmons.

Mathews, who painted *The Victorious Spirit* for the Court of Palms, was not included in the 1914 show of easel paintings by the muralists. Perhaps he was omitted since he was a San Francisco artist whose works were regularly on view in California. On the other hand, Frederick Melville DuMond (the brother of Frank Vincent DuMond), who lived and painted in Monrovia, California, was included in the 1914 show, but I find no record of his actually executing murals for the exposition.

In addition, the Pittsburgh artist Edward Trumbull provided panels for the Pennsylvania State Building; native Californian Florence Lundborg painted murals for the tea room of the California State Building, which men were allowed to view only by special invitation. See Eugen Neuhaus, *The Art of the Exposition* (San Francisco: Paul Elder and Company, 1915), pp. 56–68. There were also murals in some of the national pavilions, such as those by Mathilde Festa-Piacentini in the Italian Pavilion and by Herman Rosse in the Netherlands Pavilion. See Stella G. S. Perry and A. Stirling Calder, *The Sculpture and Mural Decorations of the Exposition* (San Francisco: Paul Elder and Company, 1915).

68. Everett C. Maxwell, "Art," *Graphic,* June 13, 1914, p. 13. In fact, however, few of the paintings shown in San Francisco and Los Angeles in 1914 appeared in the exposition's art galleries the following year; Simmons did not exhibit there at all.

69. During his third trip to Europe, in 1896–97, in the work he painted in Pont-Aven in Brittany, Hassam had already begun to adopt a less naturalistic, more decorative and expressive style. He continued to utilize this manner, depending upon his subject matter, as an alternative to more orthodox Impressionist strategies. His located California pictures generally partake of this more "advanced" mode, as was noted about his *Hill of the Sun* in 1981. See John Caldwell, "California Impressionism: A Critical Essay," in Jones, Caldwell, and St. John, *Impressionism,* p. 14.

70. *Point Lobos, Carmel* was acquired in the

late 1920s by Mr. and Mrs. William Preston Harrison, the leading art patrons of the period in Los Angeles, who donated it to the Los Angeles Museum of History, Science and Art.

71. A.V.C., "Childe Hassam at Montross'," *American Art News* 14 (December 4, 1915): 5. The "California Group" of eleven paintings was included within a show of 106 works at the Montross Gallery, *Exhibition of Pictures by Childe Hassam*, New York, November–December 1915. I am grateful to Kathleen Burnside, who is preparing the Hassam catalogue raisonné, for her assistance in regard to his 1914 California visit and the paintings he produced there.

72. Jessie Wybro, in discussing the works by the landscape painters on view in the Palace of Fine Arts, noted that such visitors to California found "their repertoire incomplete without the inevitable bit of California." (Jessie Maude Wybro, "California in Exposition Art," *Overland Monthly* 66 [December 1915]: 518–21.)

73. Kathleen M. Burnside, "Murals by American Impressionists 1892–1915," unpublished seminar paper, Graduate School of the City University of New York, fall 1984, p. 4. Burnside's essay is a brilliant exposition of the mural work by the American Impressionists.

74. Edward Simmons, *From Seven to Seventy: Memories of a Painter and a Yankee* (New York and London: Harper and Brothers, 1922), p. 338.

75. One writer noted that "Mr. Simmons' scheme was full of technical novelty and interest." (Christian Brinton, *Impressions of the Art at the Panama-Pacific Exposition* [New York: John Lane Company, 1916], p. 48.) A detail of one of Simmons's murals can be seen in color in *California's Magazine*, 2 vols. (San Francisco: California Magazine Company, 1916), vol. 2, preceding p. 129.

Childe Hassam's first forays into mural painting were also very impressionistic. They consisted of decorations he painted in 1904 for the private home of his close friend and patron Colonel Charles Erskine Scott Wood, in Portland, Oregon.

The murals were later disassembled and divided among Wood's children; the largest panel is now in the Memorial Art Gallery, University of Rochester, Rochester, New York.

76. Hassam, in De Witt Lockman, "Interview," February 2, 1921, pp. 21–22, typescript in the New-York Historical Society library; Simmons, *From Seven to Seventy*, pp. 339–40.

77. Ilene Fort points out that Hassam visited Carmel in the company of Francis McComas, a leading Tonalist watercolor painter from San Francisco. (Ilene Susan Fort and Michael Quick, *American Art: A Catalogue of the Los Angeles County Museum of Art Collection* [Los Angeles: Los Angeles County Museum of Art, 1991], pp. 210–11.) In discussing his stay in San Francisco, Hassam recalled Mathews's work and their friendship, which dated back to their study at the Académie Julian in Paris during the late 1880s. (Lockman, "Interview," p. 21.)

78. Maxwell, "Art," June 13, 1914.

79. Everett C. Maxwell, "Art," *Graphic*, June 20, 1914, p. 13.

80. Antony Anderson, "Art and Artists," *Los Angeles Times*, June 28, 1914, part 3, p. 4.

81. Robert E. Brennan and Merle Schipper, *Colors and Impressions: The Early Work of E. Charlton Fortune* (Monterey, Calif.: Monterey Peninsula Museum of Art, 1989), pp. 10, 33, quoting from page 7 of Fortune's autobiographical essay, 1969, Fortune Papers, Monterey Peninsula Museum of Art.

82. Chase's portrait of Townsley was reproduced in an article about Townsley and his role in Los Angeles art education. (David Edstrom, "A Friendly Suggestion about Art Schools," *California Southland* 18 [May 1921]: 8.)

Chase's summer school activities at Carmel are well documented. See Katherine Metcalf Roof, *The Life and Art of William Merritt Chase* (New York: Charles Scribner's Sons, 1917), pp. 246–52; Eunice T. Gray, "Chase Summer Art School," *American Art News* 13 (October 17, 1914):

2; Eunice T. Gray, "The Chase School of Art at Carmel-by-the-Sea, California," *Art and Progress* 6 (February 1915): 118–20; Frances Lauderbach, "Notes from Talks by William M. Chase," *American Magazine of Art* 8 (September 1917): 432–38.

83. Gray, "Chase School of Art," p. 120.

84. For Crow, see Ina Sizer Cassidy, "Art and Artists of New Mexico: Louise Crow," *New Mexico Magazine* 17 (December 1939): 23–24; and David F. Martin, "Louise Crow Boyac (1891–1968)," *Artifact* 1 (September–October 1995): 29–30. Butler, who was painting in an Impressionist manner after studying with Chase and who won first prize for the very impressionistic *The Tea* in Seattle's *Northwest Artists* exhibition in 1915, was considered probably the most brilliant painter in the city before he left for Europe after World War I; he returned to teach at the University of Seattle in 1923 but moved east two years later. (See Gervais Reed, "A Chronology of Art: Seattle and Environs," typescript, University of Washington, Seattle, n.d., passim.)

85. See the unpublished reports on Lewis and on this picture by Grace Dolezel in 1979 and Beverly Veress in 1987, both research docents at the Crocker Art Museum, Sacramento. My deep gratitude to Jan Driesbach, curator of the museum, for her assistance in regard to both Lewis's paintings and her photographs.

86. Schuster is sometimes said to have moved to California in 1913 or 1914, but she continued to give her address as Howard Lake, Minnesota, through the spring of 1915, when she won a silver medal in the First Annual Northwestern Artists Exhibition in Saint Paul.

87. Gray, "Chase Summer Art School"; Helen Spangenberg, *Yesterday's Artists on the Monterey Peninsula* (Monterey, Calif.: Monterey Peninsula Museum of Art, 1976), p. 34.

88. Josephine M. Blanch, "The Del Monte Gallery," *Western Art!* 1 (June–August 1914): 34; expanded by her under the same title in *Art and Progress* 5 (September 1914): 387–92.

89. Townsley wrote the obituary for his former

teacher for the *Los Angeles Times.* C. P. Townsley, "Letters to 'The Times,' Art Leader Gone," *Los Angeles Times,* December 9, 1916, part 1, p. 11.

90. Greenbaum, in Beatric de Lack–Krombach, "Art," *Graphic,* May 22, 1915, p. 12.

91. Antony Anderson, "Art and Artists: Light and Air," *Los Angeles Times,* November 19, 1916, part 3, p. 21.

92. In 1915 the Art Institute of Chicago showed a single painting each by William Silva and C. P. Townsley; in 1917, Donna Schuster; in 1919, Benjamin Brown and Joseph Raphael; in 1920, Anna Hills; in 1921, Karl Yens; in 1922, Jack Wilkinson Smith, John Rich, William Cahill, and Paul Lauritz; in 1923, Lauritz again and Maynard Dixon; in 1926, Orrin White; and in 1930, Clarence Hinkle.

93. At the National Academy of Design annuals, Hanson Puthuff exhibited in 1912; Jean Mannheim, 1913 (the Academy's own diploma portrait of William Wendt); Donna Schuster and C. P. Townsley, 1914; Helena Dunlap and Detlef Sammann, 1915 and 1918; William Silva, 1916; William Cahill, 1917; Karl Yens, 1918; and Benjamin Brown, 1920. Maurice Braun was a fairly regular exhibitor during the 1910s, but in the 1920s, aside from Hansen, Ritschel, Symons, and Wendt (who was absent from 1923 through 1928), few California artists showed regularly at the Academy until the last years of the decade, when Arthur Hill Gilbert, Edgar Payne, and Charles Reiffel sent pictures to the exhibitions. A number of California watercolorists—Mary DeNeale Morgan, John O'Shea, and Donna Schuster—participated in specialized shows in New York.

94. Frank Cuprien and John O'Shea subsequently joined several of the 1917 exhibitors in later annuals held by the society.

95. Antony Anderson, "Art and Artists," *Los Angeles Times,* April 4, 1915, part 3, p. 17. Anderson pointed out that when the picture was first shown as *Survival of the Fittest,* he had remarked that this was not a good title and should be changed.

96. Fred Hogue, "The Art of Edgar Alwyn [*sic*] Payne," *Los Angeles Times,* May 23, 1926, part 2, p. 4.

97. Sonia Wolfson, "Art and Artists," *Graphic,* May 28, 1927, p. 6.

Jack Wilkinson Smith

CHAPTER 1

In Praise of Nature

Will South

For our country here at the west of things
Is pregnant of dreams; and west of the west
I have lived; where the last low land outflings
Its yellow-white sand to the edge of the bay;
And the west wind over us every day
Blows, and throws with the landward spray
Dreams on our minds, and a dreamy unrest.
ROBINSON JEFFERS, "EPILOGUE"

California was America's destiny materialized. Here, at the farthest edge of the Union, were seemingly limitless resources: thick forests, fertile valleys, crystalline rivers, and underground troves of gold. If America really was the promised land—a belief held for so long by so many immigrants from so many countries—then California was the promise kept. This was a land of opportunity and second chances, a land where one could rejuvenate, if not reinvent, the self.

Gold and *dream* became and have remained two of the words used most repeatedly in connection with California. They suggest the state's wealth of resources, its Edenic landscape, and its therapeutic and even magical atmosphere. These words have been used as shorthand for various California myths of endless fun in the sun, of instant stardom and wealth, of carefree unconventionality unthinkable elsewhere—life styles often desired but only sometimes achieved by its residents. But they are words that can also obscure the often brutal realities of unchecked growth, violence, poverty, and oppression that have darkened so much of California's history. Finally, though, these are words that echo the greatest of America's myths: the opportunity for a better life for all, the original golden opportunity that was and remains the American dream.

70. Jack Wilkinson Smith.
Detail of *Sunlit Surf,* c. 1918.
See plate 133.

Indeed, California's history is inseparable from the larger context of American history. During the nineteenth century, the era of Impressionism's nascence and development, Californians believed, as their fellow Americans did, in creationism (the belief that the world and everything in it was made by a divine being); in patriotism (America was a great land destined to be even greater); and in the existence of certain irrefutable truths about the universal order (as God held dominion over men, for example, so men held dominion over women). A typical land-owning, business-running, and churchgoing nineteenth-century Californian could profess to understand his world with astonishing clarity and confidence, as could his eastern counterpart.

Supported by such an unshakable worldview, the average nineteenth-century American of European descent considered truth and beauty to be largely knowable too. These twin stars of the philosophical universe were identified, codified, and taught. The standard aesthetic criterion for painting was its fidelity to observable nature, that first and greatest of all creations. Art, made by mere humans, could never compete with nature, created by God. The best that artists could do was to mirror the glory and the order of nature, the perfection of its incredibly varied parts. This widely shared belief in a planned, stable, and completed environment of divine origin provided a strong foundation for the pragmatic thinking and moral certitude of the dominant social class in America. The clearest expression of American self-righteousness came at midcentury with the doctrine of Manifest Destiny, which declared that the United States had a foreordained role to colonize all the land between the East and West Coasts.

In the last decades of the nineteenth century, even the devastating Civil War, the appearance of Darwin's theory of evolution, and the Industrial Revolution did not subvert the prevailing belief in a planned and ordered universe. American ideas about truth and beauty in painting remained grounded in what was verifiable—in what could be matched and measured against the ultimate aesthetic standard of the great outdoors. Henry David Thoreau wrote in 1854: "Drive a nail home and clinch it so faithfully that you can wake up in the night and think of your work with satisfaction,—a work at which you would not be ashamed to invoke the Muse. So will help you God, and so only. Every nail driven should be as another rivet in the machine of the universe, you carrying on the work. Rather than love, than money, than fame, give me truth."[1] The typical nineteenth-century American painter envisioned his vocation to be like that of Thoreau's proudly diligent worker and, like him, sought the truth. In visual terms, this meant the laboriously accurate representation of landscapes, still lifes, or portraits.

This aesthetic credo of faithful representation also demanded spiritual interpretation. Thomas Cole had declared early in the century that he was more than "a mere leaf painter";

71. Hanson Puthuff (1875–1972).
Grand Canyon, n.d.
Oil on canvas, 72¼ x 96 in.
(183.5 x 243.8 cm). Fleischer
Museum, Scottsdale, Arizona.

he was an artist who expressed the inherent goodness and the overwhelming majesty of Creation. Art was to be morally edifying and uplifting. Landscape art, in addition to expressing such religious sentiments, was also related to the expansionist fervor of the nation. As America pushed west, so did artists who created images that were as grand as the ideology of Manifest Destiny itself. Artists absorbed the political imperatives of their time and place, and they inevitably left traces of those values on their canvases.

72. William Wendt (1865–1946). *There Is No Solitude Even in Nature*, 1906. Oil on canvas, 34 x 36 in. (86.3 x 91.4 cm). The Joan Irvine Smith Collection.

73. John O'Shea (1876–1956).
The Madrone, c. 1921.
Oil on canvas, 25¼ x 29¼ in.
(64.1 x 74.2 cm). Mills
College Art Gallery,
Oakland, California;
Gift of Albert M. Bender.

These various impulses—to replicate nature, to convey its spiritual dimensions, and to infuse the landscape with political significance—were inherited by the painters of late-nineteenth- and early-twentieth-century California known collectively, if somewhat imprecisely, as the California Impressionists. These painters—a large group, including the now-well-known artists Alson Clark, Granville Redmond, Guy Rose, and William Wendt as well as such lesser-known painters as Anne Bremer, John Frost, Evelyn McCormick, and John O'Shea—are all more direct descendants of America's Hudson River school painters than of the original French Impressionists. The California Impressionists' perception of wilderness in all its aspects—the grand, the sublime, and the intimate—derived from a worldview in which reality was stable and related more closely to the fixed and flawless images by Frederic Edwin Church and Albert Bierstadt than to the transient and tenuous landscapes by Claude Monet, Alfred Sisley, and Camille Pissarro.

To be sure, the California Impressionists did graft a variety of French Impressionist methods onto their own more academic techniques, but they could never forsake one of the basic tenets of their American philosophical heritage: truth is *in* nature; the duty of the artist is to reveal this truth, not to alter it, and certainly not to destroy it. Whereas Monet stood before the landscape and dissected its color components with the cool precision of a surgeon, the California Impressionists, like all American landscapists of their era, were essentially humble before the objects within their field of vision and preserved the integrity of them. These artists hoped to invest their canvases, as the Hudson River school painters had done before them, with positive, soul-uplifting imagery, as opposed to the French Impressionists, whose interest in the sensual and the contemporary far outweighed any such sense of moral obligation.

The more effectively an American painter translated the facts of nature onto a canvas and evoked a mood, whether awe-inspiring or pastoral, the more highly praised he was. To reveal something of nature's power, mystery, and beauty was for the artist to be akin to its Creator; the artist was like a preacher who makes the obscurity of a parable comprehensible. The artist's technical skill often determined his own estimation of his artistic merit, and it was a critical

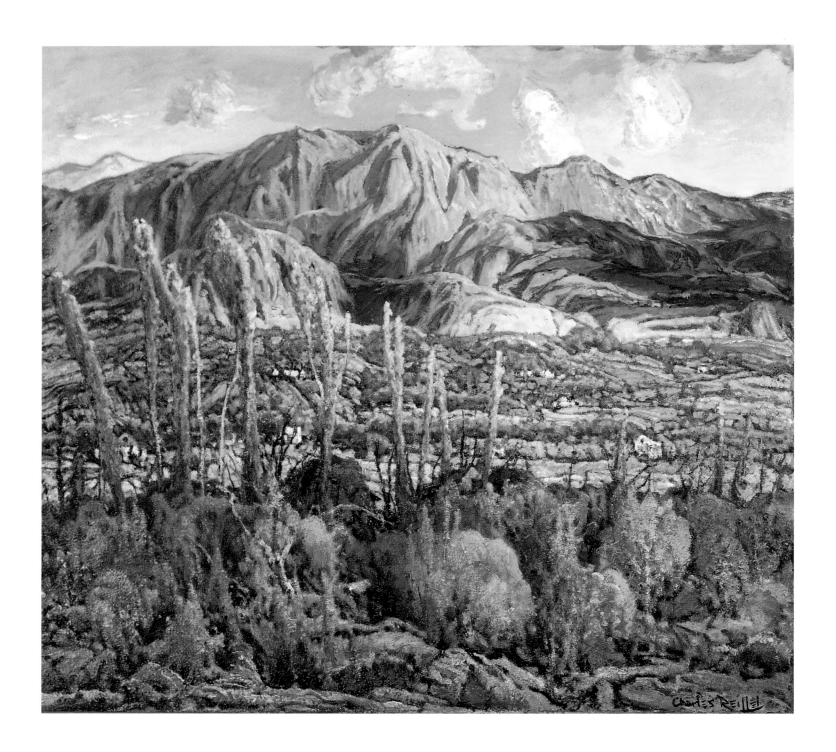

component of his public success. Many of the nineteenth-century American artists who had worked diligently to acquire the academic skills of representation were understandably loath to abandon them to French modernism.

Still, Impressionism held many attractions for Americans. The intensity of color in an Impressionist canvas closely resembled the color they actually observed in nature. Such color had a visual truth that reached beyond the polished and precise yet predominantly brown and gray descriptions of branches and rocks found in the work of their Hudson River school predecessors. So, too, the reductive approach in an Impressionist painting—in which, for example, masses of leaves became a plane of meshed strokes rather than individual leaf upon leaf— approximated nature seen out of doors and occasionally out of focus, as opposed to the constant atmospheric clarity within the studio. To paint this way was not inconsistent with the facts of nature. And the intimate scale of Impressionist painting was appealing. Not all experiences in the landscape were heroic and theatrical; on the contrary, much of nature's poetry could be quiet, even reclusive.

Numerous American painters eventually adopted the flickering, fragmented light of Impressionism, a light so different from the hushed radiance of earlier American landscape. For the French Impressionists, painting the energy, warmth, brilliance, and transience of light took precedence over idealizing the landscape, and the vitality of the paintings that resulted from this focus on light impressed all their followers who sought to interpret the landscape at home. The Impressionists' desire to capture fugitive light could determine the speed with which an image was transcribed and the overall intensity of its chromatic representation.

American painters of the nineteenth century, including the California Impressionists, adopted aspects of the French Impressionist approach—grayless color, simplified detail, intimate scale, and, most important, the idea of light itself as subject matter. The Californians continued to portray the landscape realistically, carefully retaining underlying structures and recognizable forms. But Impressionism gave them a painting method that heightened their ability to represent outdoor light and color more convincingly. Their use of selected Impressionist innovations did not obscure their accurate academic drawing or prevent their expressing some higher content in their work than mere topographical description—an aim entirely consistent with the Californians' artistic and cultural heritage. While the French Impressionists were the first among the European avant-garde in their dematerialization of nature, the California Impressionists were the last among the American Transcendentalists in their reverent praise of it.

74. Charles Reiffel (1862–1942). *Late Afternoon Glow,* c. 1925. Oil on canvas, 34 x 37 in. (86.3 x 93.9 cm). William A. Karges Fine Art, Carmel, California.

Of course, simply to describe the visual elements of California Impressionist paintings—their shapes, colors, and subjects—and to analyze the cultural context in which they were made will neither automatically nor absolutely reveal their meaning. Careful historical investigation and critical interpretation may enhance our general appreciation of this era and its art, but individual artists work in personal and idiosyncratic ways, at times confounding even our most thoughtful efforts at understanding. Artists do not react to cultural and historical stimuli in predictable patterns. Indeed, how can the present-day historian ever know what artists felt when standing beside the pristine Pacific Ocean of one hundred years ago?

The western landscape itself must be considered as a factor in any discussion of early California artists. The region's extraordinary fecundity reinforced both creationist and nationalist

77. Anna Hills (1882–1930).
Montezuma's Head, 1915.
Oil on canvas, 30 x 40 in.
(76.2 x 101.6 cm). Maxwell
Galleries, San Francisco.

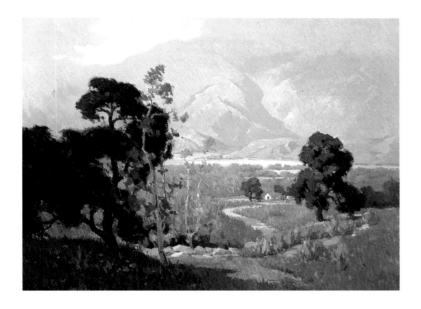

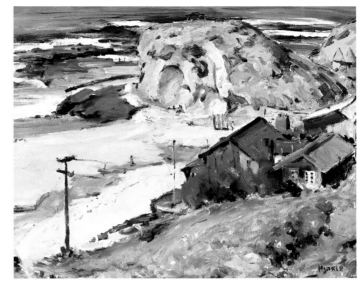

78. Elmer Wachtel (1864–1929).
Ojai Valley, n.d.
Oil on canvas, 24 x 32 in.
(60.9 x 81.2 cm). Jason Schoen,
New Orleans.

79. Clarence Hinkle (1880–1960).
Victoria Beach, Laguna,
c. 1920.
Oil on canvas, 30 x 36 in.
(76.2 x 91.4 cm). The
Fieldstone Collection of
Early California Art.

beliefs. If any land was truly blessed, it must be California, and if any land challenged the spirit of both individuality and democracy by offering opportunities and obstacles to one and all, it must be California. Here, it seemed, was every possible landscape: verdant valleys, rugged mountains, bone-dry deserts, and over a thousand miles of sand-covered shoreline. California was, and is, a land of spectacular light and color. Painting out of doors was a way of being profoundly involved with this environment, and it provided stimulation and inspiration often impossible for artists to put into words.

The appellation "California Impressionism" is used here to designate an informal school of painters who were hybrids of the then dominant strains of American culture and European artistic innovations; within that school, individual responses and modifications were everywhere apparent. This was a generation of painters who began their careers in the 1880s and 1890s already conditioned by a pragmatic yet spiritually oriented value system and attuned to the rhetoric of progress as much as to poetic reverie. They adopted aspects of French Impressionism, Barbizon school painting, and stylish formulas for figure painting observed in fashionable Salons and galleries, but they never lost their philosophical or cultural grounding in the broader spectrum of American art. To say that a given painter was a California Impressionist is to acknowledge this mixed heritage.

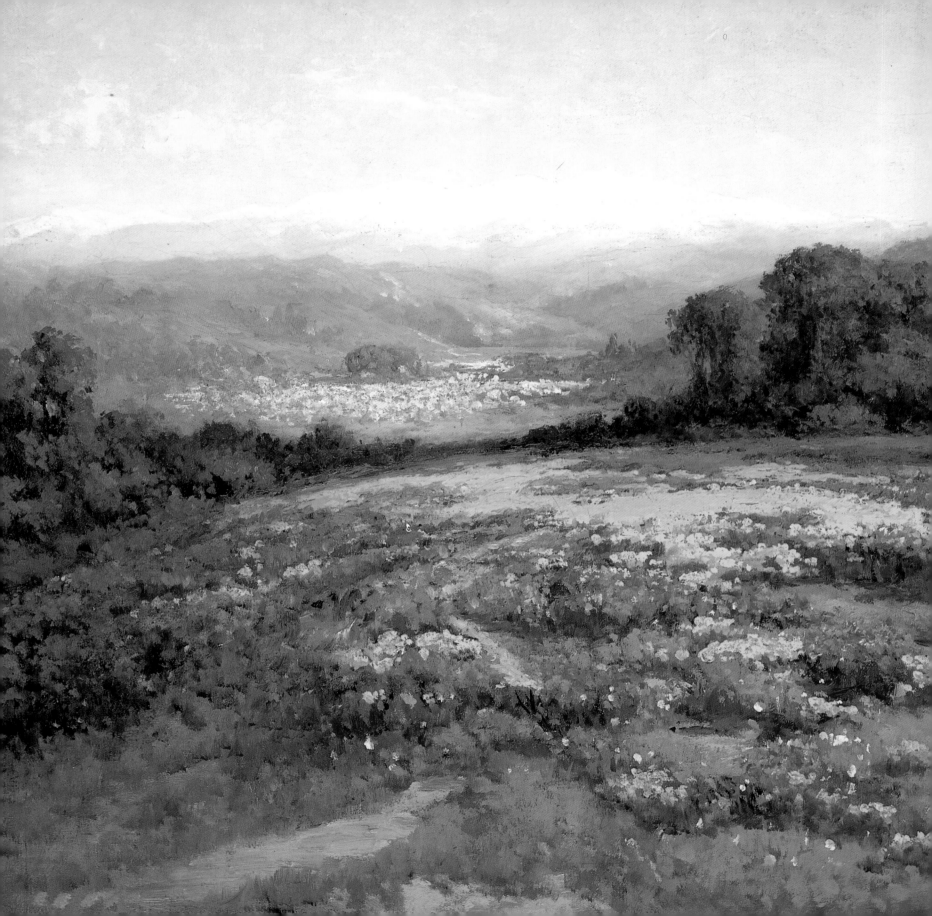

Mentors and Training

The fog was languidly retreating down the valley, leaving behind that subtle scent of summer morning. The sun was up, and from the hilltop one could see the beautiful panorama of hills and mountains extending to the sea. It was wonderful, it was magnificent, but it was not Art. It was Creation, and the inner consciousness could not be expressed, made permanent, by what is known as Art. It was too big, too immense.

GOTTARDO PIAZZONI, 1928

A New Jersey carpenter named James W. Marshall was building a sawmill for John A. Sutter when he discovered gold in the Sierra Nevada foothills in January 1848. The ensuing gold rush radically changed the social fabric and future of California. The territory comprising California, a region long desired by the expansion-minded President James Polk, had just been acquired by the United States after war with Mexico, and statehood was already inevitable. The discovery of gold merely ensured the acceleration of its admission to the Union over other territories lacking this precious resource. As the noted California historian Carey McWilliams wrote, "The union is an exclusive body, but when a millionaire knocks on your door, you don't keep him waiting too long; you let him in."[1] And so California became the thirty-first state in September 1850, while thousands of hopefuls from Mexico, Chile, Hawaii, China, Australia, France, and America—indeed, from all over the world—pursued their dreams of wealth in the fields of gold.

Sacramento, located about forty miles from the site of Marshall's discovery, was made the capital of California in 1854, but as a landlocked town it could not initiate, let alone sustain, the same level of commerce and industry as a port city. That was the role of nearby San Francisco. The community that had been a quiet home to Native Americans for over a thousand

80. William Jackson.
Detail of *Radiant Valley*, n.d.
See plate 88.

years, then a sleepy presidio under Spanish and subsequently Mexican rule, would develop rapidly into a cosmopolitan city, with newly wealthy denizens, exotic subcultures, and reckless law breakers.

San Francisco's wealthiest residents were the builders of the transcontinental railroad that joined America's East and West Coasts in 1869: Collis P. Huntington, Mark Hopkins, Leland Stanford, and the brothers Charles and Edwin Crocker. Included among the city's autonomous communities was Chinatown, with its ancient traditions and Eastern philosophies completely inaccessible to outsiders. The city's lawless were, among others, failed miners who had come in search of riches and found instead hordes of other miners to dispossess. Within a generation of California's admission to the Union, San Francisco had become the diverse, attractive, and fast-growing economic center of the state, far more advanced than the still languorous community of Los Angeles to the south.

The inducements for artists to come to San Francisco were many. The gold rush seems to have attracted the area's earliest artists.[2] For landscapists, the city's location provided proximity to the stunning scenery of Yosemite as well as the coastline. The emergence of a new and fabulously rich clientele—with new mansions having ample wall space for paintings large and small—was also surely a draw, as was the fact that there were far fewer artists per capita than in New York, say, or Paris with whom to compete for commissions or sales. For one or more of these reasons, San Francisco attracted a number of artists in its first decades as part of the United States. Some specialized in quasi-classical genre scenes, some in portraits, some in marinescapes, and still others in fashionable tropical views. The nouveau riche of San Francisco, not surprisingly, wished to commission locally the same type of art they were also buying elsewhere—art that would give them a veneer of high culture suited to their status as California's de facto aristocracy.

81. Charles Meryon (1821–1868). *View of San Francisco*, 1856. Etching, 9⅜ x 39¼ in. (24 x 99.8 cm). Fine Arts Museums of San Francisco; Achenbach Foundation for Graphic Arts.

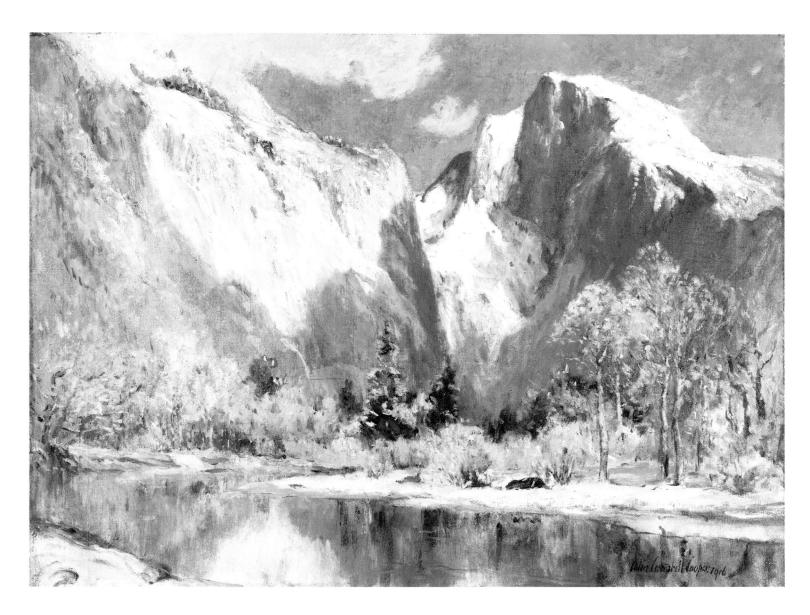

82. Colin Campbell Cooper
(1856–1937).
Half Dome, Yosemite, 1916.
Oil on canvas, 24 x 30 in.
(60.9 x 76.2 cm). Paul Bagley
Collection.

Of greatest significance to the history of impressionistic plein air painting in California was the arrival in San Francisco in 1859 of William Keith; in 1861 of Thomas Hill; and in 1862 of Virgil Williams. These three enormously talented painters, though not Impressionists themselves, all took a near pantheistic approach to nature that informed their landscapes with precision and grandeur. This approach was imparted, directly and indirectly, to the next generation of California landscapists, who were also influenced by Impressionism. The presence and success in California of these three painters contributed to an ideology prevailing among the younger artists that held nature to be sacrosanct, a vast temple of inspirational subject matter. Nature, the elders' paintings demonstrated, was the primary source for emotions and ideas. The role of the artist, their careers confirmed, was to be a conduit transmitting the glories of nature to a receptive audience.

Born in England, Thomas Hill immigrated to America in 1844 and by 1854 had chosen painting as a full-time vocation. He painted landscapes out of doors in the White Mountains of New Hampshire and associated with other White Mountain artists, including his longtime friend in Boston, Virgil Williams. Hill moved to California in 1861, apparently for health reasons, spent most of 1866 and part of 1867 in Paris, and then moved back to Boston, where he painted and exhibited a monumental oil, *The Yo-Semite Valley*.[3] The artist's affinities with the prevailing artistic attitude about landscape were partially identified in a review of this work: "It staggers Atlantic ideas of altitude and distance. There is in it an energy of inspiration which surpasses the dapper prettiness of our mountain scenery. It is the whole of what [Albert] Bierstadt gave us half, and a vision of the new world to be open to us by the lengthening arm of the railway to the Pacific."[4] While working with the White Mountain painters, Hill encountered and fully embraced the group's dominant aesthetic, which is now associated with the Hudson River school, a group of artists including Thomas Cole, Thomas Doughty, Frederic Edwin Church, and Asher B. Durand. The core philosophy of the Hudson River school was expressed in a series of letters Durand wrote to the most important art magazine at midcentury, the *Crayon*, and is summarized in Durand's statement, "It is only through the religious integrity of motive by which all real Artists have ever been actuated, that it [art] still preserves its original purity, impressing the mind through the visible forms of material beauty, with a deep sense of the invisible and immaterial."[5] Or, as Thoreau more succinctly stated, "The universe is wider than our views of it."[6]

Part of the meaning in Durand's words is that the artist would perceive and reveal something of nature's mysterious power but would also adhere to the physical facts that anyone

83. Thomas Hill (1829–1908).
Yosemite Valley, 1876.
Oil on canvas, 72 x 120 in.
(182.8 x 304.8 cm). Oakland
Museum of California;
Kahn Collection.

could see. This combination had a twofold faithfulness: to the forms of nature and to the spirit in nature. Hill's earliest California work and the pictures he exhibited in Boston are fully within this mode—a mixture of "energy" and "inspiration" and a careful delineation of the facts of nature. Hill returned to San Francisco in 1871, again for health reasons, where he painted *Yosemite Valley* (plate 83), a panorama that epitomizes the Hudson River school's grand, romantic, and spiritually bountiful view of the American landscape.

Hill's close friend Virgil Williams was born and raised in the East and studied art at the National Academy of Design in New York before going abroad for additional training. He lived in Italy about eight years, during which he met Colonel Robert Woodward of San Francisco, who invited him to come work in California at Woodward's Gardens—a combination aquarium, zoo, and art gallery intended to provide idle San Franciscans with an amusement other than drink. Williams arrived in 1862, at which time he met and painted with Hill and Keith, but he failed to achieve commercial success. He retreated to Boston in 1866, the same year Hill left for Paris; perhaps the artists shared a need for additional study and opportunity. Williams and Hill lived in Boston from 1867 to 1871, when both finally returned to San Francisco.

Williams and Hill both were exposed to Hudson River school ideas and to the popular philosophy of the British critic John Ruskin, the leading voice in England and America for the notion of truth to nature and the idea that nature contains truth within it. Of young, aspiring artists Ruskin wrote: "Their duty is neither to choose, nor compose, nor imagine, nor experimentalize; but to be humble and earnest in following the steps of nature and tracing the finger of God."[7] Williams would have been especially well informed about contemporary aesthetics, including Ruskin, since he was teaching art at Harvard during his Boston stay.

Williams's sweeping *Mount Saint Helena from Knight's Valley* (plate 84), though not as overtly theatrical as Hill's *Yosemite Valley*, is nonetheless a descendant of the beautifully clear, crisp, and impressive Hudson River school landscape. As with Hill, Williams's considerable technical skill described the geographic wonders of his subject for an audience that generally subscribed unquestioningly to a creationist view of nature. Both Hill and Williams were, for their audiences, magnificent examples of the artist as a conduit for nature's glories, although, as Durand observed, they were glories anyone could see if properly directed.

Scottish-born William Keith had arrived in San Francisco in 1859, slightly before Hill and Williams, and he initially apprenticed as a wood engraver. Perhaps influenced by his Bay Area colleagues, Keith left for European study in 1869, not long after Hill; and Keith, too, wound up living, painting, and exhibiting in Boston. He returned to San Francisco in 1872, just after Hill and Williams. One can assume that these three artists had frequent interaction from the time of their first painting outings to Yosemite together in 1862. Keith's epic landscapes painted in San Francisco during the 1870s contributed to the presence and popularity of Hudson River school ideas in California. An impressive example is his *Kings River Canyon* of 1878 (plate 85).

In the early 1870s the most celebrated of the Hudson River school artists, Albert Bierstadt, arrived in San Francisco. Bierstadt had visited the West in 1858 and spent six months in San Francisco in 1863. The paintings generated from the latter trip precipitated the artist's rise to international fame and recognition. He briefly returned to San Francisco in 1871 and then established a studio there in 1872, where he painted the large-scale, technically spectacular *Donner Lake from the Summit* (plate 86) and *Autumn in the Sierra* (City of Plainfield, New Jersey). Both of these were exhibited in the city in 1873 to great critical acclaim, which firmly established the local preeminence of the grand landscape view.

It was within the highly active artistic scene of the early 1870s that the San Francisco Art Association was founded. In the spring of 1871 a group of the most prominent local artists—possibly inspired by Bierstadt's visit—met at the home of the English-born painter Juan Buckingham Wandesforde and chartered the organization. Among those present were Hill and Keith; when the association established an art school three years later, it chose Virgil Williams as the first director.

The San Francisco Art Association's California School of Design opened on February 9, 1874, and still exists today in the form of the San Francisco Art Institute.[8] The school's curriculum—like those of the other leading American art schools of the period—was modeled after the disciplined methods of the European academies. Emphasis was placed on teaching students to draw accurately before they progressed to painting. Most of the aspiring young artists who went to the school in the 1870s, '80s, and into the '90s admired Hill, Keith, Williams, and especially Bierstadt for having achieved an unsurpassed standard of excellence. Among these early students were many of the first generation of California Impressionists. Their entrée into the art world was marked by an introduction to the academic methods of drawing and painting, and—more importantly—to the Hudson River school–based aesthetic deeply entrenched in the American mind. This aesthetic dovetailed with American religious beliefs, pragmatism, and industriousness—qualities that any honest worker, and perhaps especially an artist, should possess.[9]

Among these early students at the California School of Design were artists destined to become among the best-known and most-accomplished impressionistic landscapists in the state: Anne Bremer, John Gamble, Joseph Greenbaum, Clark Hobart, Evelyn McCormick, Granville Redmond, Guy Rose, and Theodore Wores. They belonged to the first generation of American painters to have direct contact with French Impressionism during their formative years, and the story of how they merged their aesthetic heritage with the methods of European modernism is integral to the history of plein air painting in California.

ACADEMIC EDUCATION

By the 1880s the reputation of the School of Design was solid enough that aspiring artists living in the West could study there and be competitive with alumni of the more prestigious East Coast institutions. Attending the California School of Design in 1885 were Guy Rose, Evelyn McCormick, and James T. Harwood, all of whom became good friends. Rose and Harwood later roomed together in Paris; McCormick and Rose developed a romantic relationship that lasted into the early 1890s. While at the School of Design, they and their fellow students absorbed lessons imparted by Williams, who stressed the value of studying the Old Masters and the skills needed to replicate the visible world. To Williams's emphasis on the rules of representation was repeatedly added the idea of art as the interpretation of nature, not simply its imitation.

Though not an instructor at the School of Design in the 1880s, William Keith maintained a studio on Montgomery Street, where he gave public lectures as well as informal critiques.

His ideas of this period were expressed in a lecture he delivered at the University of California in 1888:

> Imitation is not the all of art, though many may think so. It is, after all, only the foot. . . . Accuracy of drawing is held by figure painters to be one of the chief things in Art, and accuracy of drawing in landscape leads to hardness and stiffness. But there is a quality of drawing in landscape, which only a landscape painter of long experience knows the difficulty of; and that quality is truth to the nature of the thing represented. Landscape painters try to draw accurately at first, but they find, if they progress, that it is this truth of quality which they must seek for.[10]

Keith lamented that the general public preferred the "skill of the artist" above the interpretation of nature, and he pointed out that a photographically realistic painting seen next to one by Camille Corot would appear "simply as a mass of colors and hard lines." Keith's notion of truth was not unlike Thoreau's: truth, like the universe, is broader than our views of it. An artist must describe nature, but nature is a mysterious mix of things both measurable and immeasurable.

Students at the California School of Design were impressed by Keith and his ideas, as they were by those of Ruskin, whose writings they studied under Williams. At this very early stage of their careers, they combined an understanding of the merits of technical skill with respect for spiritual content—a mixture they saw all around them in San Francisco in paintings by Bierstadt, Hill, Keith, and Williams himself. This twofold influence can be seen in the work of William Jackson, who studied with Williams and who later painted alongside Keith. Jackson's work (plate 88) restates the pictorial formulas and interpretive aspirations of both his mentors.

After Williams died in 1886, Raymond Dabb Yelland, who taught outdoor sketching and painting classes from nature (plate 89), temporarily succeeded him as director. Yelland's clear, polished style of landscape painting reinforced and extended Williams's influence. Yelland's work, like that of his peers, demonstrated that academic skills learned in the classroom could be transferred to outdoor painting and that outdoor studies could be taken back into the studio for conversion into more finished works. Later California Impressionists such as Granville Redmond and William Wendt routinely completed landscapes in the studio that they had begun on site (plate 90).

In the last quarter of the nineteenth century, even those first-generation California plein-airists who did not attend the California School of Design experienced similar conditioning in their academic training, whether in the United States or abroad. Frank Cuprien and Fannie Duvall both studied at the Art Students League in New York in the late 1880s; the training there

87. Guy Rose as a student at the California School of Design, 1885, seated before his drawing of the Capitoline *Dionysius*.

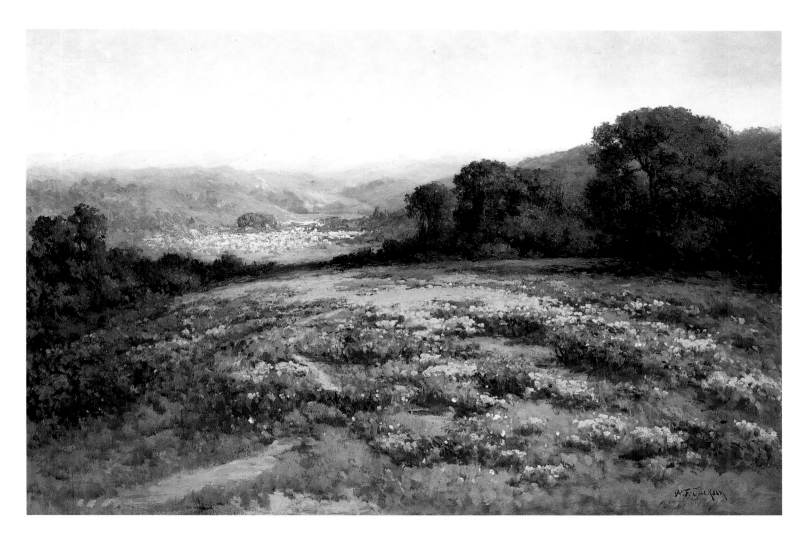

88. William Jackson (1850–1936). *Radiant Valley*, n.d. Oil on canvas, 20 x 30 in. (50.8 x 76.2 cm). Joan Irvine Smith Fine Arts, Newport Beach, California.

was still solidly in the academic mode at that point, although one league instructor, J. Alden Weir, was adopting aspects of Impressionism. Colin Campbell Cooper and Fernand Lungren both attended the conservative Pennsylvania Academy of the Fine Arts under Thomas Eakins. By far the largest contingent of eventual California pleinairists from outside San Francisco hailed from the Art Institute of Chicago. This group included Alson Clark, Edgar Payne, Hanson Puthuff, Donna Schuster, Jack Wilkinson Smith, Gardner Symons and his good friend William Wendt, and Marion Wachtel. The Art Institute's instructors in the 1880s were confirmed academics such as Henry Fenton Spread and John H. Vanderpoel.[11]

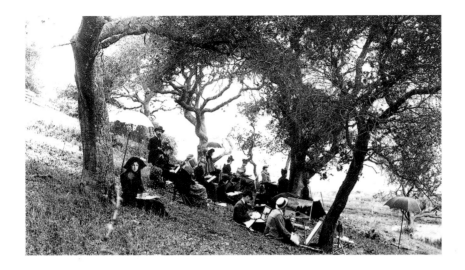

The artistic training shared by all of these artists—from the California School of Design to the Art Students League of New York—was layered with another important experience: most of the artists went on for advanced training in Europe, especially at the Académie Julian in Paris. It was there that this generation of native and future California artists encountered French Impressionism—all at about the same time, during the last decades of the nineteenth century, when Impressionism was well known in France but still new to Americans. All of these young artists shared an initial apprehension and wariness about the new painting, which so often discarded any sense of grandeur in favor of the commonplace.

For the aspiring nineteenth-century American art student, European study was a much-desired rite of passage. The advanced training offered in the art centers of Paris, Munich, and Rome was perceived as a paramount necessity; in addition, the great masterpieces and monuments of Western civilization could be viewed and copied in those cities. The art and ideas available in Europe would lift the willing American out of his provincialism and provide him with a newly cosmopolitan sophistication. And the imprimatur of European training would add luster to the artist's career, making him more authoritative and marketable at home.

By the 1880s Paris had become the destination of choice for Americans studying abroad. The City of Lights had at its center a legendary museum in the Louvre, as well as every possible cultural amenity: theater, opera, dance, and lectures were all readily accessible. Also important for the art student was that he could choose from a variety of public and private ateliers;

ABOVE, LEFT
89. Raymond Dabb Yelland with outdoor painting class from the Mark Hopkins Institute of Art, c. 1895.

ABOVE, RIGHT
90. William Wendt at the easel, 1940.

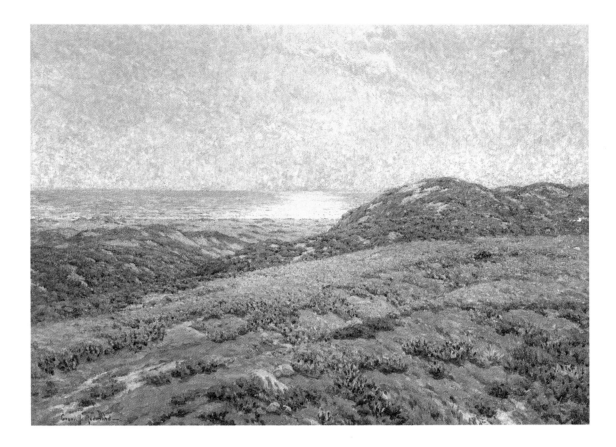

91. Granville Redmond (1871–1935). *Silver and Gold*, c. 1918. Oil on canvas, 30 x 40 in. (76.2 x 101.6 cm). Orange County Museum of Art, Newport Beach, California; Gift of Mr. and Mrs. J. G. Redmond.

see the work of many of the world's most famous and successful painters; and view the all-important annual Salon de la Société des Artistes Français, the officially sanctioned exhibition that featured the latest paintings by established and new artistic talents from the world over. No other city could match this irresistible combination of advantages.

Study at the Académie Julian was a popular option for Americans, since there was only a small fee to enroll and it had virtually no entrance requirements. However, whether the student attended the Académie Julian, the government-sponsored Ecole des Beaux-Arts, or one of the other local schools, basic instruction everywhere was based on the fundamental means of replicating visible shapes, forms, values, and color; as such, it was a continuation of their American schooling. The standards of excellence were well recognized, beginning with the academic mastery of drawing the human figure, in the traditions of Jacques-Louis David, Jean-Auguste-Dominique Ingres, and the Renaissance and classical artists they revered. Students

would labor over a single drawing eight hours a day for an entire week. An accomplished drawing was not only accurate in its proportions and convincing in its illusion of three-dimensional form, it also conveyed a sense of finish and completeness by fully describing the subject. Among the Julian's instructors were successful painters who typified the academic mode during the last quarter of the century: Benjamin Constant, Jean-Paul Laurens, and Jules Lefebvre. All were highly skilled draftsmen, and their specialties encompassed all the recognized Salon subjects—history painting, portraiture, landscape, mythological scenes, biblical and literary subjects, and, in the case of Constant, Orientalist scenes. Their canvases, featuring deftly controlled color and complex lighting effects, provided exemplars for students of what a Salon painting must look like.

It was of the utmost importance for all art students in Paris to receive favorable notice at the Salon to reward their years of study. To garner such recognition was to bolster their own credentials, to enhance their chances of commercial success at home, to be validated as an artist. Such career-related motivations, perceived as crucial at the time, did not encourage the pursuit of Impressionism, the style that appeared to abandon the logic and skill of classical drawing. European academic education—whether at the Académie Julian, the Ecole des Beaux-Arts, or elsewhere—thus deterred most Americans' assimilation of Impressionism, while it reinforced the aesthetic conditioning that students had already received at home.

The influence of French academic instruction can be seen in Eric Pape's *Site of Ancient Memphis* (plate 92). Pape is not associated with early California art today, though he was born in San Francisco, attended the California School of Design, and roomed in Paris with fellow students Guy Rose and James T. Harwood. Pape responded strongly to the Orientalism of Constant and spent two years in Egypt in search of subject matter; he showed an interior view of a mosque in Cairo at the 1892 Salon.[12] *Site of Ancient Memphis*, though not a Salon entry, reflects Pape's Salon style; it was exhibited in 1893 at the World's Columbian Exposition in Chicago.[13]

The French peasant painters—exemplified by Jules Bastien-Lepage, Jules Breton, Léon Lhermitte, and Jean-François Millet—held tremendous appeal for younger artists.[14] These were competent draftsmen who avoided rigidly painted obscure historical or classical themes, favoring instead the rural life around them, as in Breton's *The Weeders* (plate 93). Such rural scenes, usually rendered on an epic Salon scale, also appealed to a variety of artists because

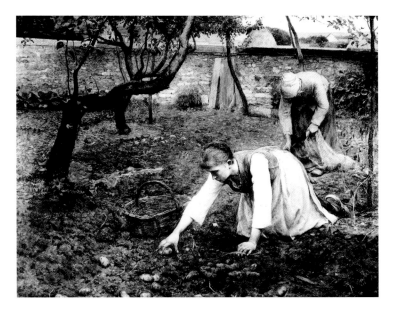

their subjects, most often workers in the field, ennobled labor and glorified the beauty of the preindustrial world. Guy Rose, who was first represented in the Salon of 1890, exhibited in 1891 two rural pictures, painted on a grand scale: *The End of the Day* (destroyed) and *The Potato Gatherers* (plate 94). *The Potato Gatherers*, which idealized hard labor with technically accomplished, classicizing peasant figures, was precisely the kind of image that perpetuated the aesthetic values that Rose and his peers had absorbed in America. *The Potato Gatherers* would have been admired by his former teachers in San Francisco foremost for its grand theme, but also for its expert command of drawing, highly finished surface, and tight control of color, which reflects the brighter palette then popular in Salon painting.

Evelyn McCormick's Salon entry of 1891, *A Garden in Giverny* (plate 95), also demonstrates an assimilation of academic principles and current influences. As in Rose's *Potato Gatherers*, *A Garden in Giverny* is carefully controlled, with clear forms and smooth, descriptive brushwork. Unlike the narrative scene chosen by Rose, McCormick's Giverny garden is devoid of figures. Though it is a large painting, the space is limited to an immediate foreground; the focus is on the diversity and detail of a thriving garden, a subject rich in pictorial possibilities. The artist may have felt, as an increasing number of painters did, that she could dispense with storytelling and classical quotation.

Four years after McCormick's Salon debut, Granville Redmond was accepted into the Salon of 1895 with a painting that featured not a historical, mythological, or classical subject, nor even a peasant or portrait, but rather a contemporary view along the Seine, entitled *Winter Morning* (*Matin d'hiver*; California School for the Deaf, Fremont). The Salon was slowly becoming receptive to changing attitudes in the art world, but it still was most likely to accept pictures that demonstrated traditional skills. In spite of its modern subject, Redmond's *Winter Morning* did precisely that.

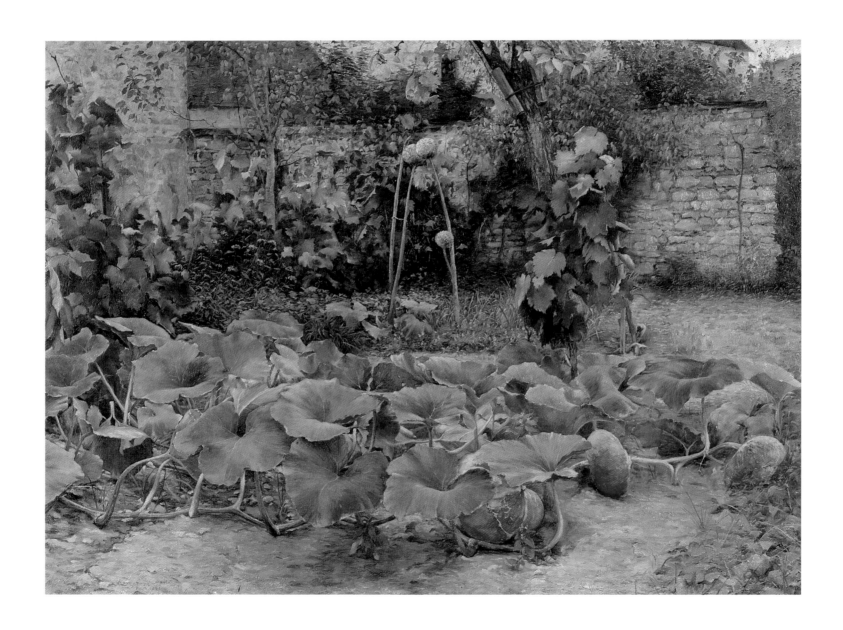

OPPOSITE

95. Evelyn McCormick
 (1869–1948).
 A Garden in Giverny, 1891.
 Oil on canvas, 34¾ x 45¾ in.
 (88.2 x 116.2 cm). University
 of California, Berkeley
 Art Museum.

BELOW

96. Granville Redmond
 (1871–1935).
 Landscape, n.d.
 Oil on canvas, 30¼ x 40½ in.
 (76.8 x 102.8 cm). Los Angeles
 County Museum of Art;
 Gift of Edith H. Redmond in
 memory of Jean Redmond.

At the age of just two and a half, Redmond had been left completely deaf by a bout of scarlet fever. He had the good fortune later to attend the Institution for the Deaf, Dumb and Blind in Berkeley, where he studied drawing under the talented artist Theophilus Hope d'Estrella, a former student of Virgil Williams's.[15] Like his teacher, Redmond went on to the California School of Design, beginning in 1890. There he studied with Raymond Dabb Yelland and Amédée Joullin and, in 1893, with San Franciscan Ernest Peixotto, who had only recently returned from study in France and had himself exhibited at the Salon.[16] Redmond had also studied painting with Arthur Mathews, the new director of the school. Mathews and his wife, Lucia, promoted a style of painting that had a

97. Maynard Dixon (1875–1946). *Portrait of Granville Redmond*, 1914. Oil on canvas, 11 x 14 in. (27.9 x 35.5 cm). Oakland Museum of California; Gift of Dr. and Mrs. Frederick Novy, Jr.

strong decorative and Tonalist emphasis. Mathews's influence can be seen in Redmond's *Winter Morning*, with its gray atmosphere wrapped around a romantic city view. Redmond's work once he returned to California was typical of the California artists of his generation, who eventually assimilated a variety of approaches to painting that could be applied to the grandeur of the state's landscape—including the academic, Impressionist (plates 11 and 91), Tonalist (plate 96), decorative, and Symbolist styles.

Toward the end of the century, an appearance at one of the Paris Salons continued to be important for any aspiring artist. In 1899 William Wendt, who would become one of the most successful of all California landscape painters, showed two paintings in the revamped Salon of the Société Nationale des Beaux-Arts.[17] Born in Germany, Wendt had emigrated to the United States in 1880. What formal training he had was from the Art Institute of Chicago, where he developed an affinity for sketching outdoors, then working up larger, finished canvases in the studio. He traveled to California from Chicago in 1894 and then again in 1896–97, with his good friend and fellow painter Gardner Symons. Wendt finally left to paint abroad in 1898, but unlike most of his peers, he did not engage in further academic study while there, though he studied art in museums and galleries. He went to Cornwall, England, with Symons, and upon his return to Chicago he exhibited his California and English landscapes at the Art Institute.

The future *Los Angeles Times* art critic Antony Anderson was then a student at the institute; years later he recalled that the Wendt exhibition "created a sensation among us students, and our enthusiasm was shared by the rest of Chicago."[18] It was during his English sojourn that Wendt submitted (whether in person or not, we don't know) two landscapes to the Paris Salon. His *Autumn Melody* is a simple, sturdily composed landscape that was recognized even at the time as not being as free in execution as his other landscape work: "An 'Autumn Melody' was Wendt's contribution to the New Salon of 1899. It is in low tones of greens and drabs, but is far less characteristic of the artist's style, and to the writer less interesting and spontaneous . . . and inferior to his buoyant fields and seas which the sun enriches with light and color."[19] No doubt Wendt was consciously paying homage to the Salon tradition when he entered this linear and smoothly polished picture, but he completely eliminated any literary references or paeans to French peasant painting. Wendt could not have known that his painting was the first pure landscape entered into a French Salon by an artist later to be associated with California Impressionism. Though Wendt's Salon entries of that year were carefully, even stiffly, painted, they nonetheless pointed toward the weakening grasp of the academic mode and the future dominance of pure landscape that he would help to establish in California.

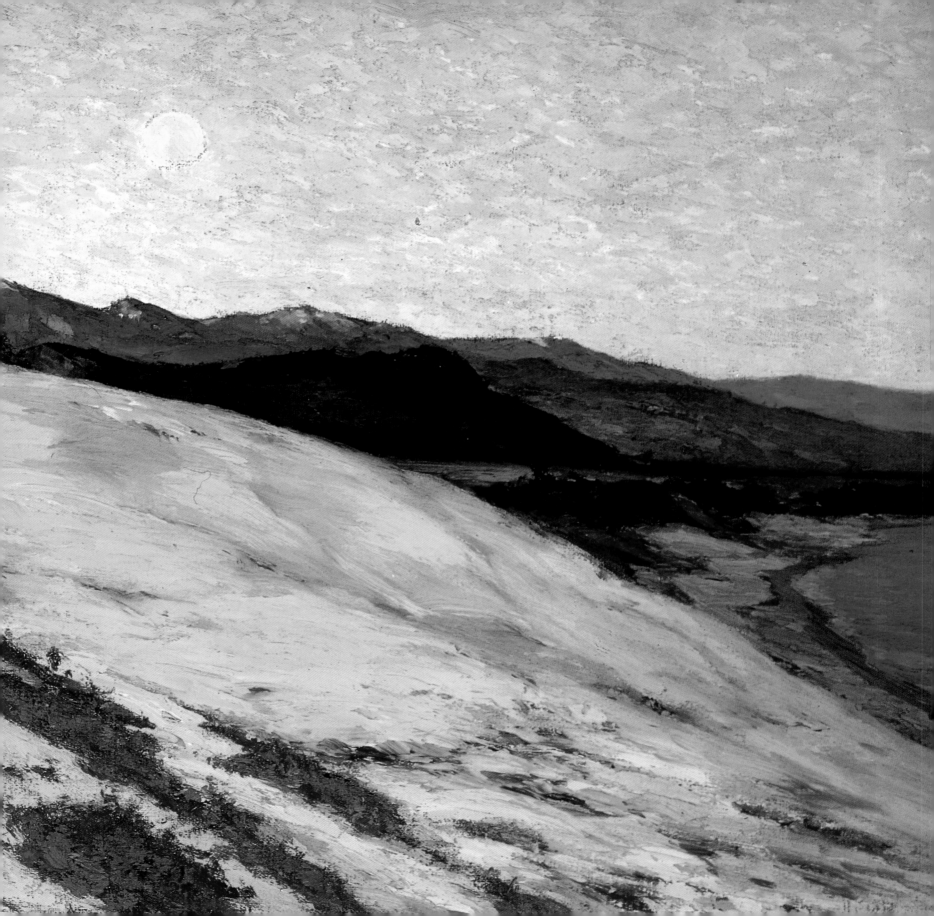

First Encounters with Impressionism

Light and air. To us of today these are the Alpha and Omega of painting. We feel that landscape, at any rate, could not exist without them. . . . Before our time, however, all painters were not so particular. They had conceived light, to be sure, but not much air, and few of them had any notion of objects bathed and transfigured by both.

ANTONY ANDERSON, NOVEMBER 19, 1916

A crucial experience for all the Californians working in France during the 1880s and '90s was their proximity to experienced pleinairists. Exposure to artists who believed in the virtues of plein air painting enabled the Californians to better understand one of the basic tenets of Impressionism: to capture fugitive light, the artist must paint broadly, quickly summarizing the forms upon which it falls. However at odds this visual empiricism was with the fact-oriented American visual ethos, it was nonetheless unavoidable when painting outdoors. As Granville Redmond once insisted, "Fifteen minutes—no one should sketch longer than that from nature. By that time, everything has changed."[1]

There were many opportunities for the Americans to paint *en plein air*. On vacation from their more official studies—whether at the Académie Julian, the Ecole des Beaux-Arts, or a private atelier—the art student in Paris could head out to rural Etaples, Crécy, Fontainebleau, Pont-Aven (plate 99), and other similarly picturesque locales. But no destination was to become as associated in the popular imagination with Impressionism as the small village of Giverny. Located near the Seine less than an hour's train ride from Paris, Giverny attracted artists of all nationalities. Claude Monet was the first and most famous to establish a house and studio there; his presence, in combination with the town's beauty and its easy accessibility

98. William Wendt.
Detail of *Malibu Coast*, c. 1897.
See plate 108.

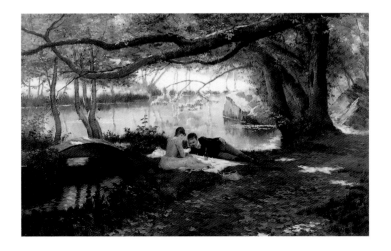

from Paris, attracted scores of painters—from Canada, Great Britain, Scandinavia, and from all over the United States, including California. Once there, no artist could have been unaware of Monet and his painting. As Guy Rose would later recall, "Monet himself was the chief object of interest in the place."[2] And it was unquestionably Monet who best represented French Impressionism for Americans.

The first artist with California connections to stay at Giverny was probably Eric Pape, who was there in May 1889[3]; the only three Californians of subsequent note to stay at Giverny in the 1890s were Ernest Peixotto (pi-zhō-tō), Guy Rose, and Evelyn McCormick. Peixotto, Pape's friend from the California School of Design, was the state's most frequent visitor to Giverny before the turn of the century, going for the first time in September 1889 and making numerous trips throughout the 1890s.[4] Unfortunately, his career is one of the least studied of the California artists, and the location of his Giverny work is presently unknown, except for a small Tonalist drawing from 1891 (plate 100).[5]

Possibly inspired by Peixotto, Guy Rose registered at the Hôtel Baudy at Giverny in July 1890, joined there by his steady companion, Evelyn McCormick. Rose and McCormick returned in May and June 1891, respectively, and stayed until July. Rose completed a number of small outdoor landscapes there in 1890–91 and probably also in 1894, and McCormick based her large Salon oil of 1891 on her Giverny studies (plate 95). Although Rose and McCormick were aware of Monet's work, and perhaps knew of the series of grain stacks that artist had been painting since the mid-1880s, no dramatic influence of Monet is apparent in their work. Their conversion to the new style was gradual, becoming evident first in their preference for palettes

ABOVE, LEFT
99. James T. Harwood (1860–1940). *Untitled (Luncheon at Pont-Aven)*, 1892. Oil on canvas, 20 3/4 x 32 in. (52.8 x 81.2 cm). Patsy and Ramon Johnson Collection.

ABOVE, RIGHT
100. Ernest Peixotto (1869–1940). *Giverny*, 1891. Charcoal pencil on paper, 4 7/8 x 8 1/4 in. (12.5 x 21 cm). The Bancroft Library, University of California, Berkeley

much lighter than those they had been taught to use in California. That Rose, McCormick, and Peixotto may have thought of themselves as Impressionists even in the early 1890s is suggested by a 1907 article in which McCormick reminisced about her student days in France: "In the summer the art students went off to Gray [Grèz] or Fontainebleu [*sic*]; the impressionists to Giverny, where Monet worked. Not that they ever saw him, but they seemed to think that some part of his atmosphere permeated the place."[6]

The little-known Lucy Bacon, the only California artist who is known to have studied directly with one of the French Impressionists, worked for a time with Camille Pissarro in the 1890s.[7] After training at the Art Students League in New York, Bacon left for France in 1892 and enrolled at the Académie Colarossi, but she soon became dissatisfied there. Bacon sought guidance from none other than Mary Cassatt, who wrote to the young painter: "I shall be most happy to see what you have done and give you any advice and help in my power. M. Pissarro

101. Lucy Bacon (1858–1932). *Garden Landscape*, c. 1894–96. Oil on canvas, 20 x 24 in. (50.8 x 60.9 cm). Fine Arts Museums of San Francisco; Gift of Ruth Vickery Brydon.

I heard the other day, was soon to be back at Eragny, and his advice will be of more assistance to you than mine, but you will have both."[8]

Bacon moved to Eragny, and there she took criticisms from Pissarro, though it is not clear how intensive her study with the master was. One snow scene she painted at Eragny (date unknown; private collection) clearly mimics the Impressionist's style.[9] Her letters home to her family in California describe the ongoing health problems that plagued her in France and kept her from painting full time. She soon moved to California (San Jose, then San Francisco) for health reasons, confident (like so many before and after her) in the state's salubrious climate. Bacon apparently abandoned her painting career shortly after 1900, when she became a Christian Scientist. She left very little work, but several of her small oils, most of which she exhibited in San Francisco in the late 1890s, have a remarkable spontaneity and freshness of execution (plate 101). Her experience suggests that there may have been more extensive contact between California artists and the original French Impressionists than has been previously assumed.

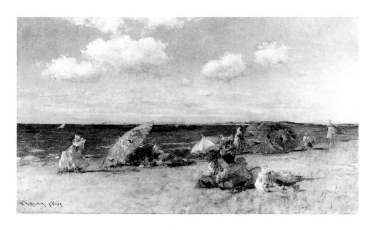

102. William Merritt Chase (1849–1916).
At the Seaside, c. 1892.
Oil on canvas, 20 x 34 in.
(50.8 x 86.4 cm). The Metropolitan Museum of Art, New York; Bequest of Adelaide Milton de Groot (1876–1967), 1967.

There were, of course, a number of artists from California who encountered Impressionism not while studying in Europe but at home, through other American artists. Prominent among these was Alson Clark. Clark's first formal training, solidly in the academic vein, was at the Art Institute of Chicago in 1893. He enrolled at the Art Students League in 1895, and there he came under the tutelage of the progressive painter William Merritt Chase. Clark had been at the league just a short time when Chase formed his own school, the Chase School of Art (which later became the New York School of Art). Clark studied with him at the new institution for the next three years, attending Chase's summer classes at Shinnecock, Long Island. While at the Chase School, Clark also took courses from Frank Duveneck, and he befriended Lawton Parker, a fellow student who, like himself, was destined to become well known for his adaptations of Impressionism.

Chase had begun to experiment with Impressionist techniques in the early 1880s, and his work of the 1890s, when Clark was his student, are most often scenes of idle recreation described with richly textured pigment and a brilliant palette. Though Chase never considered himself an Impressionist per se, his *At the Seaside* (plate 102) incorporates the short, flickering brushstrokes and atmospheric effects associated with that movement. Its subject—people relaxing at

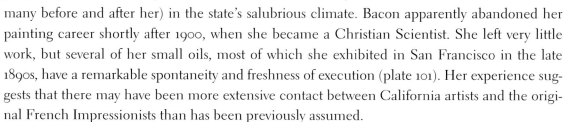

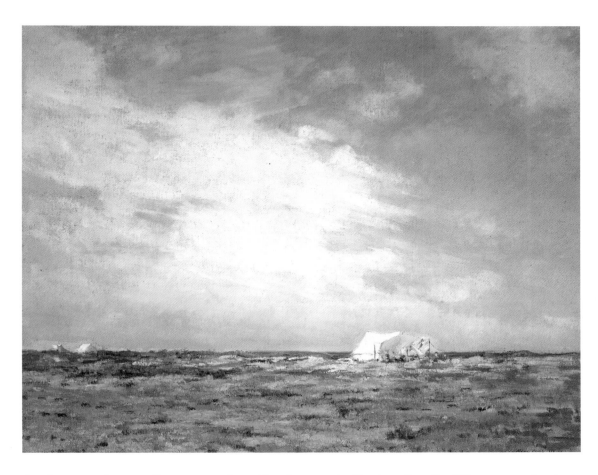

103. Alson Clark (1876–1949).
The Weekend, Mission Beach, 1924.
Oil on canvas, 25¼ x 32 in.
(64.1 x 81.2 cm). The Irvine
Museum, Irvine, California.

the shore—echoes earlier scenes of seaside pleasures by Eugène Boudin (Chase owned at least seven paintings by Boudin) and Claude Monet.[10]

 The transmission of Impressionist ideas from Boudin to Chase to Clark is immediately evident in Clark's *Weekend, Mission Beach* (plate 103). That canvas, painted no earlier than 1919, quotes a number of compositional devices that seem to derive from Chase's *At the Seaside*: the earth-to-sky ratio is similar, as is the cloud movement; the subject, seaside recreation, is the same; and Clark's palette is in nearly an identical key—no warmer or cooler. In aesthetic attitude and technical execution, Clark's painting is a testament to Chase's profound and lasting influence. Though Clark painted thousands of oils between his student years with Chase and his work in California in the 1920s, Chase had an enormous role in shaping Clark's fundamental understanding of impressionistic methods.[11]

Another California artist to be influenced by Chase, though to a lesser extent, was Euphemia Charlton Fortune. Taking art instruction first in London, then at San Francisco's California School of Design, Fortune continued her training in New York, where she took classes from Frank Vincent DuMond, who was a good friend of Guy Rose's. In New York she also attended lectures by William Merritt Chase. As with the work of Alson Clark, Fortune's later painting achieved a judicious balance between the illusion of palpable objects and the shimmering dispersion of form in flurries of broken strokes (plate 104).

The landscape of the grand view—as defined by Bierstadt, Hill, Keith, and Williams—remained dominant in California through the late 1800s, complemented in the 1890s with the rising popularity of a Tonalist movement inspired by George Inness and James McNeill Whistler and led by Arthur Mathews. Perhaps the most impressionistic painting to be seen before the turn of the century in San Francisco was Lucy Bacon's work, which she exhibited there from 1896 to 1898; presumably she showed some of the work she had done with Pissarro in France. In any event, the local community took little note of either Bacon or her work.

Peixotto's 1893 plein air painting of San Rafael (plate 25), a community located just north of San Francisco, gives, perhaps, the closest available approximation of his Giverny work. The brushwork in *Clearing by a Willow (San Rafael)* appears much freer than anything done by Rose or McCormick in the same period. Peixotto's focus on a sun-dappled path shrouded by trees bespeaks a keen interest in the quickly transcribed effects of light and shadow. This painting was made while the artist was teaching briefly at the Mark Hopkins Institute of Art; had he remained in San Francisco, Peixotto and his work could have played an important part in the development of impressionistic painting in Northern California. That the artist thought of himself, on some level, as an Impressionist is suggested by his clever illustration *Le Retour de l'impressioniste* (plate 26), for the small magazine the *Lark*. Peixotto ultimately found greater success in the East as an illustrator, though he did often return to work in California, and eventually wrote and illustrated a book on his beloved state.[12]

Guy Rose exhibited three paintings at the spring exhibition of the San Francisco Art Association in 1892, of which at least one, *November* (owned then by Evelyn McCormick; current location unknown), seems to have been a Giverny painting. Rose was not well known in the Bay Area, and these tentative experiments with a brighter palette and looser brush strokes seem not to have caused much of a stir among San Francisco's local painters and critics. This had not been the case when Rose was in Los Angeles the year before. At that time, the local press noted:

104. Euphemia Charlton Fortune (1885–1969). *Monterey Bay*, 1916. Oil on canvas, 30 x 40 in. (76.2 x 101.6 cm). Oakland Museum of California; Museum Donors' Acquisition Fund.

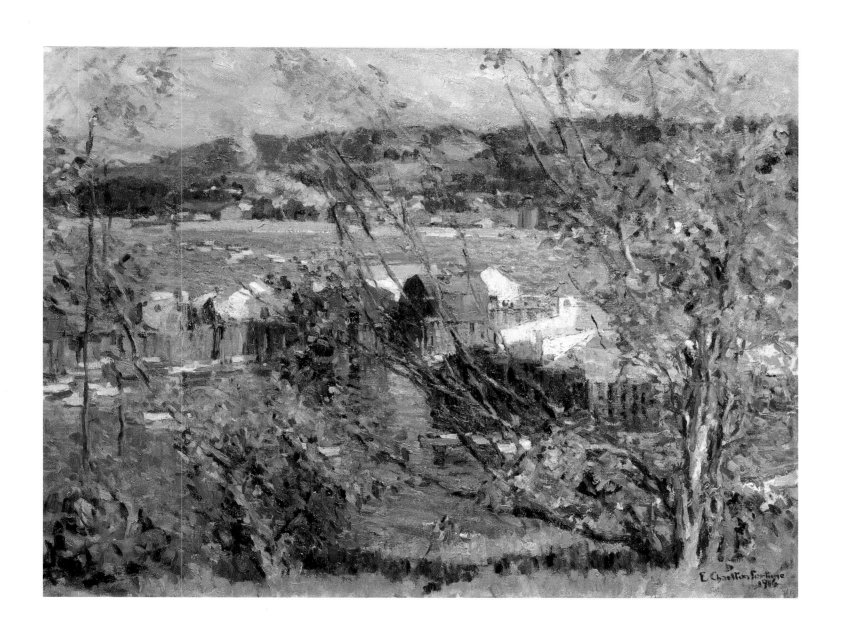

"Of all the young men and women who have left California to complete their education in Europe there are probably very few whose return has been looked forward to by the general public with as much interest as that of Mr. Guy Rose."[13]

Rose was one of the few first-generation California Impressionists to have been born there. The son of pioneer and eventual state senator, Leonard J. Rose, whose Sunnyslope ranch in the San Gabriel Valley (just north of Los Angeles) was legendary for its citrus produce and wines, Rose was touted locally for his studies in France and Salon success. Despite his familial ties and his burgeoning fame at the age of just twenty-four, Rose felt he could not remain in Los Angeles, primarily because the city did not yet have a vigorous, diverse, and competitive art community.

105. H. B. Elliott.
Los Angeles, California, 1891.
Lithograph, 30 x 43¼ in.
(76.2 x 109.85 cm). Robinson Collection.

Unlike San Francisco, whose cosmopolitan activities were fueled by the gold rush, Los Angeles in the 1890s still had a comparatively undeveloped cultural atmosphere. Life in the Southland remained largely rural and agrarian; the prevalent residence was the Spanish rancho, and Spanish continued as the dominant language. Southern California suffered from serious economic depression in the 1870s. From a population peak of 17,600 in 1876, Los Angeles shrank to just 11,000 inhabitants by 1880, the year the first asphalt was laid on Main Street. A significant increase in population did not begin until 1885, the year Rose left for his initial study in San Francisco and, more important, the year that the Atchison, Topeka and Santa Fe Railroad completed its line from Kansas City to Los Angeles and San Diego. That railroad started a price war with the Southern Pacific line (completed in 1882), and a tourism and real-estate boom began that dwarfed all previous booms in Southern California. Instant population and construction, however, do not yield instant culture—nor even a desire for it. Although Rose presented his work in October 1891 at Sanborn, Vail and Company, the art historian Nancy Moure has pointed out, it did not trigger the sudden widespread appearance of impressionistic painting in Los Angeles.[14]

Still, one very perceptive local critic, C. F. Sloane, saw a clear relationship between Rose's smaller landscapes on display in 1891 and the work of Claude Monet: "Two medium sized works that deserve more than the passing notice that it is possible to accord them here are strongly impressionistic and thoroughly imbued with the spirit of the reigning deity in Paris at present—Monet, whom, as has been formerly stated in the *Herald,* Mr. Rose met while painting out of doors one summer in Normandy."[15] Sloane recognized that Rose's approach in these smaller paintings was consciously distinct from his large Salon oils, including *The Potato Gatherers* (plate 94) and *The End of the Day* (destroyed), which were also on view at the gallery. The critic described one of the Monet-influenced paintings: "One of these is a hillside lying in full sunlight, which intensifies the warm green of the early grass, and the other is a view of the church. . . . This is in a lower tone of color than the first, but is treated in the same broad manner and has the same clear feeling of atmosphere."[16] The painting of a "hillside lying in full sunlight" is *Giverny Hillside* (c. 1891; Terra Museum of American Art, Chicago).

Sloane's enthusiasm aside, *Giverny Hillside* is not an Impressionist picture in the sense either of being quickly executed or of emphasizing generalized forms in broad, broken strokes; this is still a carefully drawn composition with clear, distinct edges. It does, however, show the artist trying to capture effects of bright outdoor light and to use details more economically than in his Salon work. This tentative move toward Impressionism, though "imbued with the spirit" of Monet more than with his technique, was appreciated at this early date, even if by only a relatively small nucleus of Los Angeles–area art afficionados.

One Los Angeles artist who may have noticed the Guy Rose exhibition and its impressionistic tendencies was Fannie Duvall. A native of New York State, Duvall had studied at the Art Students League before moving to Los Angeles in 1888. Her *Chrysanthemum Garden in Southern California* (plate 106) reveals the firm understanding of academic drawing and composition shared by many artists of her generation; it also displays a bright palette and interest in outdoor light. This mix may have been inspired by seeing Rose's Salon and Giverny work hanging together. Whereas Rose painted the French peasant in landscapes with high horizons and distant grain stacks, Duvall substituted a Southern California lady in a landscape with high horizons and distant trees, but she mimicked his canvas size, degree of finish, and palette.

However much Duvall may have been influenced by Rose, her interest in painting and her move toward an impressionistic style was not limited to simple mimicry. In 1897 she painted a brisk and atmospherically warm scene of a first communion at Mission San Juan Capistrano (plate 107). In this charming image (a theme popularized in France by Jules Breton, among

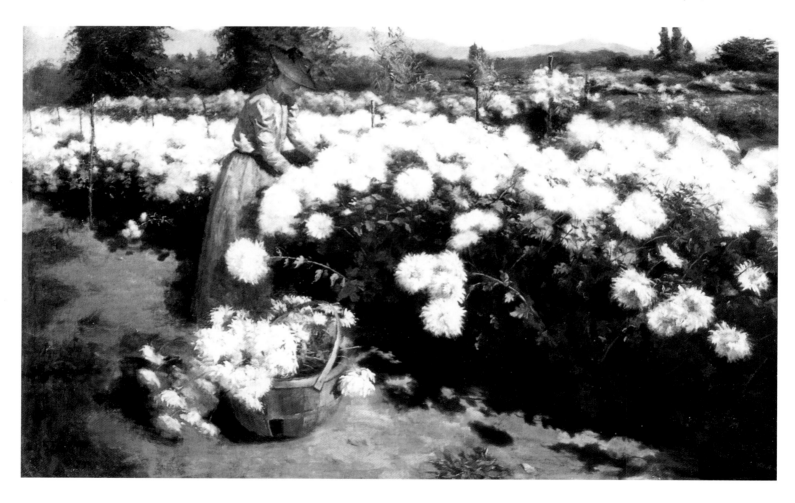

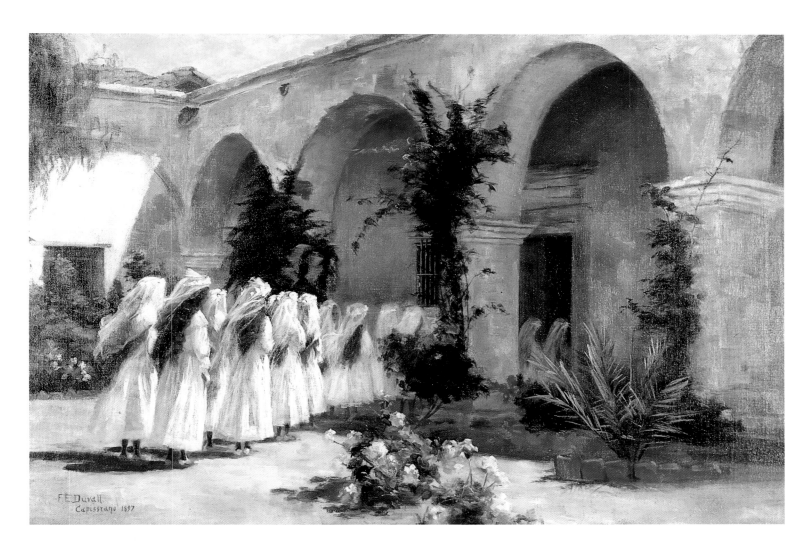

107. Fannie Duvall (1859–1934).
*Untitled (First Communion,
San Juan Capistrano)*, 1897.
Oil on canvas, 20 x 30 in.
(50.8 x 76.2 cm). The Bowers
Museum of Cultural Art,
Santa Ana, California; Gift of
Miss Vesta A. Olstead and
Miss Frances Campbell.

others), the white gowns of the young communicants form a stimulating contrast to the shadowed violets of the mission walls and the vibrant pinks of the foreground flowers. Duvall's skill and early successes led her to follow the pattern so common among the California painters: after initial academic training in the States, she went abroad for training (in her case, with Whistler in Paris) and returned to practice a hybrid style of painting that evinced academic, romantic, and Impressionist impulses all at once. Like so many of her California peers, Duvall found inspiration and renewal in travel. She told a Los Angeles reporter in 1911: "I think an artist should be moving about perpetually, to keep artistically alive. . . . If he remains in one place too long he's apt to stagnate."[17]

Indeed, the best-known San Francisco artists—Hill, Keith, and Williams—had all traveled to Southern California at different times in the 1880s in search of fresh subject matter for their northern market. Their presence in the Southland was not, however, a factor in the development of the art community there. They were visitors only and took their scenic and anecdotal views of the local missions back to San Francisco for exhibition and sale. Their picturesque views made in Southern California were extensions of their firmly established aesthetic—academically sound, with an emphasis on clarity and precision, but nonetheless drenched in romanticism. For these thoroughly accomplished and fully professional artists, the experience of sketching out of doors in the warmer, brighter climate of Southern California did not noticeably alter their mode of producing highly finished, tightly drawn pictures.

The one itinerant painter in Southern California in the 1880s who did seem to respond to the Mediterranean qualities of its light was the San Franciscan Ernest Narjot. Like Hill, Keith, and Williams, Narjot normally produced picturesque scenes characterized by a studio-bound finish more than a plein air looseness. However, his *Santa Catalina Island* (plate 31) is a convincing rendering of the way pervasive sunlight reduces details to mere patterns of color. Its subject, bathers enjoying the shoreline, has a feeling of contemporaneity like that in similar subjects by the French Impressionists, rejecting the nostalgia of picturesque ruins or the formula of the grand-view landscape. Still, Narjot remained primarily an illustrative painter, and his presence in the Southland was temporary and his influence negligible. Until Southern California developed a larger population of resident artists, California Impressionism could not flourish there.

It may have been artistic wanderlust like that described by Fannie Duvall that first took William Wendt and Gardner Symons from Chicago to Southern California; they were artist-friends who would eventually become residents. Symons arrived first, in 1890, when he established a studio south of Laguna Beach, some fifty miles south of Los Angeles. Having discovered

the geographic beauty of the state as well as its temperate climate, he may well have convinced Wendt to travel there. They visited California together for the first time in 1894, and in 1896–97 they enjoyed the unique opportunity of living at and painting the environs of Rancho Topanga Malibu Sequit, the area today known simply as Malibu.

Rancho Malibu was purchased in 1892 by Frederick Hastings Rindge, a Harvard graduate and banker from Cambridge, Massachusetts. Rindge had a love of art and learning coupled with a philanthropic bent (he gave Cambridge a public library and funded the Rindge Manual Training School for Boys), and he welcomed artists as visitors to his ranch. While at Rancho Malibu, Symons and Wendt painted a number of typical grand-view landscapes with dramatic mountains reaching back toward distant shorelines.[18]

The large-scale work done by Symons and Wendt at Rancho Malibu was supplemented by numerous small outdoor studies. In these the conciseness and quickness demanded by plein air painting were combined with their own nascent knowledge of Impressionism. One such study is Wendt's moonlit nocturne *Malibu Coast* (plate 108). *Malibu Coast* prefigures many pictorial elements that would remain favorites throughout Wendt's career, including his emphasis on solidly structured compositions of muscular, rhythmic shapes and his penchant for the romantic, exemplified here by the yellow moon at the picture's center. Wendt remained amazingly consistent throughout his career, painting the landscape with interlocking, nearly geometric planes and plunging curves. But *Malibu Coast* demonstrates that from a very early point in his career Wendt also knew how to use individual brush strokes in a summary way. Here the sandy beach is a conglomerate of subdued yet vigorous strokes of ocher and pale violet, while the sky is an array of muted pinks, blues, greens, and yellows, applied in tiny daubs designed to coalesce in the eye of the viewer. Wendt clearly understood certain aspects of Impressionism well, although he had yet to go abroad. He is perhaps the best example of a California artist who imbibed aspects of Impressionism in America first.

While in Los Angeles, Wendt also clearly expressed his feelings toward nature in a letter to his friend the artist William Griffith, demonstrating the continuity of the religious sentiments espoused by earlier American landscapists:

> The earth is young again. The peace, the harmony which pervades all, gives a Sabbath-like air to the day, to the environment. One feels that he is on holy ground, in Nature's temple.
>
> The warm green of the grass, sprinkled with flowers of many hues, is a carpet whereon we walk with noiseless tread.

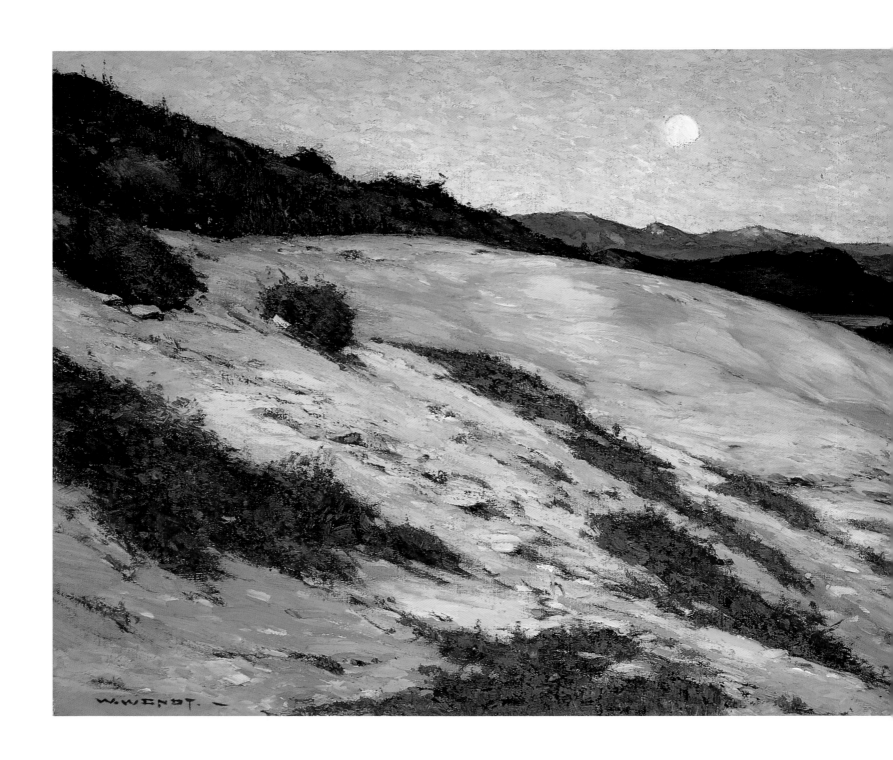

The perfume of the flowers and of the bay tree are wafted on high, like incense. The birds sing sweet songs of praise to their Creator. In the tops of the trees, the soughing of the wind is like the hushed prayers of the multitude in some vast cathedral. Here the heart of man becomes impressionable. Here, away from conflicting creeds and sects, away from the soul-destroying hurly-burly of life, it feels that the world is beautiful; that man is his brother; that God is good.[19]

Wendt would not settle in Southern California until 1906; Symons, though he established a studio south of Laguna Beach as early as 1890, moved back and forth between the East and West Coasts. Though both contributed to the origins of impressionistic painting in the Southland, their more substantive involvement with the movement was yet to come. Indeed, in the 1890s many of the key individuals associated today with the California painters had not yet fixed on the state as a home, though they had visited and, like Guy Rose, may have once lived there. The demographics were to change in the first decade of the twentieth century as more and more likeminded artists moved to California. With their increased number came exhibitions, galleries, art clubs, and, eventually, museums. In that first decade the aesthetic of the early California painters—an aesthetic that reached back to the Hudson River school but was stylistically amended by Barbizon, Impressionist, and French Salon painting—was consolidated as the art best suited to express the social, emotional, and spiritual values of California.

108. William Wendt (1865–1946).
 Malibu Coast, c. 1897.
 Oil on canvas, 18 x 28 in.
 (45.7 x 71.1 cm). Private
 collection.

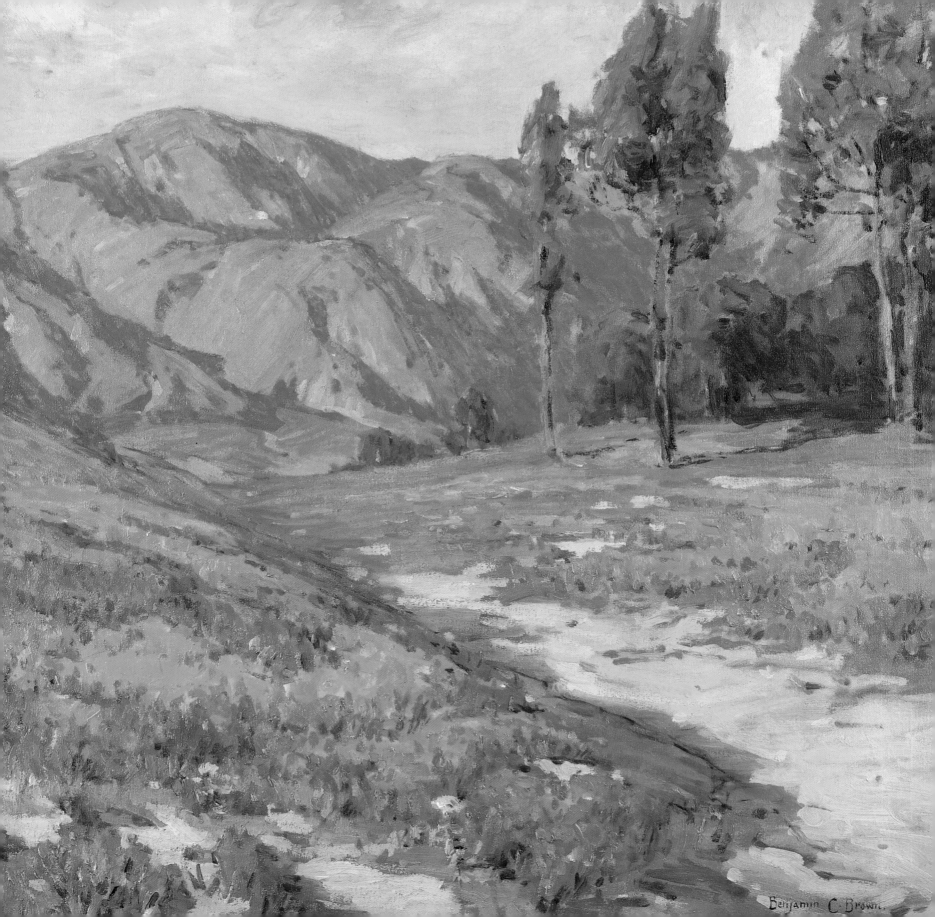

Benjamin C. Brown.

New Institutions, New Popularity

*Los Angeles is already one of the most beautiful cities in the
country, and will probably be the most beautiful of all. It is
unsurpassed in healthfulness, wealth and good order. It is a city
of lovely homes, of cultured, well-to-do people; with Eastern
education and Western cordiality.*

"LOS ANGELES," *LAND OF SUNSHINE*, 1896

That Los Angeles in the 1890s was still an impractical place for an artist to work is suggested
by Theophilus Hope d'Estrella's report on his friend Granville Redmond's move to Los Angeles
in 1898:

> Redmond has a fine studio in Eastside on the outskirts of the business center of Los Angeles. He
> has done some good work, but fate seems to be against him. Los Angeles with a population of
> about 125,000 is not the right kind of a place for artists to make a comfortable living. . . . There are
> two principal reasons: many of the Eastern visitors carry kodaks with them so that they do not care
> to buy anything in art for more than two dollars; and secondly, many of the business men have
> brought treasures of art into their new residences from the East and Europe. . . . Besides
> Redmond, there are two or three resident artists who frankly say they have to send their pictures to
> San Francisco or east to get enough money to keep them from starving.[1]

Redmond was, in fact, one of a very few professional artists living in the Los Angeles area
in 1898. That group included John Bond Francisco, who had moved there in 1892 after his
studies in Munich, Berlin, and Paris; William Lees Judson, who arrived in 1893 after several
years of painting portraits in Chicago; and Benjamin Brown, who arrived shortly before

109. Benjamin Brown.
Detail of *Landscape with
Poppy Field*, n.d.
See plate 119.

Redmond in 1896. The French-born decorative floral painter Paul DeLongpre, who was still lamenting the lack of art appreciation in Los Angeles as late as 1907, arrived in 1898.[2]

On the other hand, the sculptor Gutzon Borglum wrote a positive promotional article for the magazine *Land of Sunshine* in 1895. It was Borglum's contention that art appreciation in California in the mid-1890s was ripe for development—interestingly enough, this was precisely because its premier painters, in Borglum's opinion, remained unaffected by Impressionism:

> We have only begun. Our artists are thoroughly in earnest, and as independent of the prevailing eccentricities of Impressionism as if we lived on another planet. In fact in California we *are* quite another world. The art influence here is so direct and so pure, that Benjamin Constant remarked in 1892 that the young men from California came better prepared for the deeper studies than those from New York. . . . With many of the ablest younger painters wedded to California, such results, I believe, will follow as will excite our Eastern friends as much—and hold their interest longer.
>
> It is gratifying to note a local interest growing, which ere long will support the artist to his best efforts.[3]

Although the number of professional artists living in Los Angeles in the 1890s was small and general support for the arts weak, there was a growing impulse toward organization and promotion. After 1900 what had been little more than enthusiastic aspirations became increasingly realized goals. Existing art clubs and schools matured and stabilized, while art coverage in local newspapers and magazines increased and was largely devoted to the support and encouragement of regional painting.

Interest in the arts was alive and well in the Ruskin Art Club from 1888, when that organization, named for the nineteenth-century British critic, was founded by women interested in the group study of painting. In 1890 the short-lived (less than a year) Los Angeles Art Club was formed with the stated purpose of promoting "a higher standard of art."[4] The Art Association was also founded that year by one Louisa MacLeod; this organization functioned as a public art gallery in the downtown area. The association was followed by the Friday Morning Club, founded in 1891, which sponsored a variety of art-related talks and events; and the Ebell Club, in 1894, another group devoted to self-instruction that included the arts in its schedule. By 1897 Judson was advertising his Modern Art School at the University of Southern California, where he conducted courses in outdoor painting (plate 110).[5] However modest all of these organizations may have been, their mere existence is evidence of the gradual cultural growth of Los Angeles.

It seems reasonable to assume that the existence of these various organizations, combined with the enthusiasm for culture generated by the 1893 world's fair in Chicago, helped encourage the Los Angeles Chamber of Commerce to install an art gallery on its premises in 1894. The impressive Art Room was forty by twenty-five feet (12.2 by 7.62 meters) and was even lit at night by electric lights with tin reflectors (plate 111). The popular support for the Chamber of Commerce's Art Room is proclaimed, and perhaps exaggerated, in S. Howells Jordan's 1894 review:

> Possibly there has never been anything done in Los Angeles for the promulgation of art ideas in which the public of all classes, rich, poor, cultivated, and uncultivated, have shown the same degree of interest that they do in the fall exhibition now in progress at the art gallery, Chamber of Commerce building. Through the cooperation of the artists and their endeavors to place before the public a high standard of art, much will be done to advance the education of the people in that line.[6]

Jordan also indicated that an important component of the Art Room's exhibition was landscape painting, singling out John Bond Francisco as a "true" artist whose view of the San Fernando Valley was "in *plain air* [sic] effects—'all out doors,' we might say in English."[7] Francisco would be a contributor to the local art scene for the next thirty-seven years (plate 112), maintaining a reserved style of pleinairism that did not indulge the "eccentricities," as Borglum had put it, of Impressionism.

With the Chamber of Commerce promoting the fine arts, the various local arts groups felt that 1894 was the right time to establish a permanent museum in Los Angeles. They were no doubt so inspired by stories of the extraordinary sites at the 1893 world's fair that they ignored the economic severity around them, brought on by the nationwide depression of that same year. But the move for a local museum failed and was not revived for a dozen years; the Chamber of Commerce's Art Room was closed in 1895.

That the collapse of the Chamber of Commerce's art program and the museum initiative reflected more the rough economy than a lack of community interest seems indicated by the fact that many of the arts groups that had supported them did not collapse. The Ruskin Art Club survived and eventually found a permanent home in Los Angeles in 1899, when Frederick W. Blanchard built the Blanchard Music and Art Building (plate 113) at 233 South Broadway, a

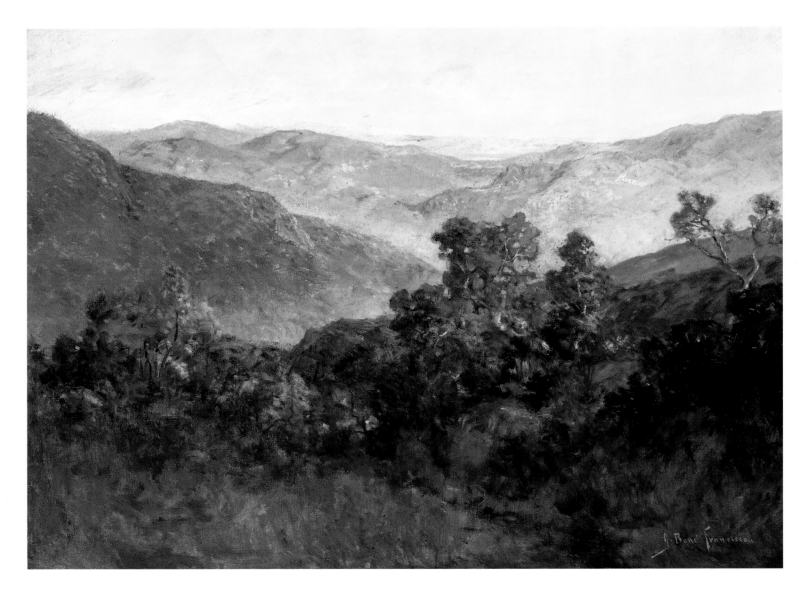

facility that featured studio space for painters and musicians and a large exhibition space on the top floor. By then, exhibition space for artists was also available in the Art Hall of the Shakespeare Club in Pasadena, built by Susan Stickney. For years the Blanchard Building and the Stickney Art Hall (later to become the Stickney Memorial School of Art, plate 114) helped satisfy the demand for exhibition venues, despite periodic lamentations by local professional artists over lack of community support.

Important to the general promotion of both Southern California and its culture in the mid-1890s was Charles Lummis, who in December 1894 took over publication of *Land of Sunshine*, a magazine devoted to the region's cultural life and letters. Lummis had moved to California in 1885 and developed a fascination with the Indian, Spanish, and Mexican heritage of the state, which he featured in his magazine and worked diligently to preserve. Among the artists associated with Lummis and his various enterprises were Carl Oscar Borg, Julia Bracken, Maynard Dixon, William Lees Judson, Fernand Lungren, Hanson Puthuff, Granville Redmond, Gardner Symons, Elmer Wachtel, and William Wendt, as well as the authors Mary Austin, Joaquin Miller, and Idah Strobridge.

Even before Lummis took control of *Land of Sunshine* (which became *Out West* in 1902), the magazine was devoted to the celebration of California. In 1894, its first year, articles were devoted to the beauty of calla lilies, the picturesque Pacific shoreline, the salutary climate, and above all, to the unlimited potential of this land and its people. The magazine was an outspoken

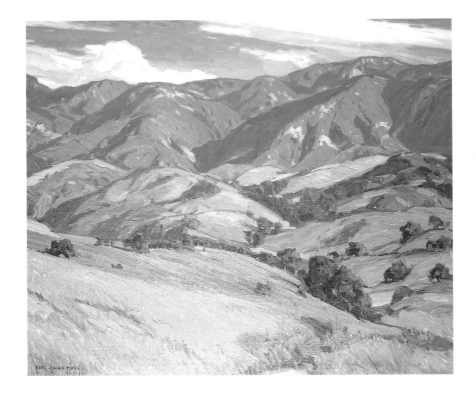

115. Carl Oscar Borg (1879–1947).
Santa Ynez Mountains, 1924.
Oil on canvas, 30 x 34 in.
(76.2 x 86.3 cm). John D.
Relfe Family.

116. William Wendt (1865–1946).
Serenity, 1914.
Oil on canvas, 30 x 36 in.
(76.2 x 91.4 cm). Paul Bagley
Collection.

117. Elmer Wachtel (1864–1929).
Desert, River, Mountains, n.d.
Oil on canvas, 36 x 48 in.
(91.4 x 121.9 cm). Private
collection.

supporter of the short-lived museum initiative; there were also articles about interesting people, fairs, parks, and missions (in 1895 Lummis founded the Landmarks Society for the preservation of California's missions and other historical structures). *Land of Sunshine* could be viewed, in hindsight, as not much more than a promotional vehicle for Southern California, were it not for the insistent sincerity of its writers; these authors (especially the Harvard-educated Lummis) were genuinely enamored of their state. The magazine was unabashedly boosterish, but it also expressed the Emersonian attitude toward nature that still resounded in the Southland. Typical is the following verse by Emma Davis:

> City of Angels! Loveliest!
> Crown jewel of the golden west!
> Haven of happiness and rest!
> Fair vision, half revealed, half lost
> Amid thy green hills, flower-embossed,
> Unscathed by heat, untouched by frost.
> Beloved of the gods thou art,
> And every highway through thy mart
> Points a new path to Nature's heart.[8]

Though Lummis covered art events and promoted individual artists in *Land of Sunshine*, throughout the 1890s there were few exhibition venues for the contemporary artist, and thus opportunities for formal reviews were scarce. There was the parlor gallery of Sanborn, Vail and Company; Kugemann's art gallery and the H. C. Lichtenberger Art Emporium both opened in 1892; and John Frederick Kanst started his gallery (destined to become a force on the local art scene over this dealer's long career) in 1895.[9] However, in this decade it remained easier and more economical for Los Angeles artists to show out of their own modest studios. Only in the years after the turn of the century did larger exhibitions, held in more accessible public spaces, become common.

After its 1899 opening, the Blanchard Music and Art Building became a much-used facility for public art activities and teaching. One of the most interesting groups to occupy it was the Art Students League of Los Angeles. The league's history has not been well documented in comparison with that of its venerable and still-viable predecessor in New York, and there are conflicting accounts of its origins.[10] However, the Los Angeles league was most likely the result of a gradual formalization of life-drawing classes taught by Hanson Puthuff (trained at the Art Institute of

118. Joseph Greenbaum
(1864–1940).
*Landscape of the
Southland,* n.d.
Oil on canvas, 18 x 24 in.
(45.7 x 60.9 cm). The Irvine
Museum, Irvine, California.

Chicago), who arrived in Los Angeles in 1903. By 1906 the league was a recognized entity and so popular that it hired two more instructors that year—Warren Hedges and Joseph Greenbaum (who had come to Los Angeles after the San Francisco fire of 1906). Life classes, portraiture, and landscape painting (in the increasingly familiar plein air mode) were all taught. Antony Anderson taught a morning class that, like Puthuff's night class, included painting and drawing from life.

Among the earliest students at the Los Angeles Art Students League were two of California's most important early modernist painters, Rex Slinkard and Stanton Macdonald-Wright, both of whom fully rejected the Impressionist-based aesthetic of their first teachers. The dominance of that aesthetic by the early 1900s was later recalled by Macdonald-Wright, who as a child took private art lessons and as a teenager painted outdoors with Greenbaum. "We were very 'sot' in our ways then, and anything that deviated from what was later jeeringly referred to as the 'Eucalyptus' school of landscape and the Chase school of figure painting was ridiculed."[11] Macdonald-Wright's own precocious success with outdoor painting is evident in a small landscape of Santa Monica he painted in 1903, at just thirteen (Joseph Chowning Gallery, San Francisco). After years of making vanguard art in Europe and New York, Macdonald-Wright would return to California to undermine the dominance of the "Eucalyptus school" that gave him his start.

Individual artists also eventually showed at the Blanchard Building. In October 1905 Benjamin Brown exhibited paintings there that were studio products based on color sketches done in the field; he also showed a number of paintings made "entirely out of doors."[12] Brown had studied art in Saint Louis and then at the Académie Julian before moving to Pasadena in 1896. Before his move he had emphasized still-life painting, but in Southern California he focused on the landscape (plates 2, 46, 119, and 120). Brown told the *Los Angeles Times* in 1905 that an artist should finish outdoor sketches in the studio, but by the 1920s he no longer felt constrained by the steadily weakening academic tradition.

119. Benjamin Brown (1865–1942). *Landscape with Poppy Field*, n.d. Oil on canvas, 40 x 50¼ in. (101.6 x 127.6 cm). Fleischer Museum, Scottsdale, Arizona.

In early 1906 the San Francisco artist Theodore Wores exhibited at the Blanchard Building. Wores's training was typical of the California Impressionists: he had been one of the first artists to enroll at San Francisco's California School of Design, where he studied with Virgil Williams; later he studied with William Merritt Chase, and in Europe he met and took criticism from Whistler. And, like Brown and the other California Impressionists, Wores had a slow and conditional conversion to Impressionism. At the time of his Blanchard show, Wores confessed that his greatest influence up to that time had been the great Spanish painter Diego Velázquez. Though Wores would later abandon the somber tones favored by Velázquez, he was pushed in the direction of loose, unpolished brush strokes by the Spanish master's bravura manner and brilliantly concise statements in paint.

OPPOSITE
120. Benjamin Brown (1865–1942). *Valley of Lupine*, n.d. Oil on canvas, 25 x 30 in. (63.5 x 76.2 cm). Fleischer Museum, Scottsdale, Arizona.

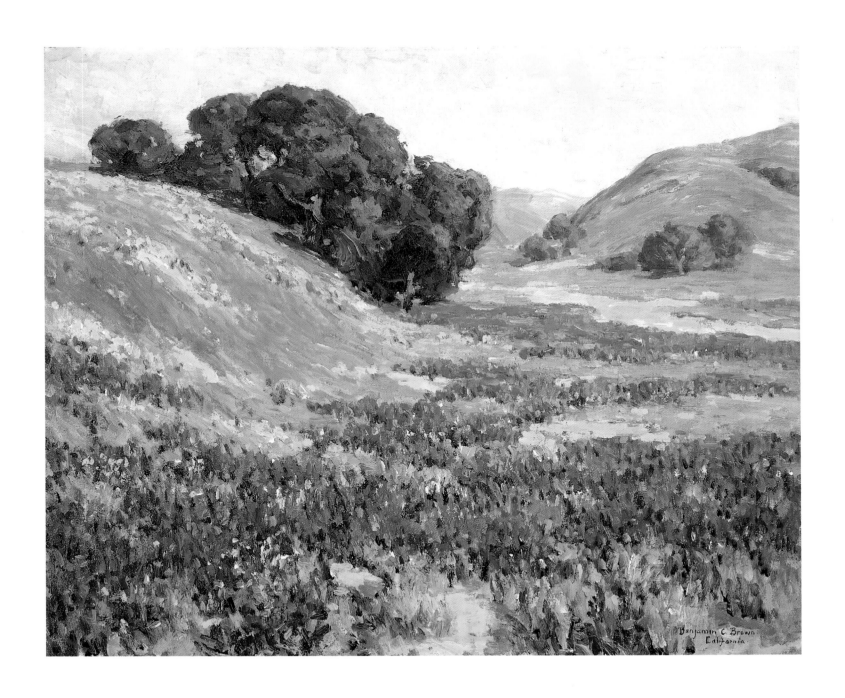

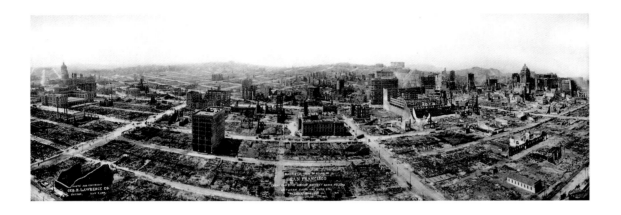

121. *Bird's Eye View of Ruins of San Francisco from Captive Airship 600 Feet above Folsom Between Fifth and Sixth Streets*, by Geo. R. Lawrence Co., Chicago, May 5, 1906.

Just weeks after Wores's Blanchard exhibition was reviewed in the *Los Angeles Times*, the most extensive earthquake in United States history rocked San Francisco on April 18, 1906 (plate 121). A devastating three-day fire destroyed four square miles of the city, killing five hundred residents and leaving five hundred thousand homeless. Numerous artists fled San Francisco after the fire destroyed their studios. Wores's studio was lost, but he remained in San Francisco and in 1907 became director of the California School of Design. Under his leadership, men and women were enrolled together in life-drawing classes for the first time—an indication, perhaps, of Wores's own cosmopolitanism.

In the same momentous year of 1906, three events crucial to the development of California Impressionism occurred: the *Los Angeles Times* hired Antony Anderson to write a weekly column documenting the activities of local artists (he held that position until 1926)[13]; the Fine Arts League was formed with the express goal of establishing a museum in Los Angeles; and the Painters' Club was founded. These events were interrelated to some degree, being all deeply involved with the recognition and promotion of California Impressionism. Of the three, it was the founding of the Painters' Club that may have had the greatest consequences for the regional pleinairists.

The Painters' Club held regular meetings where they critiqued each other's work, reviewed the paintings of prospective members, organized outdoor sketching trips, and held collegial suppers and "smokers."[14] The club's original membership (which was restricted to men) was small—notable charter members were Antony Anderson, Carl Oscar Borg, and Hanson Puthuff—but it grew steadily to accommodate many of the painters who moved to Southern California in the century's first decade, including Franz Bischoff, Jack Wilkinson Smith, and

William Wendt. (Marion Kavanaugh, who arrived in 1904, and Julia Bracken Wendt, William's wife, were denied membership in the men-only club.) Other important participants in the local art scene were also members of the club, including Frederick W. Blanchard and the curator and critic Everett C. Maxwell. In 1909 the Painters' Club disbanded after irreparable internal dissension.

The dissolving of the club cleared the way for the formation of the California Art Club, the single most powerful political force in the annals of California Impressionism.[15] Operating as a unified force politically and aesthetically, the California Art Club derived its power from the fact that it so well represented the attitudes, assumptions, and desires of the emerging California culture: both the club and Southern California fully embraced the same fundamental tenets of American idealism. Not only would the membership of the California Art Club eventually include virtually every professional artist working in an impressionistic mode, it would be ceaselessly lionized by Antony Anderson in the *Los Angeles Times*. And, when the Fine Arts League finally achieved its dream, in 1913, of a permanent museum in Los Angeles, that museum became the de facto exhibition arm of the California Art Club, hosting its annual membership shows as well as many one-artist shows.

In 1911 Wendt was elected president of the club, and in many ways, he represented the conservative nature of California Impressionism, both stylistically and ideologically. Dapper, distinguished, and much admired by his followers in the club, Wendt served as a very visible example of what an artist should aspire to, and his career summarized the nineteenth-century idealism that was the foundation of California Impressionism. No other California Impressionist so consistently essayed the sweeping, romantic, grand landscape view (or painted it nearly so well), and no other painter so strongly equated his work with the ideology of nature as Creation and nature as a source of spiritual sustenance. Wendt was a forceful critic of modernist art, giving voice to the belief, shared by his colleagues, that abstraction or any other distortion of nature was an attack on truth and therefore deeply objectionable.[16]

The premiere venue for the artists of the California Art Club was the Los Angeles Museum of History, Science and Art, which formally opened in November 1913, nearly seven years after the Fine Arts League first organized with the aim of building a museum. The work of nearly all club members was on view at the inaugural exhibition. Everett C. Maxwell, former curator for the Blanchard Building, was appointed curator of the art museum, and for the opening he also arranged, with the help of the artist Gardner Symons, for a loan exhibition of works by eastern American artists. Also a regular critic for the *Graphic*, Maxwell cautioned the Los

Angeles art community that the quality of pictures shown at the new museum would have to "be measured by national standard."[17] Included in the first loan exhibition were works by the well-known eastern Impressionists Cecilia Beaux, Frederick Frieseke, Childe Hassam, and Richard Miller. Maxwell declared that this opening show was "the most notable group of world-famed artists who have ever honored us by sending work to the coast and all should see the showing more than once."

Based on his own understanding of a national standard, Maxwell himself concluded that there were "no bad works" in the museum's debut exhibition. Among the outstanding works submitted by local artists were two "out-of-door figure studies" by Helena Dunlap, as well as oils by Franz Bischoff, Maurice Braun, Joseph Greenbaum, Anna Hills, Jean Mannheim, Granville Redmond, Detlef Sammann, and Karl Yens.

122. William Wendt (1865–1946). *Green Fields*, 1902. Oil on canvas, 28 x 36⅜ in. (71.1 x 92.3 cm). Spanierman Gallery, New York.

Antony Anderson reported that on the Sunday following the official opening, the "astonishing number" of 3,226 people visited the gallery, and another 1,700 on Monday. Before the year was out, another exhibition featuring well-known American Impressionists went on view at the new museum; it featured Colin Campbell Cooper, Hassam, Leonard Octman, Edward Redfield, and J. Alden Weir. Of Weir, Maxwell wrote: "Mr. Weir is an impressionist of the best type and his work should prove an object lesson to all skeptics who are prone to scoff at the 'new in art.'"[18]

The Los Angeles Museum of History, Science and Art instituted a program of regular one-person shows, the vast majority coming from the membership roll of the California Art Club. Throughout the rest of the decade and into the 1920s, the new museum's audience would never be deprived of a steady diet of impressionistic art that glorified the local Southern California landscape.

123. William Wendt (1865–1946).
 Cup of Gold, 1902.
 Oil on canvas, 30 x 40 in.
 (76.2 x 101.6 cm). The J. C.
 Carter Co., Inc., Santa
 Barbara, California.

CHAPTER 5

California Impressionists
at Home and Afield

In California nature cannot be ignored, she insists upon a full recognition, a perfect homage. Our painters have given her that homage, fully, freely, devotedly.

ANTONY ANDERSON, 1915

California Impressionism firmly established itself in Los Angeles with the formation of the California Art Club. No organization of comparable importance existed to promote impressionistic painting in San Francisco, but the Los Angeles club eventually took many of its exhibitions north to the Bay Area. The club's members (who eventually included artists living throughout the state) exhibited outside Los Angeles whenever and wherever possible, including such sites as the Hotel del Monte Art Gallery, founded in Monterey in 1907.

The California Art Club, whose first annual exhibition took place in January 1911 at the Hotel Ivins in Los Angeles, held a second "annual" exhibition later that same year in the Blanchard Music and Art Building; critic Antony Anderson, never at a loss for hyperbole, called the exhibition a "revolution and a revelation."[1] In at least one sense there had been a small revolution: women were admitted to the California Art Club, though they had not been to its immediate predecessor, the Painters' Club.[2] And the new club did not, according to Anderson, discriminate based on style (though it, like the rest of America, had yet to encounter the newest forms of European modernism); members were free to be "enamored of infinite detail" or to "woo the robust muse of impressionism." Included among the latter group were the artists Helena Dunlap, Detlef Sammann, Ernest Browning Smith, and Jack Gage Stark. These four painters were considered by Antony Anderson to be the most "impressionist" artists

124. Helena Dunlap.
Detail of *Young Danish Girl with Flowers*, 1917 or before.
See plate 125.

in the Los Angeles area in 1911, but all four are obscure figures today (except Dunlap, who is noted for her subsequent role as a modernist, not an Impressionist).[3]

In using the word "impressionist" as early as 1909 to describe Stark's paintings,[4] Anderson astutely interpreted Stark's use of unmixed strokes of pure color for his readership: "The impressionists hold—and not without reason—that light and atmosphere are most truly rendered by the proper juxtaposition of paint. Hence, the harlequin squares in Mr. Stark's 'Chloride Hills,' and the long strips of color and the criss-crossing of his 'El Tacalito.'" Such "harlequin squares" appear in Stark's *California Landscape* (plate 39), a painting clearly aspiring to a more French, and thus more daring, method of Impressionism than that favored by his colleagues. Indeed, Anderson saw Stark—not Elmer Wachtel, Granville Redmond, or William Wendt—as the local representative of the style. Anderson went so far as to declare that Stark's paintings at the Steckel Gallery were "an educator and an eye-opener to the purblind public of Los Angeles."[5]

When Helena Dunlap had her first one-artist show in Los Angeles, also at the Steckel Gallery, in October 1911, Anderson wrote, "We need pictures like hers in Los Angeles because they are 'so different.'"[6] In a 1913 review of the fourth annual exhibition of the California Art Club, Anderson came to the defense of what were undeniably Dunlap's Post-Impressionist influences in a painting entitled *Breakfast,* where a young woman with blue hair lies in bed holding a teacup:

> But what a storm of abuse this talented painter has raised! What a tempest rages round the blue teacup the girl in the picture is holding! A hundred critics attack the girl's blue hair—for blue it undeniably is. A hundred others declare she looks like an invalid. This because she is breakfasting in bed, thus making the critics confuse moral censorship with that of art. Why isn't the hussy up and dressed, like all proper Puritans?[7]

It is highly indicative of both the vagaries of art history and shifting public taste that few of Dunlap's works painted in or around 1911 could be readily located for this book. In 1914, when the critic Everett C. Maxwell was surveying the art scene in San Francisco, he met the artist, who was on a painting trip in the north. He noted that one of her canvases was then the sensation of the city, and that San Franciscans considered Dunlap "our most promising painter."[8] *Paris Studio* (plate 41) dates from the time of her show at the Steckel Gallery, while *Young Danish Girl with Flowers* (plate 125), painted in or before 1917, is a later painting that shows Dunlap's continuing interest in impressionistic technique. She would eventually experiment with a variety of modernist techniques, for which she remains best known today.

125. Helena Dunlap (1876–1955). *Young Danish Girl with Flowers,* 1917 or before. Oil on canvas, 34½ x 38½ in. (87.6 x 97.7 cm). Michael Johnson Fine Arts, Fallbrook, California.

Also making his debut as an Impressionist in 1911 was Detlef Sammann, whose painting inspired Anderson to peg the artist as a follower of Monet[9] and continue with his insightful attempts to educate his readers about impressionistic methods: "Correct [visual] analysis is never at any time an easy task, and when a man breaks up a ray of color into its component parts, matches them in dull paint, and then places this paint on canvas in such a way as to produce living grays, he may be termed a wonder worker. Mr. Sammann has done this very thing in the twenty or thirty new canvases in his show, convincing us that the true impressionist is at least as intellectually vigorous as he is artistically 'impressionistic.'"[10]

126. Detlef Sammann (1857–1921).
Monterey Cypress, Pebble Beach, 1915.
Oil on canvas, 24 x 36 in. (60.9 x 91.4 cm). Mr. and Mrs. Richard M. Scaife.

Sammann exhibited again in Los Angeles throughout 1912 but left the city later that year, building a studio in Pebble Beach, near Carmel. Anderson was not the only critic to recognize Sammann's talent, or to mourn his move from Los Angeles—Maxwell wrote that Sammann's departure would be "keenly felt in local art circles."[11] However true that may have been then, the work of Sammann—like that of Stark, Dunlap, and the elusive Ernest Browning Smith— is little known today.[12] One of the few known paintings by Sammann is a 1915 work, *Monterey Cypress, Pebble Beach* (plate 126); although an attractive image, it is not nearly as impressionistic as the known work by Stark, leaving one to wonder what, precisely, Sammann's work looked like at the time Anderson alluded to the style of Monet.

That other local artists recognized the modernity of Stark and his fellow Impressionists is clear from Joseph Greenbaum's 1915 comment about landscape art: "The general public looks too much to subject in landscape whereas with the modern movement subject means nothing—line, color and composition everything. Such artists as Helena Dunlap, Jack Stark and [Northern California artist] Bruce Nelson apply this method in their work. This country is ideal for the modernist. Things are so vibrating that under certain conditions one can fairly see the color dance and almost observe the particles of the spectrum."[13]

By the time of the California Art Club's third annual exhibition, in November 1912, most of the members seemed to be exploring aspects of Impressionism (though not as obviously as had Dunlap, Sammann, Smith, and Stark)—especially the use of brighter palettes based on direct observation of nature. Many of the names now prominently associated with California Impressionism were participants in that show, including Franz Bischoff, Carl Oscar Borg, Maurice Braun, Benjamin Brown, Frank Cuprien, Jean Mannheim, Hanson Puthuff, Jack Wilkinson Smith, Gardner Symons, and William Wendt. Writing about the exhibition and about California art in general, Maxwell asserted: "The yearly exhibitions of the California Art Club are the milestones of our western progress, the touchstones of our success in art. To be sure, a few of our good painters do not belong to the association, but one by one they are getting in line with this growing movement and the catalogue already includes a representative number."[14] Maxwell also reflected the unbridled optimism he shared with Antony Anderson, and no doubt with many of the artists, about the future of California art: "From a dozen different writers upon subjects pertaining to the development and trend of art in the west, the word has gone forth to the world that California, that land of golden light and purple shadows, is destined in the course of the next few years to give us a new school of landscape painting."[15]

Landscape painting dominated the club's first exhibitions and would continue to do so

127. William Wendt (1865–1946).
Arcadian Hills, 1910.
Oil on canvas, 40½ x 55½ in.
(102.8 x 140.9 cm). The Irvine
Museum, Irvine, California.

throughout its existence, though figurative and still-life paintings were also regularly displayed. Landscapes by the California Impressionists did not constitute a new school of American landscape painting; rather, they unabashedly extended the romantic, spiritual, and near-mystical impulses of the nineteenth century. For example, William Wendt's *Arcadian Hills* (plate 127), painted in 1910 and shown at the California Art Club the following year, is an updated version of Virgil Williams's *Mount Saint Helena from Knight's Valley* (plate 84) and a host of other Hudson River school–type landscapes that captured with geographic precision the spellbinding aspects of God's creation. Here, Wendt's trademark use of sweeping, interlocking shapes describes an otherwise simple composition split between earth and sky. The artist maximized the visual drama of deep shadows played against greens bathed in sunlight and harmonized the angular geometry of trees with the swirl of low hills. What might have been a humble landscape view was aggrandized and given a title that implied a mythic region of peace.

Unlike such predecessors in California as Thomas Hill, Williams, and Albert Bierstadt, Wendt did not require spectacular views, such as those in Yosemite, for inspiration; for him, all of nature was spectacular. His ability to find pictorial potential almost anywhere, no matter how seemingly common the site, was something Wendt had absorbed from the French Impressionists, though Wendt seems to have been selective in his use of their legacy. Nonetheless, his intention was still to celebrate nature's glory. Wendt's arcadian hills, which seem to loom into the viewer's space, continue the tradition of the majestic view practiced years before by Thomas Cole and his colleagues, although without the diminutive figures those artists had inserted to establish a grandiose scale.

Mountains would play a major role in the work of the California Impressionists, as they had for earlier American landscapists (though not of the French Impressionists). From the state's rolling coastal range to the towering peaks of the Sierras, their dynamic forms and looming presence provided the forms to express the arcadian, the majestic, and the heroic, over and over again. Hanson Puthuff's *Hills of Santa Ynez* (plate 128) and *Approaching Twilight, Topanga Canyon* (plate 130) both capture the pastel incandescence of California's foothills, while Marion Kavanagh Wachtel's later *Cottonwoods* (plate 129) uses the electric blue of a distant mountain to intensify the yellow of autumnal cottonwood leaves. Though snow scenes are comparatively rare in California landscape painting, snow does appear in mountain scenes such as Jack Wilkinson Smith's *Sierra Slopes* (plate 131) and Paul Lauritz's *End of Winter, High Sierras* (plate 132). Like Wendt's *Arcadian Hills*, all of these paintings attempt to capture the romantic drama of seasons and sunlight.

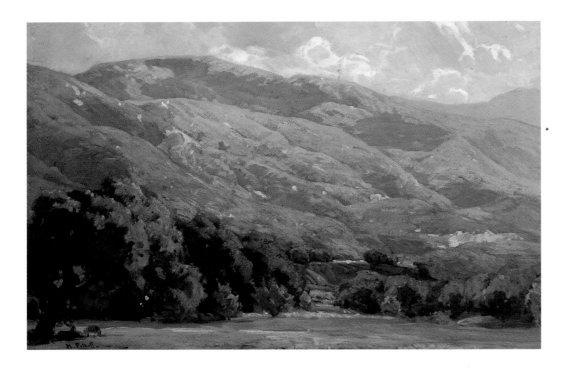

128. Hanson Puthuff (1875–1972).
Hills of Santa Ynez, c. 1915.
Oil on canvas, 20 x 24 in.
(50.8 x 60.9 cm). The Bowers
Museum of Cultural Art,
Santa Ana, California; Gift
of Mr. Sherman Stevens,
Martha C. Stevens Memorial
Art Collection.

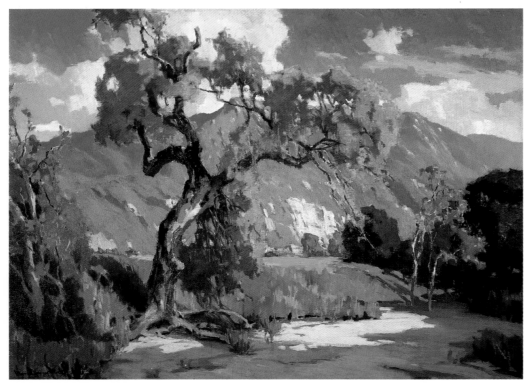

LEFT
129. Marion Kavanagh Wachtel
(1876–1954).
Cottonwoods, 1938.
Oil on canvas, 30 x 40 in.
(76.2 x 101.6 cm). Private
collection.

OPPOSITE
130. Hanson Puthuff (1875–1972).
Approaching Twilight,
Topanga Canyon, n.d.
Oil on canvas, 32½ x 40 in.
(82.5 x 101.6 cm). Private
collection.

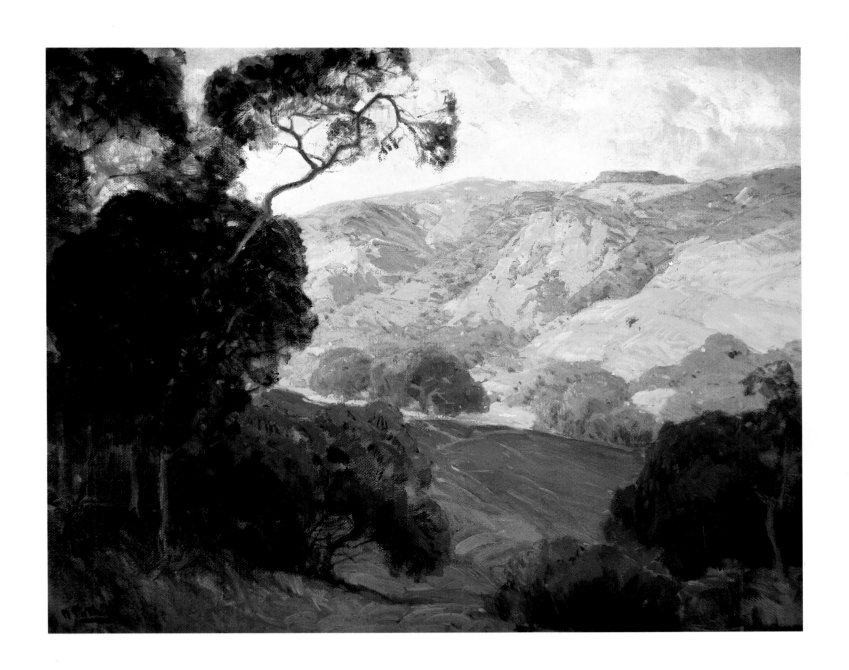

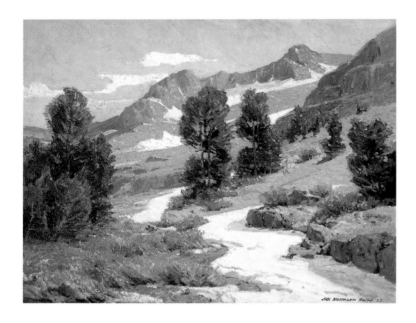 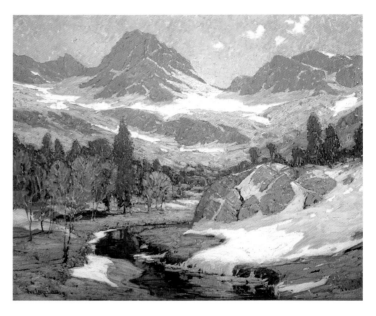

Of equal interest to the California Impressionists was the ocean. In thousands of images, large and small, California artists painted the sea—a subject always near at hand and ideally suited to their fascination with outdoor light and color. The sea was also a subject perfectly suited to the pursuit of the sublime: just as the seasons could suggest death and rebirth, so the impenetrably deep ocean could represent the mystery of the human condition or the abstract concept of changelessness. The hack painters that eventually flocked to California painted ocean scenes that did little more than follow formulas, but a number of the genre's earliest interpreters earnestly tried to paint the intimations of the infinite they felt at the ocean's shore. Among these were Jack Wilkinson Smith and William Ritschel, who were original participants in the California Art Club's annual exhibitions.

Smith was from Chicago, where as a teenager he had studied with Gardner Symons and where he was aware of William Wendt, both of whom were no doubt the source for Smith's infatuation with and later relocation to California. He arrived in Los Angeles in 1906, where he became associated with the Painters' Club and its successor, the California Art Club. Though virtually every member of that body would paint the ocean at some point and with some regularity, Wilkinson is one of the few who specialized in it and who achieved the visual radiance sought by his peers.

Smith's entry in the California Art Club's second annual was *Sunlit Foam*, probably the painting known today as *Sunlit Surf* (plate 133). In it, Smith employed what would become a basic formula for ocean views: imposing rock formations are seen left and right, a crashing wave sends spray upward, and in the picture's background a flat, calm ocean fuses with the horizon. The dramatic visual movement from the foreground of agitated water back toward the empty sky effectively creates an illusion of deep space. The sequence of S-curves that forms the foreground tidewater contrasts sharply with the stillness of the distant horizon, allowing Smith to balance the force and the calm of nature together in one image.

Munich-trained William Ritschel was in the same 1911 California Art Club exhibition with Smith and Wendt, represented by a presently unlocated view of Holland. In 1911 he settled in Carmel, a tiny coastal village in the northern part of the state, where he would live the rest of his life. Ritschel's *Morning on the Pacific Coast* (plate 134) shares compositional elements with Smith's *Sunlit Surf*, though their similarity is due more to the artists' similar vantage points on comparable landscapes than to any mutual influence. Here again are the rugged rocks, crashing waves, and diffuse blend of ocean horizon and muted sky. Neither Ritschel nor Smith stayed tied to this format; each saw the myriad pictorial possibilities of the shoreline. Ritschel's *Carmel Coast* (plate 135) reverses the composition of *Morning on the Pacific Coast*: rocks of shifting shape and color are moved to the background, while a calm inlet made of short, staccato brush strokes fills the foreground. It is a scene that contradicts the notion of the grandiose; tightly enclosed and intimate, it looks like something the artist happened upon rather than sought out. The idea of an offhand view glimpsed almost by chance is yet another legacy of the French Impressionists, who scanned their own world for the minutiae of everyday life and turned them into paintings. But, like Wendt, Ritschel also continued to seek the transcendent in nature, a search that found its most mature expression in his seascapes of the late 1910s and '20s.

A landscape painter whose spiritual proclivities were as pronounced as those of Wendt was Maurice Braun. Born in Hungary, Braun received academic training in New York, expanded somewhat by study in 1901 with William Merritt Chase. When Braun moved to San Diego in 1909, it was because he was attracted not by the landscape but by the Universal Brotherhood and Theosophical Society, which had been founded at Point Loma by Katherine Tingley in 1897. Braun had long been associated with the theosophical movement, and Tingley gave him a studio and living space in downtown San Diego's Isis Theater Building, then owned by the society. In 1912 Braun established the San Diego Academy of Art in that building, and he began exhibiting regularly with the California Art Club.

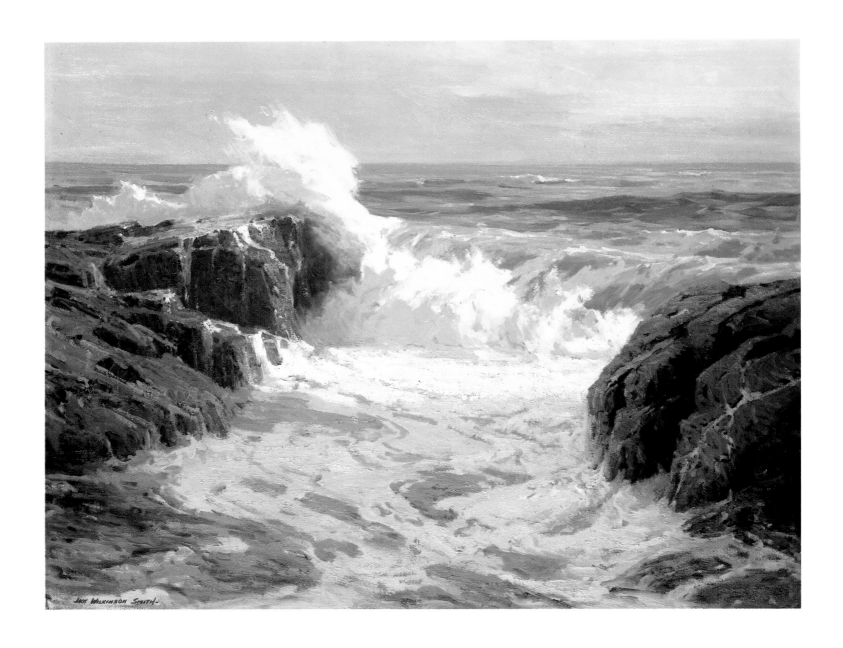

OPPOSITE

133. Jack Wilkinson Smith
(1873–1949).
Sunlit Surf, c. 1918.
Oil on canvas, 33¼ x 42¼ in.
(84.4 x 107.3 cm). The Buck
Collection.

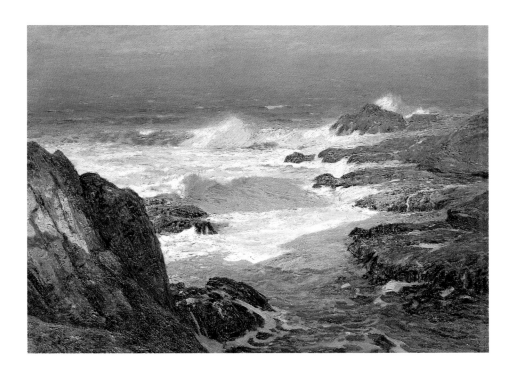

134. William Ritschel (1864–1949).
*Morning on the Pacific
Coast,* n.d.
Oil on canvas, 30 x 40 in.
(76.2 x 101.6 cm). Barbara
and Thomas Stiles.

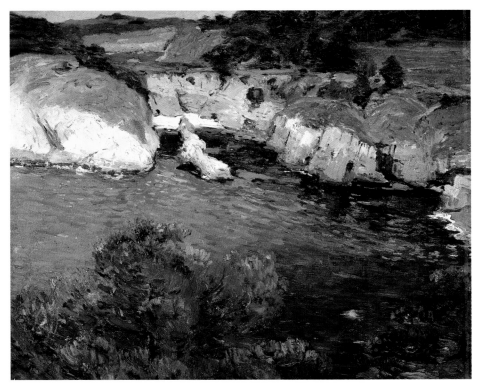

135. William Ritschel (1864–1949).
Carmel Coast, n.d.
Oil on canvas, 20 x 24 in.
(50.8 x 60.9 cm). Barbara
and Thomas Stiles.

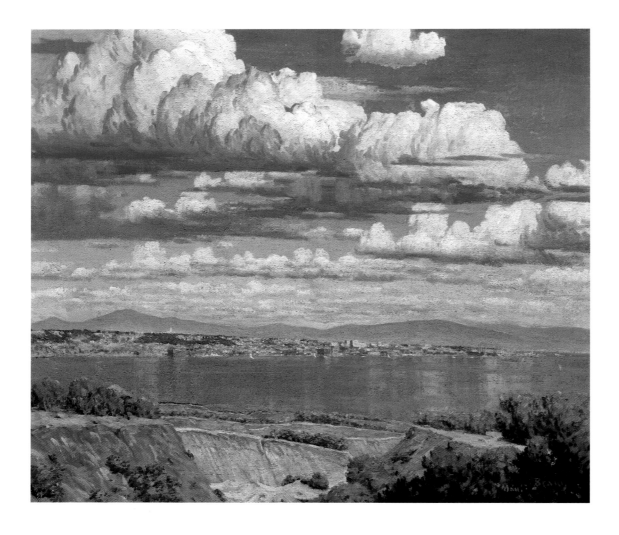

136. Maurice Braun (1877–1941). *Bay and City of San Diego* (also known as *San Diego from Point Loma*), 1910. Oil on canvas on board, 30⅛ x 34⅛ in. (76.5 x 86.6 cm). Mr. and Mrs. William R. Dick, Jr.

Founded in New York in 1875 by Helena Blavatsky, the Theosophical Society attempted to merge truths common to all religions, combining aspects of Buddhism, Hinduism, and Christianity. Natural and supernatural phenomena played a central role in the theosophical worldview, and within this broad-based system of mystical belief, light was a crucial symbol. Though it would be misleading to assert that Braun painted his landscapes with a "theosophical light," he clearly did use light to help open the viewer's eyes to the marvelous, if not the miraculous. As Braun wrote, "The art student finds in Theosophy a clear, bright light by which, with true vision, fully alive to the real issues, his best efforts may come to their proper maturity."[16]

137. Maurice Braun (1877–1941).
The Brook, c. 1917.
Oil on canvas, 36 x 42 in.
(91.4 x 106.6 cm). John D.
Relfe Family.

An example of Braun's early work in the Southland is *Bay and City of San Diego* (plate 136), in which strips of receding cumulus clouds hover over a city reduced to glittering spots on a distant shore. Light engulfs the entire scene—irradiating the clouds and the yellow-orange foreground, and reflecting off the flat, mirrorlike ocean. In his creation of intense, still light and quiet forms, Braun was far more like the nineteenth-century Luminist John Kensett than any French Impressionist. Polished, precise, and pristine, this is an image of nature suspended in time. Braun's commitment to nature as a vehicle for revelation would culminate in *California Valley Farm* of about 1920 (plate 214), perhaps the clearest example of how the early American grand-view landscape aesthetic survived in the pantheism of the California Impressionists.

Among the few figure paintings to appear in the early exhibitions of the California Art Club, the most accomplished were by Jean Mannheim. After training at the Académie Julian, he eventually moved to Los Angeles, where in 1908 he opened a studio in the Blanchard Building and took students. He was a founding member of the California Art Club, and his singular status as a figurative artist caught Maxwell's eye. The critic wrote in his review of the club's third annual that Mannheim's figure studies were "a welcome variation from the surfeit of landscape renderings that always characterize a Western salon."[17] Mannheim's adoption of brighter color and looser brushwork was a typically gradual process, but by 1915 the influence of Impressionism on his work was noticed in the local press: "His pictures are keyed higher than they used to be, and at the same time are fuller of color—a happy result of working from models outdoors."[18] Among the most appreciated of these were the studies of his young children playing in the garden or wading in pools (plates 76 and 138). By the 1920s Mannheim had completely abandoned the solid structure and restricted palette of his earlier work in favor of abbreviated descriptions of form painted with bold juxtapositions of bright yellow and violet—as in *Study in Sunlight* (plate 139). Throughout the various stylistic changes in his work, Mannheim's chief contribution to art in the Los Angeles area was maintaining a figurative tradition.

In a similar way, Franz Bischoff maintained the presence of still-life painting in the Southland. When Bischoff moved to Los Angeles in 1906, the preeminent local still-life artist was Paul

138. Jean Mannheim (1862–1945).
Our Wisteria, c. 1912.
Oil on canvas, 24 x 20 in.
(60.9 x 50.8 cm). Orange
County Museum of Art,
Newport Beach, California;
Museum purchase.

139. Jean Mannheim
(1862–1945).
Study in Sunlight, n.d.
Oil on canvas, 24 x 20 in.
(60.9 x 50.8 cm). Barbara
and Thomas Stiles.

DeLongpre, who painted painstakingly accurate arrangements of flowers in watercolor. Financially successful and publicly acclaimed, DeLongpre died in 1911, the same year Bischoff's work was in the first annual exhibition of the California Art Club—two paintings, one a landscape and one a study of a rose that was praised in the *Los Angeles Times* for its color and accuracy. Franz Bischoff had inadvertently become heir to DeLongpre's title "le roi des fleurs."

Bischoff's career in the context of California Impressionism is additionally interesting because—unlike his peers, who adopted Impressionist techniques from a combination of French and American sources—he seems to have learned the mode primarily from his fellow Californians, as the next generation of California painters would increasingly tend to do. Born in Bohemia (then part of the Austrian Empire), Bischoff studied ceramics in Vienna and took his first job in America as a decorator of china. He became very successful at painting elegant, detailed florals (not unlike DeLongpre's) on ceramic vases. Once in Los Angeles, Bischoff took up landscape painting for the first time and also began painting floral arrangements on canvas as well as continuing to paint on china. His earliest floral canvases (plate 140) are wildly effusive, and they combine his decorative sensibilities with the lush, creamy brushwork he observed in the pictures by his Los Angeles colleagues.

Bischoff's landscape work (plates 21, 141, and 142), like his still-life painting, was an extension of his decorative and craft-oriented vision. His color became flushed with pinks and reds, his compositions a maelstrom of bold, expressionistic strokes. He was an artist in whom the American ideology of truth to nature had not been culturally instilled, yet who was nonetheless attracted to the sensual qualities he observed in local painting. The art of Franz Bischoff points toward the perhaps inevitable corruption of the controlling ideology in favor of the more easily accessible surface effects offered by impressionistic painting.

In the fall of 1914 the fifth annual exhibition of the California Art Club was held at the Los Angeles Museum of History, Science and Art. But the most sensational exhibition that season was not the club's but a brief show in late September 1914 of work painted by Robert Henri (plate 143), leader of New York's Ash Can school of Realist painters, who had been painting in San Diego over the summer. An inspirational teacher, he had been invited by arts enthusiast and former pupil Alice Klauber. Of this show, Maxwell wrote, "I think no one will dispute my statement that no single exhibit in our local art history aroused so much interest or challenged so high a standard of critical comparison."[19] Local groups and classes visited the show and found Henri's work to be of "great educational value." Indeed, the vigor and self-confidence of Henri's bold approach to painting, emphasizing a nonidealized view of the world recorded in

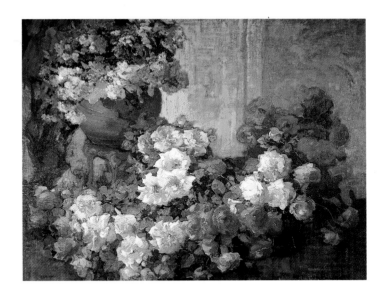

140. Franz Bischoff (1864–1929).
Roses, n.d.
Oil on canvas, 40 x 50 in.
(101.6 x 127 cm). Fleischer
Museum, Scottsdale, Arizona.

141. Franz Bischoff (1864–1929).
Spring Flowers—San Fernando Valley, c. 1925.
Oil on canvas, 24 x 32 in.
(60.9 x 81.2 cm). William A.
Karges Fine Art, Carmel,
California.

142. Franz Bischoff (1864–1929).
Gold-Rimmed Rocks and Sea, n.d.
Oil on canvas, 30 x 40 in.
(76.2 x 101.6 cm). Paul Bagley
Collection.

broad, economical brush strokes, no doubt had wide appeal locally.[20] Antony Anderson had even thought (or hoped) that Henri might move to Southern California, but the artist returned to New York. Before leaving, however, he gave Anderson his own surprisingly enthusiastic impressions of the future of painting in the Southland: "Without a doubt, California—and specifically Southern California—will develop tremendously in art throughout the next few years and ultimately it will have the strongest school of outdoor painting in the country, or any country, for that matter. It's bound to happen. Consider the possibilities!"[21]

Impressionism did not dominate the art scene in San Francisco in the first decades of this century as it did in the Southland. The popularity of the Tonalist approach to painting in the Bay Area at the end of the nineteenth century was given support by William Keith's conversion to a Barbizon-influenced style of landscape painting that, broadly understood, involved the use of muted, evenly layered veils of color. Tonalism was related to Impressionism in that its practitioners worked directly from nature, but it emphasized the use of silvery, soft-focused forms (perfectly suited to the cool, misty San Francisco landscape) and not the high-key color common to Impressionist practices (perfectly suited to perpetually sunny Los Angeles).

143. Robert Henri (1865–1929).
The Beach Hat, 1914.
Oil on canvas, 24 x 20 in.
(61 x 50.8 cm). The Detroit
Institute of Arts; City of
Detroit Purchase.

Working in San Francisco during the 1890s, Arthur Mathews adapted the Tonalist method of creating flat, diffuse shapes to his own landscape and figure work. Mathews's flair for decorative pattern, which was strongly allied with the Arts and Crafts movement, remained hugely popular into the early twentieth century (plate 144). A former student at the Académie Julian, Mathews served as director of the Mark Hopkins Institute of Art from 1890 to 1906, when the school and his own studio were destroyed by the earthquake and fire. While director of the school, Mathews painted low-key images of imaginary landscapes populated with dancing women, musicians, and stylized trees. His interest was in a personal vision of beauty, not in the more literal interpretation of nature afforded by Impressionism. His sense of imagination and adventure influenced many students, including Granville Redmond, Gottardo Piazzoni, and the watercolorist Francis McComas.

After the devastation wrought by the 1906 earthquake and fire in San Francisco, a number of artists left the city, including John Gamble and Joseph Greenbaum. Arthur Mathews chose to remain in San Francisco and to help rebuild the city. Also remaining in town was the much-

respected Theodore Wores, who in 1907 followed Mathews as director of the San Francisco Institute of Art (the new incarnation of the Mark Hopkins Institute of Art). Wores had achieved a considerable reputation for his exotic and picturesque oils of Japan, where he resided from 1885 to 1887, and of San Francisco's Chinatown. At the institute he continued to paint very carefully rendered pictures that detailed the costumes and locales of his subjects. By 1910, having traveled the world, the fifty-one-year-old Wores had adopted a much brighter palette than when under the sway of the Spanish Baroque, James McNeill Whistler, and memories of Virgil Williams, and he moved away from portraits as his primary subject matter. His *Relic of the Past* (plate 145), painted in Monterey, is an example of the popular subject of the outdoor garden. Like the California Impressionists in general, Wores retained careful draftmanship and clear forms but presented them arrayed in rich, high-key color. The artist's narrative sensibility is also evident in this picture; the verdant garden and its charming young inhabitant were by then a romantic trope tinged with nostalgia. Still, Wores's chromatic palette and close-cropped outdoor scene exemplify the increasingly impressionistic manner he would exploit in later years.

To what extent the Tonalist aesthetic of William Keith and Arthur Mathews and the continued appeal of more traditional approaches to painting held sway in Northern California is evidenced by the large yearly exhibitions held at the Hotel del Monte Art Gallery in Monterey, which was founded (with Mathews) in 1907 to promote California art in the wake of the earth-

144. Arthur Mathews (1860–1945). *Youth*, c. 1917. Oil on canvas, 38 x 50 in. (96.5 x 127 cm). Oakland Museum of California; Gift of the Oakland Art Museum Guild.

quake. Most of the pictures in the gallery's debut exhibition were Tonalist, even those by artists later associated with Impressionism, including Joseph Greenbaum's entry, *A Gray Day*, and Elmer Wachtel's *Golden Hour* (both illustrated in the show's catalog).

The popularity of this Tonalist style continued in subsequent shows at the Hotel del Monte. The chairman of the exhibition committee in 1909 was William Keith; others on the committee were Mathews's protégé Gottardo Piazzoni and the Tonalist photographer Arnold Genthe. Keith was well represented in the 1909 exhibition, as was his longtime associate Thomas Hill. Piazzoni had numerous canvases on view, as did Mathews's wife and former student, Lucia K. Mathews. Other painters of a decidedly Tonalist orientation included the watercolorist Percy Gray, the portrait and genre specialist

Mary Curtis Richardson, and Virgil Williams's former student the landscapist Lorenzo P. Latimer. Anne Bremer, yet another former student of Mathews's, showed a painting entitled A *Gray Day* (unlocated), suggesting its Tonalist character, though she would later develop a far more coloristic style (plate 146).

Evelyn McCormick also showed at the Hotel del Monte in 1907 and 1909.[22] Despite her early exposure to Impressionism in France and her time spent at Giverny, McCormick never developed a loose handling of paint or summary execution of forms but always kept her architectural drawing rigidly linear. She did, however, adopt a signature use of bright midday light against the walls of old buildings on and around the Monterey peninsula. Her painting from

145. Theodore Wores (1859–1939). A *Relic of the Past*, 1910. Oil on canvas, 16 x 24 in. (40.6 x 60.9 cm). Mr. and Mrs. Robert Lovett.

146. Anne Millay Bremer
(1868–1923).
An Old-Fashioned Garden, n.d.
Oil on canvas, 20 x 24 in.
(50.8 x 60.9 cm). Mills
College Art Gallery, Oakland,
California.

about 1910, *Casa Jesus Soto* (plate 147), displays a skillful play of light against shadow and vivid, naturalistic color. McCormick reported to the *San Francisco Call* in 1908: "I seldom finish a picture. I work always direct from nature and never trust my memory on lights or coloring."[23]

Though the Tonalist method and sensibility dominated the Hotel del Monte's earliest shows, the gallery did attract those working in other styles: Hanson Puthuff, John Gamble, and Benjamin Brown were represented in the 1909 exhibition. Gamble, a former School of Design student under Virgil Williams, had moved to Santa Barbara after the 1906 earthquake destroyed his San Francisco studio; he painted broad, richly colored fields of flowers (plates 148 and 149). Both Brown, who had been living in Pasadena since 1906, and Puthuff, in Los Angeles since 1903, were painting sun-filled landscapes by 1909.

147. Evelyn McCormick
(1869–1948).
Casa Jesus Soto, c. 1910.
Oil on canvas, 14 x 20 in.
(35.5 x 50.8 cm). Paula and
Terry Trotter.

For many years after its founding, the Hotel del Monte Art Gallery functioned as an important venue for contemporary California art, despite the initial emphasis on Tonalism and Northern California artists. Josephine Blanch was quite right when she wrote in 1914, "When the history of California art is written Monterey Peninsula will furnish a colorful and important chapter and the Del Monte Gallery will be recognized as a large factor in the development of the State."[24]

Tonalism's dominance kept impressionistic painting at bay in San Francisco until after the Panama-Pacific International Exposition of 1915. However, in the years just prior to the exposition, the artists living or temporarily working in Carmel and Monterey made that area, for a brief time, the center of the most advanced Impressionist painting being done in the state. Detlef Sammann had relocated there in 1911; Clark Hobart was there by 1912; and Jack Gage Stark and Ernest Browning Smith painted there in 1912.

The shoreline north and south of Carmel affords some of the most spectacular beauty in all of California. Word of the area's scenic wonders had already attracted not only many

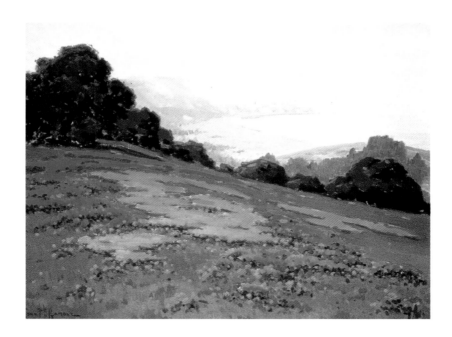

148. John Gamble (1863–1957).
*Poppies and Lupine, Santa
Barbara,* n.d.
Oil on canvas, 18 x 24 in.
(45.7 x 60.9 cm). Fleischer
Museum, Scottsdale, Arizona.

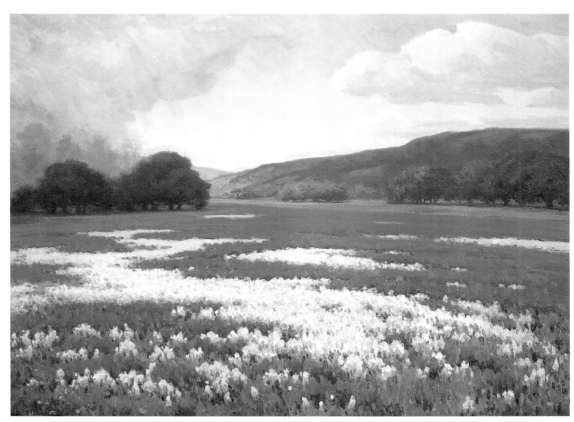

149. John Gamble (1863–1957).
Passing Shower, n.d.
Oil on canvas, 30 x 40 in.
(76.2 x 101.6 cm).
Candice Bergen.

California painters and writers but also America's most famous Impressionist, Childe Hassam (plate 52), when he was in the Bay Area in 1914 working on his mural for the Panama-Pacific International Exposition. The California artist Mary DeNeale Morgan, who had settled in Carmel in 1910 (plate 150), may have seconded Euphemia Charlton Fortune's invitation to William Merritt Chase to teach a summer painting class there in 1914.[25] Chase's only known landscape from that summer is a view of nearby Monterey, which looks strikingly unlike Monterey and is hardly impressionistic (plate 151). Nonetheless, Chase's prestige and reputation, as well as his perceptive critiques, were highly influential. Among Chase's students was the artist C. P. Townsley, who served as director of Chase's summer school (plate 152). Townsley, who that year became director of the Stickney Memorial School of Art (which had opened in the Stickney Building in Pasadena in 1913), used Carmel as the site for his own summer classes scheduled through Stickney in 1915–16. Townsley's position at Stickney ensured that Chase's ideas and methods would continue to be influential in California, however indirectly, even after Chase's death in 1916.

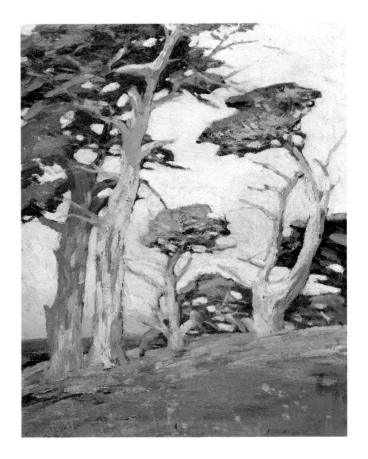

Chase's presence at Carmel in 1914, Hassam's visit, and the surge in artistic activity up and down the coast that year were part of a larger swell of excitement related to the upcoming Panama-Pacific International Exposition in San Francisco. Donna Schuster, one of Chase's students in Carmel, spent much time in 1914 painting a series devoted to the exposition's construction site, which she showed at the Los Angeles Museum of History, Science and Art in December 1914.[26] The museum's big exhibition in the summer of 1914 was the advance showing of ninety canvases by ten of the muralists to be featured at the exposition, including the work of Childe Hassam and Robert Reid.

As critic Alma May Cook put it, the summer show at the museum was "one of wide interest and brings to Los Angeles one of the largest collections of work by well-known artists that the city has

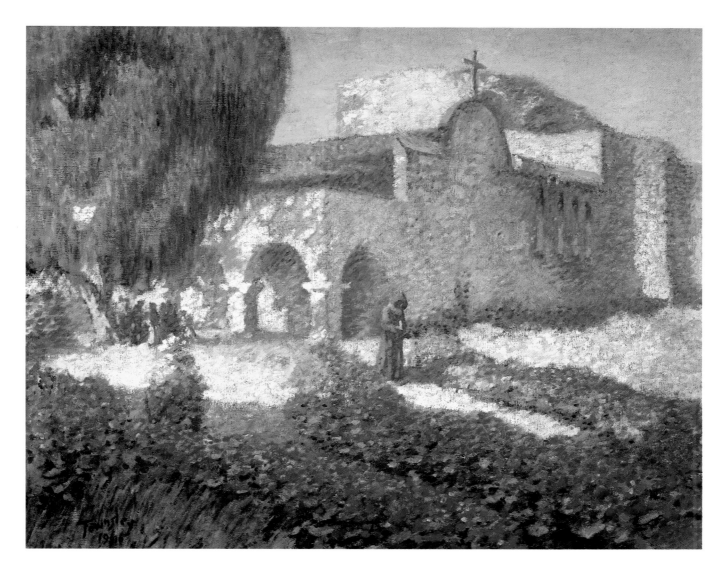

OPPOSITE, TOP

150. Mary DeNeale Morgan
(1868–1948).
Monterey Cypress, n.d.
Oil on canvas, 24 x 18 in.
(60.9 x 45.7 cm). John D.
Relfe Family.

OPPOSITE, BOTTOM

151. William Merritt Chase
(1849–1916).
Monterey, 1914.
Oil on board, 15 x 20 in.
(38.1 x 50.8 cm). Oakland
Museum of California.

ABOVE

152. C. P. Townsley (1867–1921).
*Mission San Juan
Capistrano*, 1916.
Oil on canvas, 32 x 40 in.
(81.2 x 101.6 cm). Joan Irvine
Smith Fine Arts, Newport
Beach, California.

seen."[27] Los Angeles was being primed for the San Francisco extravaganza, and the city was aware of it. Cook's review of the visitors' show gave her an opportunity to praise the merits of local artists: "If you are willing to be perfectly honest with yourself you will own up that the local exhibitions are just as interesting and show just as large a percentage of good canvases as that which is being sent throughout the west to represent these men [Hassam, Reid, et al.]." Cook found Reid's work "refreshing" and "delightfully loose" but thought Hassam's figures would have been juried out of any local exhibition. Cook's attitude, no doubt shared by a number of local artists and patrons, was that California art at the exposition would be acknowledged as the equal of its eastern counterparts.

The pattern followed by the typical California Impressionist was initial academic training in art, either in California or elsewhere in the United States, followed by European study and eventual long-term residency in the Golden State. Joseph Raphael was an exception to this pattern. Raphael (pronounced RUH-fell) studied at the Mark Hopkins Institute of Art from 1893 to 1897, then made the obligatory pilgrimage to Paris in 1903. Atypically, the artist spent the next thirty-seven years in Europe. From about 1904 to 1911 he divided his time between Paris and the art center of Laren, southeast of Amsterdam. At Laren, Raphael painted figures in a dark manner derived from the Dutch masters. He achieved considerable success in this style; his large oil *La Fête du Bourgmestre* (Fine Arts Museums of San Francisco) received an honorable mention at the Paris Salon of 1906 and was subsequently purchased by a group of friends in San Francisco and given to the San Francisco Art Association. That same year, the San Francisco art patron Raphael Weil purchased Raphael's *Town Crier* (Fine Arts Museums of San Francisco) for the M. H. de Young Memorial Museum. Raphael stayed closely connected to the city; in 1910 he had a solo exhibition at the San Francisco Institute of Art (comprising work in his dark figural style), and beginning in 1913 Helgesen Galleries, an important venue for modernist art, gave him annual exhibitions at its location on Sutter Street. He also participated in the annual group shows at the Institute of Art when able to do so, and he eventually sent etchings and paintings for exhibition in the city. Albert Bender, a noted San Francisco patron and relative of the artist Anne Bremer, also took an interest in Raphael and his work at this time, and the two carried on a regular correspondence.

Sometime after his solo exhibition of 1910, Raphael's style underwent a radical transformation from his large-scale, carefully drawn, somber-toned pictures to modest-sized landscapes of high-key color. He wrote to Bender in 1911 that he was working on a series of small, outdoor

OPPOSITE, LEFT

153. Vincent van Gogh (1853–1890). *The Plain of Auvers*, 1890. Oil on canvas, 28¾ x 36¼ in. (73 x 92.1 cm). Carnegie Museum of Art, Pittsburgh; Acquired through the generosity of the Sarah Mellon Scaife family.

OPPOSITE, RIGHT

154. Joseph Raphael (1869–1950). *Tulip Fields of Noordwijk*, c. 1912. Oil on canvas, 26½ x 28¼ in. (67.3 x 71.7 cm). Mr. and Mrs. Mark Salzberg.

PAGE 170

155. Joseph Raphael (1869–1950).
The Garden, c. 1912.
Oil on canvas, 28¼ x 30¼ in.
(71.7 x 76.8 cm). Garzoli
Gallery, San Rafael,
California.

landscapes and began sending some of them to him. Raphael's regular experimentation with outdoor painting, in combination with his routine exposure to art innovations in Paris, may have influenced the artist's new impressionistic style. Also, the influence on Raphael of that most famous of Dutch masters, Vincent van Gogh, should be considered, although it has not previously been suggested. Though van Gogh's work (plate 153) was little known to the art world at the time of his death in 1890, his influence was felt soon after through several major early-twentieth-century exhibitions, including one in Paris and one in Amsterdam in 1905. Raphael could have seen either or both of these; it should be noted, too, that the Dutch painter's nephew and devotee, Vincent Villem van Gogh, lived in the tiny town of Laren at the time Raphael was there. By 1910 van Gogh's work was prominently featured in a major exhibition of Post-Impressionism in London, and he had become world famous.

Raphael's work after 1910 is distinguished by thick, turbulent brushwork similar to that of van Gogh, and he adopted as his subjects the tulip fields and gardens of Holland. One of Raphael's favorite painting locales was Noordwijk, on the Dutch coast. Works similar to his *Tulip Fields of Noordwijk* (plate 154) and *Fields of Linkebeek, Holland* (plate 156) were certainly among the canvases he sent to Helgesen Galleries for his annual shows.

The Garden (plate 155) could have been seen at Helgesen's as part of a group of over sixty

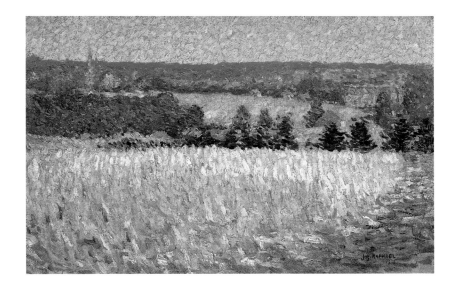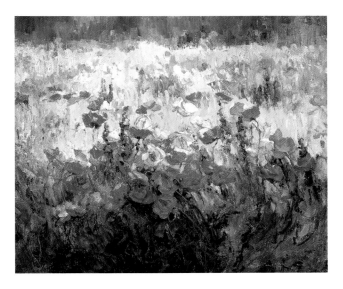

ABOVE, LEFT

156. Joseph Raphael (1869–1950).
*Fields of Linkebeek,
Holland*, n.d.
Oil on canvas, 17¾ x 27¼ in.
(45 x 69.2 cm). Maxwell
Galleries, San Francisco.

ABOVE, RIGHT

157. Mary Herrick Ross (1856–1935).
My Studio Garden, n.d.
Oil on canvas, 26 x 30 in.
(66 x 76.2 cm). The Redfern
Gallery, Laguna Beach,
California.

of Raphael's paintings shown there in 1913. It was exhibited again at the San Francisco Institute of Art in 1916, where it was awarded the First Purchase Prize. Local appreciation for Raphael and the expressive power of his work must have had an impact on the subsequent development of Bay Area plein air painting, which would be more boldly expressionistic than the Southern California work. Indeed, unlike the majority of California Impressionists who were working outside the state between 1900 and 1915, Raphael's work was constantly shown to the public and patrons. Everett C. Maxwell wrote in early 1914: "How the San Franciscans do worship Joseph Raphael! And he truly deserves it for he is indeed and in truth a great figure painter."[28] Raphael's intense palette and flamboyant brush stroke may have been the inspiration for the ebullient *My Studio Garden* (plate 157) by the little-known Mary Herrick Ross, an early student at the California School of Design and a lifelong resident of the Bay Area. The thick, twisting configuration of reds, yellows, and greens in Ross's *Garden* recalls the dynamic surface effects to be found in works like Raphael's *In the Orchard* (plate 158).

Another native San Franciscan who expatriated early in his career was Jules Pagès, who moved to France around the turn of the century and who, like Raphael, remained abroad until the outbreak of World War II. A former student at both the California School of Design and the Académie Julian in Paris, Pagès became an instructor at the latter. He did eventually adopt some impressionistic methods, looking to Edgar Degas as a source of inspiration. Degas, while universally recognized as an Impressionist, nonetheless retained a high level of academic drawing

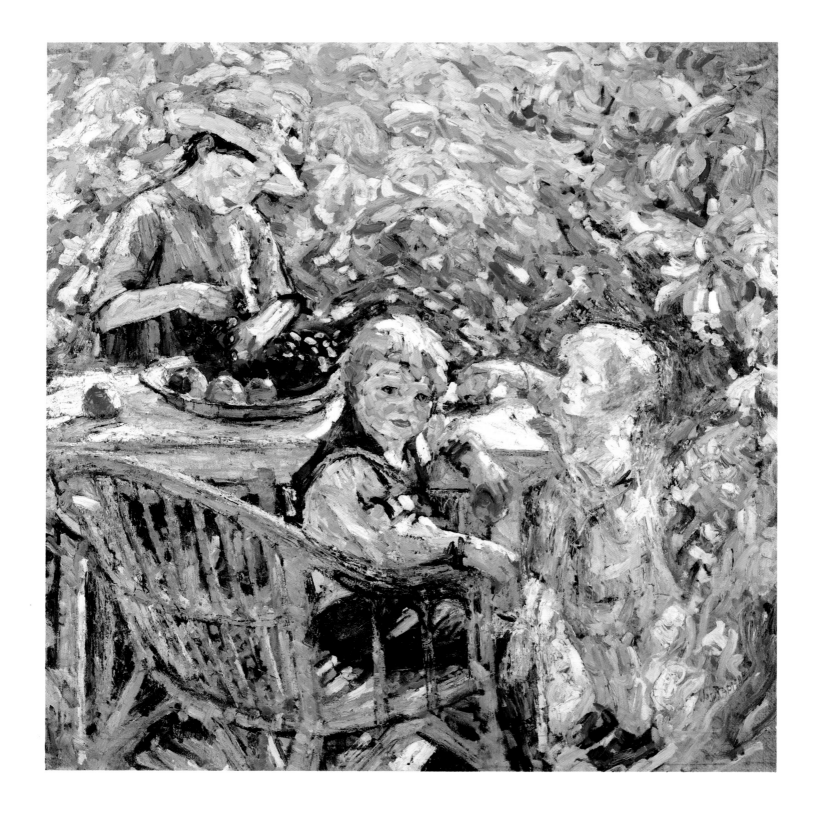

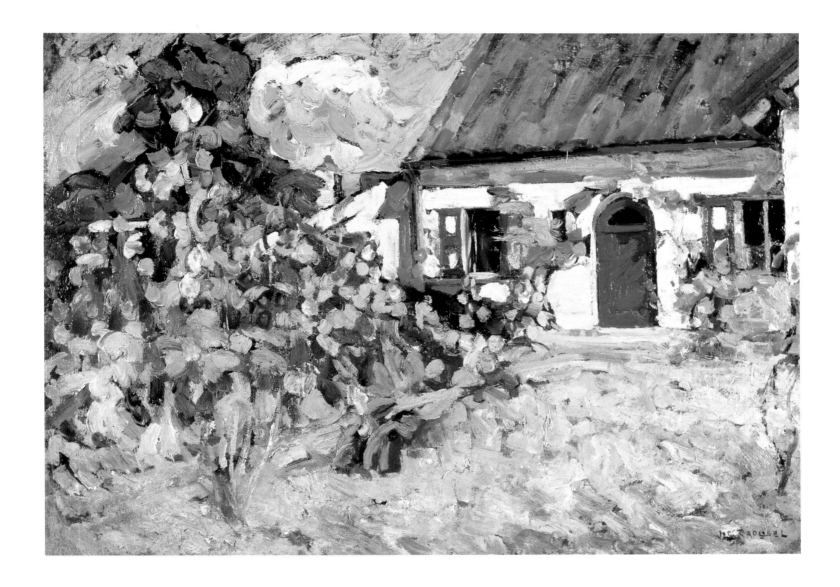

OPPOSITE

158. Joseph Raphael (1869–1950).
In the Orchard, c. 1915–17.
Oil on canvas, 58½ x 58¼ in.
(148.5 x 147.9 cm). Fleischer
Museum, Scottsdale, Arizona.

ABOVE

159. Joseph Raphael (1869–1950).
The New Blue Door, c. 1923.
Oil on canvas, 27¼ x 38¼ in.
(69.2 x 97.1 cm). Paul Bagley
Collection.

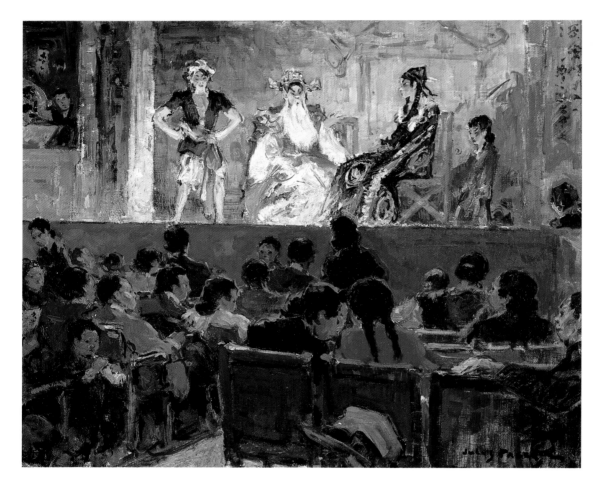

160. Jules Pagès (1867–1946). *Chinese Theater, China Town*, n.d. Oil on canvas, 15 x 18 in. (38.1 x 45.7 cm). Oscar and Trudy Lemer.

in his own work, which Pagès admired and on occasion attempted to emulate. On one of his visits to his native San Francisco, Pagès painted a scene from a Chinese theater in Chinatown (plate 160) that suggests comparison with Degas's pictures of performers on stage, where the angle of viewing is oblique, seemingly glimpsed by chance, and the subjects are animated by swift but accurate drawing.

Pagès had several one-artist shows in Los Angeles at the Steckel Gallery beginning in 1909, and his work was frequently seen in San Francisco. In a 1907 exhibition at the important gallery Vickery, Atkins and Torrey the artist showed a number of outdoor landscape and garden scenes painted in Brittany.[29] A local critic noted then his "genius for painting light." In 1907, too, Evelyn McCormick defended Pagès's work against negative criticism, presumably by local

proponents of Tonalism: "[Pagès's] style is of the more modern and is strong and vivid, while most of the work out here [San Francisco] is rather of the kind that is usually called Whistlerian, though it is not like anything Whistler ever did."[30] Pagès's own enthusiasm for Impressionism, which he believed was based on a thorough knowledge of drawing, was made known in a brief 1914 article: "Impressionism—real Impressionism—has been the true turn and the real renaissance in modern art."[31]

The best-known Southern California artist living and working in France during the first decades of this century was Guy Rose. After his brief return to Los Angeles in 1891, Rose supported himself as an illustrator in New York. By 1894 he was temporarily back in Paris when he also revisited Giverny. In 1899, he returned to Europe and after several years of Continental travel and sporadic stays in Paris, in 1904 he and his wife acquired an old stone cottage in Giverny, a move perhaps intended to help Rose regain his health, which had been damaged by lead poisoning.[32]

At Giverny, Rose befriended fellow painters Theodore Earl Butler, Frederick Frieseke, Edmund W. Greacen, Lawton Parker, Lilla Cabot Perry, Louis Ritman, and two artists later to be associated with California Impressionism, Alson Clark and Richard Miller. Once he felt well enough to resume working with oils, Rose produced scores of landscapes and figure paintings before leaving Giverny in 1912. Though he knew the work of his American friends at Giverny quite well, the primary source for his style, and theirs, was that of Claude Monet.

Monet's work represented the idea of modernity to the younger Americans. He dematerialized form while painting the blurring effects of outdoor light mixed with intense color. For American artists of Rose's generation and background, who inherited an aesthetic that demanded truthful descriptions of nature, Impressionism offered an expanded chromatic range, emphasis on light, and directness of observation that would not necessarily conflict with their inherited mandate to paint the verifiable facts of nature. Rose's Giverny work represents this synthesis of the traditions of detailed representation and the increasingly abstract propositions of Monet.

Rose's success in assimilating Impressionist techniques to academic methods is seen in his tour de force, *The Old Bridge, France* (plate 161). The structure of the bridge is rendered with architectural precision, while a full three-quarters of the vertical composition is occupied by patterns of light vibrating on the river Epte. The composition is organized like a frame within a frame, pulling the eye deeper into the still space and quickening reflections. The placement of the bridge near the upper edge of the canvas may have been inspired by Monet's *Road Bridge, Argenteuil* (plate 162), a painting Rose could have seen at the artist's Giverny studio.[33] Rose echoed Monet even more directly in his *Poppy Field* (plate 163), which parallels in

LEFT
161. Guy Rose (1867–1925).
 The Old Bridge, France,
 c. 1910.
 Oil on canvas, 39½ x 32 in.
 (100.3 x 82.2 cm). Rose Family
 Collection.

162. Claude Monet (1840–1926).
 The Road Bridge,
 Argenteuil, 1874.
 Oil on canvas, 21 x 28½ in.
 (53.3 x 72.3 cm). Unlocated.

all compositional respects Monet's *Field of Grain with Poppies* (Musée de Strasbourg). Indeed, Rose seems to have painted the very same field, located in the northern part of the valley of Giverny from a spot looking east.

Though he worked in early-twentieth-century France in the shadow of Monet, Rose nonetheless remained close to his cultural roots in America. His adult attitude toward nature was in many respects unchanged from his student years—it was still humble and subservient. One of the paintings that best embodies Rose's continued adherence to notions of the grand, awe-inspiring power of landscape is *The Large Rock* (plate 164), a view of the limestone cliffs overlooking Giverny that recalls in its optical breadth Thomas Hill's views of Yosemite.

Rose's figurative work at Giverny reflected trends popular in both Europe and America. His outdoor figures, as in *The Blue Kimono* (plate 165), repeat the well-traveled subject of the idealized woman placed in a colorful outdoor setting, which was used by both the French Impressionists and academic painters.[34] *The Difficult Response* (plate 187) uses the equally familiar formula of situating the model (in this case, she seems to be the artist's wife) in a richly decorated interior near a window, thus allowing for brilliant lighting effects. In every picture,

the figure is virtually a prop, included solely as a human complement to the beauty of nature. Like the floral environment of *The Blue Kimono*, the model herself is in bloom—young, healthful, and radiant. The scene is an updated rendition of the garden of earthly delights. Rose's *Green Parasol* (plate 166) is another example of the romanticized female figure perfectly in harmony with the nature around her.

It has been argued that even though the American Impressionists may have been consciously apolitical, their art nonetheless perpetuated a view of women as passive objects.[35] Art is unquestionably multivalent in conveying different levels of meaning, not only at the time of its creation but also to subsequent viewers with ever-shifting aesthetic (or nonaesthetic) criteria. The California Impressionists generally adopted the idealizing, decorative, and highly sensuous

163. Guy Rose (1867–1925).
Poppy Field, c. 1910.
Oil on canvas, 23⅝ x 28¾ in.
(60 x 71.7 cm). Rose Family
Collection.

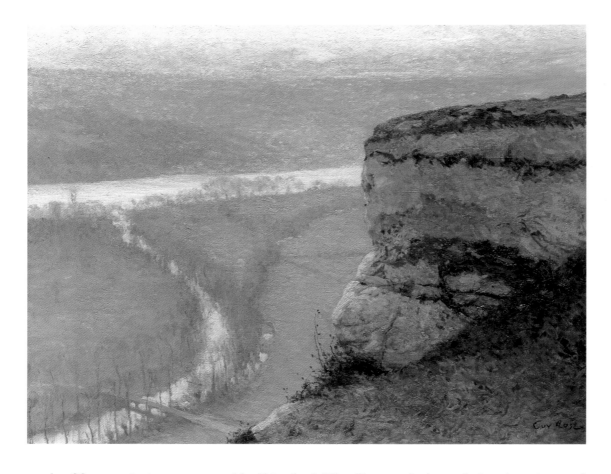

mode of figure painting represented by Frieseke, Miller, Rose, and a host of other American and European painters. To insert an attractive woman into nature was to layer beauty upon beauty, and to make the figure a part of the environment. And, for the California Impressionists, inter-action with the environment was always positive—an act of enjoyment, meditation, or praise. In California Impressionist figure paintings such as Mannheim's *Lonely Tea Party* (plate 167) and Donna Schuster's *In the Garden* (plate 168), the figures are not only youthful and attractive, they are absorbed in their contentment. Alson Clark's *Reverie* (plate 169; formerly called *Medora on the Terrace*) is one of the clearest examples of how the figure in a California Impressionist painting is not required to act, but rather merely to be; here, Medora, the artist's wife, is so con-tent she sleeps. The sun-dappled terrace is quiet, the setting obviously comfortable. She is com-pletely serene, like the scene around her.

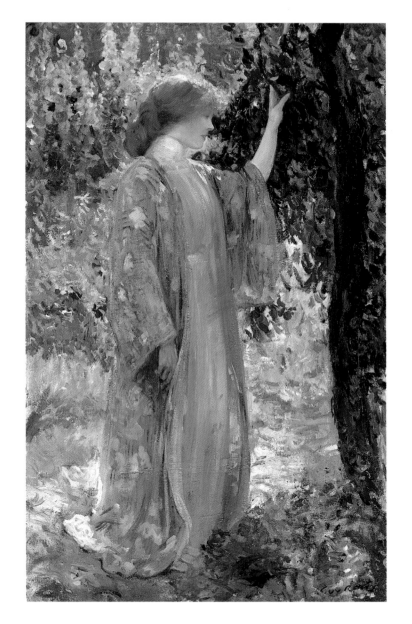

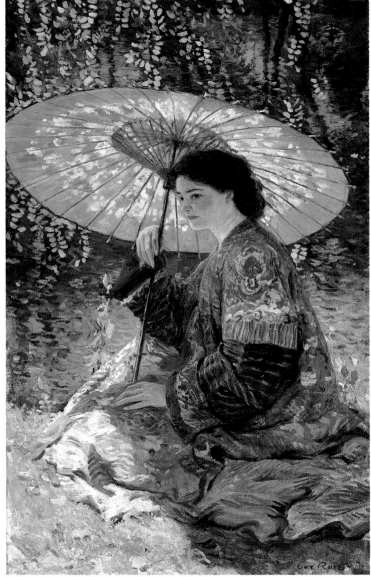

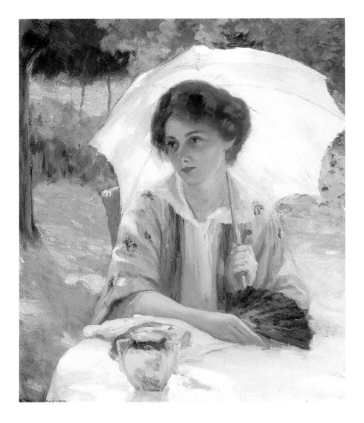 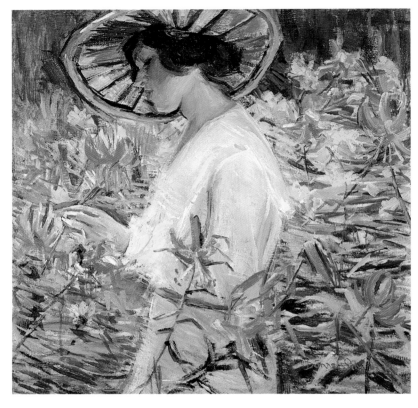

Clark, who had visited Rose in Giverny during his own stay there in 1910, did not move to California until 1919, and his work was little seen in the Golden State until then.[36] After studying with Chase in New York, Clark arrived in Paris in late 1898. Disgusted with the carnival atmosphere at the Académie Julian, he enrolled in the Académie Carmen, the newly established atelier where Whistler taught. And, though Clark complained that "the whole school is rotten,"[37] Whistler placed the interpretation of nature far above the mere representation of it, and his esoteric theories of beauty and his imaginative yet highly disciplined approach to painting expanded Clark's understanding of the artistic process.

Clark remained with Whistler less than a year before embarking on a series of travels around Europe and between the Continent and North America that would continue until the outbreak of World War I. In 1906 he returned to the city of his birth, Chicago, where he had a one-artist show at the Art Institute of Chicago that was well received by critics; many of the pictures were French views painted in somber tonalities derived from Whistler.

ABOVE, LEFT

167. Jean Mannheim (1862–1945). *Lonely Tea Party*, 1916. Oil on canvas, 26 x 20 in. (66 x 50.8 cm). Stephen and Suzanne Diamond.

ABOVE, RIGHT

168. Donna Schuster (1883–1953). *In the Garden*, 1917. Oil on canvas, 30 x 30 in. (76.2 x 76.2 cm). Fleischer Museum, Scottsdale, Arizona.

In November 1906 Clark was in Canada on the first leg of a projected trip to Japan. While there, he worked on a number of winter scenes, including *Winter in Quebec* (plate 170). The artist was fascinated with the variations in color and value present in the snow, which occupies two-thirds of the composition. While some of his earlier work only mimicked Whistler, in *Winter in Quebec* Clark more successfully orchestrated the subtle rhythms and shifts in tone seen in the receding snowbanks and played the delicate blue shadows of the drifts off a blue sky punctuated with white clouds. Whistler's mastery of painting with shades of blue and gray seems to have had a conceptual influence on Clark. *Winter in Quebec* integrates design concepts derived from Whistler's aesthetic without compromising Clark's desire to articulate on canvas a specific scene and set of climatic conditions.

Clark's ability to balance influences with his own desire to paint palpable, sensuous

169. Alson Clark (1876–1949). *Reverie* (formerly *Medora on the Terrace*), 1920. Oil on canvas, 36 x 46 in. (91.4 x 116.8 cm). Rose Family Collection.

170. Alson Clark (1876–1949).
Winter in Quebec, 1907.
Oil on canvas, 30 x 44 in.
(76.2 x 111.7 cm). Fleischer
Museum, Scottsdale, Arizona.

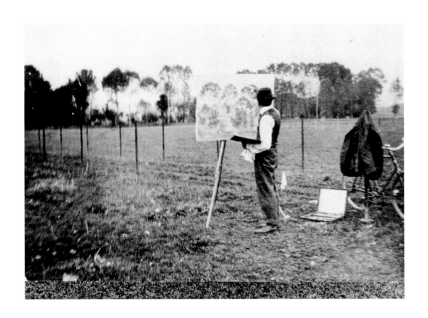

171. Alson Clark painting at Giverny, France.

landscapes and figures led him to incorporate Impressionist strategies—some of which he had first encountered while a student of Chase—into his work toward the end of the decade. He returned to France in the summer of 1907 and spent the better part of 1910 in Normandy, when he visited Giverny (plate 171). Without overestimating the importance of a single trip in the life of an inveterate traveler, Clark's time in Giverny does seem to correspond to a definite move toward Impressionism in his art. There, in the company of Frederick Frieseke, Lawton Parker, and Guy Rose, Clark was no doubt challenged to bring into his own work the intensity of color he observed in that of his colleagues, an intensity he had largely forgone in deference to a modified Whistlerian Tonalism. As Clark said himself in 1910, "In Paris . . . competition and comment are so keen that a man is kept up to his best work, which would be difficult in a lonely desert in Arizona."[38]

Clark's *Hillside, Giverny* (plate 172) surveys a modest hillside and the roofs of village houses descending in the middle ground, with a bright, cloud-spotted sky in the distance. Clark converted the sweep of the foreground hill into a field of broken brush strokes, with individual daubs of yellow, blue, green, and red placed side by side, unmixed—a common Impressionist idiom. Like others working before him at Giverny, Clark reached beyond the simple transcription of a picturesque scene (though he achieved that as well) to record and interpret the sensual data of light and color around him. However, his interest in the abstract possibilities of color and light as pure sensations had to coexist with an optimistic description of the picturesque. While Monet's pictures of water lilies were evolving into abstract sensuality and increasingly stressed inward-focused, individual perceptions, American painters retained a need to address the essential goodness of nature.

Clark's involvement with impressionistic painting was more than mere flirtation during a Giverny vacation. Back in New York State the next year, the artist painted a series of Impressionist-inflected landscapes around the Thousand Islands area. Clark's otherwise straightforward composition of water and trees in *Thousand Islands* (plate 173) minimizes landscape elements in favor of the glittering, fractured surface of reflected light.

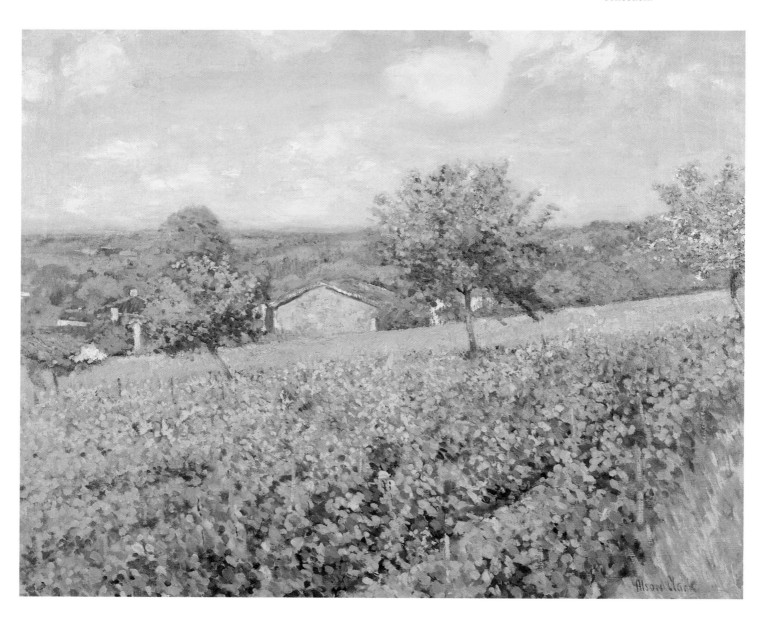

172. Alson Clark (1876–1949). *Hillside, Giverny*, c. 1911. Oil on canvas, 25½ x 31⅞ in. (64.7 x 80.9 cm). Private collection.

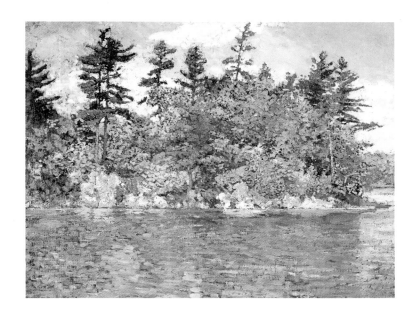

173. Alson Clark (1876–1949).
Thousand Islands, n.d.
Oil on canvas, 29½ x 37½ in.
(74.9 x 95.2 cm). Fleischer
Museum, Scottsdale, Arizona.

Exploration of color and light for their own sake did not hold Clark's attention, for he aspired to create larger, more traditionally impressive paintings. In 1913 he was persuaded by the writer Henry Kitchell Webster to go to Panama to record the construction of the canal. It was not Clark's intention to critique the industrial revolution but rather to document the inexorable expansion of the American political and economic presence; his paintings would imply that this was both inevitable and necessary. His painting of the canal's construction (plate 175) is not, as today's sensitivity to environmental issues might have us wish, a condemnation of wholesale ecological destruction. Clark painted the Panamanian landscape from a commanding perspective in order to dramatize the integration of industry and nature. The image is handsomely designed, richly colored, and strongly lit, infusing the scene with a positive feeling. Clark's attitude toward the Panama Canal was, in fact, completely consistent with the prevailing sentiment toward it in the United States, one that generated the Panama-Pacific International Exposition in 1915 to celebrate its completion.

That monumental world's fair would be the site of Impressionism's triumph in California, if not the United States. It would stimulate California Impressionism's period of greatest productivity and creativity, which would last for over a decade before declining into stereotype and sterility in the late 1920s.

Ascendancy

There is no other land so lovely, so constant, so generous. It lies between the desert and the sea—God's two sanatoriums for weary flesh and weary mind. The Sierra's eternal snows, the desert's clean, hot breath, the Ocean's cool winds and the warmth of the sinuous current of Japan winding through it, all combine to make a climate hopelessly unrivaled by even the most favored shores of the Mediterranean. It is a land of artists' dreams, endless with flower-flamed uplands, swinging lomas and majestic mountains. It changes with every color of the day and is soft and sweet unspeakably under low-hanging stars and great, shining moons.

JOHN S. MCGROARTY, 1911

Building a functional waterway between the Atlantic and Pacific was a problem with a long history. The idea of connecting the two oceans can be traced back to Charles v of Spain in 1523, but it was only after a series of blunt political maneuvers managed according to President Theodore Roosevelt's "speak softly and carry a big stick" political philosophy that one of the most grandiose engineering feats of all time was begun, in 1907. The Panama Canal was finished seven years later.

Talk of an international fair to celebrate the proposed Panama Canal began in 1904, the year after rights to the land for the canal were secured, but deciding on a host city for the fair took several years. San Francisco, still the major financial and cultural center of California, was reeling from the destruction of the 1906 earthquake and fire. That made it seem an unlikely candidate to host a fair that aspired to equal the grandeur of the 1893 World's Columbian Exposition in Chicago. But ambitious it was: having systematically rebuilt itself, the city recognized

174. Bruce Nelson.
Detail of *The Summer Sea,*
c. 1915.
See plate 182.

175. Alson Clark (1876–1949). *Panama Canal*, 1913. Oil on canvas, 25½ x 32 in. (64.7 x 81.2 cm). James Zidell.

the completion of the canal as an opportunity to show off its own re-creation. Though the cities of San Diego and New Orleans both competed to be the site of the fair, San Francisco was made the official venue by an act of Congress in January 1911.

On a two-mile parcel of land on the shore of the bay at the northern edge of the city, a complex of immense buildings was constructed to house the Panama-Pacific International Exposition, which opened on February 20, 1915 (plate 176). At its center was the ponderous Palace of Fine Arts, designed by the Berkeley architect Bernard Maybeck and intended as a symbol of "the mortality of grandeur"—even though the structure's heavy-handed quotations of classical architecture made it a textbook example of grandeur, an irony apparently lost on contemporary critics of the exposition. Nearby was the Tower of Jewels, bedecked with over fifty thousand pieces of colored glass illuminated at night by thirty-six colored searchlights. If

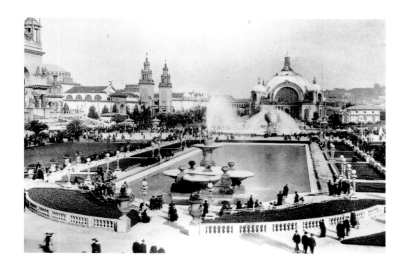

176. View of the Festival Hall and South Gardens at the Panama-Pacific International Exposition, from *Robert A. Reid's Official Souvenir View Book of the Panama-Pacific International Exposition at San Francisco, 1915.*

Chicago had built a complex dubbed the "White City" in 1893, then San Francisco had succeeded in building a fantastic mosaic, a multicolored shrine to the current and future prosperity of California and the United States.

Over the next ten months, more than two million people visited the exposition, where there were marvels in abundance inside the Palace of Machinery, the Palace of Horticulture, the Fountain of Energy, and, of course, the Palace of Fine Arts. There Impressionism and international variants thereof dominated the 120 galleries. As William Gerdts observed in his book *American Impressionism* (1984), the Panama-Pacific International Exposition not only established the preeminence of American Impressionism, it enshrined it.[1] The venerable William Merritt Chase, teacher and mentor to so many of the California artists, was honored with his own gallery of thirty-two paintings; the equally famous Childe Hassam showed thirty-eight.

There were Impressionist painters from nearly every region of America, and exhibiting with them in force were those from California. They took their place on the walls of the Palace of Fine Arts along with the major figures in American art: Thomas Cole, Thomas Eakins, and Winslow Homer, as well as the early California painters Albert Bierstadt, Thomas Hill, and William Keith. Among the California Impressionists showing at the exposition were Maurice Braun, Benjamin Brown, Alson Clark, Evelyn McCormick, Jean Mannheim, Jules Pagès, Hanson Puthuff, Joseph Raphael, Granville Redmond, Guy Rose, and William Wendt. Their canvases were nearly all landscapes: Braun showed three views of sunlit California hills; Brown, a dramatic scene of the Golden Gate; and Clark, his series on the building of the Panama Canal (plate 175). Raphael was represented by scenes of Holland, including tulip fields, while Rose won a silver medal for his romantic reverie *November Twilight.* Wendt seemed to sum up the aesthetic ambitions of the group with the title of one of his entries: *The Land of Heart's Desire.*[2] Other California painters with work on view, most but not all associated with Impressionism, included Carl Oscar Borg, Anne Bremer, Euphemia Charlton Fortune, William Cahill, Colin Campbell Cooper, Maynard Dixon, Maren Froelich, Armin Hansen, Clarence Hinkle, Clark Hobart, Fernand Lungren, Arthur Mathews, Bruce Nelson, Edgar Payne, Charles Reiffel, John Rich, William Ritschel, Donna Schuster, and Orrin White.

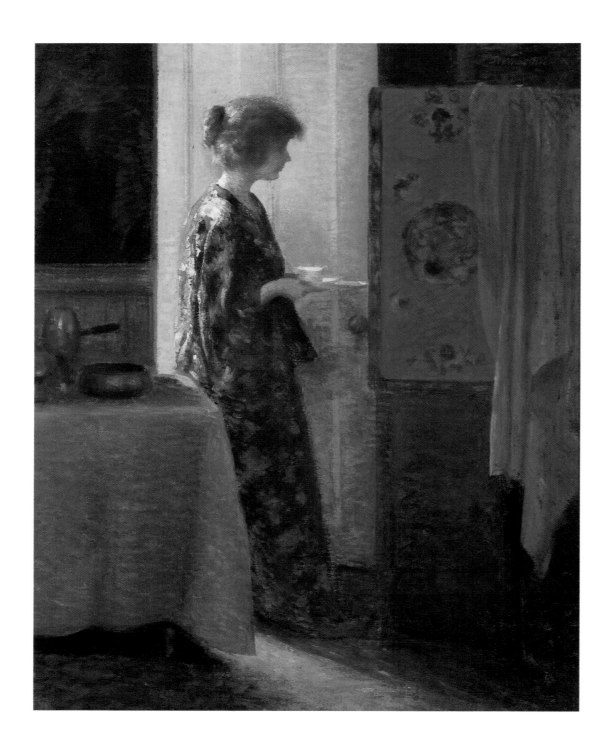

LEFT

177. John Rich (1876–1954).
The Blue Kimono, c. 1914.
Oil on canvas, 25 x 20 in.
(63.5 x 50.8 cm). Maureen
Murphy Fine Arts, Santa
Barbara, California.

OPPOSITE

178. Maren Froelich (1870–1921).
Chinese Robe, c. 1910.
Oil on canvas, 51 x 31 in.
(129.5 x 78.7 cm). Oakland
Museum of California; Gift
of Dr. William S. Porter.

John Rich's *Blue Kimono* (plate 177) and Maren Froelich's *Chinese Robe* (plate 178) were both variations on the well-worn subject of an elegantly posed and appointed woman in an interior. The theme descended from a variety of European sources, including Salon, Impressionist, and grand-manner portraiture traditions, and it was adopted wholeheartedly by the many Americans who routinely aspired to evoke sophisticated cosmopolitanism. Both Froelich's and Rich's accomplished reinterpretations (like William Cahill's slightly later *Thoughts of the Sea*, plate 62) testify to how effectively Californians assimilated not only Continental formulas but also the compositional strategies of painters such as Frank W. Benson and Edmund C. Tarbell of the Boston school, who further popularized images of the elegant, languorous female in an interior.

Donna Schuster and Euphemia Charlton Fortune, who had both studied at Chase's 1914 summer school in Carmel, painted views of the exposition itself. Fortune painted some of the most impressionistic work of her career in the years around the exposition, including her vaporous *Summer* of 1914 (plate 243); her exposition scene of 1915 (plate 179); and her tour de force, *Monterey Bay* (plate 104), painted the following year. These three paintings make a convincing argument for the extraordinary impact of the exposition in terms of anticipation, realization, and subsequent inspiration.

Pure landscape was the subject matter favored by most of the Californians exhibiting at the exposition, including some work that stretched the traditional boundaries of acceptable landscape painting

179. Euphemia Charlton Fortune
(1885–1969).
*Panama-Pacific International
Exposition*, 1915.
Oil on canvas, 12 x 16 in.
(30.4 x 40.6 cm). Oscar and
Trudy Lemer.

within the state. Among these was Clark Hobart's *Blue Bay: Monterey* (plate 180), with its terse ribbon of limpid color and its reductive patterning that smacks of European modernism. Hobart's first art instruction had been, typically, at the California School of Design as a young man, and he also studied privately with William Keith. After working as a commercial artist in New York from 1903 to 1911, Hobart moved to Monterey. He must have been affected by the work of American Impressionists and vanguard artists like Robert Henri that he saw in New York, for *The Blue Bay: Monterey* is far removed from Keith's dark, brooding Barbizon-influenced work and from the heavily orchestrated seascapes, such as William Ritschel's, that Hobart would have seen in Monterey.

Other California artists with distinctively modern temperaments at the exposition were Bruce Nelson, Maynard Dixon, and Fernand Lungren. Lungren was first in Los Angeles in 1903 and then in Santa Barbara by 1907. He exhibited a painting at the fair entitled *In the Abyss*,

OPPOSITE
180. Clark Hobart (1868–1948).
The Blue Bay: Monterey,
c. 1915.
Oil on canvas, 20 x 24½ in.
(50.8 x 62.2 cm). Fine Arts
Museums of San Francisco;
Museum Purchase, Skae
Fund Legacy.

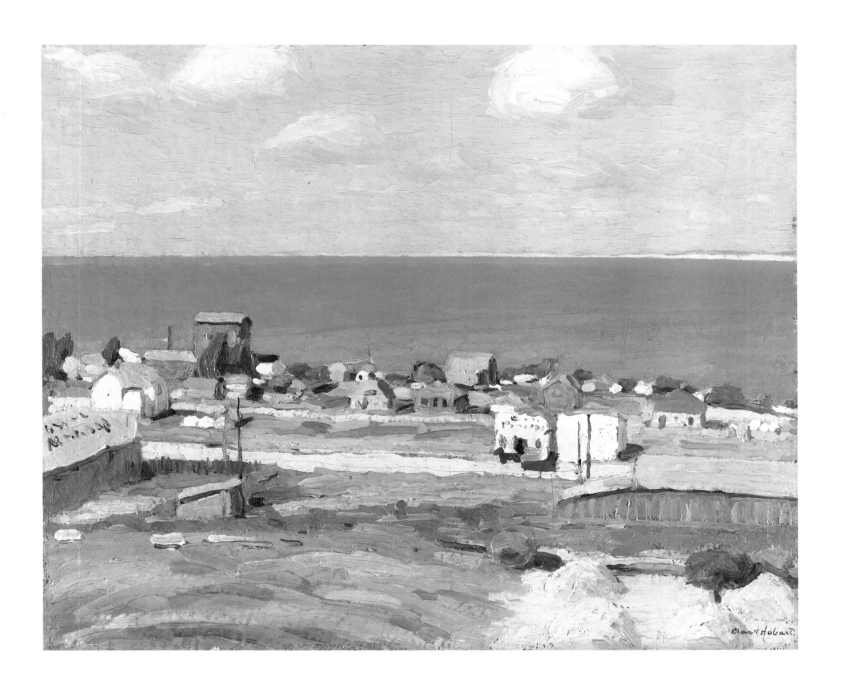

181. Fernand Lungren (1859–1932). *Wall Street Canyon*, n.d. Oil on canvas, 36 x 27 in. (91.4 x 68.5 cm). The J. C. Carter Co., Inc., Santa Barbara, California.

ABOVE, LEFT

182. Bruce Nelson (1888–1952). *The Summer Sea*, c. 1915. Oil on canvas, 30 x 40 in. (76.2 x 101.6 cm). The Irvine Museum, Irvine, California.

ABOVE, RIGHT

183. Bruce Nelson (1888–1952). *Orchard in Santa Clara Valley*, n.d. Oil on canvas, 24 x 30 in. (60.9 x 76.2 cm). Oakland Museum of California; Gift of Jean Haber Green.

Grand Canyon, a work no doubt similar to his *Wall Street Canyon* (plate 181), in which the composition creates a steep, plunging perspective terminating abruptly near the picture's center. Like Hobart, Lungren was very interested in the use of flat patterning, as in the violet shadow on the canyon floor, to create bold contrasts that tend to emphasize the flatness of the picture plane.

Bruce Nelson had established a studio in Pacific Grove (not far from Carmel) in 1913, and in the years around the exposition he painted some of the most dynamic landscapes by any member of the California school (plates 63, 182, 183, and 250). He had a solo exhibition at Helgesen Galleries in San Francisco in 1914 that possibly contained some of these works. After serving in World War I, Nelson moved to New York and unfortunately seems to have stopped painting.

Maynard Dixon, himself a bronze medalist at the exposition, responded strongly to the Impressionist works he saw there, though only for a brief time before pursuing his own, highly individual interpretations of western space and light. Dixon's *Arizona Desert* (plate 184), painted after his participation in the exposition, uses intense colors applied with a directness and speed that are wholly Impressionist. Even though Dixon's interest in Impressionism soon waned in favor of a more personal style based on a graphic, almost hard-edged description of forms, he retained a brilliant palette. California Impressionism thus lost a major painter, though Dixon's mature work constitutes one of the most original and creative contributions to California art as a whole.

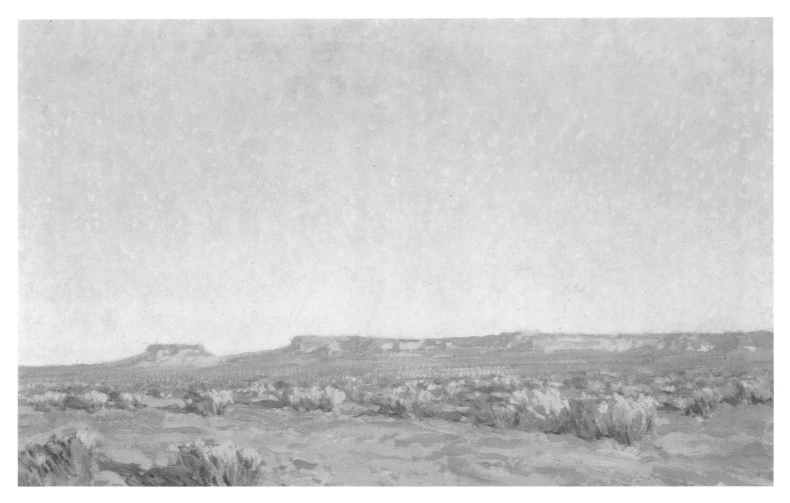

California artists recognized in 1915 that their work had earned a place within the larger scheme of American painting and that the Panama-Pacific International Exposition validated the professionalism and achievement of its painters. Immediately following the exposition, a large, well-illustrated book containing twenty-one essays was published, confirming that validation. Its rather weighty title says it all: *Art in California: A Survey of American Art with Special Reference to Californian Painting, Sculpture and Architecture Past and Present Particularly as Those Arts Were Represented at the Panama-Pacific International Exposition.*[3]

Everett C. Maxwell, then curator of art at the Los Angeles Museum of History, Science and Art, astutely noted in his essay for the book: "The Hudson River school reached out its ten-

184. Maynard Dixon (1875–1946). *Arizona Desert*, c. 1915. Oil on canvas (possibly formerly oil on canvas laid down on panel), 20⅛ x 30 in. (51.1 x 76.2 cm). The Torch Collection of Torch Energy Advisors Incorporated, Houston.

tacles and carried its message to the vast wilderness beyond the Rockies, and there, in that magic land of golden light and purple shadows, it grew and flourished and lived long after its exponents and their influence had vanished from the section that knew them first."[4] He also echoed the widespread enthusiasm about California that expanded during the time of the exposition, writing, "I think that none who are familiar with present-day conditions will dispute me when I declare that out of this land of silent places will come a native art as strong, as vital, and as colorful as the land that inspired and fostered it."[5]

While Maxwell identified the spiritual roots of California art in the Hudson River school, another essayist in the volume, Michael Williams, articulated the nature of that spirituality more clearly in "The Pageant of California Art":

> Unless art, like man, believes in and is obedient to the spirit of God, it is doomed to madness, decay, and death. . . . [California] is a state of natural health. It is the land of the great out of doors, a region where art may touch the life-giving bosom of Mother Earth once more, and be fructified anew; where it may put aside its dreary, tortuous intellectualism and the blighting madness of self-deification, and turn its eyes once again to the stars, to the great mountains, and to the sea, not merely for their own sakes, but because, real and actual as they are, they are but symbols of divine realities.[6]

Williams was strongly seconded in the book by the sculptor A. Stirling Calder, whose essay's title aptly summarizes its content: "Art Is Praise and All Things in Life Are Its Subjects."

The pervasive self-confidence and optimism that clustered around the exposition and California art related not only to deep-rooted American religious traditions but was also part of the patriotic fervor sweeping the nation as it faced the possibility of going to war. Alma May Cook, a Los Angeles critic in charge of the educational activities of the California Art Club, contributed an essay to *Art in California*—"What Art Means to California"—that perhaps best summarized the nationalistic and spiritual sentiments underpinning the belief that California was destined to become a new leader in world art:

> "But California is so isolated, so far from the center of the art world," comes the wail of the last few years. Isolated, yes; . . . but that will prove a blessing for which we should thank a kind, but unappreciated fate. Because of our distance we are more self-dependent, and therefore more self-reliant. We but hear of the latest "style" in art. The newest "ists" and "isms" are but names to us.

We are not even exposed to the contagion. . . . Yet another reason for thankfulness: we lack the "atmosphere" which attracts the dilettante. We are as yet something of pioneers and it is only the true artist in heart and soul who is willing to help build up the art to come. It is the worthwhile men and women who come to our shores to call them home.[7]

The moral certitude and cultural nationalism expressed by Cook and her colleagues ran strong throughout the 1910s and '20s, supporting both the continued vitality of California Impressionism and its commercial success. Indeed, it was only when this certitude was questioned, and often abandoned, during the unsettling years of the Great Depression that the preeminence of California Impressionism faded.

Less well known than the Panama-Pacific International Exposition in San Francisco, but still of importance to the triumph of Impressionist painting in California, was the Panama-California Exposition, also of 1915 (but so popular it was extended through 1916), held in San Diego's Balboa Park (plate 185). The city had competed to be the officially sanctioned exposition site, and when it lost to San Francisco, it went ahead with plans for a celebration anyway, adopting the unofficial "Panama-California"

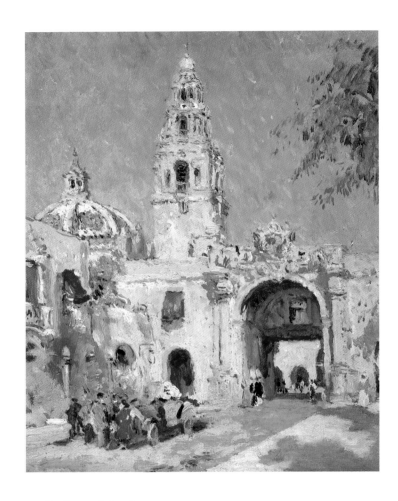

185. Colin Campbell Cooper (1856–1937). *Panama-California Exposition, San Diego, 1916*, 1916. Oil on board, 14 x 10½ in. (35.3 x 26.6 cm). Dr. and Mrs. Edward H. Boseker.

designation (though in 1916 it was allowed to add the word *International*). Part of the fair was a major art exhibition installed in the California Building (now the San Diego Museum of Man). Robert Henri, who was widely respected for his fierce aesthetic independence, helped with the selection of artists. He included several of his fellow New York Realists in the show—including George Bellows, William Glackens, George Luks, and John Sloan—along with many of the American and California Impressionists who had been featured in the Panama-Pacific International Exposition. San Diego's own prominent artists were featured, including Maurice Braun's former student, Alfred R. Mitchell (plate 186).

In 1914 Guy Rose returned permanently to California, and his presence contributed to the final consolidation of California Impressionism's preeminence. Rose had not been a permanent

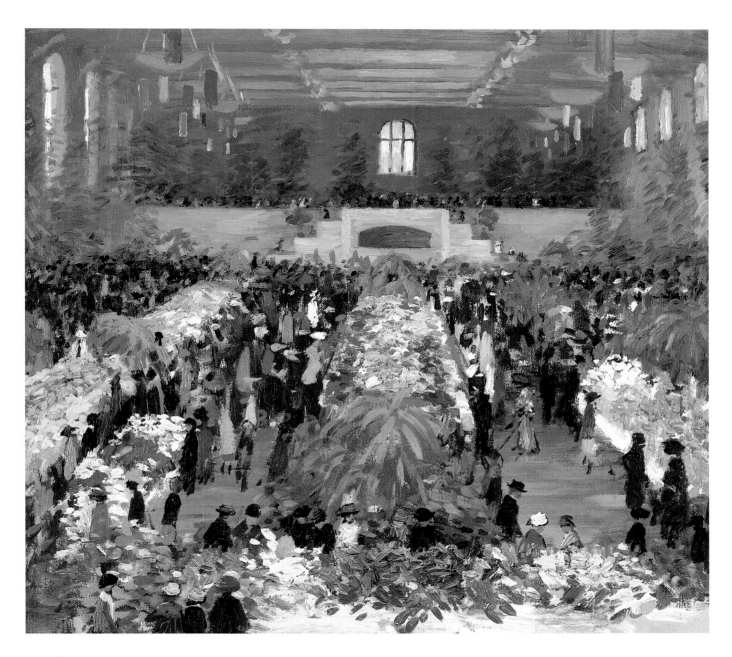

186. Alfred R. Mitchell
(1888–1972).
Flower Show in Balboa Park,
c. 1925.
Oil on canvas, 18 x 20 in.
(45.7 x 50.8 cm). San Diego
Historical Society.

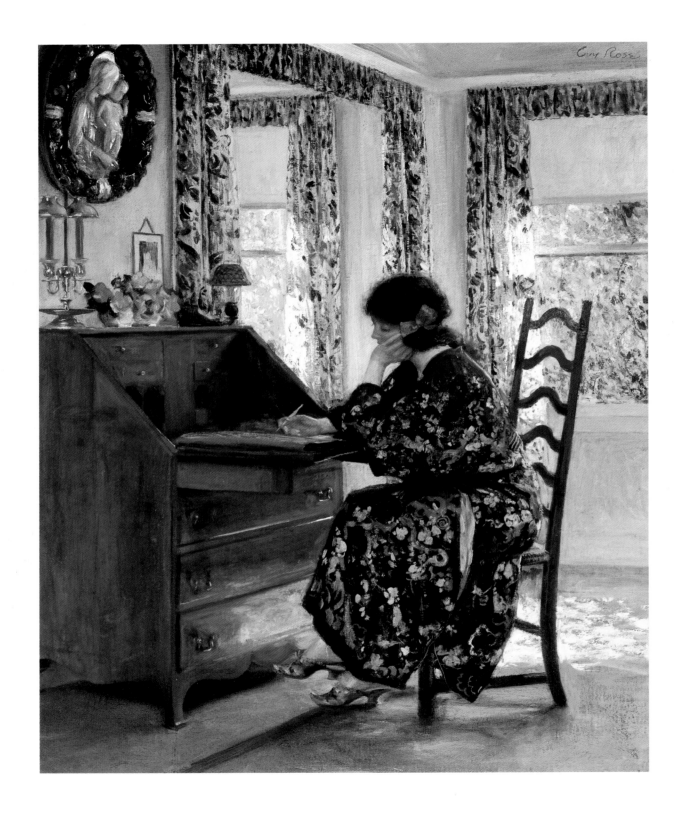

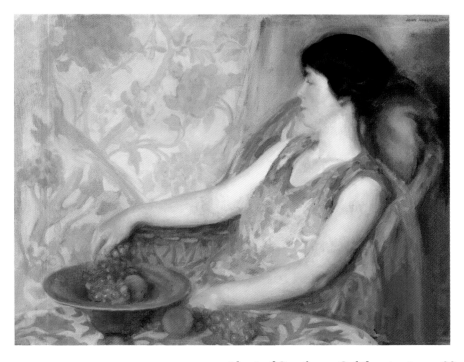

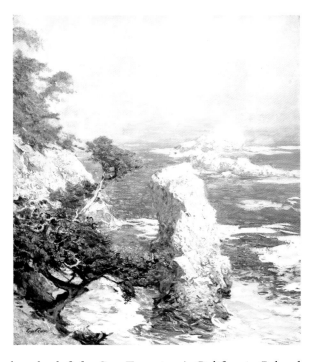

resident of Southern California since 1885, when he left for San Francisco's California School of Design. At that time, there were few professional artists in the Los Angeles area, but by the time he returned in 1914, there was an active contingent of regional painters, including those who had been established in California for years—William Wendt, the husband-and-wife duo of Elmer and Marion Wachtel, and Hanson Puthuff, as well as more-recent additions such as John Rich, who arrived in 1914. As Antony Anderson wrote in the *Los Angeles Times* soon after he met Rose: "We have artists galore, and more are coming all the time, driven here by eastern winters and lured here by our perpetual summers. . . . Guy Rose, notwithstanding his adventures around the globe, is 'one of us,' his birthplace being the historic village of San Gabriel."[8] Within six months of his arrival, Rose exhibited a large group of his Giverny works, including *The Difficult Response* (plate 187), at the Steckel Gallery in Los Angeles.[9] Anderson made the following astute observation: "The return of Guy Rose . . . was an event of importance to Los Angeles, and of even greater interest and importance is the fact that his stay will probably be permanent."[10]

In 1915 Rose, apparently in good health, was as active in the arts as at any point in his career. In addition to his numerous shows, he became a member of the board of governors of the

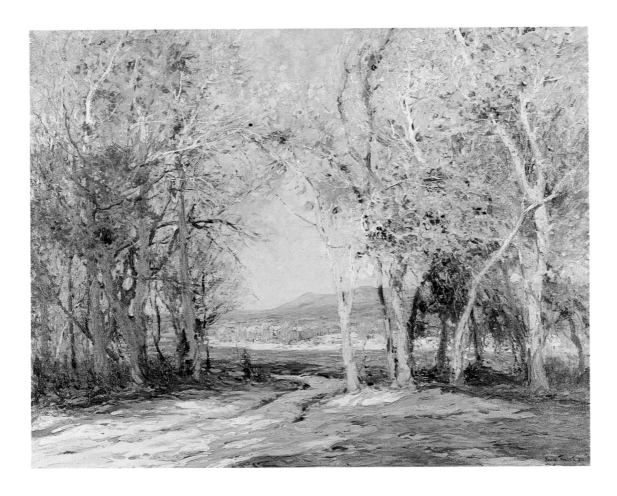

190. John Frost (1890–1937).
*Cottonwoods on the Mojave
River*, 1923.
Oil on canvas, 30 x 36 in.
(76.2 x 91.4 cm). Private
collection.

Los Angeles Museum of History, Science and Art, joined the California Art Club, exhibited two oils in the Panama-Pacific International Exposition,[11] and began to teach at the Stickney Memorial School of Art in Pasadena. His outdoor painting continued unabated, and in February 1916 he had his first one-artist exhibition at the new museum. Indeed, the years 1918 through 1921 were a period of particular achievement for Rose. His *Mist over Point Lobos* (plate 189), painted at Carmel, is a measure of the artist's mastery over his methods and his ability to convey what he perceived. He expertly evoked sensations in the viewer through his description of the dense, mist-filled atmosphere over the opalescent sea. Rose's international credentials, his unflagging enthusiasm for painting, and the high caliber of his work had considerable impact on local artists. Among those most influenced by Rose was John Frost, the son of the painter

and illustrator Arthur B. Frost, who had been Rose's hunting and fishing companion at Giverny. The younger Frost studied painting with Richard Miller in Paris before moving to Pasadena in 1919, in part for health reasons—he had contracted tuberculosis years before while in Europe. In Pasadena, he resumed his own friendship with Rose and emulated the delicate, diffuse atmospheric effects of his paintings (plates 13, 59, 190, and 191).

Competition, and no small degree of self-confidence, was fueled by a series of one-artist shows by painters from Northern and Southern California that was instituted at the Los Angeles Museum of History, Science and Art late in 1914 by its director, Frank Daggett. Granville Redmond was officially the first in this sequence (though Euphemia Charlton Fortune had

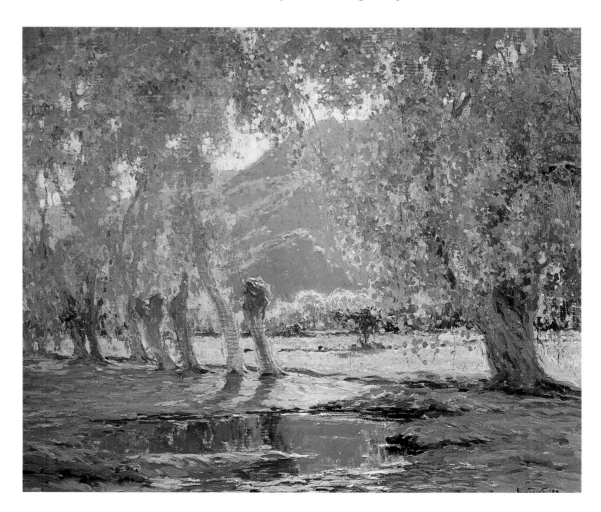

191. John Frost (1890–1937). *Pool at Sundown*, 1923. Oil on panel, 24 x 28 in. (60.9 x 71.1 cm). Joan Irvine Smith Fine Arts, Newport Beach, California.

just shown her Panama-Pacific series at the museum in November of that year); Redmond was followed by Hanson Puthuff and Donna Schuster (who moved to Los Angeles in 1915). The series continued in 1915 with Elmer Wachtel, Marion Wachtel, Norman St. Clair, Jean Mannheim, Benjamin Brown, Armin Hansen, Clark Hobart, John Rich, and Joseph Greenbaum. The shows in the series were interspersed with group exhibitions by the California Art Club and by loan exhibitions such as the First Annual Exhibition of Contemporary American Painters, which opened in March 1916 and included works by the former School of Design teacher Emil Carlsen and the Giverny painter Frederick Frieseke. Of the fifty-three artists represented in that show, only thirteen were from Southern California—a fact that caused outspoken discontent among local artists, who believed California art to be the equal now of art being created anywhere.[12]

Into this active Los Angeles art scene arrived the artist Richard Miller in 1916, who brought to the Southland a broad understanding of Impressionist techniques (plate 192). Miller was an old friend of Rose, having painted with him at Giverny; Miller then settled in Pasadena, where he contributed to the prevailing interest in plein air painting and offered criticisms at the Stickney Memorial School of Art. His *Daydreams* (plate 61) was most likely painted in Pasadena at the home of Eva Scott Fenyes, a student at the Stickney. Though Miller stayed in Southern California only two years, Mabel Urmy Seares noted in 1917 that "his presence has been a great inspiration to a group of local painters who for several years have been in revolt against the use of the old palette in depicting this preeminently sunny climate."[13]

The years following the Panama-Pacific International Exposition coincided with the heyday of California Impressionism in the North and, especially, the South. Exhibition after exhibition touted one or more California pleinairist, while local critics continued to praise them. Sales of California paintings also seem to have increased in this era (patronage of the California Impressionists is an area in need of more study, as William Gerdts has pointed out). Guy Rose, for example, wrote to his New York dealer, William Macbeth, that he had sold more paintings than any other local artist.[14] Near the end of 1917 he sent Macbeth one of his most seminal images of Southern California, *Laguna Eucalyptus* (plate 193), which the dealer promptly sold.[15]

Surveying the art on view at the Los Angeles Museum in the summer of 1916, the critic Ward Winchell wrote with much satisfaction: "The exhibition [of California art] is eminently sane. Here are no freakish Futurists, nor Vorticists. No painters of beautiful states of the soul who use ugly combinations of meaningless crude colors as proper soul paints. Here is no betrayed hatred of the things that used to be revered in art, such as composition of mass and line, color, drawing, sentiment, dramatic concentration."[16] Winchell had some knowledge of the very latest

192. Richard Miller (1875–1943). *Morning Sunlight*, c. 1914. Oil on canvas, 39½ x 32 in. (100.3 x 81.2 cm). Private collection.

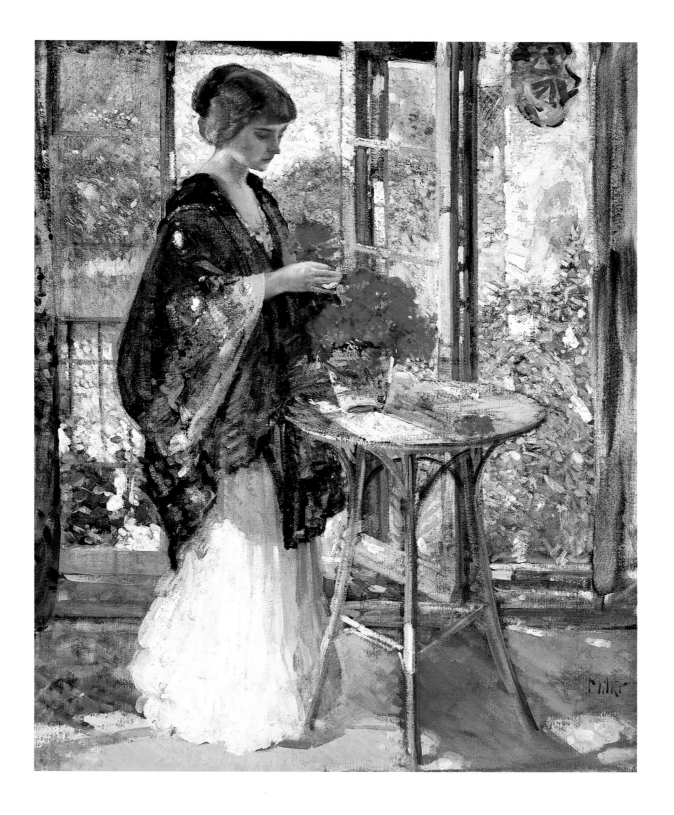

art movements being practiced abroad and that had been seen in New York in the now famous Armory Show of 1913, and no doubt a number of other Angelenos had a similar smattering of awareness of the very latest art movements; what is certain is that they were happy, as Alma May Cook had phrased it that same year, not to be "exposed to the contagion." Although all was not right with the world in 1916, all was thought to be right in California, and Californians liked it that way.

Impressionistic painting was given its biggest boost in Northern California after the Panama-Pacific International Exposition when William Clapp moved to Oakland in 1917. During his training in Paris, Clapp had been influenced not only by Impressionism but also by the often antinaturalistic strategies of Post-Impressionism, especially the flat, patterned designs of Henri Matisse and the Fauves (he had attended the 1905 Salon d'Automne, where the Fauves made their controversial debut). By 1908, back in his native Montreal, Clapp was associated with the avant-garde Canadian painters known as the Group of Seven.[17] After a two-year stay in Cuba beginning in 1915, Clapp returned to his hometown of Oakland, where he immediately got involved in promoting impressionistic painting (plate 194). In April 1917 he was instrumental in organizing a group of about thirty local painters (one of whom was Selden Gile) for the promotion and exhibition of what was considered to be avant-garde painting.[18] By 1918, Clapp was the third curator of the Oakland Museum (which had opened two years before—another result of the exposition), and he held that position for thirty-one years. As curator, Clapp tirelessly promoted modern idioms in painting, including the work of the Society of Six, a group to which Clapp himself belonged.

The Society of Six was loosely organized in 1917 but did not begin formally exhibiting as a group until 1923. It comprised Clapp and five other painters who were, for the most part, a generation younger than the first California Impressionists: Bernard von Eichman, August Gay, Selden Gile, Maurice Logan, and Louis Siegriest.[19] Clapp was the only member of this group who fit the profile of the typical California Impressionist; he had an initial academic background in art, followed by training in Europe. His fellow Society of Six members were far less interested in abiding by the general tenets of impressionistic painting and even less, those of academic painting. Lacking this traditional orientation to art, the younger painters could more easily assimilate the raw and vigorous brushwork of a painter such as Joseph Raphael, whose work they knew well from local exhibitions and admired. Indeed, their own expressionist-oriented work (plates 20, 195, and 196)—with its brilliant color, reduction of detail, emphasis

193. Guy Rose (1867–1925). *Laguna Eucalyptus*, 1917. Oil on canvas, 40 x 30 in. (101.6 x 76.2 cm). The Irvine Museum, Irvine, California.

194. William Clapp (1879–1954).
Bird-Nesting, n.d.
Oil on canvas, 36½ x 28¾ in.
(92.7 x 73 cm). Oakland
Museum of California; Gift of
Mr. and Mrs. Donn Schroder.

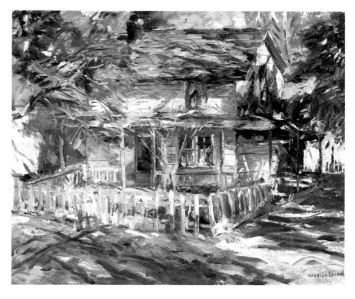

on flattened patterns, and personal idiosyncrasies—relates more to the rise of modernism in California than to Impressionism.

Still, the painting of the Society of Six did incorporate Impressionist methods, underscoring the idea that the terms *Impressionism* and *modernism* are conditional and should not be understood as mutually exclusive. In Gile's *Boat and Yellow Hills* (plate 198), for example, the angled, broken stroke so common to the Impressionist approach is used to define the green and violet shadow on the otherwise bright yellow hill; the sunlit portion of the water is defined by those colors as well as yellow, orange, and spots of brilliant red. One of Gile's larger-scale plein air works, *Boat and Yellow Hills* was a quick but carefully orchestrated response to the midday sunlight and color.

The Society of Six, whether defined as California Impressionists or not, shared with those painters a preference for working out of doors, for high-key color, and for finding subjects in their immediate surroundings. But their willingness to depart from nature and experiment with abstract design also allied them with the Post-Impressionists, especially the Fauves. All of the society's members worked diligently and creatively at outdoor painting, contributing to the history of California Impressionism at the same time that their work pointed toward and prepared the way for other forms of modernist painting in the state.

The formal dissemination of Impressionism became much more common in the years

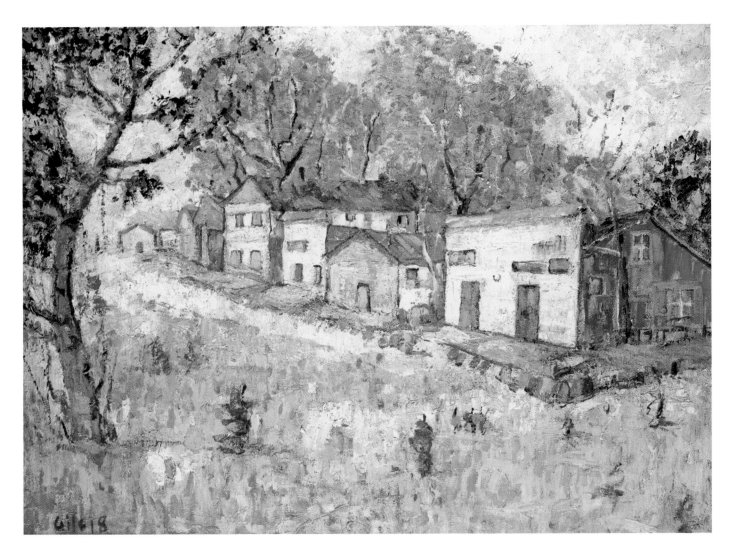

ABOVE
197. Selden Gile (1877–1947).
Gold Rush Town, 1918.
Oil on canvas, 22 x 28 in.
(55.8 x 71.1 cm). John D.
Relfe Family.

OPPOSITE
198. Selden Gile (1877–1947).
Boat and Yellow Hills, n.d.
Oil on canvas, 30½ x 36 in.
(77.4 x 91.4 cm). Oakland
Museum of California;
Gift of Dr. and Mrs.
Frederick Novy, Jr.

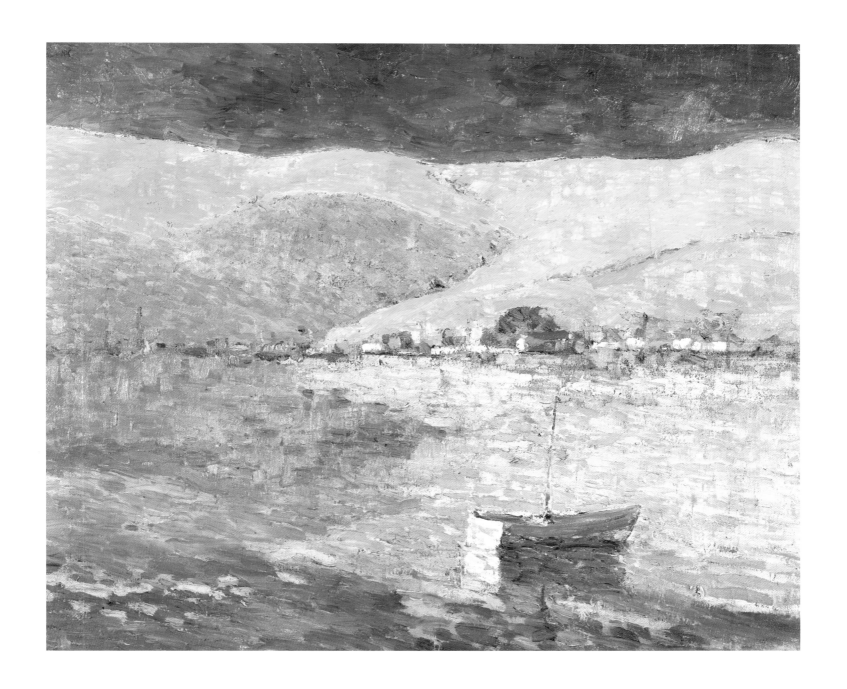

after the exposition. In 1918 William Clapp became curator at the Oakland Museum and he also founded the Clapp School of Art. That same year, a bit farther south, Armin Hansen began teaching summer classes in Monterey for the California School of Fine Arts, and Harrison Gray, owner of the *Los Angeles Times*, gave his residence to Los Angeles County to be an art school where leading California Impressionists, including Donna Schuster, would teach. Guy and Ethel Rose spent the summer of 1918 and the next two summers painting in Carmel. In the fall of 1919 Guy became director of the Stickney Memorial School of Art in Pasadena. Instruction by the California Impressionists seemed to be everywhere, and their work could be seen up and down the state.

Armin Hansen, nearly twenty years younger than Guy Rose and William Wendt, was a native San Franciscan who represents the second generation of California Impressionists. He

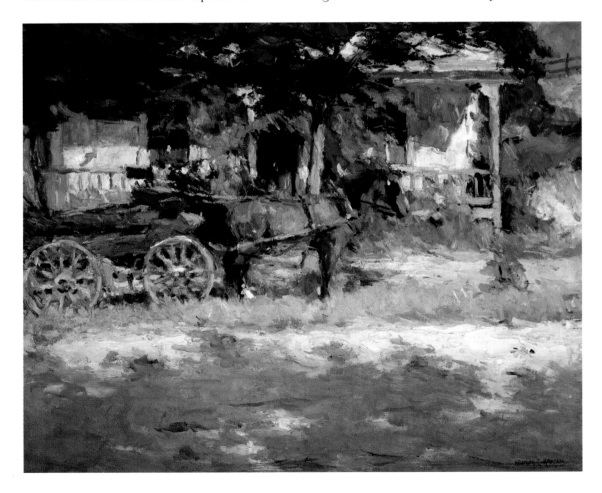

199. Armin Hansen (1886–1957). *The Farm House*, c. 1916. Oil on canvas, 30 x 36 in. (76.2 x 91.4 cm). The Irvine Museum, Irvine, California.

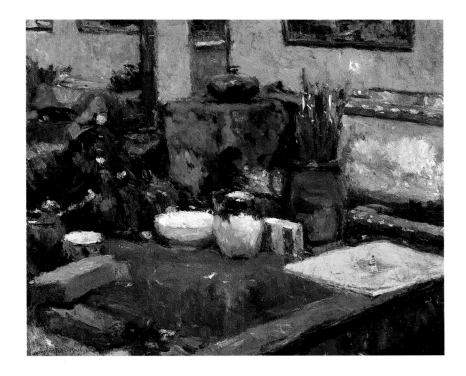

200. Armin Hansen (1886–1957).
My Work Table, 1917.
Oil on canvas, 30¼ x 36 in.
(76.8 x 91.4 cm). The Buck
Collection.

studied with Arthur Mathews; when the California School of Design was destroyed in 1906, Hansen left for Europe to continue his studies, but he opted for Germany rather than Paris. His principal instructor there was Carlos Grethe, a member of the German Secessionist movement who practiced a colorful impressionistic style and whose subjects were often maritime scenes. Hansen developed his own vigorous approach to Impressionism, focusing on sea views and fishermen. His return to San Francisco in 1912 after six years abroad, along with Clapp's move there in 1917, increased the visibility and prestige of impressionistic painting in the north.

Hansen exhibited six etchings and two paintings in the Panama-Pacific International Exposition, winning a silver medal. He moved to the Monterey area in 1916, most likely to be closer to the fishing industry, which provided him with the subject matter for which he remains best known (plate 244). However, Hansen also painted more traditional Impressionist subjects. *The Farm House* (plate 199), painted the year after the exposition, is one of the most striking achievements of his career; its sense of transient light is fully convincing, its summary notations of color breathtakingly simple and effective. The plain porch and the horse and carriage in the front yard are all ostensibly motionless, but they are transformed into visually shifting waves of iridescent color by the artist's broad and forceful yet utterly deft brushwork. In addition, Hansen's still-life painting ranks among the most visually compelling work done by any California Impressionist, though that genre was the least practiced by the group (Franz Bischoff and, to a lesser extent, Clarence Hinkle being the other notable exceptions). The surface of *My Work Table* (plate 200) scintillates with movement, in contrast to the scene of stillness it represents; the objects seem to coalesce and break apart in brilliant colors while the image remains coherent and seemingly whole.

Donna Schuster, like Hansen, was a second-generation California Impressionist. Many stages in her career, however, paralleled those of her senior colleagues: she had studied at the Art Institute of Chicago, and she went on a 1912 painting tour of Belgium with a group led by

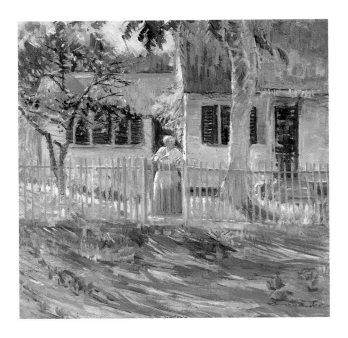

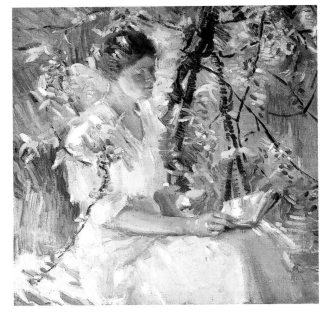

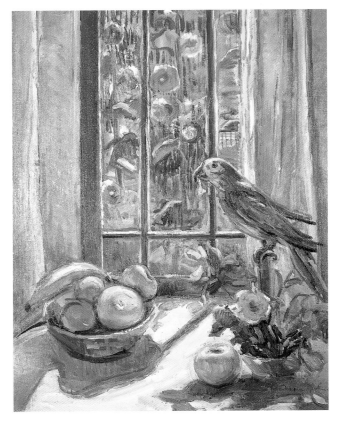

201. Donna Schuster (1883–1953).
Morning Sunshine, 1917.
Oil on canvas, 29½ x 29½ in.
(74.9 x 74.9 cm). The Redfern
Gallery, Laguna Beach,
California.

202. Donna Schuster (1883–1953).
Summer Dream, c. 1917.
Oil on canvas, 30 x 30 in.
(76.2 x 76.2 cm). George Stern
Fine Arts, Los Angeles.

203. Donna Schuster (1883–1953).
Morning Radiance, n.d.
Oil on canvas, 28 x 38 in.
(71.1 x 96.5 cm). Paul Bagley
Collection.

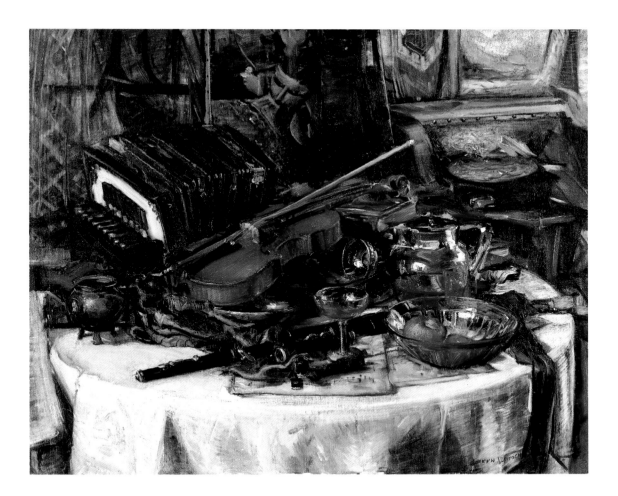

204. Joseph Kleitsch (1882–1931).
Highlights, c. 1925.
Oil on canvas, 38 x 46 in.
(96.5 x 116.8 cm). Private
collection.

William Merritt Chase and attended Chase's summer school at Carmel in 1914. Schuster moved to Los Angeles in 1915, and her paintings made in the years immediately following the exposition were her most Impressionist. *Morning Sunshine* (plate 201) and *Summer Dream* (plate 202) are typical examples of her adaptations of the Impressionist palette and the concomitant use of light, flickering brushstrokes. Schuster occasionally plied still-life themes, such as her boldly colored *Morning Radiance* (plate 203). Her use of heavy lines of pure color to outline objects and shadows and to emphasize their edges anticipated the working methods of the contemporary California painter Wayne Thiebaud. The energy that suffuses this canvas prefigures Schuster's later willingness to experiment with modernist strategies not unlike those being explored by the Society of Six to the north.[20]

Surely one of the most ambitious still-life paintings to be painted by an artist associated with California Impressionism is Joseph Kleitsch's *Highlights* (plate 204) of the mid-1920s. The Hungarian-born Kleitsch had been active in Denver, Kansas, Mexico City, and Chicago before

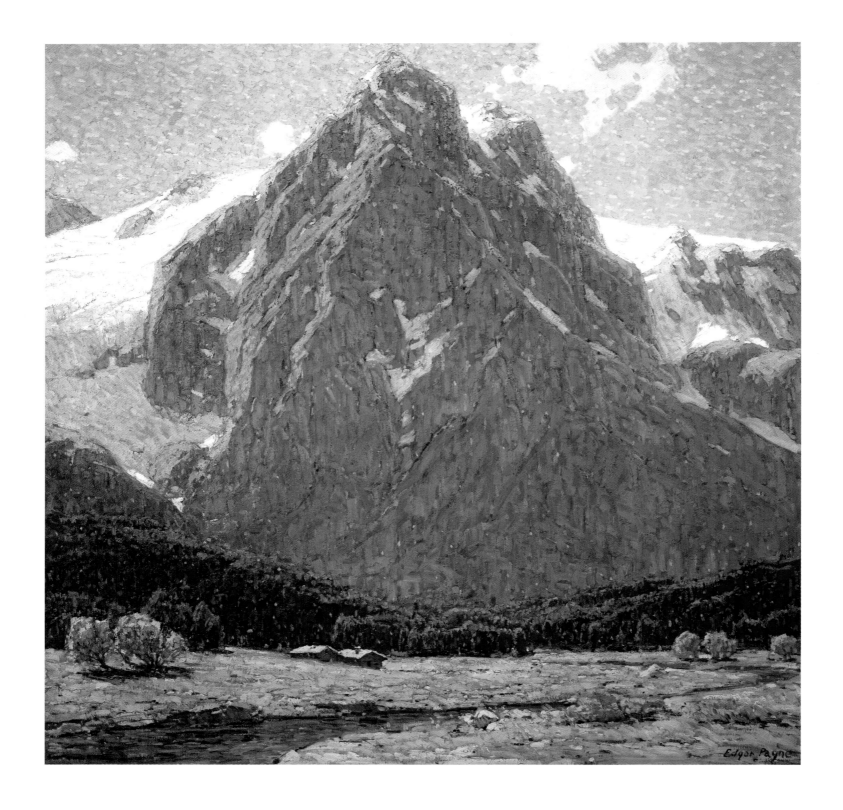

OPPOSITE
205. Edgar Payne (1883–1947).
Swiss Mountain, n.d.
Oil on canvas, 62 x 62 in.
(157.4 x 157.4 cm). Fleischer
Museum, Scottsdale, Arizona.

BELOW
206. Anna Hills (1882–1930).
The Old Ranch, n.d.
Oil on canvas, 24 x 30 in.
(60.9 x 76.2 cm). Fleischer
Museum, Scottsdale, Arizona.

moving to Laguna Beach in 1920. *Highlights*, a large-scale, dark-toned tour de force, is far more Baroque in sensibility than Impressionist, calling to mind the Dutch, Flemish, and Spanish still-life traditions and the virtuoso techniques of Frans Hals and Diego Velázquez rather than, say, the small, economical late still lifes of Edouard Manet. Spectacular in execution, Kleitsch's still life evidences the ongoing willingness of California painters to borrow from more traditional sources.

Kleitsch's decision to settle in Laguna Beach, as opposed to Los Angeles, in 1920 was based in part on the presence there of an active and vital art community.[21] Gardner Symons had settled in Arch Beach, just south of Laguna, in 1903, and by the 1920s over two dozen professional artists resided there, including Frank Cuprien, William Wendt, and Karl Yens. Characterized as a "bohemia on the edge of the frontier,"[22] Laguna Beach was a secluded village with just a few hundred residents. It resembled similar art colonies in the East, such as Old Lyme, Connecticut, where artists could avail themselves of a picturesque landscape, offer each other mutual support and encouragement, and keep close to their markets.

It was in the summer of 1918 that Edgar Payne built a studio at Laguna Beach. He and Anna Hills (plate 206), who had settled there in 1913, founded the Laguna Beach Art Association, a group that shared and spread the philosophy of the California Art Club. Few other artists' works display so clearly as Payne's the ongoing connections between California Impressionism and earlier aesthetic sensibilities. His renditions of looming, awe-inspiring mountains (plates 205 and 251) seek to overwhelm the viewer, in the tradition of Albert Bierstadt and Thomas Hill. Payne made frequent use of thick, blocky strokes of high-key color but laid them over stable, pyramidal forms. He also painted many boat-filled harbors, with compositions fractured by masts and sails, depicting cargo ships as if they were floating mountains (plate 67). Payne's theories are recorded in his instructive book *Composition of Outdoor Painting.*[23]

Hills, though far less inclined to paint monumental compositions than Payne, also represents the hybrid aesthetic of the California Impressionists. *Montezuma's Head* (plate 77) may be

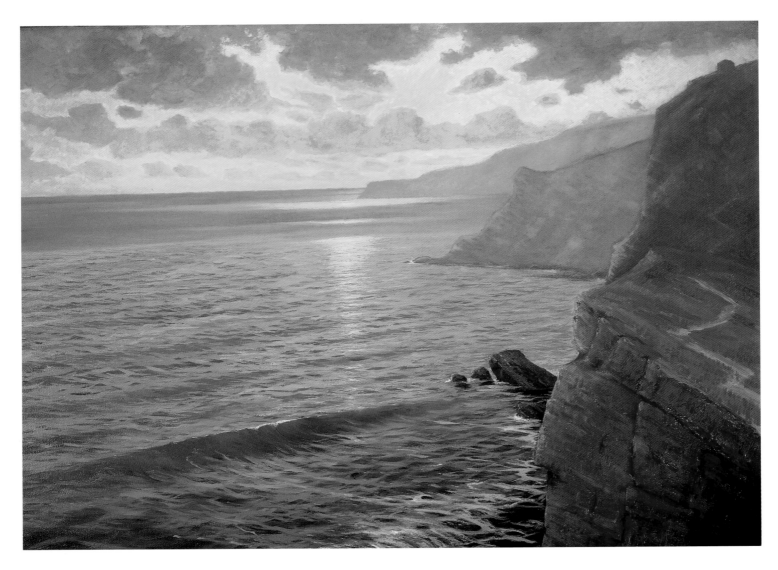

compared to works by Payne because of its formidable size and weighty forms, but Hills more frequently opted for an intimate view, as in *The Old Ranch* (plate 206).

The standard themes of California Impressionism were routinely expounded by all the members of the Laguna Beach colony. Dreamy ocean vistas were a favorite of Cuprien, whose *Golden Sunset, Near Portuguese Bend, Palos Verdes* (plate 207) coincidentally echoes Guy Rose's *The Large Rock* (plate 164) with its imposing rocky cliff played off a distant view beyond. Yens's *My Kate* (plate 222) masterfully revisits the subject of the solitary woman, as does Clarence Hinkle's *Woman in a Hammock* (plate 208). Thomas Hunt's *Grape Arbor* (plate 209) is a particularly vigorous variation on the theme of the sun-dappled arbor, pergola, or porch.

207. Frank Cuprien (1871–1946). *Golden Sunset, Near Portuguese Bend, Palos Verdes*, c. 1910. Oil on canvas, 30 x 40 in. (76.2 x 101.6 cm). Private collection.

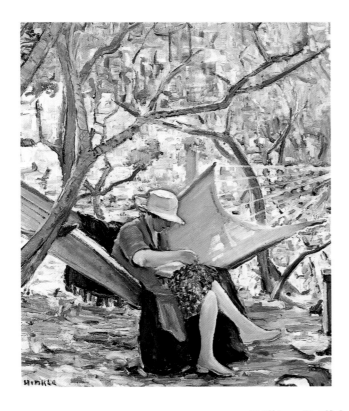

208. Clarence Hinkle (1880–1960).
Woman in a Hammock,
c. 1929.
Oil on canvas, 36 x 30 in.
(91.4 x 76.2 cm). Orange
County Museum of Art,
Laguna Beach, California;
Gift of Mable Hinkle.

209. Thomas Hunt (1882–1938).
The Grape Arbor, n.d.
Oil on canvas, 28 x 30 in.
(71.1 x 76.2 cm). William A.
Karges Fine Art, Carmel,
California.

William Griffith, yet another alumnus of the Académie Julian, moved to Laguna in 1920. He became a specialist in pastel, a medium widely used by the French Impressionists as well as by East Coast American Impressionists such as Hassam and Twachtman but decidedly uncommon among the Californians. Sparkling with a rapid execution, Griffith's exuberant *Diver's Cove* (plate 6) describes a contemporary seashore scene related to images by the French Impressionists.

A member of the Laguna Beach Art Association who painted somewhat atypical coastal scenes was Arthur Rider. Though a second-generation California Impressionist, the long-lived Rider nonetheless experienced the typical education: after academic training in Chicago, he later studied at private academies in Paris. Then he had the good fortune to meet and paint with the Spanish Impressionist Joaquín Sorolla (plate 210) while working in Valencia and was greatly influenced by his subject matter and his ability to capture intense outdoor lighting effects, especially in his Sorolla-influenced beach scenes (plate 212).[24]

In the late 1910s and early 1920s California Impressionism was entrenched from the Bay Area to San Diego. These were years of prodigious productivity and achievement for the California

Impressionists, a time when self-promotion, if not self-aggrandizement, seemed in order. In 1919 ten California artists unabashedly formed the Ten Painters Club in direct emulation of their more famous East Coast Impressionist peers, the Ten American Painters.[25] So self-confident, content, and complacent were the California Impressionists that they took no notice of the gradual decline in the uncontested power and primacy of the California Art Club.

In the spring of 1918, while California Impressionism was flooding galleries, museums, and art schools, the critic Arthur G. Vernon lamented the absence of modern painters from the California Art Club (which now hosted two annual shows instead of just one) and declared that the organization would suffer from this lack and become like the National Academy in New York, which he seemed to dismiss as sterile and predictable.[26] Then, as if Vernon had somehow conjured him up, Stanton Macdonald-Wright, a modernist of international stature, returned to his native Southern California that fall. Macdonald-Wright's presence, charisma, and organizational skills would be the central forces of a small but persistent challenge to the preeminence of California Impressionism, a challenge marked by fits and starts but one that would not go away. Though the 1920s saw a continuation of the status quo for California Impressionists, that decade would also witness their decline. These painters would be routinely challenged by modernism after 1920 and by social realism and American Scene painting beginning in the 1930s; by the heyday of abstraction in the years following World War II they were completely forgotten.

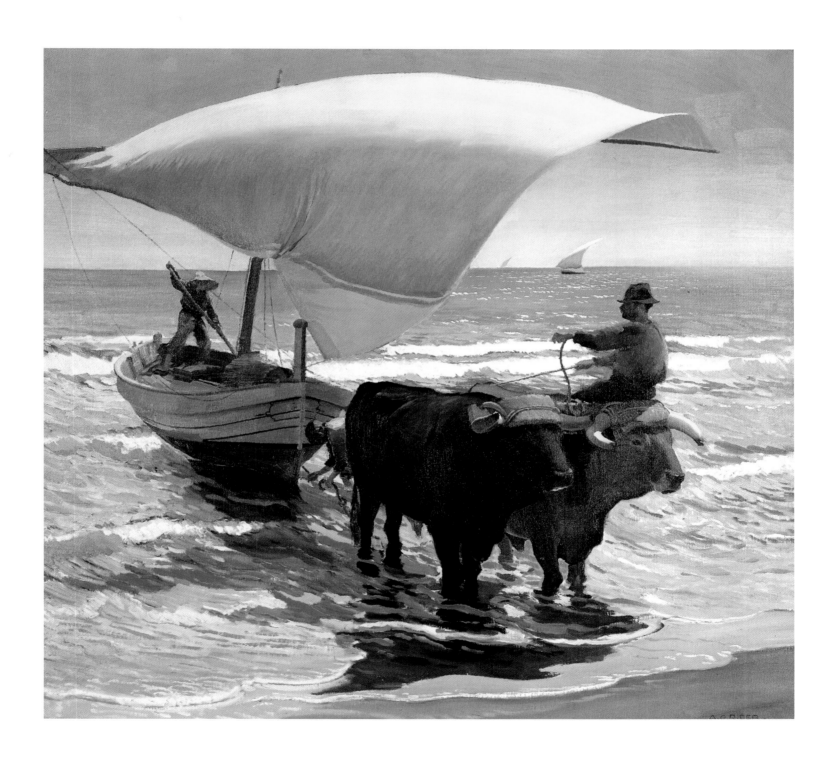

CHAPTER 7

The Final Decade

All art is moral, but only the art of literature can deal with morality per se; painting touches it but lightly, music not at all. But the spirit of man breathes through each and all of the arts man's hopes, fears, passions and aspirations, his perpetual search for God. This is why art becomes somewhat of a religion to the artist.
ANTONY ANDERSON, 1920

The general response by the California Impressionists to the economic boom of 1920s Los Angeles was to flee it or ignore it. A few of the older artists, such as William Wendt, avoided the city altogether; most of the second-generation California Impressionists cheerfully continued to paint ocean, desert, and mountain views as if nothing were changing around them. California plein air paintings by this latter group resembled the work of older landscapists, but the underlying belief in nature as a conduit to the transcendent—in nature as Creation—that had infused the work of Thomas Hill, William Keith, and Virgil Williams was no longer vital.

One sign of the times was a notice in the *California Art Club Bulletin*, established for the benefit of its members in 1925: "However enthusiastic we are about our work and no matter what our ideals, our exhibitions will be stronger when we can offer cash prizes in our exhibitions."[1] Such pursuit of financial recognition, as opposed to the mystical revelations of nature, was becoming more important. Certainly earlier painters had not balked at the idea of a cash prize or the sale of a painting, but the idea of money as the primary incentive for making art would have been distasteful to them. The commodification of art reflected, in a sense, the commodification of California itself.

In 1909, the year the California Art Club was founded, Hollywood Boulevard was still lined with orange trees, and horse-drawn carriages were still a common sight. By 1918 the city's

213. William Wendt.
Detail of *Where Nature's God Hath Wrought*, 1925.
See plate 215.

downtown traffic routes were being planned exclusively for the automobile. Indeed, by the mid-1920s, with over 400,000 cars in the city, driving had become a way of life and downtown traffic jams a common occurrence. The surge of building and industrial expansion that took place in the 1920s physically altered the City of Angels from what any first-generation California Impressionist had experienced while growing up there. The migration to Southern California over this ten-year period was astonishing: at the beginning of the decade the city's population was 576,673; by 1930 it was 1,470,516. Throughout the decade, city planners, entrepreneurs, boosters, and various other visionaries promoted Los Angeles as a city where the perennial American search for the good life could still be successful.

However, the good life was defined less and less by the peaceful communion with the outdoors that was essential to the art of the first-generation California Impressionists. The common push for economic growth and material gain was everywhere apparent in Southern California, where most of these artists lived and worked: Oil derricks bloomed in the hills, highways spread out like tentacles over the state, and the film industry burgeoned. Throughout the decade, evidence mounted that if California really was Eden, then Eden could be built over and corrupted.

The beliefs that underpinned the early work of the California Impressionists were not, of course, wholly obliterated; they still found sporadic expression throughout the 1920s, and younger artists occasionally understood, as opposed to merely mimicked, the deep-seated empathy with nature that was expressed in their mentors' paintings. Indeed, some of California Impressionism's most iconic images were created in the 1920s, at a time when the challenge of modernism and widespread environmental change were threatening Impressionism's innermost ideals.

Among these icons is Maurice Braun's *California Valley Farm*, painted in the early 1920s (plate 214). No signs of Southern California's exponential growth intrude in this image of plenitude and harmony. The land and the light are expansive, bountiful, and undisturbed. Braun's sympathies with Theosophy and its emphasis on the balance between nature and spirit can legitimately be perceived in *California Valley Farm*, and those sympathies were wholly consistent with the concerns of all the California Impressionists for whom nature was a sanctuary. Braun's painting elegantly restates the respect for nature as the source for both inspiration and sustenance that was inherited and promulgated by his, the first, generation of California Impressionists.

Another icon is *Where Nature's God Hath Wrought*, painted by William Wendt in 1925 and purchased the next year for the Los Angeles Museum of History, Science and Art (plate 215).

214. Maurice Braun (1877–1941).
California Valley Farm,
c. 1920.
Oil on canvas, 40 x 50 in.
(101.6 x 127 cm).
Joseph L. Moure.

215. William Wendt (1865–1946).
*Where Nature's God Hath
Wrought*, 1925.
Oil on canvas, 50½ x 60 in.
(128.2 x 152.4 cm). Los Angeles
County Museum of Art;
Mr. and Mrs. Alan C. Balch
Collection.

Here Wendt summarized his own penchant for grandeur, for experiencing in nature the fundamentals of life's processes, at a time when he was keenly aware of the destruction being wreaked by California's rampant development.[2] Wendt, Braun, and a number of their colleagues continued to focus on such pristine views; recording society's changes and the damaged landscape was not, for them, within the purview of art.

In the mid-1920s William Ritschel continued to paint virtuosic interpretations of the shoreline at Carmel (plate 216), happily at a distance from both San Francisco and Los Angeles. His *Moon Path across the Sea* (plate 217) defines the unpeopled vastness of the mystic ocean—spare streaks of yellow light recede into the cold, blue-gray infinitude of the Pacific. With his Impressionist-based vocabulary, the artist evoked a sense of the ocean's impenetrable mystery.

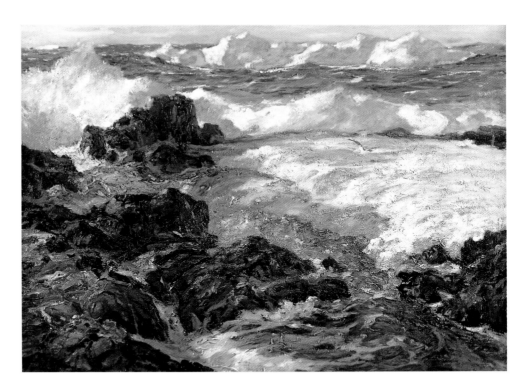

216. William Ritschel (1864–1949).
Glorious Pacific, 1926.
Oil on canvas, 30 x 40 in.
(76.2 x 101.6 cm). Daniel
Hansman and Marcel Vinh.

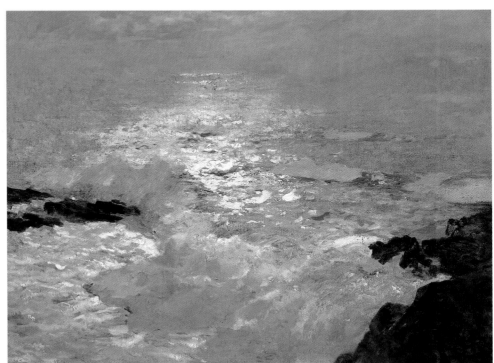

217. William Ritschel (1864–1949).
Moon Path across the Sea, 1924.
Oil on canvas, 30 x 40 in.
(76.2 x 101.6 cm). The Buck
Collection.

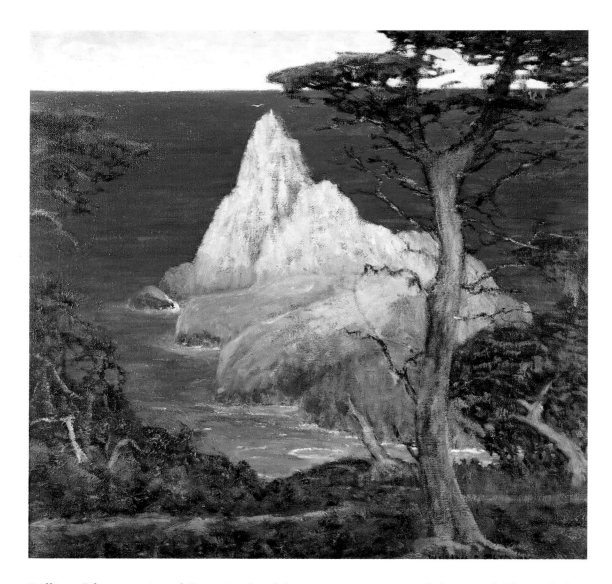

218. William Silva (1859–1948).
Calm Blue Day—Point Lobos, 1935.
Oil on canvas, 32 x 32 in.
(81.2 x 81.2 cm). John D.
Relfe Family.

219. Theodore Wores (1859–1939).
My Studio Home in Saratoga, 1926.
Oil on canvas, 15½ x 19¾ in.
(39.3 x 50.1 cm). St. Francis
Memorial Hospital, San
Francisco.

William Silva, a native of Georgia who did not start painting until the age of fifty, settled in Carmel in 1913 and produced imposing, high-key views of the sea throughout the 1920s and into the 1930s, including *Calm Blue Day—Point Lobos* (plate 218).

Theodore Wores painted his most clearly Impressionist landscapes in the 1920s. He built a second studio and home in Saratoga (plate 219), not far north from Ritschel, where he could retreat from his home in San Francisco. From Saratoga, Wores worked in and around the Santa

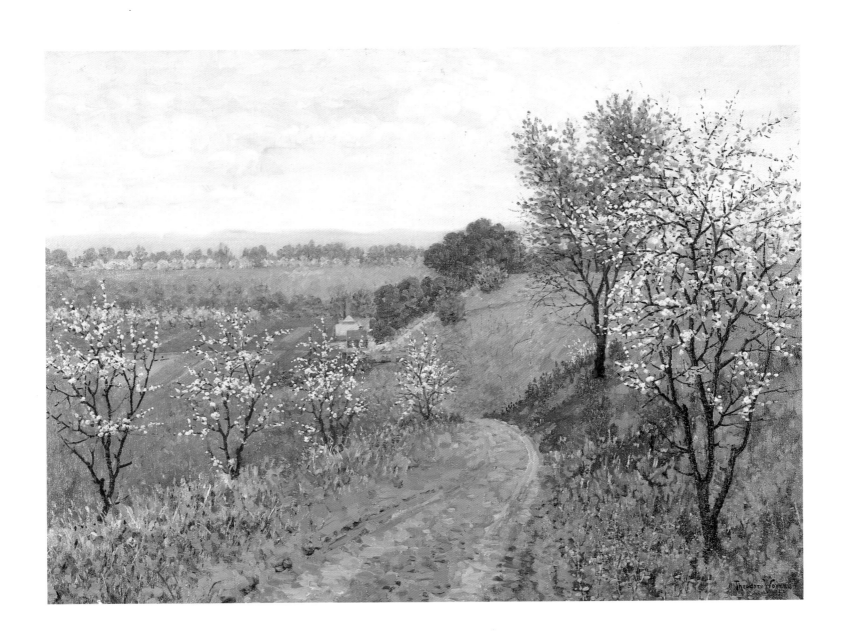

OPPOSITE

220. Theodore Wores (1859–1939).
*Road with Blossoming
Trees*, 1922.
Oil on canvas, 36 x 49 in.
(91.4 x 124.4 cm). From
the City of Santa Clara
Collection, cared for by the
Triton Museum of Art, Santa
Clara, California; Gift of
Mrs. Theodore Wores.

221. Jack Wilkinson Smith
(1873–1949).
Rough Sea and Rocks, 1925.
Oil on canvas, 33 x 42 in.
(83.8 x 106.6 cm). Los Angeles
Athletic Club.

Clara Valley, southeast of the Bay Area. Wores seems to have realized that these were his most Impressionistic canvases (plate 220), resulting from years of labor: "From the start I learned to paint not only the elusive atmosphere and mood of the moment—the misty dawn, the glow of sunset, the changing lights and shadows of scudding clouds—but to paint rapidly with a keen eye and sure hand. To that end, as a youth I worked for years, seeking the facility of the old masters, whether painting a human being or a sea of blossoms."[3]

Jack Wilkinson Smith was another who, like Ritschel, made ocean scenes a specialty (though he painted mountain views as well), and his work of the mid-1920s describes a world unshadowed by development (plate 221). Smith admitted that his worldview was entrenched in the nineteenth century: "I am beginning to think I am old-fashioned, in fact I hope so. I only wish that I could be as old-fashioned as Frank Duveneck and Winslow Homer and have their

same clarity of thought and vision."[4] Smith voiced the scorn of the California Impressionists for modern painting: "In the next few years when the world has regained its balance and sanity, there is going to be a great demand for cyclone cellars by certain directors of Museums and public galleries who fell for this rot, and in many private collections there are going to be many pictures turned toward the wall by their red-faced collectors."[5]

The inclination to work in what were then considered to be modern styles manifested itself in Los Angeles with the formation of the Modern Art Society in 1916. This small group, which included Helena Dunlap and Karl Yens, banded together more out of disdain for the jury system used by the California Art Club than because they were stylistically radical. Dunlap's *Young Danish Girl with Flowers* (plate 125) is an example of her work from this period, which barely diverges from Impressionism and certainly reflects no awareness of the latest innovations emanating from Europe. Nonetheless, the group's desire to avoid the California Art Club's jury system was a genuine attack on the club's privileged status—an attack that intensified in 1919, when the California Progressive Group (again led by Dunlap), an outgrowth of the Modern Art Society, petitioned the Los Angeles Museum of History, Science and Art for exhibition space. The group was not granted its own show, but the spring exhibition normally held at the museum for members of the California Art Club was opened up to include nonmembers in a show called *Painters and Sculptors of California*.

The California Progressive Group was a serious annoyance to the California Art Club but hardly a full-scale assault on the prevailing aesthetic values. That assault came the very next year, when the *Exhibition of American Modernists* opened at the Museum of History, Science and Art. The show was organized by Stanton Macdonald-Wright with help from his brother, the critic Willard Huntington Wright, and from the famed New York art dealer and photographer Alfred Stieglitz. It

222. Karl Yens (1868–1945). *My Kate*, n.d. Oil on canvas, 36 x 29¼ in. (91.4 x 74.2 cm). The Buck Collection.

223. Stanton Macdonald-Wright
 (1890–1973).
 *American Synchromy
 No. 1*, 1919.
 Oil on canvas, 34¼ x 23 in.
 (86.9 x 58.4 cm). Wadsworth
 Atheneum, Hartford,
 Connecticut; The Ella Gallup
 Sumner and Mary Catlin
 Sumner Collection Fund.

included work by some of the most avant-garde American painters of the time, including Marsden Hartley, John Marin, and Man Ray.

Stanton Macdonald-Wright had returned to Los Angeles in 1918 after years of study in Paris, where he and Morgan Russell had founded the abstract painting movement they called Synchromism. He had shown in Munich and Paris, and it was his idea to re-create in Los Angeles a version of the important *Forum Exhibition of Modern American Painters* held in New York in 1916. The *Forum Exhibition* spotlighted American modernism, which, its organizers believed, had been overshadowed by European modernism in the more famous Armory Show of 1913. Macdonald-Wright, using his formidable verbal skills and citing his international credentials, talked the director Frank Daggett into sponsoring the show at the Museum of History, Science and Art, the hallowed ground of the California Art Club.

Macdonald-Wright's *Exhibition of American Modernists* of 1920 did not elicit the same kind of controversy generated by the Armory Show, but it similarly baffled the viewing public and inspired several mocking reviews. Typical of the negative reaction was "Futuristic Art Shocks L.A.—Paint Daubs Spoil Canvas—Masterpieces Go to Cellar": "In the main art gallery at Exposition Park loud peals of laughter resound where once stalked silence and reverence. The gallery is thronged with curiosity seekers instead of the long lines of art lovers who once crowded its portals. . . . Some call it bolshevistic."[6]

Antony Anderson, an acquaintance of both Stanton and Willard, admitted in his *Los Angeles Times* review of the show that until very recently he had been horrified by modern art (specifically, Cubism and Futurism), but he was now trying to be more sympathetic to modernism in general.[7] His review did not attempt to provide insight (on the contrary, he admitted his ignorance of much of what he saw), but it did try to legitimize the work according to his own aesthetic standard, which was based on a conventional conception of beauty. He called Charles Demuth's watercolors notable for their "crispness of execution," while George Of's flowers were "lovely." Anderson felt that Macdonald-Wright's works—though he confessed he did not fully understand them—were among the best in the show because the nudes (such as *American Synchromy No. 1* [plate 223]) harked back to heroic figures by Michelangelo.[8] Others less sympathetic than Anderson were shocked by Macdonald-Wright's frontal view of a Futurist-looking writhing male nude. The critic Fred Hogue, also writing about the show for the *Los Angeles Times*, called Macdonald-Wright "one of the most hopeless of the moderns."[9]

Yet, despite Macdonald-Wright's seemingly wasted efforts and financial disappointments, he managed to make the modernist point of view more familiar to Southern Californians. Indeed, reviews of modernist exhibitions regularly appeared in the Los Angeles press, making it difficult for the public and the local art community to ignore the new art. Unquestionably, this was the decade when modernist painting established itself as a permanent and visible fixture in the south, as it was to a lesser extent in the north due to the exhibitions of the Society of Six and William Clapp's curatorial openness at the Oakland Museum. Nonetheless, modernist painting was still considered more a curiosity than news. Compared to the traditional plein air landscape painters in California, members of the modern art groups made only minimal progress toward being accepted.[10] The general skepticism about modern art was voiced by the emeritus leader of the California Impressionists, William Wendt: "If they [modern artists] could only be induced to look at them, these flip young painters would learn a lot from the American landscape painters of a past generation—even from the much despised Hudson River School [who] studied nature with a reverent thoroughness that should put many of our present day painters to the blush."[11] And the artist Charles Reiffel reiterated the basic premise of the California Impressionists when he wrote, "All artists begin art by what we might say is actual representation of Nature, but it does not become art until it has interpretation." Regarding modernism, he added: "But neither in the experiments should Nature be distorted out of all semblance."[12]

The impressionistic painters in the California Art Club far outnumbered the handful of artists who defined themselves as modernists. However, even though the modern movements in Los Angeles and San Francisco originally had only limited influence on local painters, from the very start they offered an alternative to the conservatism and complacency of the average California artist and art lover in the early 1920s. From 1920 onward, members of the California Art Club and their many admirers had painters in their midst who saw the world in a different way and who were sufficiently thoughtful to ably defend the modernist point of view.

One of the biggest boons for California Impressionism in the 1920s, when it was beset by an increasing number of challenges, was the relocation of Alson Clark to Southern California. Clark moved in 1919 because he was told that the ear he had damaged during World War 1 might have a chance to heal in California's therapeutic climate. He settled in Pasadena and resumed his friendship with Guy Rose, whom he had not seen in years. When Rose suffered a stroke in 1921, Clark took over his classes at the Stickney Memorial School of Art and remained there until 1923. Clark instantly became active on the California art scene, quickly attracting

OPPOSITE, LEFT
224. Alson Clark (1876–1949). *Ruins of San Juan Capistrano*, 1919. Oil on board, 31 x 25 in. (78.7 x 63.5 cm). Joan Irvine Smith Fine Arts, Newport Beach, California.

OPPOSITE, RIGHT
225. Frank Coburn (1862–1938). *Olvera Street*, c. 1925–30. Oil on Masonite, 27 x 23 in. (68.5 x 58.4 cm). The Bowers Museum of Cultural Art, Santa Ana, California; Gift of Mrs. Georgia DeLong.

wide admiration and influence. He painted the desert (plate 60), the ocean (plate 103), and the missions (plate 224) with equal facility. Clark continued to exhibit in Chicago and New York as well as in Los Angeles; he won numerous awards and sold many paintings. Like other Impressionist artists of his generation, he shunned the city and industrialization as subjects.

Among the few artists associated with California Impressionism who did paint scenes related to urban development were Frank Coburn and Sam Hyde Harris, although their work remained romantically prettified, lacking the grit of New York's Ash Can school.[13] Frank Coburn's view of downtown Los Angeles, *Rainy Night* (plate 10), shares the Ash Can painters' somber palette but avoids social commentary in favor of the shimmering interplay between city lights and rain-soaked streets. His much later depiction of Los Angeles's Olvera Street (then a famed tourist attraction known for its food and pageantry; plate 225) records the rich, colorful, and inviting atmosphere of the town.

Sam Hyde Harris falls into the second generation of California Impressionists. He made a living from commercial art, designing posters and advertisements, but he studied evenings and weekends at the Art Students League of Los Angeles, with Stanton Macdonald-Wright as well as with the traditionalist Hanson Puthuff. Harris seems to have never even experimented with Macdonald-Wright's modern manner, but he achieved a near-modern effect by instilling a certain bleak sparseness in his pictures of shipyards (plate 226) and abandoned gas pumps (plate 227). Still, Harris was more like Puthuff than Macdonald-Wright, casting his subject matter in the standard pictorial mold so prevalent around him.

Most harbor scenes painted in California exploited the picturesque possibilities of this subject matter. Conspicuous among these is the work of George Kennedy Brandriff, a self-trained contemporary of Harris, whose *Harbor Douarnenez* (plate 228) and *Busy Quay* (plate 229) use broad patches of bold color in a manner more decorative than either Impressionist or expressionist. Brandriff's enthusiasm was for illustrative compositions and for heavily textured, stylized surfaces that were often more self-referential than descriptive.

Just as landscape continued to be the subject of choice for California artists during the 1920s, so genre paintings remained relatively scarce, with William Ritschel's scenes of Monterey fishing life being the major exception. John Christopher Smith, Franz Bischoff's good friend

ABOVE, LEFT

226. Sam Hyde Harris (1889–1977). *Todd Shipyards, San Pedro*, n.d. Oil on canvas, 20 x 23 in. (50.8 x 58.4 cm). The Irvine Museum, Irvine, California.

ABOVE, RIGHT

227. Sam Hyde Harris (1889–1977). *Neglected (Gas Pump)*, n.d. Oil on canvas, 25 x 30 in. (63.5 x 76.2 cm). Fleischer Museum, Scottsdale, Arizona.

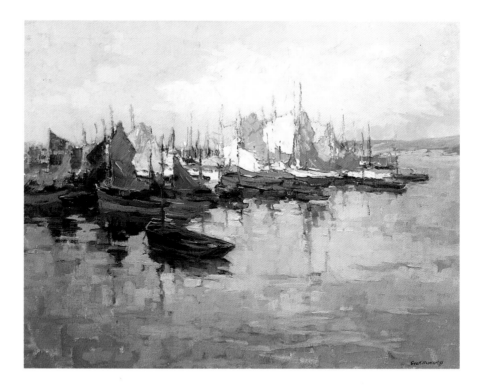

228. George Kennedy Brandriff
 (1890–1936).
 Harbor Douarnenez, c. 1929.
 Oil on canvas, 28 x 34 in.
 (71.1 x 86.3 cm). The Buck
 Collection.

229. George Kennedy Brandriff
 (1890–1936).
 Busy Quay, n.d.
 Oil on canvas, 24 x 29½ in.
 (60.9 x 74.9 cm). The Redfern
 Gallery, Laguna Beach,
 California.

and painting companion, produced a view of MacArthur Park (plate 230) in downtown Los Angeles with a sensual verve reminiscent of park scenes by the French Impressionists. Smith's visually stimulating blend of figures, palm trees, and urban architecture has a complex, mosaic-like surface. Christian von Schneidau was also interested, for a time, in subject matter similar to Ritschel's, but the best of these works he painted in the East (plate 255).

The California missions (twenty-one were built between 1769 and 1820) had been popular subjects long before the era of California Impressionism: William Keith, Jules Tavernier, and Virgil Williams painted some of them, while Edwin Deakin and Henry Chapman Ford painted all of them.[14] For these artists, the missions were like the ruined abbeys and castles painted by European Romantics such as Caspar David Friedrich—highly picturesque and deeply romantic in their evocation of memory, loss, and the passage of time. The California Impressionists' attraction to the missions is further evidence of their far greater willingness to continue art traditions of the past than the French Impressionists, who did not paint images of ruins. Indeed, when painting the missions, the California Impressionists were operating with several different motives at once: they could indulge a nostalgia for an earlier California without oil fields and subdivisions; they could evoke the *vita brevis* symbolism of ruins; and, finally, the mission paintings proved to be highly salable to tourists.

Elmer Wachtel's *Capistrano Mission* (plate 231) depicts the mission in stark, distant, and architecturally rigid terms. C. P. Townsley's later version of the same mission (plate 152) takes a closer view, playing up the contrast between the blue tracery of shadows on white walls as well as the intense reds and greens of the foreground flowers. Townsley catered to religious sentiment by including a solitary padre, head down as he walks the garden path. Arthur Rider's still later painting of the same mission (plate 232) is the most intimate view of the three, moving in so close to the building that the rooftop cross, central to Wachtel and Townsley's paintings,

230. John Christopher Smith (1891–1943).
The Plaza, Los Angeles, c. 1928.
Oil on canvas, 24 x 30 in. (60.9 x 76.2 cm). Paul Bagley Collection.

231. Elmer Wachtel (1864–1929).
Capistrano Mission, n.d.
Oil on canvas, 15 x 25½ in.
(38.1 x 64.7 cm). Fleischer
Museum, Scottsdale, Arizona.

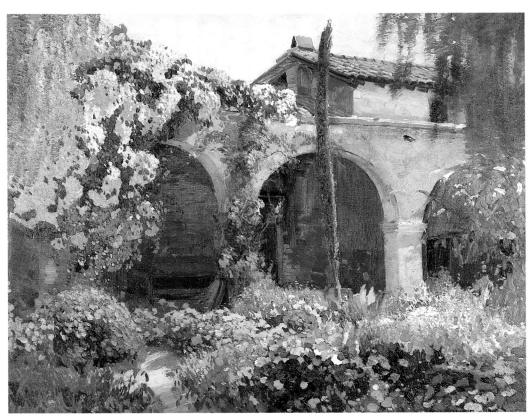

232. Arthur Rider (1886–1975).
*Mission San Juan
Capistrano*, 1930.
Oil on canvas, 24 x 30 in.
(60.9 x 76.2 cm). Dr. and
Mrs. Edward H. Boseker.

disappears. Rider's image capitalizes on the thriving floral environment, emphasizing visual stimulation over Wachtel's careful architectural description and Townsley's pious narrative.

In the midst of Southern California's rapid growth in the 1920s and the growing challenge of modernist painting to the supremacy of traditional plein air landscape, California Impressionism was more visible to other California artists than it had ever been. In 1924 an exhibition of art by "Western Impressionists," comprising only work by Southern California artists, was shown at the Oakland Museum; in 1926 the Oakland-based Society of Six exhibited in Los Angeles. Northern and Southern California artists exhibited at other popular venues, such as the venerable Hotel del Monte Art Gallery in Monterey and the state fair in Sacramento, and in outlying areas such as Pasadena, Laguna, and San Diego. Few professional California painters in the 1920s could claim ignorance of the Impressionists' work, and amateur versions of it proliferated. But the combined forces of modernism, urban growth, and the California Impressionists' own repetitious output slowly and subtly eroded the elevated status of local plein air painting.

In 1925, the year of Wendt's seminal canvas *Where Nature's God Hath Wrought* (plate 215), the Los Angeles–based Group of Independents reorganized to form the Modern Art Workers in order to promote new and different art forms in the Southland. The indefatigable Macdonald-Wright wrote the group's manifesto, proclaiming: "We feel the time is ripe to get a more cosmopolitan atmosphere into the art life here, build up some real vitalizing competition, and tear down a few 'taboos.'"[15] Just months earlier Antony Anderson had made something of a confession in his column:

> The reviewer of art in The Times has been asked more than once how he keeps it up. How does he manage to write about the same painters—often the same pictures—year in and year out, without tiresome repetition. (The questioner is generally polite enough to suggest a lack of repetition.)
>
> To this query there is no adequate answer. For the reviewer harbors fears of an endless repetition. If, by chance, he steers clear of it, it is because he never looks at an article again when once printed. He wipes the slate clean and begins all over again.[16]

Anderson lasted only another year at the *Los Angeles Times* before the era of his unstinting support for California Impressionism came to an end. In 1927 Arthur Millier, the paper's newly appointed art critic, reviewed the annual exhibition of the California Art Club and

233. Orrin White (1883–1969).
Landscape with Sycamores, n.d.
Oil on canvas, 38 x 38 in.
(96.5 x 96.5 cm). James Zidell.

234. Charles Reiffel (1862–1942).
Snowbound, 1920.
Oil on canvas, 34 x 37 in.
(86.3 x 93.9 cm). Paul Bagley
Collection.

found it to be "middle of the road." He admired the work of Orrin White and even more the work of Charles Reiffel, whom Millier later linked to Cézanne and van Gogh.[17] However, Millier found much more in the show that was formulaic: "Glancing around the room, the rule seems to be the beautiful, the charming, or the pretty picture. That is often the artist's aim, and that is what the public expects from it. But where are the penetrating comments on our life and people?"[18]

The intellectual Millier, himself an etcher of considerable ability, was far more receptive to modernism than his wide-eyed predecessor, Anderson, and he recognized the flagging energies of the local plein air painters, a phenomenon that was likewise noticed by outside observers. In 1928 Henry DeKruif, a member of the California Art Club, visited Chicago on a business trip and was given an opinion on the state of California art:

He [DeKruif] called on four of the oldest and most reputable dealers in the city, and was surprised to learn that they found his work refreshing. It was unusual, they told him, to see something original coming out of California! They accused the painters of pandering too much to the tourist

trade, and of painting all alike; but that when they do paint and draw well, the artists don't paint a subject that anybody wants! In days gone by, California paintings were much admired; but, these dealers lamented, the old time standard was not maintained and nothing new or original was produced. Therefore, no more sales were made.[19]

It was also in 1928 that Millier urged local artists to move on from their fixation on impressionistic methods and explore the possibilities of modernism. Writing for the *Argus*, a short-lived San Francisco art journal, Millier lambasted Los Angeles painters for their addiction to "a diluted form of Impressionism, unable to take the step that will reveal the un-material form of Cézanne, the passion of Van Gogh's line and color and the carefully related color harmonies of Matisse, principally because it has never been confronted with these."[20] Finally, it was critic Merle Armitage who wrote in 1928 that art of the California Impressionists was

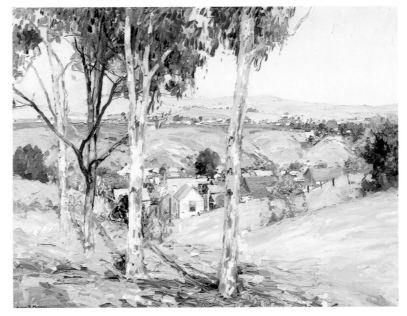

"harmless," and he teasingly called them "the Eucalyptus School."[21] The name, bestowed at the moment of the school's decline, has survived into present-day usage to describe all California pleinairists with Impressionist tendencies. Both Millier and Armitage hoped to prod the California Impressionists out of what they perceived to be an aesthetically spent artistic movement, but far more effective than their harsh words were the changes caused by the Great Depression and World War II. The perfect world of the California Impressionists was increasingly proven to be imperfect. The former idealism, pantheism, and mysticism of California Impressionism had been compromised and soon were forgotten.

California Impressionist paintings did not cease to be painted altogether with the onset of the Depression—history rarely provides such convenient demarcations. Many of the group's foremost practitioners continued working throughout the 1930s, into the 1940s, and beyond.

237. Elmer Wachtel (1864–1929). *Santa Paula Valley*, n.d. Oil on canvas, 30 x 40 in. (76.2 x 101.6 cm). John D. Relfe Family.

238. Arthur Hill Gilbert
(1894–1970).
Cloudy Day on the Seine, 1927.
Oil on canvas, 32 x 40 in.
(81.2 x 101.6 cm). Paul Bagley
Collection.

Younger painters such as Arthur Hill Gilbert, some native to the Golden State and some not, continued to study abroad (plate 238), discover Impressionism, and eventually join the ranks of the California Art Club.

Indeed, California today is still a land of sunshine, although one that would be largely unrecognizable to the early Impressionists, and what remains of the poppy fields and beaches is still golden to those millions who will never fully know California's past but who will help shape its future. The resurgence of interest in California's early painters over the past two decades has, one hopes, less to do with their value on the commercial art market than with nostalgia for a cleaner, healthier, and less threatening environment. Indeed, the current fascination with paintings of a pristine California may reflect the very simple fact that one does not cherish what one has until it is gone. And the old California is undeniably gone.

But the appreciation of California Impressionism should not be just a sentimental journey into a past viewed through rose-colored glasses. Rather, the communicative power of art allows us to experience in our own time and place the emotional and spiritual enthusiasm for nature that the California Impressionists felt in theirs. California Impressionism's views of land and light are a testament to the earth's life-sustaining resources and life-enriching images—an optimistic vision we can carry with us into the far future.

239. Gardner Symons (1862–1930).
*Southern California
Beach*, 1925.
Oil on canvas, 25 x 30 in.
(63.5 x 76.2 cm). James Zidell.

NOTES

1. IN PRAISE OF NATURE

Epigraph: John Robinson Jeffers, "Epilogue," in *Flagons and Apples* (Los Angeles: Grafton Publishing Company, 1912), p. 45.

1. Henry David Thoreau, *Walden; or, Life in the Woods* (1854; reprint, New York: Signet Classics, 1960), p. 219.

2. MENTORS AND TRAINING

Epigraph: Gottardo Piazzoni, "Three Pioneer Artists," *Argus* 3 (September 1928): 1.

1. Carey McWilliams, in T. H. Watkins, *California: An Illustrated History* (New York: American Legacy Press, 1983), p. 105.

2. The best known of these is Charles Christian Nahl, a native of Germany who trained in Dresden and Paris before eventually moving to California and working a stint in the gold fields. Once he returned to painting, Nahl found patrons among the railroad tycoons and gave them large-scale renditions, competently painted, of classical and quasi-classical themes.

3. For a biographical sketch of Thomas Hill, see Marjorie Dakin Arkelian, *Thomas Hill: The Grand View* (Oakland, Calif.: Oakland Museum, 1980).

4. "The Yo-Semite Valley by Mr. Thomas Hill," *Boston Transcript*, January 27, 1868; quoted ibid., p. 17. According to Arkelian, this painting was eventually purchased by Charles Crocker in San Francisco and then most likely destroyed in the fire of 1906. Another monumental Hill painting done in Boston, *The Great Canyon of the Sierras* (1871) also achieved critical acclaim when exhibited there; it is now in the Crocker Art Museum, Sacramento.

5. Asher B. Durand, "Letters on Landscape Painting," *Crayon* (February 14, 1855): 97.

6. Henry David Thoreau, *Walden* (1854), in *The Writings of Henry David Thoreau* (Boston: Houghton Mifflin, 1906), vol. 2, p. 352.

7. John Ruskin, *Works of John Ruskin*, ed. E. T. Cook and Alexander Wedderburn (London: George Allen, 1903), vol. 3, p. 623.

8. The school's various name changes can be confusing. In 1874 the San Francisco Art Association established the California School of Design. In 1893 Edward Searles gave the Mark Hopkins mansion on Nob Hill to the association for its use, so the School of Design moved and its name was changed to the Mark Hopkins Institute of Art; this school was razed by fire in 1906. In 1907 the school was rebuilt and the name changed to the San Francisco Institute of Art. In 1916 the association built a new school on Russian Hill and called it the California School of Fine Arts. In 1961 the California School of Fine Arts and the San Francisco Art Association joined under one name, the San Francisco Art Institute.

9. The argument has been made that American artists who later resisted French Impressionism's complete dissolution of form did so not because of an aesthetic ideology that combined religious sentiment with a pragmatic interest in the verifiable but because of a fear of the dissolution of traditional religious values in society. Kathleen Pyne has written: "But what is perhaps more revealing of the nature of the American resistance to French Impressionism is the way in which the dreaded specter of Darwinian struggle, particularly of a class war, could be intimated in an artistic mode, especially a method based on violent contrast or barbaric color, as the landscape style of Monet and Renoir was perceived to be." (Pyne, "Social Conflict and American Painting in the Age of Darwin," in William U. Eiland, ed., *Crosscurrents in American Impressionism at the Turn of the Century* [Athens, Ga.: Georgia Museum of Art, 1996], p. 81.) I reject Pyne's general thesis because even though Darwin became well known in the late nineteenth century, his theory of evolution, and especially its implications, was not widely understood, let alone accepted, during that era. The idea that mid- to late-nineteenth-century artists, a typically unscientific lot, actively feared Darwinian thinking or that they reacted swiftly, subtly, and negatively to something they had no scientific background to understand seems to me to be singularly untenable.

10. Keith, in Brother Cornelius, *Keith: Old Master of California* (New York: G. P. Putnam's Sons, 1942), p. 205.

11. For an overview of art in Chicago during this period, see William H. Gerdts, "The Near Midwest," in *Art across America* (New York: Abbeville Press, 1990), vol. 2, pp. 281–328.

12. For the most detailed and thorough discussion of American painting at the French Salons, see Lois Fink, *American Art at the Nineteenth-*

Century Paris Salons (Cambridge: Cambridge University Press; Washington, D.C.: National Museum of American Art, 1990). For a list of Pape's Salon work, see p. 377.

13. See Carolyn Kinder Carr, et al., Revisiting the White City: American Art at the 1893 World's Fair (Washington, D.C.: National Museum of American Art and National Portrait Gallery, Smithsonian Institution, 1993), illustrated in black and white, p. 298. Pape did not return to California but enjoyed a highly successful career as an illustrator in Boston. He also directed the Eric Pape School of Art there and was an accomplished landscapist. See Regina Armstrong, "An American Painter: Eric Pape," International Studio 17 (August 1902): 83–89.

14. The most lucid explanation of Jules Bastien-Lepage's influence on American artists in Paris is William H. Gerdts, American Impressionism (New York: Abbeville Press, 1984), p. 26.

15. Redmond's instruction at the School of Design had actually begun in 1887, when he enrolled, at d'Estrella's behest, in the Saturday drawing classes there. Since Peixotto, McCormick, and Rose were all studying at the school, it is likely that Redmond first made contact with them then.

16. Redmond exhibited a portrait of Ernest Peixotto's brother, Sidney, in the 1893 San Francisco Art Association Spring Exhibition. See Mary Jean Haley, Granville Redmond (Oakland, Calif.: Oakland Museum, 1988), p. 103.

17. Reproduced in Charles Francis Browne, "Some Recent Landscapes by William Wendt," Brush and Pencil 6 (September 1900): 263.

18. Anderson, in Ruth Westphal, Plein Air Painters of California: The Southland (Irvine, Calif.: Westphal Publishing, 1982), p. 172.

19. Browne, "Some Recent Landscapes," p. 262.

3. FIRST ENCOUNTERS WITH IMPRESSIONISM

Epigraph: Antony Anderson, "Of Art and Artists: Light and Air," Los Angeles Times, November 19, 1916.

1. Redmond, in Arthur H. Millier, "Our Artists in Person [Granville Redmond]," Los Angeles Times, March 22, 1931.

2. Guy Rose, "At Giverny," Pratt Institute Monthly 6 (December 1897): 81.

3. Pape's presence at Giverny is recorded as May 7–10, 1889, in the guest register of the Hôtel Baudy, transcribed and extracted by Carol Lowrey in William H. Gerdts, Monet's Giverny: An American Colony (New York: Abbeville Press, 1993), pp. 222–27. On Eric Pape, see Lucius E. Ladd Jr., "Boston Artists and Their Work: Mr. Eric Pape, Whose Ability Has Been Recognized by Artists All Over the World," New England Home Magazine 11 (May 6, 1900): 259–65; and Regina Armstrong, "An American Painter: Eric Pape," International Studio 17 (August 1902): 83–89. I thank my collaborator, William H. Gerdts, for the Ladd article on Pape and for so generously sharing information on all the California artists found in his personal research library.

4. See Lowrey, register of the Hôtel Baudy, p. 222.

5. A number of early sketchbooks by Ernest Peixotto are in the Ernest Peixotto Papers, Bancroft Library, University of California, Berkeley. Unfortunately, there are no diaries, letters, or other documentary material in these papers to supplement our knowledge of his career.

6. McCormick, in Hanna Astrup Larsen, "Jules Pages May Succeed the Late Julian as Head of Art Academy in Paris," San Francisco Call, July 22, 1907.

7. Personal letters from Pissarro, his wife, and son Lucien are in the possession of Bacon's descendants. We are grateful to Robert K. Vickery of Salt Lake City and to his sister, Ruth Vickery Brydon of Lake Havasu City, Arizona, for generously sharing information about Bacon and her relationship with Pissarro.

8. Mary Cassatt to Lucy Bacon, c. 1892, courtesy of Robert K. Vickery, Salt Lake City.

9. Correspondence between Lucy Bacon and members of the Pissarro family suggests a genuine

closeness. Bacon sent money to Mme Pissarro during World War I, and in the 1920s Lucien Pissarro wrote to Lucy to ask for her help in locating his father's work in America for his catalogue raisonné.

10. Ronald Pisano, William Merritt Chase (New York: Watson-Guptill Publications, 1982), p. 62.

11. On Clark, see Jean Stern, "Alson Clark: An American at Home and Abroad," in California Light, 1900–1930, ed. Patricia Trenton (Laguna Beach, Calif.: Laguna Art Museum, 1990), pp. 113–36. Stern, a longtime scholar of California art, is largely responsible for the rediscovery and recognition of Alson Clark; he first identified and explicated the relationship between Chase and Clark, and my discussion is indebted to his efforts.

12. Ernest C. Peixotto, Romantic California (New York: Charles Scribner's Sons, 1911).

13. C. F. Sloane, "Mr. Rose's Paintings," Los Angeles Herald, October 4, 1891.

14. Nancy Dustin Wall Moure, Loners, Mavericks, and Dreamers: Art in Los Angeles before 1900 (Laguna Beach, Calif.: Laguna Art Museum, 1994), p. 63. This volume (hereafter cited as Loners, Mavericks, and Dreamers) is indispensable to the student of early California painting for its thoroughness and wealth of information.

15. Sloane, "Mr. Rose's Paintings." The nature of Rose's relationship with Monet poses a question to American art scholars. Ethel Rose, Guy's wife, stated that Guy did not study with Monet (Laguna Life, October 27, 1922), but she meant he did not study in a formal way. In fact, none of the Giverny artists studied with Monet formally. However, she also makes it very clear that her husband did know Monet personally: "I do not know of any American painter in Giverny, except [Frederick William] MacMonnies and ourselves, who ever knew Monet socially."

16. Sloane, "Mr. Rose's Paintings."

17. Duvall, in Los Angeles Times, December 10, 1911; in Patricia Trenton, "Islands on the Land: Women Traditionalists of California," in Trenton, ed., Independent Spirits: Women Painters of

the *American West, 1890–1945* (Los Angeles: Autry Museum of Western Heritage; Los Angeles, Berkeley, and London: University of California Press, 1995), p. 44.

18. Perhaps the best example of this type is Symons's *Big Boney* (1897), illustrated in color in *Loners, Mavericks, and Dreamers,* p. 36. Discussing the relation between outdoor sketches and works finished in the studio, Symons later said: "Do you realize how difficult it is to retain in a finished canvas the virility and freshness of a first sketch made in *plein air,* and who has not, in retouching it to pass a jury, seen it ebb its life away, and lose all the vital and dramatic qualities it should retain." (Quoted in Thomas Shrewsbury Parkhurst, "Gardner Symons: Painter and Philosopher," *Fine Arts Journal* 33 [November 1916]: 556–65.) I thank Michael Hullet for sharing information on the history of Frederick Rindge.

19. Wendt, in William A. Griffith, foreword to *William Wendt Retrospective Exhibition* (Los Angeles: Los Angeles County Museum, 1939).

4. New Institutions, New Popularity

Epigraph: "Los Angeles, Queen of the Southwest," *Land of Sunshine* 6 (December 1896): 55.

1. Theophilus Hope d'Estrella, "The Itemizer," *Weekly News,* January 7, 1899. *Weekly News* was (and remains) the newspaper of the California School for the Deaf (the former Institution for the Deaf, Dumb and Blind), first in Berkeley, now in Fremont.

2. In 1907 DeLongpre wrote to Charles Lummis: "I have resigned from everything [clubs] as the complete, *absolutely complete* lack of appreciation in Art in Los Angeles will oblige me after a struggle of 8 years to go back to the great Art City in America, dear old New York, which was my home for 10 years." (October 5, 1907, Lummis Correspondence, Southwest Museum, Highland Park, Calif.; in *Loners, Mavericks, and Dreamers,* p. 44.)

3. John Gutzon Borglum, "An Artist's Paradise," *Land of Sunshine* 2 (May 1895): 106.

4. Henry Winifred Splitter, "Art in Los Angeles before 1900," *Historical Society of Southern California Quarterly,* 1959, p. 135.

5. One such advertisement appears in *Land of Sunshine* 7 (September 1897): 196.

6. S. Howells Jordan, "The Chamber of Commerce Art Room," *Land of Sunshine* 1 (November 1894): 123.

7. Ibid.

8. Excerpt from Emma J. C. Davis, "On the Hills," *Land of Sunshine* 1 (November 1894): 115.

9. For a brief account of the Kanst Art Galleries in the dealer's own words, see Antony Anderson, "Twenty-five Years of Art," in his column "Art and Artists," *Los Angeles Times,* October 10, 1920. Kanst commented: "I have been in the art business in Los Angeles exactly twenty-five years. During that time many changes have taken place both in art dealers and the kind of art handled. In those far-off days a photogravure steel engraving and sometimes an etching was high art. The artists who had the temerity to show their works in Los Angeles were indeed few and far between. Yet some of them did succeed in keeping the wolf from the door by doing other work than painting. It is needless to tell you, of course how many artists we have now, not a few of them standing in the front rank of the best in any country."

10. One account gives 1890 as the founding year: "It is affiliated with the Art Students League of Los Angeles, which is the oldest art school in that city, having been founded by Antony Anderson, former art critic of the *Times,* about 1890." From "Student's League Grows," undated newsclip, Archives of American Art, Smithsonian Institution, Washington, D.C., LA 5, reel 152. For founding dates of 1906, see the *Los Angeles Times,* April 22 and July 8, 1906. Hanson Puthuff seems to have been the founder, with Anderson's help. One league instructor in 1906 was the now obscure C. P. Nielson.

11. On Stanton Macdonald-Wright, see Will South, "Stanton Macdonald-Wright (1890–1973): From Synchromism to the Federal Art Projects" (Ph.D. diss., Graduate Center of the City University of New York, 1994).

12. "Art and Artists," *Los Angeles Times,* October 29, 1905.

13. Though it has often been reported that the "Art and Artists" column of the *Los Angeles Times* was inaugurated in 1906, it actually originated in 1905, written by R. MacKay Fripp. Anderson himself may have been writing "Art and Artists" by late 1905, since the unsigned article on Benjamin Brown published on October 29 of that year bears his style and trademark use of an introductory poem.

14. On the founding of the Painters' Club, see *Los Angeles Times,* March 25, 1906. The minutes for the club are preserved today by the current membership of the California Art Club. The author thanks Peter and Elaine Adams, current officers of the California Art Club, for their enthusiastic support of this study.

15. "Exit the Painters' Club," *Los Angeles Times,* December 12, 1909. The most recent work on the California Art Club is Nancy Moure's "The California Art Club to 1930," in Paul Bockhorst, et al., *Impressions of California: Early Currents in Art, 1850–1930* (Irvine, Calif.: Irvine Museum, 1996), pp. 81–103. Also recent is Susan Landauer, "The California Art Club: A History (1909–1995)," *American Art Review* 8 (February–March 1996): 144–51. In Moure's essay, she speculates that one cause of the Painters' Club's demise was backlash against an all-male club, and another was that only one "top-ranking painter," Wendt, had joined the group. An alternative and contemporaneous version of the club's disbanding is given by one of its members, C. P. Austin, in his article "The California Art Club," *Out West* 3 (December 1911): 3–11. Essentially, there was a dispute after the first exhibition as to whether the work of all members would be hung; some members opposed the idea

of a jury, others advocated it. During preparations for a subsequent exhibition, painters whose works were juried out staged a revolt, hanging their works in defiance of the selection committee's rejection. "Feeling was tense," Austin recorded, and "after it was apparent that there was neither contriteness nor forgiveness forthcoming, it was agreed to disband the club, in gentlemanly fashion."

16. "The modern way of many young painters, flip wielders of the brush who are forever striving for an 'effect' I have no patience with. These men are too easily satisfied, too jubilant over mere cleverness. Nature has more to say than can be caught in a minute, she has lessons for us that may take a lifetime in the learning and I belive she intends that we landscape painters should mix brains with our paint." (William Wendt, in *Los Angeles Times*, June 11, 1922.)

17. Everett C. Maxwell, "Art," *Graphic*, November 1913, clipping in the Los Angeles Museum of History, Science and Art Scrapbooks, on file at Los Angeles County Museum of Natural History (hereafter cited as Museum Scrapbooks).

18. Everett C. Maxwell, "Art," *Graphic*, January 1914, copy in the Museum Scrapbooks.

5. CALIFORNIA IMPRESSIONISTS AT HOME AND AFIELD

Epigraph: Antony Anderson, "Art and Artists," *Los Angeles Times*, October 17, 1915.

1. Antony Anderson, "Art and Artists: Art Club's Exhibition," *Los Angeles Times*, November 26, 1911.

2. Anderson reported the following in his "Art and Artists" column for the *Los Angeles Times*, January 1, 1911: "The rapid strides that we in Los Angeles are taking in the intelligent appreciation of art is largely due to the indefatigable zeal of our women, in clubs, as well as singly." It also must be noted that the wife of William Wendt, the highly talented sculptor Julia Bracken Wendt, would have been refused membership in her husband's club had the exclusion of women been continued.

William's prestige, in combination with Julia's undeniable talent, may have been factors leading to the change of the rule.

3. None of these four painters has been included in any of the modern exhibitions on California Impressionism.

4. Antony Anderson, "Art and Artists: Pictures by an Impressionist," *Los Angeles Times*, November 21, 1909. Stark was cited as a "disciple of the impressionistic school" in the *Kansas City Star*, September 23, 1908. Granville Redmond was cited as an Impressionist earlier in 1909 by William Montgomerie. On Redmond and Impressionism, see Montgomerie, *Graphic*, September 18, 1909, clipping in the artist's file of the Oakland Museum's library: "Impressionism has, undoubtedly, quickened our sense for the beauty with which the changes in the atmosphere clothe the world; this is a great deal, and for this we should be thankful. This seems to be Redmond's main idea, and to my mind he has succeeded to such a high degree that his paintings would therefore be reckoned with the best of the eastern artists."

5. Antony Anderson, "Art and Artists: Has He Astigmatism?," *Los Angeles Times*, November 28, 1909.

6. Antony Anderson, "Art and Artists: Pictures of Places," *Los Angeles Times*, October 22, 1911.

7. Antony Anderson, "Art and Artists: Various Points of View," *Los Angeles Times*, October 26, 1913.

8. Everett C. Maxwell, "Art: Art Affairs in San Francisco," *Graphic*, March (?) 1914, clipping in Museum Scrapbooks.

9. Antony Anderson, "Art and Artists: Landscapes by Sammann," *Los Angeles Times*, March 5, 1911.

10. Antony Anderson, "Art and Artists: Pictures by an Impressionist," *Los Angeles Times*, March 12, 1911.

11. Everett C. Maxwell, "Art," *Graphic*, December 7, 1912, p. 9.

12. On Smith, see Antony Anderson, "Art and Artists," *Los Angeles Times*, May 16, 1909;

March 19, 1911; April 7, 1912; July 21, 1912; and April 19, 1914.

13. Greenbaum, in Beatric de Lack-Krombach, "Art," *Graphic*, May 22, 1915, p. 12.

14. Everett C. Maxwell, "Exhibition of California Art Club," *Fine Arts Journal* 28 (January–June 1913): 190.

15. Ibid., p. 189.

16. Maurice Braun, "Theosophy and the Artist," *Theosophical Path* 14 (January 1918): 7. See also Braun, "What Theosophy Means to Me," *Theosophical Path* 35 (October 1928): 367–68, in which the artist writes, regarding World War 1: "The divine side of life, which is the only part of it that is permanent, will not permit such conditions to exist forever. No matter how discouraging the picture, there is this other side, the divine, permanent side awaiting its time. It only remains for those who have a little more light to hold on to it and to see that it shines more and more brightly in the hope that it may help to illuminate the way."

17. Maxwell, "Exhibition," p. 192.

18. Review of Mannheim's February 1915 exhibition at the Los Angeles Museum of History, Science and Art, *Los Angeles Examiner*, February 7, 1915, clipping in Museum Scrapbooks.

19. Maxwell, "Art," undated clipping from the *Graphic*, in Museum Scrapbooks. On Henri's visit, see Martin Petersen, "Art in San Diego before 1930," in Paul Bockhorst et al., *Impressions of California: Early Currents in Art, 1850–1930* (Irvine, Calif.: Irvine Museum, 1996), pp. 149–50. Petersen notes that it was during this visit that Henri became involved in the planning and preparation for the Panama-California International Exposition held in 1915–16 in San Diego.

20. One local artist to be subsequently identified as a Henri student was the burgeoning modernist Henrietta Shore: "Another pupil of Robert Henri is Henrietta Shore, who exhibits three canvases. Miss Shore's work is never ugly, but often it seems to declare that the artist paints with too firm a conviction of how it should be done. Her theories

quite submerge her subjects." (Antony Anderson, "Art and Artists," *Los Angeles Times*, October 17, 1915.) Anderson also recognized Bert Cressey as a Henri devotee, one whose brushwork, however, was "needlessly sloppy."

21. Henri, in Antony Anderson, "Art and Artists: Fifth Annual Exhibition," *Los Angeles Times*, October 11, 1914.

22. McCormick was credited at the time with being one of the "pioneers" of the art colony at Monterey, along with Mary Brady. See Ellen Dwyer Donovan, "California Artists and Their Work," *Overland Monthly* 51 (January 1908): 25–33. Brady's career awaits further research. In 1907 McCormick praised Brady's innovative spirit, which manifested itself in Paris when the two were students at the Académie Julian: "The ateliers are a world by themselves, with little idea of anything that goes beyond the little conventional groove. I remember an instance that showed their limitations. Our own Miss Brady was held in high esteem over there. Benjamin Constant said she drew like an old master. Once she went off for her vacation and when she came back she had resolved to strike out in a different direction. She sought for mass and body rather than line. The first thing she did was a figure standing out in a mass of shadow. It was as good as her former work, but it was of a kind not so easily understood." (Quoted in Hanna Astrup Larsen, "Jules Pagès May Succeed the Late Julian as Head of Art Academy in Paris," *San Francisco Call*, July 22, 1907.)

23. McCormick, in Lucy B. Jerome, "In the Art World," *San Francisco Call*, November 8, 1908.

24. Josephine M. Blanch, "The Del Monte Art Gallery," *Art and Progress* 5 (September 1914): 392.

25. See *Six Early Women Artists: A Diversity of Style* (Carmel, Calif.: Carmel Art Association, 1991), p. 77. On Chase and his work at Carmel, see William Gerdts's introduction to the present study.

26. *Water Colors of the Panama Pacific Exhibition at San Francisco by Donna Norine Schuster* (Los Angeles: Los Angeles Museum of History,

Science and Art, 1914), copy in the Museum Scrapbooks.

27. Alma May Cook, "Wendt Paintings Given to Manual Arts High School," *Los Angeles Tribune*, June 21, 1914.

28. Everett C. Maxwell, "Art: Art Affairs in San Francisco," *Graphic*, March(?), 1914, clipping in Museum Scrapbooks.

29. Hanna Astrup Larsen, "Life of the Plain People Appeals to Artist Pagès," *San Francisco Call*, March 4, 1907.

30. McCormick, in Larsen, "Jules Pagès May Succeed the Late Julian," July 22, 1907.

31. Jules Pagès, "A Definition of Art," *Western Art!* 1 (April 1914): 23.

32. Lead, a common but deadly component of oil paints, is absorbed into the system through the skin. In Rose's case, the absorption of lead from oil paints may have been his second unfortunate ingestion of the toxin: a childhood gunshot wound may have left him with high residual levels of lead that never decreased, since he took up oil painting while he was recuperating from the accident.

33. Rose could well have seen either in Paris or in Monet's studio another painting of this same bridge with the same composition, which was exhibited at the *Exposition d'art moderne* in Paris, 1912. See *Le Pont routier d'Argenteuil* in Daniel Wildenstein, *Claude Monet: Biographie et catalogue raisonné* (Lausanne, Switzerland: Bibliothèque des Arts, 1974), vol. 1, p. 250, no. 314. Monet's composition may have been inspired, in turn, by Whistler's *Nocturne: Blue and Gold—Old Battersea Bridge* (1872–75; Tate Gallery, London).

34. The model in *The Blue Kimono* was reported to be the same used by the academician Paul Chabas in his well-known painting *September Morn* (1912?; Metropolitan Museum of Art, New York).

35. Ilene Fort has suggested that the Victorian view of women shared by the American Impressionists was threatened by industrialization and the suffrage movement, making Rose's figurative

paintings a "reactionary response to the threat to traditional middle-class values" (Ilene Susan Fort, "Cosmopolitan Guy Rose," in *California Light: 1900–1930*, ed. Patricia Trenton [Laguna Beach, Calif.: Laguna Art Museum, 1990], p. 98).

36. The life and work of Alson Clark were first documented in and interest in him revived by Jean Stern's *Alson S. Clark* (Los Angeles: Petersen Publishing Company, 1983). Stern's original research was modified in subsequent essays (see note 37).

37. Clark, in Jean Stern, "Alson Clark: An American at Home and Abroad," in *California Light*, p. 125.

38. Ibid.

6. ASCENDANCY

Epigraph: John S. McGroarty, *California: Its History and Romance* (Los Angeles: Grafton Publishing Company, 1911), p. 7.

1. William H. Gerdts, *American Impressionism* (New York: Abbeville Press, 1984), p. 306.

2. "The Land of Heart's Desire" is the title of a chapter from John S. McGroarty's *California: Its History and Romance*, which Wendt would have known, since his painting was reproduced on page 3. Another Wendt painting known by the same title is reproduced in Nancy Dustin Wall Moure, *William Wendt, 1865–1946* (Laguna Beach, Calif.: Laguna Beach Museum of Art, 1977), p. 15.

3. *Art in California: A Survey of American Art with Special Reference to Californian Painting, Sculpture and Architecture Past and Present Particularly as Those Arts Were Represented at the Panama-Pacific International Exposition* (San Francisco: R. L. Bernier, 1916).

4. Everett C. Maxwell, "The Structure of Western Art," ibid., p. 35.

5. Ibid., p. 36.

6. Michael Williams, "The Pageant of California Art," in *Art in California*, p. 60.

7. Alma May Cook, "What Art Means to California," in *Art in California*, p. 74.

8. Antony Anderson, "Two Newcomers," *Los*

Angeles Times, December 27, 1914. The other new-comer was Theodore B. Modra, born in Poland.

9. Many of Guy Rose's titles were apparently changed by Ethel Rose and Earl Stendahl to enhance their salability at his 1922 and 1926 retrospective exhibitions. (Roy Rose, interview with author, September 1994.) However, at least one, *The Difficult Response (La réponse difficile)*, was retitled by Rose himself, having appeared under that title in a show at the Los Angeles Museum of History, Science and Art in March 1918; it was called *Petit Bleu* at the 1915 Steckel Show. (Antony Anderson, "Guy Rose's Impressions: In the Realm of Art," *Los Angeles Times*, March 31, 1918.)

10. Anderson, "Two Newcomers."

11. The two paintings (both now unlocated) were *The Backwater* and *November Twilight*, listed in *Catalogue of the Department of Fine Arts, Panama-Pacific International Exposition* (San Francisco: Wahlgreen Company, 1915).

12. "It is with no small satisfaction that we see our local artists hold their own with the eastern contributors. William Ritschel, Helena Dunlap, Edgar Keller, Hanson Puthuff, Donna Schuster, William Cahill, and Guy Rose need make no very low obeisance to these representative Eastern men." (Unidentified critic reviewing *Contemporary American Painters* [possibly Mary N. Dubois writing for the *Graphic*], March 11, 1916, clipping in Museum Scrapbooks.) Guy Rose, one of the jurors and also an exhibitor in *Contemporary American Painters*, made a rare and uncharacteristic appearance in print to counter the largely uncontested chauvinism that had developed in his absence. In a letter to the *Los Angeles Times*, Rose made it clear that worthy art was still being created outside the Southland: "Of the strictly local men, none were invited out of deference to the silly idea that seems to prevail here that every painter in Southern California is the best in the world." (Rose to Antony Anderson, *Los Angeles Times*, March 12, 1916.)

13. Mabel Urmy Seares, "Modern Art and Southern California," *American Magazine of Art* 9 (December 1917): 63.

14. Rose to William Macbeth, April 5, [1917?], Macbeth Gallery Papers, Archives of American Art, Smithsonian Institution, Washington, D.C., roll 2628.

15. *Laguna Eucalyptus* (plate 193) almost certainly dates from 1917. It first appeared in an exhibition at Macbeth's gallery in February 1918 and was sold by Macbeth for three hundred dollars the next month.

16. Ward Winchell, untitled review, *Los Angeles Examiner*, July 9, 1916.

17. See Joan Murray, with an essay by Lawren Harris, *The Best of the Group of Seven* (Edmonton, Canada: Hurtig Publishers, 1984).

18. See "Will Bohemia Arise in Oakland?" *Oakland Tribune*, April 22, 1917.

19. The standard work on the Society of Six is Nancy Boas, *The Society of Six: California Colorists* (San Francisco: Bedford Arts, 1988).

20. Schuster experimented with Cézannesque color and perhaps even with Stanton Macdonald-Wright's difficult Synchromist color theories; she is reported to have studied with him in or around 1928.

21. See Susan M. Anderson and Bolton Colburn, "Painting Paradise: A History of the Laguna Beach Art Association, 1900–1930," in Paul Bockhorst, et al., *Impressions of California: Early Currents in Art, 1850–1930* (Irvine, Calif.: Irvine Museum, 1996), pp. 109–29.

22. Ibid., p. 112.

23. Edgar A. Payne, *Composition of Outdoor Painting* (Hollywood, Calif.: Seward Publishing Company, 1941).

24. For Sorolla, see Eleanor Tufts, "The Lure of Impressionism in Spain and Latin America," in Norma Broude, ed., *World Impressionism: The International Movement, 1860–1920* (New York: Harry N. Abrams, 1990), especially pp. 231–40.

25. On the Ten Painters Club of California, see Antony Anderson, "Of Art and Artists: Pictures by Guy Rose," *Los Angeles Times*, August 10, 1919. The ten painters were Maurice Braun, Benjamin Brown, R. Clarkson Colman, Edgar Payne, Hanson Puthuff, Guy Rose, Jack Wilkinson Smith, Elmer Wachtel and Marion Wachtel, and William Wendt.

26. Arthur G. Vernon, "Modern Art in California," *Graphic* 13 (April 20, 1918).

7. THE FINAL DECADE

Epigraph: Antony Anderson, "Of Art and Artists: California Art Club's Exhibition," *Los Angeles Times*, October 17, 1920.

1. *California Art Club Bulletin* 1 (November 1925): 2.

2. Art critic Fred Hogue recorded Wendt's feelings about development: "When the builders come to slay the trees and scar the flowering slopes with roads and houses, he [Wendt] moves on to a deeper seclusion." (Hogue, in John Alan Walker, "William Wendt, 1865–1946," *Southwest Art* 4 [June 1974]: 43.)

3. Wores, in *Abstract from California Art Research*, W.P.A. Project 2874, ed. Gene Hailey (San Francisco: Works Progress Administration, 1937), vol. 10, p. 133.

4. Jack Wilkinson Smith, undated typescript of a speech given on the occasion of an exhibition of his paintings at the Biltmore Galleries, Los Angeles, Jack Wilkinson Smith Papers, Bancroft Library, University of California, Berkeley.

5. Ibid.

6. "Futuristic Art Shocks L.A.—Paint Daubs Spoil Canvas—Masterpieces Go to Cellar," *Los Angeles Record*, February 19, 1920, clipping from the Museum Scrapbooks for 1913–23, Exposition Park. See also "Modern Art Exhibition Varied," *Los Angeles Express*, February 12, 1920, Museum Scrapbooks: "decidedly freaky."

7. Antony Anderson, "Our American Modernists," *Los Angeles Times*, February 13, 1920, clipping in the Museum Scrapbooks for 1913–23.

8. Ibid.

9. Fred Hogue, "Jazz Paintings Worth Study," *Los Angeles Times*, February 20, 1920.

10. Perhaps the most regrettable evidence of this lack of acceptance is the fact that the former New Yorkers Walter and Louise Arensberg, who moved to Hollywood in 1924, were unable to find a permanent home in California for their impressive collection of modern art, which eventually went to the Philadelphia Museum of Art.

11. Wendt, in *Los Angeles Times*, June 11, 1922; in Nancy Moure, *William Wendt, 1865–1946* (Laguna Beach: Laguna Beach Museum of Art, 1977), p. 22.

12. Charles Reiffel, "The Modernistic Movement in Art," *Modern Clubwoman*, January 1930, p. 4.

13. Colin Campbell Cooper was well known for his urban scenes, but these he did in the East; in the West he painted architectural subject matter but not city views. Arguably, Los Angeles lacked a downtown with sufficient pictorial drama. See Albert W. Barker, "A Painter of Modern Industrialism: The Notable Work of Colin Campbell Cooper," [Appleton's] *Booklover's Magazine* 5 (March 1905): 326–37.

14. See Jean Stern, et al., *Romance of the Bells: The California Missions in Art* (Irvine, Calif.: Irvine Museum, 1995).

15. SMW [Stanton Macdonald-Wright], "An Open Letter from a Modernist," *Los Angeles Times*, October 4, 1925. In this letter Wright noted that George Stojana was president, Mabel Alvarez vice-president, and Edouard Vysekal treasurer of the Modern Art Workers.

16. Antony Anderson, "Of Art and Artists," *Los Angeles Times*, March 1, 1925.

17. "I referred to Reiffel as a member of a genuine American school of landscape painting, yet, without Cézanne and perhaps Van Gogh, we should never have the Reiffel of today. He is definitely American in his delight in the objectivities of landscape and the healthy, almost childlike, joyousness of his rhythmic designs. But his treatment of planes and spaces stems from Cézanne, while the vital, nervous flow of line reminds us of the great Dutchman." (Arthur H. Millier, "Charles Reiffel, American Landscape Painter," *Argus* [July–August 1928]: 6.)

18. Arthur H. Millier, "California Art Club Exhibition Reviewed," *Los Angeles Times*, November 27, 1927.

19. Henry DeKruif, "Chicago's Point of View," *California Art Bulletin* 3 (September 1928): 3.

20. Millier, in *Argus* 2 (February 1928).

21. See "The 'Eucalpytus School,'" *Los Angeles Times*, September 16, 1928.

Artists' Biographies

WILL SOUTH

LUCY BACON

Born 1858, Pitcairn, New York

Died 1932, San Francisco, California

See plate 101.

Painter. Attends Potsdam (New York) Normal School, graduating sometime before 1879. Moves to Brooklyn and attends Art Students League of New York; exhibits at National Academy of Design in 1890. Leaves for France in 1892, most likely supported by her brother, merchant Albert Sylvester Bacon. In Paris, studies at Académie Colarossi before leaving to work with Camille Pissarro (with the encouragement of Mary Cassatt), making her perhaps the only California artist of her era to study with a French Impressionist. Moves to San Jose, California, in 1896, then to San Francisco. Related by marriage to art dealer Robert K. Vickery of Vickery, Atkins and Torrey, an important gallery in San Francisco in the 1890s. Exhibits in San Francisco in the later 1890s. Apparently quits painting shortly after 1900, after converting to Christian Science.

FRANZ ARTHUR BISCHOFF

Born 1864, Bomen, Austria

Died 1929, Pasadena, California

See plates 21, 140–42.

Painter, ceramist. Receives art training at craft schools, first in Bomen, then Vienna. Immigrates to United States in 1885, works as a china decorator in New York City; later establishes Bischoff School of Ceramic Art in Detroit. First visits California in 1900, moves with his family, 1906, to San Francisco, then Los Angeles. In 1908 builds a studio-home along the Arroyo Seco in South Pasadena that includes a gallery, ceramic workshop, and painting studio; begins to paint landscapes. Takes numerous painting trips up and down the California coast. Paints Zion National Park, Utah, in 1928, in company of friend and fellow painter John Christopher Smith. Member California Art Club, Los Angeles; Painters' Club, Los Angeles; and Laguna Beach Art Association.

CARL OSCAR BORG

Born 1879, Osterbyn Ostra, Sweden

Died 1947, Santa Barbara, California

See plate 115.

Landscape painter. Immigrates to United States in 1901, travels extensively in the East and in Canada. To Los Angeles in 1903. Encouraged by Charles Lummis to paint images of Native Americans and southwestern landscape. With support from Phoebe Hearst (mother of William Randolph Hearst), paints in Europe, 1910–14. Moves to San Francisco, 1914; silver medalist at Panama-Pacific International Exposition, San Francisco, 1915. Beginning in 1916, spends part of each year for the next fifteen years living with Hopi and Navajo peoples. Lives in Santa Barbara, 1918–24, then Hollywood. Moves to New York in 1936 before final relocation to Santa Barbara in 1945. Member California Art Club, Los Angeles; Laguna Beach Art Association; Painters' Club, Los Angeles; Painters of the West, Los Angeles; Printmakers Society of California, Los Angeles; Salmagundi Club, New York; and San Francisco Art Club; elected to National Academy of Design, New York, 1938.

GEORGE KENNEDY BRANDRIFF

Born 1890, Millville, New Jersey

Died 1936, Laguna Beach, California

See plates 228, 229, 240.

Landscape, still-life, and figure painter. To California in 1913; enrolls in College of Dentistry and opens his own practice, 1918, in Hemet. A part-time painter, studies with Carl Oscar Borg, Anna Hills, and Jack Wilkinson Smith. Builds a studio in Laguna Beach in 1927, becomes a full-time painter the next year. Member California Art Club, Los Angeles, and Painters of the West, Los

240. George Kennedy Brandriff (1890–1936). *March Winds,* n.d. Oil on canvas, 30 x 36 (76.2 x 91.4 cm). Private collection.

Angeles; president of Laguna Beach Art Association from 1934 until his suicide in 1936.

MAURICE BRAUN

Born 1877, Nagy Bittse, Hungary

Died 1941, San Diego, California

See plates 15, 47, 136, 137, 214.

Landscape painter. Immigrates with family to United States, 1881. Studies at National Academy of Design, New York, 1897–1900; then with William Merritt Chase for a year before going to Europe for a six-month tour. Returns to New York, 1903. Moves to California, 1909. Opens a studio on Point Loma, San Diego; founds San Diego Academy of Art, 1912. Affiliated with the American Theosophical Society. Gold medalist at Panama-California Exposition, San Diego, 1915–16. In 1920s, spends part of each year painting in the East, including at the art colony in Old Lyme, Connecticut. One-artist show at Fine Arts Gallery of San Diego, 1928; founding member San Diego Art Guild, 1915, and Contemporary Artists of San Diego, 1929. Member California Art Club, Los Angeles, and Laguna Beach Art Association. Retrospective exhibition at M. H. de Young Memorial Museum, San Francisco, 1954.

ANNE MILLAY BREMER

Born 1868, San Francisco, California

Died 1923, San Francisco, California

See plate 146.

Landscape painter, muralist. Studies at Mark Hopkins Institute of Art, San Francisco, with Arthur Mathews; Art Students League, New York; then in Paris with Edmond Aman-Jean and at Académie Moderne and La Palette. Exhibits at Salon d'Automne, 1911. Returns to San Francisco, where she is an advocate for modern tendencies in art. Exhibits at Hotel del Monte Art Gallery, Monterey, 1907–14. Bronze medalist at Panama-Pacific International Exposition, San Francisco, 1915. One-artist shows at Tolerton Gallery, San Francisco, 1916, and at Arlington Galleries, New York, 1917. Member Cali-

fornia Art Club, Los Angeles; San Francisco Sketch Club; and San Francisco Society of Women Artists.

BENJAMIN CHAMBERS BROWN

Born 1865, Marion, Kansas

Died 1942, Pasadena, California

See plates 2, 46, 119, 120.

Landscape painter, printmaker. Initial training at Saint Louis School of Fine Arts. Visits California, 1886. To Europe, 1890, with friend and fellow artist William Griffith; studies one year at Académie Julian (1894–95). To Pasadena, 1896; focuses on landscape painting. Silver medalist at Seattle Exposition, 1909; bronze medalist for etching, Panama-Pacific International Exposition, San Francisco, 1915. Along with his brother, Howell, founds Printmakers Society of California, Los Angeles. Member California Art Club, Los Angeles, and Pasadena Society of Artists.

WILLIAM VINCENT CAHILL

Born 1878, Syracuse, New York

Died 1924, Chicago, Illinois

See plate 62.

Figure and landscape painter, illustrator. Studies at Art Students League, New York, under Tonalist painter Birge Harrison and illustrator Howard Pyle. Later shares studio in Boston with John Rich; in 1914 the two move to Los Angeles, where they establish School for Illustration and Painting. Cahill teaches briefly at University of Kansas in 1918, returns to Laguna Beach the next year. Beginning in 1920, resides in San Francisco for two years before relocating to Chicago. Member California Art Club, Los Angeles, and Laguna Beach Art Association.

WILLIAM HENRY CLAPP

Born 1879, Montreal, Canada

Died 1954, Oakland, California

See plates 12, 35, 36, 194, 241.

Landscape painter, museum administrator. Studies at Art Association of Montreal under William

241. William Clapp (1879–1954).
A Road in Spain, 1907.
Oil on canvas, 28¼ x 36 in. (71.7 x 91.4 cm).
The Montreal Museum of Fine Arts; Gift of Henry Morgan & Co., Ltd.

Brymner, 1900–1903. To Paris, 1904; attends Académie Julian, Académie de la Grande Chaumière, and Académie Colarossi, 1904–8. Influenced by Impressionism and Post-Impressionism. Paints landscapes in Chézy-sur-Marne, France, and Belgium, 1906; Spain, 1907. Returns to Montreal, 1908; paints views of rural Quebec. Exhibits at Art Association of Montreal, Canadian Art Club, and Royal Canadian Academy. Exhibits eighty-nine Impressionist paintings at Johnson's Art Galleries, Montreal, 1914. Lives and works in Cuba, 1915–17. Settles in Oakland, 1917. Becomes curator, Oakland Art Gallery (later Oakland Museum), 1918, director, 1920–49. Member Society of Six, an Oakland-based group of modernist painters.

ALSON SKINNER CLARK

Born 1876, Chicago, Illinois

Died 1949, Pasadena, California

See plates 14, 37, 60, 103, 169, 170–73, 175, 224, 242.

Landscape, figure, and portrait painter; muralist; lithographer. Studies at Art Institute of Chicago, 1895–96; at Art Students League, New York, 1896; and with William Merritt Chase in New York and Shinnecock, Long Island, 1896–98. Studies in Paris

242. Alson Clark (1876–1949).
Wash Day, Panama, 1913.
Oil on canvas, 21½ x 25¾ in. (54.6 x 65.4 cm).
Paul Bagley Collection.

with James McNeill Whistler, late 1898, and at Académie Delecluse, 1900–1901. Based in Chicago in early decades of the century, but travels extensively throughout Europe, living in Paris for part of each year. In Giverny, summer 1910; associates with Lawton Parker, Frederick Frieseke, and Guy Rose. Also active in Watertown, New York; Quebec; and Panama. Returns to United States, 1914. Exhibits eighteen paintings of Panama Canal at Panama-Pacific International Exposition, San Francisco, 1915; wins a bronze medal. Serves in World War I; settles in Pasadena, 1919, to recuperate from wounds; becomes associated with the California Impressionists. Teaches at Stickney Memorial School of Art, Pasadena. Member California Art Club, Los Angeles; Pasadena Society of Artists; Salmagundi Club, New York; and Society of Western Artists, Chicago.

FRANK COBURN

Born 1862, Chicago, Illinois
Died 1938, Santa Ana, California
See plates 10, 225.

Landscape and urban genre painter. Studies briefly at Art Institute of Chicago. To Los Angeles, 1908; paints still life in a dark, Barbizon school manner, but becomes best known for nocturnal views of Los Angeles. Chewing-gum magnate William Wrigley reportedly purchases thirty-one of Coburn's canvases. Active in local organizations; makes numerous painting trips. In 1928 gives up his Los Angeles studio and paints either at home in Santa Ana or out of his studio–mobile home named El Vagabundo. One-artist show at Bowers Museum, Santa Ana, 1938, just prior to his death.

COLIN CAMPBELL COOPER

Born 1856, Philadelphia, Pennsylvania
Died 1937, Santa Barbara, California
See plates 9, 38, 65, 82, 185.

Portrait, landscape, and genre painter. Studies at Pennsylvania Academy of the Fine Arts, 1879. To Europe, 1886; in Paris studies at Académie Julian, 1886–90; Académie Delecluse; and Académie Viti. Exhibits at the Salon, 1890 and 1899. Returns to United States, 1895; teaches painting at Drexel Institute, Philadelphia. Returns to Europe regularly, painting scenes of famous architectural monuments. Gold medalist at Panama-Pacific International Exposition, San Francisco, 1915. Visits Los Angeles, 1915; settles in Santa Barbara, 1921; serves as head of Santa Barbara School of the Arts. To Europe again, 1923. Retrospective exhibition at Kievits Galleries, Pasadena, 1929. Member American Water Color Society, New York; California Art Club, Los Angeles; National Academy of Design, New York; National Arts Club, New York; New York Society of Painters; New York Watercolor Club; Philadelphia Watercolor Club; San Diego Art Guild; Santa Barbara Art Club.

FRANK WILLIAM CUPRIEN

Born 1871, Brooklyn, New York
Died 1946, Laguna Beach, California
See plates 75, 207.

Landscape painter, marine specialist. Studies at Cooper Union Art School and Art Students League, New York; then in Philadelphia with Carl Weber; receives criticism from marine painter William Trost Richards. To Europe; studies at Académie Julian, Paris. Also studies music seriously, writing original compositions and graduating from Royal Conservatories in Munich, 1905. To California, c. 1912; builds a studio-home in Laguna Beach, 1914. Silver medalist at Panama-California Exposition, San Diego, 1915–16. Founding member of Laguna Beach Art Association, 1918; president, 1921–22.

LAFAYETTE MAYNARD DIXON

Born 1875, near Fresno, California
Died 1946, Tucson, Arizona
See plates 97, 184.

Landscape and figure painter, illustrator, muralist. Early but brief study at California School of Design, San Francisco, in 1893; begins illustrating for the popular magazine *Overland Monthly* that year and shortly thereafter for *Land of Sunshine* magazine, based in Southern California. Loses studio in 1906 fire in San Francisco. To New York 1907–12; illustrates for *Scribner's* and *Harper's Monthly*. Bronze medalist at Panama-Pacific International Exposition, San Francisco, 1915. Paints numerous murals in California, 1920s and 1930s, including for Mark Hopkins Hotel, San Francisco, 1926, and California State Library, Sacramento, 1928. Prolific interpreter of western landscape and Native American themes; in 1930s his work takes on social themes and he paints WPA murals. Numerous exhibitions and professional affiliations, including American Artists Congress, New York; Berkeley Art League; Bohemian Club, San Francisco; Oakland Art Association; Painters of the West, Los Angeles; and Salmagundi Club, New York.

HELENA ADELE DUNLAP

Born 1876, Los Angeles, California
Died 1955, Whittier, California
See plates 41, 125.

Figure painter, lithographer. Studies at Art Institute of Chicago; Pennsylvania Academy of the

Fine Arts; with William Merritt Chase in New York; and then with André Lhote in Paris. Returns to Los Angeles, 1911; regarded by critic Antony Anderson as a preeminent local Impressionist painter. Gold medalist at Panama-California Exposition, San Diego, 1915–16. Member California Art Club, Los Angeles, and cofounder Modern Art Society, Los Angeles.

FANNIE ELIZA DUVALL

Born 1859, Port Byron, New York
Died 1934, Los Angeles, California
See plates 106, 107.

Genre and landscape painter, pastelist. Studies at Art Students League, New York. Moves to Los Angeles, 1888. Exhibits in the World's Columbian Exposition, Chicago, 1893. To Paris after 1900; studies at Académie de la Grande Chaumière. Back in Southern California, in 1919 establishes a studio in the Arroyo Seco, Pasadena, where she makes pastel portraits, landscapes, and still lifes. Member American Federation of Arts, New York; California Art Club, Los Angeles; and Laguna Beach Art Association.

EUPHEMIA CHARLTON FORTUNE

Born 1885, Sausalito, California
Died 1969, Carmel, California
See plates 54, 55, 104, 179, 243.

Landscape and portrait painter. At age twelve is sent to a convent school in Edinburgh; later enrolls at Edinburgh College of Art, followed by study at Saint John's Wood School of Art in London. To United States, 1905; enrolls at Mark Hopkins Institute of Art, San Francisco, and then Art Students League, New York. Two-year sojourn in England begins 1910. In California by 1912. Establishes studio-home in Monterey, 1915; teaches plein air painting. Silver medalist, Panama-Pacific International Exposition, San Francisco, 1915. One-artist show, Helgesen Galleries, San Francisco, 1916. To Europe, 1921; paints in London; Cornwall, England; Paris, Saint-Tropez, and Cannes,

243. Euphemia Charlton Fortune (1885–1969).
Summer, 1914.
Oil on canvas, 22¼ x 26 in. (56.5 x 66 cm).
Fine Arts Museums of San Francisco; Museum Purchase, Skae Fund Legacy.

France; silver medalist, Paris Salon, 1924. Back to Monterey, 1927. A devout Roman Catholic, she founds the Monterey Guild to produce art for the church. Member California Art Club, Los Angeles; Monterey Guild; San Francisco Art Association; and Society of Scottish Artists, Edinburgh.

MAREN MARGRETTIE FROELICH

Born 1870, Fresno, California
Died 1921, San Francisco, California
See plate 178.

Landscape, still-life, and figure painter. Studies at California School of Design, San Francisco, with Emil Carlsen and Arthur Mathews, and privately with William Keith. Later studies in Paris with American Impressionist Richard Miller and at Académie Casteluchio. Returns to San Francisco; teaches at California School of Design. Also active in the Carmel art community. Exhibits at World's Columbian Exposition, Chicago, 1893; Panama-Pacific International Exposition, San Francisco, 1915; Bohemian Club, San Francisco; and Mark Hopkins Institute of Art, San Francisco.

JOHN FROST

Born 1890, Philadelphia, Pennsylvania
Died 1937, Pasadena, California
See plates 13, 59, 190, 191.

Landscape painter. Son of famed illustrator Arthur B. Frost. In Paris with his family, he and older brother, A. B. Frost Jr., study at Académie Julian. John studies with Richard Miller in Paris, 1906–8, and visits him in Giverny during this period. Returns to United States by 1915; works as an illustrator. To Pasadena, 1919, for health reasons; paints with Guy Rose, whom he knew in Giverny, and with Alson Clark. One-artist show at Stendahl Gallery, Los Angeles, 1927. Member California Art Club, Los Angeles; Painters and Sculptors Club, Los Angeles; Pasadena Society of Artists.

JOHN MARSHALL GAMBLE

Born 1863, Morristown, New Jersey
Died 1957, Santa Barbara, California
See plates 148, 149.

Landscape painter. As a young man, travels to New Zealand with parents. Moves to San Francisco in 1883 for health reasons; studies at California School of Design, 1886, with Emil Carlsen and Virgil Williams. To Europe, 1890; in Paris studies at Académie Julian (1891–92) and Académie Colarossi. Returns to San Francisco, 1893; loses studio and its contents in 1906 fire. To Europe again, 1908–10; returns to United States via the Orient. Moves to Santa Barbara; becomes a specialist in painting wildflowers. Member American Federation of Arts, New York; Foundation of Western Art, Los Angeles; San Francisco Art Association; and Santa Barbara Art Association.

AUGUST FRANÇOIS GAY

Born 1890, Rabou, France
Died 1949, Carmel, California
See plate 195.

Painter of landscapes and figures, etcher. Immigrates to the United States with his family in 1900; settles in Alameda, California, and later moves

to San Francisco. In 1915 visits and is impressed by Panama-Pacific International Exposition, San Francisco; attends night classes at California School of Fine Arts. Meets and befriends Selden Gile; the two become roommates and Gile greatly influences Gay's style. Gay moves to Monterey in 1919, where he shares studio space with painter Clayton Price. Works in local fish factories and as a custom picture framer. Continues to paint and show in the Bay Area with Society of Six throughout the 1920s.

ARTHUR HILL GILBERT

Born 1894, Mount Vernon, Illinois
Died 1970, Stockton, California
See plate 238.

Landscape painter. Attends United States Naval Academy at Annapolis, Maryland. Following military service moves to Los Angeles, c. 1920. Studies at Otis Art Institute, then goes to Europe for additional training. Moves to Monterey, 1930, where he specializes in coastal views. A frequent exhibitor in California throughout 1920s and 1930s; also exhibits at National Academy of Design, New York, where he wins Hallgarten Prize, 1929; at Art Institute of Chicago; and at Pennsylvania Academy of the Fine Arts, Philadelphia. Member Bohemian Club, San Francisco; California Art Club, Los Angeles; Carmel Art Association; Laguna Beach Art Association; and Salmagundi Club, New York.

SELDEN CONNOR GILE

Born 1877, Stow, Maine
Died 1947, San Rafael, California
See plates 20, 197, 198.

Landscape painter. To California, 1901. Settles in Oakland, 1905, where he works twenty-two years for the tile-manufacturing firm of Gladding, McBean and Company; retires in 1927 to paint full-time. Instrumental in forming the Society of Six in 1917, a group of modernist painters who begin to exhibit together formally in 1923. Gile

and other members of the Six influence the direction of Impressionism after the Panama-Pacific International Exposition in 1915. During the 1920s he and other members of the Society of Six represent the most experimental and unorthodox art being done in Northern California.

JOSEPH DAVID GREENBAUM

Born 1864, New York, New York
Died 1940, Los Angeles, California
See plate 118.

Landscape and portrait painter. To San Francisco at age thirteen with his family; attends California School of Design followed by Munich Academy of Fine Arts and Académie Julian, Paris. Exhibits at the Salon in 1896. Moves to San Francisco; loses his studio in 1906 fire. Moves to Los Angeles and takes studio in Blanchard Music and Art Building; teaches and paints portraits of prominent citizens. One-artist show at Steckel Gallery, Los Angeles, 1907; gold medalist, Seattle Exposition, 1909. Teaches at Art Students League of Los Angeles; among his students are Southern California's two most significant modernists, Rex Slinkard and Stanton Macdonald-Wright.

WILLIAM ALEXANDER GRIFFITH

Born 1866, Lawrence, Kansas
Died 1940, Laguna Beach, California
See plate 6.

Landscape painter, pastelist. Some art study at Washington University, Saint Louis. To Europe with friends Benjamin Brown and Edmund H. Wuerpel, 1890; studies at Académie Julian, Paris, 1892–93. Back in United States, teaches at University of Kansas at Lawrence for twenty-one years. Suffering from bronchial problems, moves to California where friend Brown lives, 1920. Settles in Laguna Beach, where he serves as president of the Laguna Beach Art Association, 1920–21 and 1925–27. Member California Art Club, Los Angeles.

ARMIN CARL HANSEN

Born 1886, San Francisco, California
Died 1957, Monterey, California
See plates 66, 199, 200, 244.

Landscape painter, marine specialist. Early lessons from his father, Hermann Hansen. Studies at California School of Design, San Francisco, with Arthur Mathews, 1903–6. To Germany for two years at Royal Academy in Stuttgart, with impressionistic painter Carlos Grethe. To San Francisco, 1912; teaches at University of California, Berkeley. Moves to Monterey, 1913, where his subject matter is primarily seascapes and fishing genre. Teaches privately; in 1918 these classes are incorporated into California School of Fine Arts as Monterey Summer School. Silver medalist, Panama-Pacific International Exposition, San Francisco, 1915. One-artist exhibitions, Los Angeles Museum of History, Science and Art, 1915, and Helgesen Galleries, San Francisco, 1916. Founding member, Carmel Art Association. Member California Society of Etchers, San Francisco; National Academy of Design, New York; Salmagundi Club, New York; San Francisco Art Association; and Société Royale des Beaux-Arts, Brussels.

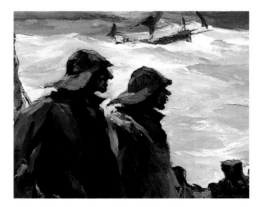

244. Armin Hansen (1886–1957).
Northwest Wind, n.d.
Oil on canvas, 18 x 22 in. (45.7 x 55.8 cm).
The Buck Collection.

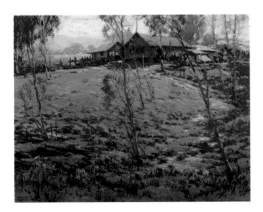

245. Sam Hyde Harris (1889–1977).
Hillside, c. 1930.
Oil on canvas, 28 x 34 in. (71.1 x 86.3 cm).
Joseph L. Moure.

SAM HYDE HARRIS

Born 1889, Brentford, England
Died 1977, Alhambra, California
See plates 44, 226, 227, 245.
Landscape painter. Immigrates with family to United States in 1904; settles in Los Angeles. Pursues career as commercial artist; takes evening and weekend courses at Art Students League of Los Angeles and Cannon Art School. To Europe for six months, 1913. Studies privately with Hanson Puthuff; later with Jean Mannheim and Edgar Payne, 1920s. Member California Art Club, Los Angeles; Laguna Beach Art Association; and Painters and Sculptors Club, Los Angeles.

JAMES TAYLOR HARWOOD

Born 1860, Lehi, Utah
Died 1940, Salt Lake City, Utah
See plate 99.
Landscape, still-life, and portrait painter; etcher. Studies at California School of Design, San Francisco, 1885, with Virgil Williams; befriends Guy Rose. To Europe, 1888; in Paris studies at Académie Julian, 1888–90, and Ecole des Beaux-Arts, 1891. Paints out of doors at French village of Etaples in the summers. First artist from Utah to show at Paris Salon, 1892. Returns to Utah, where he has long and influential career as a teacher. Moves to Oakland, 1920. Teaches in the local school system; paints coastal scenes in Monterey, Carmel, and San Francisco Bay Area. Returns to Utah, 1922; heads Art Department at University of Utah. Travels frequently to California throughout 1920s and 1930s; produces paintings and etchings.

FREDERICK CHILDE HASSAM

Born 1859, Dorchester, Massachusetts
Died 1935, East Hampton, New York
See plates 51, 52.
Landscape, figure, and genre painter; etcher. Studies at Académie Julian, Paris, 1886–89; influenced by Impressionism and becomes a leading exponent of that style in United States. In 1898 cofounds the Ten American Painters, a group formed to show and promote their own Impressionist-oriented work. Though a critic of modernism, Hassam is represented in the 1913 Armory Show. Numerous exhibitions and awards throughout his lifetime; is widely influential on younger American artists. Paints in California, 1914; exhibits at Panama-Pacific International Exposition, San Francisco, 1915.

ANNA ALTHEA HILLS

Born 1882, Ravenna, Ohio
Died 1930, Laguna Beach, California
See plates 77, 206.
Landscape painter. Initial art education at Olivet College, Michigan, then Art Institute of Chicago and Cooper Union Art School, New York. To Europe; studies at Académie Julian, Paris. To Los Angeles, c. 1912; to Laguna Beach, 1913. Bronze medalist at Panama-Pacific International Exposition, San Francisco, 1915. One-artist show at Kanst Gallery, Los Angeles, 1916. Founding member Laguna Beach Art Association, 1918; president, 1922–25 and 1927–30. Teaches, lectures, and organizes art exhibitions. Member California Art Club, Los Angeles, and Washington Water Color Club, Washington, D.C.

CLARENCE KELSER HINKLE

Born 1880, Auburn, California
Died 1960, Santa Barbara, California
See plates 7, 79, 208, 246.
Landscape, still-life, and genre painter. Receives first instruction from William F. Jackson at art school, Crocker Art Gallery, Sacramento, then attends Mark Hopkins Institute of Art, San Francisco, under Arthur Mathews. Studies at Art Students League, New York, then Pennsylvania Academy of the Fine Arts, with Thomas Anshutz and William Merritt Chase. To Europe, 1906, on scholarship; two years in Holland and fours years in France include study at the Ecole des Beaux-Arts and Académie Julian, Paris. To San Francisco, 1913; decorates several buildings for Panama-Pacific International Exposition, 1915. Moves to Los Angeles, 1917;

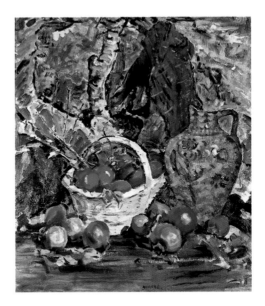

246. Clarence Hinkle (1880–1960).
Pomegranates, n.d.
Oil on canvas, 36 x 32 in. (91.4 x 81.2 cm). The J. C. Carter Co., Inc., Santa Barbara, California.

teaches at Los Angeles School of Art and Design, then at Chouinard School of Art. Moves to Santa Barbara, 1935; paints full-time. Member California Art Club, Los Angeles; Laguna Beach Art Association; and Painters and Sculptors Club, Los Angeles.

CLARK HOBART

Born 1868, Rockford, Illinois
Died 1948, Napa, California
See plates 28, 180.
Landscape painter, etcher. To California as a child; studies at California School of Design, San Francisco, and privately with William Keith. Studies at Art Students League, New York; goes to Paris. Art editor in New York, 1903–11. Moves to Monterey, California, in 1911. Influenced by Panama-Pacific International Exposition, San Francisco, 1915. Moves to San Francisco, 1916, and works on monotypes and portraits. Member Bohemian Club, San Francisco; California Society of Etchers, San Francisco; and San Francisco Art Association.

THOMAS LORRAINE HUNT

Born 1882, London, Canada
Died 1938, Santa Ana, California
See plate 209.
Landscape painter. Studies first with his father, painter John Powell Hunt, then with Hugh Breckenridge at Pennsylvania Academy of the Fine Arts, Philadelphia. About 1923, moves to California and pursues primary career as a real estate developer, though he soon becomes active in local art circles. Builds studio-home in Laguna Beach, 1927. Exhibits often in Southern California; wins numerous awards, including first prize, California State Fair, 1923, and first prize, Laguna Beach Art Association, 1927.

WILLIAM FRANKLIN JACKSON

Born 1850, Council Bluffs, Iowa
Died 1936, Sacramento, California
See plate 88.
Landscape painter. To California at age twelve;

studies at California School of Design, San Francisco, under Virgil Williams, then paints with William Keith. Becomes best known for views of poppy fields. In 1884, when the William H. Crocker family deeds their art gallery to Sacramento, becomes curator and director of its art school. Member Art Commission of Panama-Pacific International Exposition, San Francisco, 1915, and Sacramento Board of Education.

WILLIAM LEES JUDSON

Born 1842, Manchester, England
Died 1928, Los Angeles, California
See plate 110.
Landscape painter. Immigrates to United States with family, 1852; resides in Brooklyn. Serves in Civil War. Studies at Académie Julian, Paris, 1878–81; active as portrait painter in Chicago by 1890. To California for health reasons, 1893; begins to focus on landscape. In 1896 joins faculty of University of Southern California; establishes art department in 1901, located then in the Garvanza district on the Arroyo Seco, near Pasadena. Bronze medalist at Panama-California Exposition, San Diego, 1915–16. Teaches outdoor painting in an impressionistic style. Member California Art Club, Los Angeles, and Laguna Beach Museum of Art.

JOSEPH KLEITSCH

Born 1882, Nemet Szent Mihaly, Hungary
Died 1931, Santa Ana, California
See plates 5, 64, 204, 235, 247.
Landscape, portrait, and figure painter. Immigrates to United States sometime after 1901; to Denver, 1905. In Kansas briefly in 1907, then to Mexico City, 1907–9, where he paints President Francisco Madero and his wife. In 1909 moves to Chicago; becomes active in local arts organizations and exhibits at Art Institute of Chicago. To Laguna Beach, California, 1920; continues to paint portraits and becomes avid landscapist as well. First one-artist show in California at Stendahl Galleries, Los Angeles, 1922. To Europe again, 1925; returns

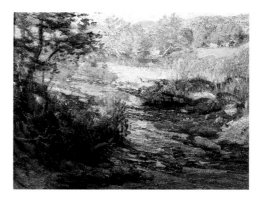

247. Joseph Kleitsch (1882–1931).
Laguna Canyon, 1923.
Oil on canvas, 32 x 42 in. (81.2 x 106.6 cm).
Barbara and Thomas Stiles.

to California, 1927. Member Chicago Society of Artists; Laguna Beach Art Association; Painters and Sculptors Club, Los Angeles; and Palette and Chisel Club, Chicago.

PAUL LAURITZ

Born 1889, Larvik, Norway
Died 1975, Glendale, California
See plate 132.
Landscape painter. Early study at Larvik School in Norway. Immigrates to Canada, c. 1905. Paints in Oregon and Alaska before moving to Los Angeles, 1919. Teaches at Chouinard School of Art and Otis Art Institute, Los Angeles. Member California Art Club, Los Angeles (president for two years); Laguna Beach Art Association; Painters and Sculptors Club, Los Angeles; Royal Society of Art, London; and Salmagundi Club, New York.

MAURICE GEORGE LOGAN

Born 1886, San Francisco, California
Died 1977, Orinda, California
See plate 196.
Landscape painter. Studies at San Francisco Art Institute with Theodore Wores and Frank van

Sloun, then at Art Institute of Chicago. In 1915 opens a studio in San Francisco and has a successful career in commercial art. Becomes member of Society of Six. In 1935 joins antimodernist Society for Sanity in Art. Paints until age eighty-two. Member American Water Color Society, New York; Bohemian Club, San Francisco; California Water Color Society, Los Angeles; Oakland Art Association; and Society of Western Artists, Chicago.

FERNAND HARVEY LUNGREN

Born 1859, Hagerstown, Maryland
Died 1932, Santa Barbara, California
See plate 181.

Landscape painter, illustrator. Studies at Pennsylvania Academy of the Fine Arts, Philadelphia, under Thomas Eakins; starts career in New York illustrating for *Scribner's*, *Harper's*, and *Century*; additional training in Paris at Académie Julian. To Cincinnati; influenced by J. H. Sharp and Henry Farny to adopt western subject matter. First goes west in 1892, hired by Santa Fe Railway to make illustrations along the route. To Los Angeles, 1903. Settles in Santa Barbara, 1907; instrumental in founding Santa Barbara School of the Arts. Exhibits at Panama-Pacific International Exposition, San Francisco, 1915.

MARIE EVELYN MCCORMICK

Born 1869, Placerville, California
Died 1948, Monterey, California
See plates 29, 95, 147.

Landscape painter. Studies at California School of Design, San Francisco, under Virgil Williams and Emil Carlsen, then Académie Julian, Paris, 1889–c. 1891. To Giverny, July 4, 1890, and stays through the year; returns to Giverny, June 1891. Exhibits in Salon de la Société des Artistes Français, Paris, 1891, and World's Columbian Exposition in Chicago, 1893. After 1906 fire in San Francisco, moves to Monterey and is a founder of Hotel del Monte Art Gallery, 1907; later commissioned by Monte-

rey to depict the city's historic buildings. Exhibits at Panama-Pacific International Exposition, San Francisco, 1915. Member Carmel Art Association and San Francisco Art Association.

JEAN MANNHEIM

Born 1862, Kreuznach, Germany
Died 1945, Pasadena, California
See plates 48, 76, 138, 139, 167, 248.

Landscape, portrait, and figure painter. First trip to America, 1881. Returns to Europe; studies in

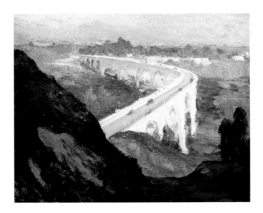

248. Jean Mannheim (1862–1945).
Colorado Street Bridge, Pasadena, n.d.
Oil on board, 20 x 23¾ in. (50.8 x 60.3 cm).
George Stern Fine Arts, Los Angeles.

Paris at Académie Julian, Académie Colarossi, and Académie Delecluse. Returns to America; resides in Chicago and paints portraits. Spends summers in Europe. Exhibits at Paris Salon, 1897. In 1903 teaches at Brangwyn School of Art, London. In 1905 teaches at Denver Art School. Moves to Los Angeles, 1908; opens a studio in the Blanchard Music and Art Building and teaches. Gold medalist at Panama-California Exposition, San Diego, 1915–16. Founding member California Art Club, Los Angeles; member Laguna Beach Art Associa-

tion, Long Beach Art Association, and Pasadena Art Club.

RICHARD EMIL MILLER

Born 1875, Saint Louis, Missouri
Died 1943, Saint Augustine, Florida
See plates 61, 192.

Figure and marine painter, muralist. Studies at Saint Louis School of Fine Arts, mid-1890s, and Académie Julian, Paris, 1898–99; spends several years in Paris. Exhibits at Paris Salons and in the United States. Teaches at Académie Colarossi, Paris, early 1900s. Begins summering in Giverny, c. 1906. Teaches summer classes in Saint-Jean-du-Doigt, France, starting in 1911. Is recognized internationally for portrayals of women in gardens and interiors. Returns to United States, late 1914. In Pasadena, 1917; teaches at Stickney Memorial School of Art, where he influences development of Impressionism in Southern California. Lives in Provincetown, Massachusetts, after 1918. Designs murals for State Capitol, Jefferson City, Missouri, 1919–23.

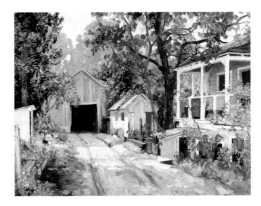

249. Alfred R. Mitchell (1888–1972).
Julian Hotel, c. 1929.
Oil on canvas, 40 x 50 in. (101.6 x 127 cm).
Paul Bagley Collection.

ALFRED RICHARD MITCHELL

Born 1888, York, Pennsylvania

Died 1972, San Diego, California

See plates 186, 236, 249.

Landscape painter. To California, 1908; settles in San Diego. Studies under Maurice Braun at San Diego Academy of Art, 1913. In 1916 enrolls at Pennsylvania Academy of the Fine Arts, Philadelphia; studies with Daniel Garber and Edward Redfield. Silver medalist at Panama-California Exposition, San Diego, 1915–16. Serves in the army, 1918–19. To Europe on scholarship, 1920–21. Returns to San Diego. Founding member Associated Artists of San Diego (1929). Member Laguna Beach Art Association and La Jolla Art Association.

MARY DENEALE MORGAN

Born 1868, San Francisco, California

Died 1948, Carmel, California

See plate 150.

Landscape painter. Early and longtime pupil of William Keith; also studies at California School of Design under Virgil Williams and Emil Carlsen, 1884–92, and again in 1895. Opens a studio in Oakland, 1896. First one-person exhibition at Hahn Gallery, Oakland, 1907. To Carmel by 1908; student of William Merritt Chase during his summer classes at Carmel, 1914. Awarded a silver medal at Panama-Pacific International Exposition, San Francisco, 1915; Member California Water Color Society, Los Angeles; Carmel Art Association; Laguna Beach Art Association; and National Association of Women Painters and Sculptors. One-person exhibition at Hotel del Monte Art Gallery, 1934.

ERNEST NARJOT

Born 1826, Saint-Malo, France

Died 1898, San Francisco, California

See plate 31.

Landscape and genre painter. Studies art in Paris before participating in California gold rush, 1849; both mines and paints for the next thirteen years.

In 1865 establishes successful studio in San Francisco, painting detailed genre scenes based on his mining experiences. Many works lost posthumously in the 1906 fire in San Francisco. Member San Francisco Art Association.

ERNEST BRUCE NELSON

Born 1888, Santa Clara, California

Died 1952, New York, New York

See plates 63, 182, 183, 250.

Landscape painter. Studies engineering at Stanford University in 1905; meets Robert B. Harshe, head of the art department, who influences him to change major to architecture. Works as architect in San Francisco after graduation. Goes to New York and studies at Art Students League, including summer classes at Woodstock, New York, with Tonalist painter Birge Harrison. Returns to San Francisco, 1912. Opens studio in Pacific Grove, 1913; teaches and exhibits in Los Angeles and San Francisco. Has one-artist shows at Helgesen Galleries, San Francisco, 1914, and at Oakland Museum, 1916. Silver medalist at Panama-Pacific International Exposition, San Francisco, 1915. Serves in

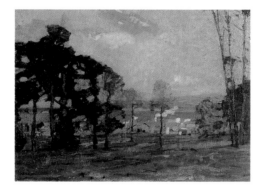

250. Bruce Nelson (1888–1952).
The Village, c. 1915.
Oil on canvas, 18¼ x 24¼ in. (46.3 x 61.5 cm).
Fine Arts Museums of San Francisco; Museum Purchase, Skae Fund Legacy.

World War 1, then lives and paints in Cooperstown, New York; presumably moves to New York City after that and stops painting sometime in the mid-1920s.

JOHN O'SHEA

Born 1876, Ballintaylor, Ireland

Died 1956, Carmel, California

See plate 73.

Landscape painter. Immigrates to United States as teenager; studies at Art Students League, New York, at least one year with George Bridgman; works briefly at Tiffany and Company as engraver. To Pasadena, 1913. Takes a studio in Laguna Beach, 1914, and has solo exhibition at Friday Morning Club in Los Angeles that year. Visits Carmel and Monterey, 1916. One-artist shows at Helgesen's Galleries, San Francisco, 1919; then in 1920 at Kingore Galleries, New York. Settles in Carmel Highlands, 1923; builds a house he names Tynalacan. Member American Water Color Society, New York; Bohemian Club, San Francisco; California Art Club, Los Angeles; Carmel Art Association (founded in 1927, later is director); and San Francisco Art Association.

EDGAR ALWIN PAYNE

Born 1883, Washburn, Missouri

Died 1947, Hollywood, California

See plates 67, 68, 205, 251.

Landscape painter. In Chicago by 1907; studies briefly at Art Institute of Chicago. Begins painting landscapes, exhibits at Palette and Chisel Club, Chicago. Visits California in 1909 and again in 1911, when he meets Elsie Palmer; they marry in 1912. Resides in Chicago until 1917, exhibits at Art Institute and Palette and Chisel Club. To California, 1917; settles in Laguna Beach. Remains an inveterate traveler throughout his career; paints throughout the Southwest, Canada, and Europe, 1922–24, again in 1928; exhibits at Paris Salon, 1923. Writes the book *Composition of Outdoor*

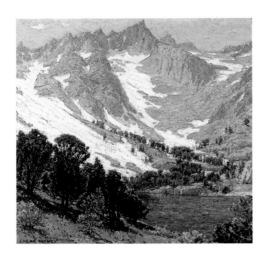

251. Edgar Payne (1883–1947).
Lake Sabrina (Rugged Slopes of Tamarak), n.d.
Oil on canvas, 45 x 45 in. (114.3 x 114.3 cm).
Barbara and Thomas Stiles.

Painting in 1941 (still in print). Member California Art Club, Los Angeles; Chicago Art Club; Laguna Beach Art Association (founding member and president, 1918); Palette and Chisel Club; and Salmagundi Club, New York.

ERNEST CLIFFORD PEIXOTTO

Born 1869, San Francisco, California
Died 1940, New York, New York
See plates 25, 26, 100.
Landscape and figure painter, muralist, and illustrator. Studies at California School of Design, San Francisco, c. 1886–88, and Académie Julian, Paris, 1888–90, 1891–93. Teaches at California School of Design, 1893. In Giverny frequently, 1889–95. Exhibits at Paris Salon in 1890, 1891, and 1895, as well as in the United States. Gains wide reputation as muralist and illustrator. Active primarily in New York; Fontainebleau, France; and Cornish, New Hampshire. Writes and illustrates the book *Romantic California*, 1911. Official artist for Ameri-

can Expeditionary Force, 1918. Director of mural painting, Beaux-Arts Institute, New York, 1919–26. Writes numerous travel books. Affiliated with many art organizations, including Art Commission of the City of New York and Fontainebleau School of Fine Arts. Member National Society of Mural Painters, New York, and Society of Illustrators, New York.

HANSON DUVALL PUTHUFF

Born 1875, Waverly, Missouri
Died 1972, Corona del Mar, California
See plates 71, 128, 130.
Landscape painter. Attends University of Denver Art School, graduates in 1893, then studies at Chicago Academy of Fine Arts. To Los Angeles, 1903. Supports himself painting billboards while also painting plein air landscapes. Instrumental in founding Art Students League of Los Angeles with critic Antony Anderson, 1906. Silver medalist at Panama-California Exposition, San Diego, 1915–16. Begins painting full-time in 1926. Founding member Painters' Club, Los Angeles, and California Art Club, Los Angeles; member Laguna Beach Art Association, Painters and Sculptors Club, Los Angeles; and Pasadena Society of Artists.

JOSEPH MORRIS RAPHAEL

Born 1869, Jackson, California
Died 1950, San Francisco, California
See plates 17–19, 154–56, 158, 159.
Landscape, still-life, and genre painter. Studies at California School of Design, San Francisco, 1887–97, under Arthur Mathews and Douglas Tilden. To Paris, 1902; studies at Académie Julian. Remains in Europe for the next thirty-seven years, living in Holland, France, and Belgium; exhibits at Paris Salons of 1904, 1905, and 1906. Silver medalist at Panama-Pacific International Exposition, San Francisco, 1915. While living abroad regularly exhibits his Impressionist-influenced work in San Francisco. Flees World War II in

Europe, 1939, and establishes studio on Sutter Street in San Francisco.

GRANVILLE RICHARD SEYMOUR REDMOND

Born 1871, Philadelphia, Pennsylvania
Died 1935, Los Angeles, California
See plates 11, 91, 96, 252.
Landscape painter. Scarlet fever leaves him deaf at age two-and-a-half; attends Institution for the Deaf, Dumb and Blind in Berkeley (now the California School for the Deaf, Fremont). Receives encouragement and instruction from deaf artist Theophilus Hope d'Estrella; enrolls at California School of Design, San Francisco, 1890. To Europe, 1893; studies at Académie Julian, Paris, and shows at Salon of 1895. Returns to California; settles in Los Angeles, later Monterey, then San Mateo before returning to Los Angeles in 1917. Meets and befriends Charlie Chaplin and appears in seven silent movies. Continues to paint throughout California with a style that vacillates between Tonalism and Impressionism. Member Bohemian Club, San Francisco; California Art Club, Los Angeles; Laguna Beach Art Association; and San Francisco Art Association.

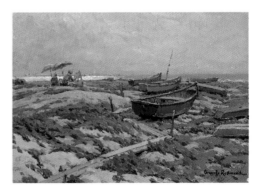

252. Granville Redmond (1871–1935).
By the Sea, c. 1920.
Oil on canvas, 12 x 16 in. (30.4 x 40.6 cm).
Joseph L. Moure.

CHARLES REIFFEL

Born 1862, Indianapolis, Indiana
Died 1942, San Diego, California
See plates 22, 74, 234.

Landscape painter. Begins as lithographer at Stowbridge Lithography, Cincinnati; in 1891 joins Stafford Company, Nottingham, England. On tour of Europe, studies briefly under Carl Marr at Munich Academy of Fine Arts—his only formal training. Returns to United States, c. 1897; resides in Buffalo where he continues to work as a lithographer. Exhibits at Albright Gallery in Buffalo, 1904; 1908, wins Fellowship Prize, Buffalo Society of Artists. In 1912 moves to art colony in Silvermine, Connecticut; helps to organize Silvermine Artists' Guild and is its first president, 1923. To San Diego, 1925; becomes active in local art community. Member Arts Club of Washington, D.C.; California Art Club, Los Angeles; Chicago Galleries Association; Cincinnati Art Club; Laguna Beach Art Association; Salmagundi Club, New York; and San Diego Art Guild.

JOHN HUBBARD RICH

Born 1876, Boston, Massachusetts
Died 1954, Los Angeles, California
See plates 177, 188.

Figure, portrait, still-life painter. Studies at the Art Students League, New York, 1898–1902, then goes to the School of the Museum of Fine Arts, Boston, where he receives a scholarship to travel and study in Europe. Teaches at the Groton School, Boston, 1912. In 1914, meets artist William Cahill, and the two move to Los Angeles together and establish the School for Illustrating and Painting; Rich also teaches at the University of Southern California and Otis Art Institute. Member California Art Club, Los Angeles; Laguna Beach Art Association; Salmagundi Club, New York; and San Diego Art Guild. One-person shows at Los Angeles Museum of History, Science and Art, 1917 and 1939; silver medal at Panama-California Exposition, San Diego, 1915–16; winner of California Art Club's Harrison Prize for best painting, 1922.

ARTHUR GROVER RIDER

Born 1886, Chicago, Illinois
Died 1975, Los Angeles, California
See plates 24, 211, 212, 232.

Landscape painter. Studies at Chicago Academy of Fine Arts, then at Académie Colarossi and Académie de la Grande Chaumière, Paris. Spends summers painting in Spain, where he comes under the strong influence of Spanish Impressionist Joaquín Sorolla. Visits California in 1920s; settles there in 1931. Works for Twentieth Century–Fox and MGM studios until retiring at eighty-four. Paints fishermen and children on the beach in manner derivative of Sorolla. Member California Art Club, Los Angeles; Chicago Galleries Association; Laguna Beach Art Association; and Painters and Sculptors Club, Los Angeles.

WILLIAM FREDERICK RITSCHEL

Born 1864, Nuremburg, Germany
Died 1949, Carmel, California
See plates 43, 134, 135, 216, 217, 253.

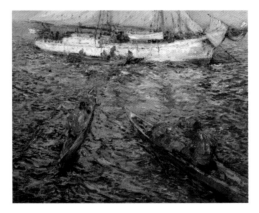

253. William Ritschel (1864–1949).
Southsea Trader, n.d.
Oil on board, 30 x 36 in. (76.2 x 91.4 cm).
Barbara and Thomas Stiles.

Landscape painter, marine specialist. Studies at Munich Academy of Fine Arts, followed by extensive travel in Europe. Immigrates to United States, 1895; exhibits in New York before moving to California sometime after 1909. Gold medalist at Panama-Pacific International Exposition, San Francisco, 1915. In 1918 constructs a huge stone house called Castle a Mare on a bluff overlooking the Pacific in Carmel. Paints in South Seas, 1921–22; visits Orient in 1924. Member Carmel Art Association; National Academy of Design, New York; Salmagundi Club, New York; San Francisco Art Association; and Society of Western Artists, Chicago.

GUY ORLANDO ROSE

Born 1867, San Gabriel, California
Died 1925, Pasadena, California
See plates 3, 4, 8, 87, 94, 161, 163–66, 187, 189, 193.

Landscape and figure painter, illustrator. Studies at California School of Design, San Francisco, 1885–87, and Académie Julian, Paris, 1888–89. Lives in France, 1888–90; exhibits at Salon in 1890, 1891, and 1894. Returns to United States in 1891, and becomes a successful illustrator in New York. Returns to Paris, 1893–94, and again in 1899, when he travels extensively throughout Europe and North Africa. Buys a cottage in Giverny and resides there, 1904–12. Exhibits with the "Giverny Group" in New York, 1910. Settles in Pasadena, 1914. Holds numerous one-artist shows in Los Angeles area; exhibits in New York and elsewhere in the United States. Director of Stickney Memorial School of Art, Pasadena, 1919–21. Member California Art Club, Los Angeles, and Los Angeles Museum of Science, History and Art (board member).

MARY HERRICK ROSS

Born 1856, San Francisco, California
Died 1935, Piedmont, California
See plate 157.

Still-life painter. Ross is first painter to enter California School of Design, San Francisco, when it

opens in 1874 (according to Edan Hughes), where she studies with Virgil Williams. Lives in Bay Area her entire life, painting primarily still lifes; examples of her work are uncommon. Exhibits at World's Columbian Exposition in Chicago, 1893; Mark Hopkins Institute of Art, San Francisco, 1897; in various local exhibitions throughout the 1910s and '20s.

DETLEF SAMMANN
Born 1857, Westrehever, Germany
Died 1921, Dresden, Germany
See plates 40, 126.

Landscape painter, muralist. Trains as a muralist in Dresden, then studies four years with Wilhelm Ritter at the Academy of Art and College for Industrial Art, Dresden. Immigrates to New York, 1881; works as interior decorator. To California, 1898; active in San Diego before moving to Pasadena. Paints murals in local houses, including that of prominent Los Angeles businessman Edward L. Doheny. Moves north to Pebble Beach, 1912; exhibits at Hotel del Monte Art Gallery, Monterey, and with the San Francisco Art Association. In Los Angeles, exhibits with California Art Club (wins Best of Show award at the club's fourth annual exhibition, 1913); Friday Morning Club and Kanst Art Galleries (both Los Angeles), both 1914. Returns to Dresden, 1921.

DONNA NORINE SCHUSTER
Born 1883, Milwaukee, Wisconsin
Died 1953, Los Angeles, California
See plates 168, 201–3.

Landscape painter. Attends Art Institute of Chicago, then Boston Museum of Fine Arts School, studying with Edmund C. Tarbell and Frank W. Benson. Takes a painting tour of Belgium with William Merritt Chase, 1912; studies with Chase again in Carmel, 1914. Paints series of watercolor sketches in San Francisco depicting the construction of the Panama-Pacific International Exposition, fall 1914. Silver medalist, Panama-Pacific International Exposition, San Francisco, 1915. In 1923 builds studio-home in Griffith Park, Los Angeles. Member California Art Club, Los Angeles; California Water Color Society, Los Angeles; Laguna Beach Art Association; and West Coast Arts, Laguna Beach.

WILLIAM POSEY SILVA
Born 1859, Savannah, Georgia
Died 1948, Carmel, California
See plate 218.

Landscape painter. A prosperous merchant, Silva begins his art career when nearly fifty years old; studies at Académie Julian, Paris, 1907. Returns to United States, 1910; exhibits in the South. Moves to California, 1913; settles in Carmel and specializes in views of local landscape. In 1928 wins two-thousand-dollar Edgar B. Davis Prize in San Antonio, Texas, competition. Member California Art Club, Los Angeles; Carmel Art Association; Mississippi Art Association, Jackson; New Orleans Art Association; Salmagundi Club, New York; Society of Washington Artists, Washington, D.C.; and Southern States Art League, New Orleans.

JACK WILKINSON SMITH
Born 1873, Paterson, New Jersey
Died 1949, Monterey Park, California
See plates 131, 133, 221.

Landscape painter. Studies at Art Institute of Chicago, where he sees work of William Wendt. Later studies with Frank Duveneck at Cincinnati Art Academy. Visits California in 1906; settles in Alhambra, where he lives next to sculptor Eli Harvey and painter Frank Tenney Johnson. Silver medalist at Panama-California Exposition, San Diego, 1915–16. An outspoken critic of modern art, in 1923 he helps to found the Biltmore Salon, devoted to the promotion of western art and artists. Member California Art Club, Los Angeles; Laguna Beach Art Association; Painters' Club, Los Angeles; and

Sketch Club, Los Angeles (which gives him a one-artist show in 1914).

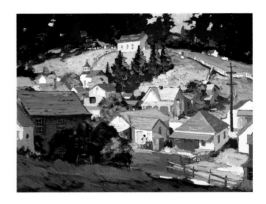

254. John Christopher Smith (1891–1943). *Cambria*, n.d. Oil on canvas, 24 x 30 in. (60.9 x 76.2 cm). Fleischer Museum, Scottsdale, Arizona.

JOHN CHRISTOPHER SMITH
Born 1891, Ireland
Died 1943, Los Angeles, California
See plates 230, 254.

Landscape painter. To United States, c. 1903; serves in American Expeditionary Force during World War I. Studies with Robert Henri in New York after the war. Goes to Chicago before moving to Los Angeles in 1920. With close friend Franz Bischoff, paints along the California coast; adopts elements of Bischoff's geometric and highly colorful technique. Paints in Zion National Park, Utah, with Bischoff, 1928. The two exhibit together until Bischoff's death in 1929, the year Smith apparently retires from painting and begins to focus on interior design.

JACK GAGE STARK
Born 1882, Jackson County, Missouri
Died 1950, Santa Barbara, California
See plate 39.

Landscape painter. To Paris by 1900 for study at

Académie Delecluse and La Palette. Back in United States, lives in New Mexico until about 1915. Exhibits regularly in Los Angeles, where he is perhaps the first artist to be called an Impressionist by critic Antony Anderson, in a review of 1909. Moves to Los Angeles, 1915. After military service in World War I, returns to California, living first in Los Angeles and later in Santa Barbara. Member California Art Club, Los Angeles.

GEORGE GARDNER SYMONS

Born 1862, Chicago, Illinois
Died 1930, Hillside, New York
See plates 42, 239.

Landscape painter. Studies at Art Institute of Chicago, where he befriends and paints with William Wendt. He and Wendt paint in California, 1896; they travel together to Cornwall, England, 1898. Builds a studio at Laguna Beach, c. 1903; maintains studio in Brooklyn, New York, and in the Berkshires of Massachusetts. Member California Art Club, Los Angeles; Chicago Society of Artists; Laguna Beach Art Association; National Academy of Design, New York; National Arts Club, New York; and Salmagundi Club, New York.

CHANNEL PICKERING TOWNSLEY

Born 1867, Sedalia, Missouri
Died 1921, London, England
See plate 152.

Landscape painter. Studies with William Merritt Chase in New York City, followed by studies in Paris at Académie Julian, 1880–81, and Académie Delecluse. Works as assistant at Chase's Shinnecock Summer School on Long Island, New York, and director of the Carmel Summer School during Chase's summer classes in Carmel, California, 1914. Decides to reside permanently in California in 1914; becomes director of the Stickney Memorial School of Art, Pasadena. Becomes director of Otis Art Institute, Los Angeles, 1918. Member Salmagundi Club, New York.

CHRISTIAN VON SCHNEIDAU

Born 1893, Smoland, Sweden
Died 1976, Orange, California
See plate 255.

Landscape, portrait, and genre painter; muralist. As a young man, studies with private tutors in Sweden. Immigrates to United States in 1906, lives in Minnesota; later studies at Art Institute of Chicago. To Los Angeles in 1917; establishes Von Schneidau School of Fine Art. Remains an active teacher and exhibitor throughout his life. One-

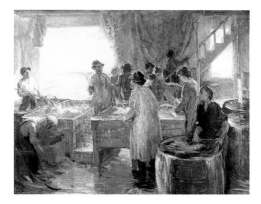

255. Christian von Schneidau (1893–1976).
 Fishmarket, Provincetown, n.d.
 Oil on canvas, 46 x 56 in. (116.8 x 142.2 cm).
 Fleischer Museum, Scottsdale, Arizona.

artist show at Los Angeles Athletic Club and Franklin Galleries, Hollywood, 1922. Member California Art Club, Los Angeles; California Water Color Society, Los Angeles; Laguna Beach Art Association; Los Angeles Art Association; and Painters and Sculptors Club, Los Angeles.

ELMER WACHTEL

Born 1864, Biltmore, Maryland
Died 1929, Guadalajara, Mexico
See plates 78, 117, 231, 237.

Landscape painter. Moves to Southern California in 1882 to live with his brother John, who is

married to Guy Rose's sister and who manages the Rose ranch. A musician as well as a painter, Wachtel plays first violin with the Philharmonic Orchestra in Los Angeles, 1888. To New York in 1895 to study at Art Students League; leaves after only two weeks. Returns to California, 1896; illustrates Charles Lummis's magazine *Land of Sunshine,* which runs a feature article on Wachtel. Marries artist Marion Kavanaugh, 1903; they become permanent painting companions. One-artist exhibitions at Los Angeles Museum of History, Science and Art, 1915 and 1918; memorial exhibition at Kanst Art Galleries, Los Angeles, 1930.

MARION KAVANAGH WACHTEL

Born 1876, Milwaukee, Wisconsin
Died 1954, Pasadena, California
See plates 129, 256.

Landscape painter. Studies at Art Institute of Chicago; in New York with William Merritt Chase; and in San Francisco with William Keith, who refers her to the artist Elmer Wachtel, whom she marries in 1903. The two travel extensively together, painting. Kavanagh (she drops the *u* from

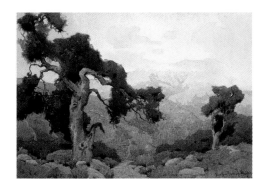

256. Marion Wachtel (1876–1954).
 San Gabriel Canyon, n.d.
 Watercolor on paper, 18 x 24 in. (45.7 x 60.9 cm).
 Oakland Museum of California; Gift of Joseph L. Moure in honor of Nancy Dustin Wall Moure.

her maiden name after marriage) has one-artist shows at Los Angeles Museum of History, Science and Art in 1915 and 1917. Member American Water Color Society, New York; Pasadena Society of Artists; and Society of Western Artists, Chicago.

WILLIAM WENDT

Born 1865, Bentzen, Germany
Died 1946, Laguna Beach, California
See plates 16, 32, 33, 72, 90, 108, 116, 122, 123, 127, 215.
Landscape painter. Immigrates to United States in 1880; settles in Chicago, where he works as a commercial artist. Attends classes at Art Institute of Chicago; befriends Gardner Symons. Travels to California, 1896, with Symons, then to Cornwall, England, 1898. Exhibits at Paris Salon of 1899. Settles in California with his wife, the sculptor Julia Bracken Wendt, 1906. Moves to Laguna Beach, 1912. Among his many awards are a silver medal from Panama-Pacific International Exposition, San Francisco, 1915, and a gold medal from Pan-American Exhibition, Los Angeles, 1925. Regularly exhibits in Los Angeles, Chicago, and New York. Founding member and president for many years of California Art Club, Los Angeles. Member Laguna Beach Art Association; Painters' Club, Los Angeles; and National Academy of Design, New York.

ORRIN AUGUSTINE WHITE

Born 1883, Hanover, Illinois
Died 1969, Pasadena, California
See plate 233.
Landscape painter. After earning bachelor's degree from Notre Dame University in 1902, early career is in textile design. To Los Angeles, 1912; works in interior design and paints landscapes in free time. Decides to paint full-time after his work is accepted for exhibition at Panama-Pacific International Exposition, San Francisco, 1915. Builds studio in Pasadena, 1923; makes regular sketching trips to Palm Springs, the Sierra Nevada, and Mexico. One-artist exhibitions at Battey Gallery, Pasadena, 1916; Stendahl Galleries, Los Angeles, 1929; and Los Angeles County Museum, 1940. Member California Art Club, Los Angeles, and Society of Western Artists, Chicago.

THEODORE WORES

Born 1859, San Francisco
Died 1939, San Francisco
See plates 145, 219, 220.
Landscape, portrait, and genre painter. Takes lessons at age twelve from Joseph Harrington; is one of the first students to enroll at California School of Design, San Francisco, in 1874, under Virgil Williams. To Europe for training at Royal Academy, Munich; influenced by Frank Duveneck and James McNeill Whistler. Back to San Francisco in 1881; paints views of Chinatown. Travels extensively: to Japan in mid-1880s, then Europe, and Japan again in the 1890s, before returning to San Francisco in 1898; in Hawaii, Samoa, and Spain,

1901–3. Loses his home and studio in fire of 1906; next year he becomes dean of the Mark Hopkins Institute of Art, San Francisco. In 1913, paints in Hawaii and Canada; in 1915–17, in New Mexico. Gold medalist at Panama-Pacific International Exposition, San Francisco, 1915. Establishes a studio in Saratoga, California, 1926, and concentrates on impressionistic landscapes in addition to figure studies and genre scenes. Numerous exhibitions and awards. Member Bohemian Club, San Francisco; Century Club, New York; New English Art Club, London; Salmagundi Club, New York; and San Francisco Art Association.

KARL JULIUS HEINRICH YENS

Born 1868, Altona, Germany
Died 1945, Laguna Beach, California
See plate 222.
Landscape and figure painter, muralist. Studies in Berlin with Max Koch, then in Paris at Académie Julian. Immigrates to United States, 1901. To Southern California in 1910; moves to Laguna Beach, 1918. Member California Art Club, Los Angeles; California Water Color Society, Los Angeles; Laguna Beach Art Association (founding member); Painters and Sculptors Club, Los Angeles; San Diego Fine Arts Society; and Society of Western Artists, Chicago.

Acknowledgments

Our goal with *California Impressionism* is to provide an overview of the events and artists involved with Impressionist painting in the Golden State from about 1890 to 1930, an overview that will introduce California art and artists to a larger audience. This volume represents a collaboration: we took equal share in determining which works would be reproduced in color and in mapping the historical scope of the study, and we carried on a continual dialogue about the nature of Impressionism and the vagaries of art history.

This work would never have materialized without the vision of Mort and Donna Fleischer. The Fleischers—longtime collectors of California art and founders of the Fleischer Museum in Scottsdale, Arizona, which is dedicated to the sharing of that collection—saw the need for a comprehensive volume on the subject that was not limited to a single artist, group of artists, region of the state, or theme, and, most importantly, one not restricted to a California audience. It was not their intention to "preach to the converted" with this book but rather to assist in bringing early California art to the attention of the entire country and the world. It was Mort and Donna who conceived of this book, who connected the publisher and the authors, and who have supported its production.

Our study has, of course, been dependent on the work of many people who have been diligent for years in their efforts to unearth and promote California art. We found at every turn that Californians and non-Californians alike were ready and willing to support our efforts, giving generously of their time and expertise. In the museum field, we thank Peter C. Keller, executive director, Armand J. Labbé, director of research and collections, and Jacqueline Bryant, curatorial researcher, Bowers Museum of Cultural Art, Santa Ana, California; Dawn Pheysey, Museum of Art at Brigham Young University, Salt Lake City; Janice Driesbach, Crocker Art Museum, Sacramento; Patricia Junker, associate curator, American art, Fine Arts Museums of San Francisco; Jean Stern, director, Irvine Museum, Irvine, California; Bolton Colburn, curator, and Victoria Chapman, registrar, Laguna Art Museum, Laguna Beach, California; Ilene Susan Fort, curator of American art, Los Angeles County Museum of Art; Katherine B. Crum, director, Art Gallery, Mills College, Oakland, California; Margaret Conrads, Nelson-Atkins Museum of Art, Kansas City, Missouri; Harvey Jones, senior curator, art, and Kathy Borgogno, Oakland Museum, Oakland, California; Robert Henning, director of curatorial services, Santa Barbara Museum of Art, Santa Barbara, California; Susan Berry, director, Silver City Museum, Silver City, New Mexico; and Barney Bailey, collections manager, and Stephanie Cannizzo, rights and reproductions, University Art Museum/Pacific Film Archive, Berkeley, California.

Among the collectors of California art, we thank Joseph Ambrose and Michael Feddersen, Los Angeles; Paul and Kathleen Bagley, Princeton, New Jersey; Dr. and Mrs. Edward H. Boseker, Santa Ana, California; Gerald E. and Benthe Buck, Laguna Hills, California; Henry F. and Jennifer Burroughs, Los Angeles; Stephen and Suzanne Diamond, Santa Clara, California; John and Patrick Dilks, Carmel, California; Thomas Gianetto, Los Angeles; Daryn and William L. Horton, Los Angeles; Oscar and Trudy Lemer, San Francisco; Bob Lovett, Atlanta; Joseph Moure, Pasadena, California; Forrest and Sue Nance, Carmel, California; Genelle Relfe, San Francisco; Roy C. Rose, Carmel Highlands, California; Mr. and Mrs. Mark Salzburg, Basking Ridge, New Jersey; Dr. A. Jess Shenson, San Francisco; Joan Irvine Smith, Irvine, California; Thomas and Barbara Stiles, New York; Mr. and Mrs. Robert Veloz, Montecito, California; Marcel Vinh, Los Angeles; and Mr. and Mrs. James Zidell, Los Angeles.

Among the dealers of California art, many of whom shared their libraries and historical insights as well as valuable logistical knowledge, we thank Barbara Klein, Craftsmans' Guild, San Francisco; Dewitt C. McCall III, De Ru's Fine Art Gallery and Fine Art Books, Bellflower, California; John and Joel Garzoli, Garzoli Gallery, San Rafael, California; Phyllis Hattis, New York; Michael Johnson, Fallbrook, California; William Karges, Whitney Ganz, and Patrick Kraft of William Karges Fine Art, Los Angeles and Carmel, California; Mark and Colleen Hoffman, Maxwell Galleries, Ltd., San Francisco; Maureen Murphy, Maureen Murphy Fine Arts, Montecito, California; Alfred C. Harrison Jr., director, and Jessie Dunn-Gilbert, North Point Gallery, San Francisco; Nathaniel Owings, Owings-Dewey Fine Art, Santa Fe; Ray

Redfern, director, and Robert Haltom, gallery assistant, Redfern Gallery, Laguna Beach, California; Jason Schoen, New Orleans; Ira and Gavin Spanierman, Spanierman Gallery, New York; George Stern, director, and Robyn Dunn, gallery assistant, George Stern Fine Arts, Los Angeles; Gary Breitweiser, Studio 2, Santa Barbara, California; and Terry and Paula Trotter, Trotter Galleries, Carmel, California.

Key individuals representing private clubs and corporations were also invaluable to our project. We thank Peter and Elaine Adams, California Art Club, Pasadena; William L. Horton, Lawrence P. Day, and Harry G. Richter, California Club, Los Angeles; Robin Stropko, Fieldstone Collection of Early California Art, Newport Beach, California; and Dr. Patricia Trenton, curator, Los Angeles Athletic Club, who not only made works of art belonging to the Athletic Club available to us, but whose scholarship and curatorial achievements in California art provided us with ideas and information necessary to our own project.

Indeed, a number of independent scholars paved the way for the creation of *California Impressionism*. First among these is Nancy Moure, whom we may call the Dean of Historians of California Art. Her groundbreaking efforts and accomplishments in this field provide the foundation upon which subsequent studies, including this one, have been built.

We are also indebted to the following individuals: Susan M. Anderson; Nancy Boas, especially for her work on the Society of Six; Paul Bockhorst; Kathleen Burnside; the late John Caldwell; Edan Hughes, San Francisco, author of the invaluable *Artists in California*, soon to be published in a third and final edition; the late Bruce Kamerling; Phil Kovinick and Marian Yoshiki-Kovinick, for their research on the project; Susan Landauer; David M. Martin; Stephen H. Meyer; Walter Nelson-Rees and James L. Coran; Martin Petersen; and Ruth Westphal.

Librarians, as ever, were indispensable. Thanks especially to Dorothy Greenland and Myron Patterson, Fine Arts Division, Marriott Library, University of Utah; and to Jeff Gunderson, San Francisco Art Institute.

Many descendants of the artists included here were generously helpful. They include: Barbara Douglass, San Diego, for her assistance with Detlef Sammann; Ida G. Hawley, Fallbrook, California, for her assistance with William Griffith; Nicholas Kilmer, for his assistance with Frederick Frieseke; Johanna Sibbett, for her assistance with Joseph Raphael; and Robert K. Vickery, Salt Lake City, for his assistance with Lucy Bacon.

We are grateful to the staff and freelancers at Abbeville Press for their professionalism as well as their patience: Mary Christian and Nancy Grubb, editors; Elizabeth Boyle, picture researcher; Celia Fuller, designer; and Lou Bilka, production manager.

Finally, for their continued support, understanding, and benevolent guidance, we thank our families: Abigail Gerdts and Allison and Sara South.

Selected Bibliography

WILL SOUTH

ARCHIVAL AND UNPUBLISHED SOURCES

Archives of American Art, Smithsonian Institution, Washington, D.C.: Philip Leslie Hale Papers; Ferdinand Perret Papers; Earl Stendahl Papers; Mabel Woodward Papers; Macbeth Gallery Papers; Joseph Moure Papers (unfilmed).

Archives of California Art, Oakland Museum, Oakland, Calif.: Euphemia Charlton Fortune Papers.

Boettger, Suzaan. "The Art History of San Diego to c. 1935." Seminar paper, Graduate School of the City University of New York, January 1986. Courtesy of William H. Gerdts.

Breitweiser, Gary. "Art in Santa Barbara: A Brief History," 1982. Typescript, Santa Barbara, Calif.

Comstock, Sophia P. "Painters of Northern California." Paper presented at the Kingley Art Club, Sacramento, March 15, 1909. Typescript, California State Library, Sacramento.

Fletcher, Robert H. "Memorandum of Artist," 1906. Manuscript, California State Library, Sacramento.

_____. "The Progress of Art in California." In "Art and Music in California," *News Notes of California Libraries* (California State Library) 3 (January–October 1908): 3–29.

_____, ed. *The Annals of the Bohemian Club.* 5 vols. San Francisco, 1898–1972.

Frank C. Havens' World Famed Collection of Valuable Paintings by Great Ancient and Modern Masters. Auction brochure, 1917. Copy in Oakland Public Library, Oakland, Calif.

Harwood, James Taylor. *A Basket of Chips.* Memoirs, typescript copy in the James T. Harwood Papers, Special Collections, Marriott Library, University of Utah, Salt Lake City, 1985.

_____. Letters to Harriet Richards [later Harriet Richards Harwood], 1888–90. Private collection. Numerous references to Guy Rose and to other California painters.

Higgins, Winifred Haines. "Art Collecting in the Los Angeles Area, 1910–1960." Ph.D. diss., University of California, Los Angeles, 1963.

Inventory of American Art. National Museum of American Art, Smithsonian Institution, Washington, D.C.

Lytle, Rebecca Elizabeth. "People and Places: Images of Nineteenth-Century San Diego." M.A. thesis, San Diego State University, 1978.

"*Registre pour inscrire les voyageurs, 1887–1899, Hôtel Baudy, Giverny, France.*" Department of Prints, Drawings, and Photographs, Philadelphia Museum of Art. Transcribed and extracted by Carol Lowrey, in William H. Gerdts, *Monet's Giverny: An Impressionist Colony.* New York: Abbeville Press, 1993.

Rose, Ethel. "Camping in Algeria." Courtesy of the Rose Family Collection.

Rose Family Collection. Letters, photographs, and unpublished articles in the private collection of descendants of Guy Rose.

San Francisco Art Association Collection. School Committee Meetings/Awards Minute Book, 1873–1905, San Francisco Art Institute.

Schwartz, Ellen. *Guide to the Baird Archive of*

California Art: University Library, University of California. Davis: Department of Special Collections and Library Associates, University Library, University of California, 1979.

_____. *Nineteenth-Century San Francisco Art Exhibition Catalogues: A Descriptive Checklist and Index.* Davis: Library Associates, University Library, University of California, 1981.

Scrapbooks of the Los Angeles Museum of History, Science and Art, 1914–17, on file at Los Angeles County Museum of Natural History.

BOOKS AND EXHIBITION CATALOGS

Anderson, Antony. *Elmer Wachtel: A Brief Biography.* Los Angeles: Carl A. Bundy Quill and Press, 1930.

Anderson, Antony, and Peyton Boswell. *Catalogue of the Guy Rose Memorial.* Los Angeles: Stendahl Galleries, 1926.

Anderson, Antony, and Fred S. Hogue. *Edgar Alwyn [sic] Payne and His Work.* Los Angeles: Stendahl Galleries, 1926.

Anderson, Antony, Fred S. Hogue, Alma May Cook, and Arthur Millier. *William Wendt and His Work.* Los Angeles: Stendahl Galleries, 1926.

Anderson, Antony, and Earl Stendahl. *Guy Rose: Paintings of France and America.* Los Angeles: Stendahl Galleries, 1922.

Anderson, Antony, et al. *Art in California: A Survey of American Art with Special Reference to California Painting, Sculpture and Architecture Past and Present Particularly as Those Arts Were*

Represented at the Panama-Pacific International Exposition. San Francisco: R. L. Bernier, 1916.

Arkelian, Marjorie. *Tropical Scenes by the Nineteenth-Century Painters of California.* Oakland, Calif.: Oakland Museum, 1971.

———. *The Kahn Collection of Nineteenth-Century Paintings by Artists in California.* Oakland, Calif.: Oakland Museum, 1975.

Armin Hansen: The Jane and Justin Dart Collection. Introduction by Jo Farb Hernandez and essays by Anthony R. White and Charlotte Berney. Monterey, Calif.: Monterey Peninsula Museum of Art, 1993.

"Art Department." In *Final Report of the California World's Fair Commission . . . Chicago, 1893,* pp. 53–55, 125–27, 168–70. Sacramento, 1894.

Artists of California: A Group Portrait in Mixed Media. Oakland, Calif.: Oakland Museum, 1987.

Art of California: Selected Works from the Collection of the Oakland Museum. Oakland, Calif.: Oakland Museum; San Francisco: Chronicle Books, 1984.

Baird, Joseph Armstrong. *A Century of California Painting, 1870–1970.* Los Angeles: Crocker-Citizens National Bank, 1970.

———, comp. *Catalogue of Original Paintings, Drawings and Watercolors in the Robert B. Honeyman, Jr., Collection.* Berkeley: Friends of the Bancroft Library, University of California, 1968.

———, ed. *From Frontier to Fire: California Painting from 1816 to 1906.* Davis: University of California, 1964.

———. *Fifteen and Fifty: California Painting at the 1915 Panama-Pacific International Exposition, San Francisco, on Its Fiftieth Anniversary.* Davis: University of California, 1965.

———. *Theodore Wores and the Beginning of Internationalism in Northern California Painting, 1874–1915.* Davis: Library Associates, University Library, University of California, 1978.

———. *From Exposition to Exposition: Progressive and Conservative Northern California Painting, 1915–1939.* Sacramento: Crocker Art Museum, 1981.

———. *Views of Yosemite: The Last Stance of the Romantic Landscape.* Fresno, Calif.: Fresno Arts Center, 1982.

Baird, Joseph Armstrong, and Ellen Schwartz. *Northern California Art: An Interpretive Bibliography to 1915.* Davis: Library Associates, University Library, University of California, 1977.

Ball, Maudette W. *Southern California Artists, 1890–1940.* Laguna Beach, Calif.: Laguna Art Museum, 1979.

Berger, John A. *Fernand Lungren: A Biography.* Santa Barbara, Calif.: Schauer Press, 1936.

Berry, Rose V. S. *The Dream City: Its Art in Story and Symbolism.* San Francisco: Walter N. Brunt, 1915.

Boas, Nancy. *The Society of Six: California Colorists.* San Francisco: Bedford Arts, 1988.

Bockhorst, Paul, et al. *Impressions of California: Early Currents in Art, 1850–1930.* Irvine, Calif.: Irvine Museum, 1996.

Brinton, Christian. *Impressions of the Art at the Panama-Pacific International Exposition.* New York: John Lane Company, 1916.

California Art in Retrospect—1850–1915. San Francisco: Golden Gate International Exposition, Palace of Fine Arts, 1940.

California Collection of William and Zelma Bowser. Oakland, Calif.: Oakland Museum, 1970.

California Painters, 1860–1960. Sacramento, Calif.: E. B. Crocker Art Gallery, 1965.

California Painters Abroad. San Francisco: California Historical Society, 1963.

Carr, Carolyn Kinder, et al. *Revisiting the White City: American Art at the 1893 World's Fair.* Washington, D.C.: National Museum of American Art; National Portrait Gallery, Smithsonian Institution, 1993.

Catalogue of Paintings by Guy Rose. Los Angeles: Los Angeles Museum of History, Science and Art, 1919.

Catalogue of the Department of Fine Arts, Panama-Pacific International Exposition. San Francisco: Wahlgreen Company, 1915.

Catalogue of the Exhibition of Fine Arts, Pan-American Exposition. Buffalo: David Gray, 1901.

Catalogue of the Fifth Annual Exhibition of Selected Paintings by American Artists. Buffalo: Buffalo Fine Arts Academy, 1910.

Charles Arthur Fries: A Memorial Exhibition of His Painting Offered by the Fine Arts Society of San Diego. San Diego: Fine Arts Gallery, 1941.

Charles Reiffel: A Memorial Exhibition of His Paintings. San Diego: Fine Arts Gallery, 1942.

Coen, Rena Neumann. *The Paynes, Edgar and Elsie, American Artists.* Minneapolis: Payne Studios, 1988.

The Creative Frontier: A Joint Exhibition of Five California Jewish Artists, 1850–1928. Berkeley, Calif.: Judah L. Magnes Museum; San Francisco: Temple Emanu-El Museum, 1975.

Dominik, Janet. *Early Artists in Laguna Beach: The Impressionists.* Laguna Beach, Calif.: Laguna Art Museum, 1986.

Donna Norine Schuster, 1883–1953. Essay by Leonard R. de Grassi. Downey, Calif.: Downey Museum of Art, 1977.

Dorian Society. *Kern County Collects: The California Landscape.* Bakersfield, Calif.: California State University, 1990.

Enman, Tom K. *Fiftieth Anniversary History and Catalogue, 1918–1968.* Laguna Beach, Calif.: Laguna Beach Art Association, 1968.

Exhibition of Oils and Water Colors by Donna Schuster. Los Angeles: Los Angeles Museum of History, Science and Art, 1917.

Exhibition of Paintings by Guy Rose. Los Angeles: Los Angeles Museum of History, Science and Art, 1918.

Exhibition of Paintings by Joseph Kleitsch. Los Angeles: Stendahl Galleries, 1928.

Exhibition of Paintings by William Wendt and Sculpture by Julia Bracken Wendt. Los Ange-

les: Los Angeles Museum of History, Science and Art, 1918.

Exhibition of Paintings from the Museum's Permanent Collection. Los Angeles: Los Angeles Museum of History, Science and Art, 1923.

Exhibition of Water Colors by Donna Schuster. Los Angeles: Los Angeles Museum of History, Science and Art, 1920.

Fehrer, Catherine. "List of Students Enrolled at the Julian Academy." In *The Julian Academy, Paris,* unpaginated. New York: Shepard Gallery, 1989.

Feinblat, Ebria, and Bruce Davis. *Los Angeles Prints, 1883–1980.* Los Angeles: Los Angeles County Museum of Art, 1980.

Final Report of the California World's Fair Commission, Including a Description of All Exhibits from the State of California, Collected and Maintained under Legislative Enactments, at the World's Columbian Exposition, Chicago, 1893. Sacramento: A. J. Johnston, State Printer, 1894.

Fort, Ilene Susan, with Trudi Abram. *American Paintings in Southern California Collections.* Los Angeles: Los Angeles County Museum of Art, 1996.

Gamwell, Lynn, and Phil Kovinick. *Reaching the Summit: Mountain Landscapes in Southern California, 1900–1986.* Laguna Beach, Calif.: Laguna Art Museum; Saddleback College Art Gallery, 1968.

Gerdts, William H. *American Impressionism.* New York: Abbeville Press, 1984.

_____. "Northern California" and "Southern California." In vol. 3 of *Art across America: Two Centuries of Regional Painting, 1710–1920.* New York: Abbeville Press, 1990.

_____. *Lasting Impressions: American Painters in France, 1865–1915.* Chicago: Terra Foundation for the Arts, 1992.

_____. *Monet's Giverny: An Impressionist Colony.* New York: Abbeville Press, 1993.

Glenn, Constance, et al. *The Landscapes of Wil-*

liam Wendt. Long Beach: University Art Museum, California State University, 1989.

Griffith, William A. "Foreword." *William Wendt Retrospective Exhibition.* Los Angeles: Los Angeles County Museum, n.d.

Hailey, Gene, ed. *California Art Research.* 20 vols. San Francisco: Federal WPA Project, 1937.

Haley, Mary Jean. *Granville Redmond.* Based on "Granville Redmond," unpublished, by Mildred Abronda. Introduction by Harvey L. Jones. Oakland, Calif.: Oakland Museum, 1989.

Hatfield, Dalzell. *Joseph Kleitsch and His Work.* Los Angeles: Stendahl-Hatfield Art Galleries, 1928.

Hitchcock, Ripley. *The Art of the World, Illustrated in the Paintings, Statuary, and Architecture of the World's Columbian Exposition.* 5 vols. New York: D. Appleton, 1894.

Hoag, Betty Lochrie. *Del Monte Revisited.* Carmel, Calif.: Carmel Museum of Art, 1969.

Hopkins, Henry T. *Painting and Sculpture in California: The Modern Era.* San Francisco: San Francisco Museum of Modern Art, 1977.

Horizon: A Century of California Landscape Painting. Sacramento, Calif.: California Arts Commission, 1970.

Hough, Katherine Plake. *California's Western Heritage.* Palm Springs, Calif.: Palm Springs Desert Museum, 1986.

Hughes, Edan Milton. *Artists in California, 1786–1940.* San Francisco: Hughes Publishing Company, 1986.

Impressionistic Paintings by Western Artists Assembled by Oakland Art Gallery: September 17–October 14, 1924. Los Angeles: Los Angeles Museum of History, Science and Art, 1924.

Jeppson, Lawrence. *William Henry Clapp, American Impressionist.* Privately printed, 1992.

Jones, Harvey L., John Caldwell, and Terry St. John. *Impressionism: The California View.* Oakland, Calif.: Oakland Museum, 1981.

Jones, Harvey L., Janet Blake Dominik, and Jean

Stern. *Selections from the Irvine Museum.* Irvine, Calif.: Irvine Museum, 1992.

Jones, Harvey L., et al. *One Hundred Years of California Sculpture.* Oakland, Calif.: Oakland Museum, 1982.

Jones, Harvey L., Paul C. Mills, and Nancy Dustin Wall Moure. *A Time and Place: From the Ries Collection of California Painting.* Oakland, Calif.: Oakland Museum, 1990.

Joyes, Claire. "Giverny's Meeting House, the Hôtel Baudy." In *Americans in Brittany and Normandy, 1860–1910,* edited by David Sellin. Phoenix: Phoenix Art Museum, 1982.

Koeninger, Kay. *Myth and Grandeur: California Landscapes, 1864–1900.* Claremont, Calif.: Montgomery Gallery, Pomona College, 1987.

Korb, Edward L. *A Biographical Index to California and Western Artists.* Lawndale, Calif.: DeRu's Fine Arts, 1983.

Landauer, Susan, et al. *California Impressionists.* Athens, Ga.: Georgia Museum of Art; Irvine, Calif.: Irvine Museum, 1996.

Loan Collection of Paintings by American Artists. New York: Union League Club, 1894.

Martin, Jean. *Louis Sloss, Jr., Collection of California Paintings.* San Francisco: California Historical Society, 1958.

Maurice Braun Retrospective Exhibition of Paintings. San Francisco: M. H. de Young Memorial Museum, 1954.

Miller, Dwight. *California Landscape Painting, 1860–1885: Artists around Keith and Hill.* Stanford, Calif.: Stanford Art Gallery, 1975.

_____. *Painters of the Nineteen-Twenties.* Claremont, Calif.: Pomona College Gallery, 1972.

Mills, Paul, and Donald C. Biggs. *California Pictorial, 1800–1900.* Santa Barbara, Calif.: Santa Barbara Museum of Art, 1962.

Mills, Paul Chadbourne. *The Golden Land.* San Diego: San Diego Museum of Art, 1986.

Moore, Eudorah M., and Robert W. Winter. *California Design, 1910.* Pasadena, Calif.: Pasadena Center, 1974.

Moure, Nancy Dustin Wall. *William Wendt, 1865–1946*. Laguna Beach, Calif.: Laguna Art Museum, 1977.

———. *Painting and Sculpture in Los Angeles, 1900–1945*. Los Angeles: Los Angeles County Museum of Art, 1980.

———. *Publications in Southern California Art, 1, 2, and 3*. Los Angeles: Dustin Publications, 1984.

———. *Loners, Mavericks and Dreamers: Art in Los Angeles before 1900*. Laguna Beach, Calif.: Laguna Art Museum, 1993.

———, et al. *Drawings and Illustrations by Southern California Artists before 1950*. Laguna Beach, Calif.: Laguna Art Museum, 1982.

Nash, Steven A., et al. *Facing Eden: 100 Years of Landscape Art in the Bay Area*. San Francisco: Fine Arts Museums of San Francisco; Berkeley: University of California Press, 1995.

Nelson-Rees, Walter, and James Coran. *If Pictures Could Talk: Stories about California Paintings in Our Collection*. Oakland, Calif.: WIM, 1989.

Neuhaus, Eugen. *The Galleries of the Exposition: A Critical Review of the Paintings, Statuary, and the Graphic Arts in the Palace of Fine Arts at the Panama-Pacific International Exposition*. San Francisco: Paul Elder and Company, 1915.

———. *The History and Ideals of American Art*. Stanford, Calif.: Stanford University Press, 1931.

One Hundred Twenty Years of California Paintings, 1850–1970. San Jose, Calif.: San Jose Museum of Art, 1971.

Orr-Cahall, Christina, ed. *The Art of California: Selected Works from the Collection of the Oakland Museum*. Oakland, Calif.: Oakland Museum Art Department; San Francisco: Chronicle Books, 1984.

Our First Five National Academicians: The Carmel Art Association Presents an Exhibition of Works by Paul Dougherty, Arthur Hill Gilbert, Armin Hansen, William Ritschel, Howard E. Smith. Introduction by Gael Donovan. Carmel, Calif.: Carmel Art Association, 1989.

Paintings: Guy Rose—Paul Sample. Santa Barbara, Calif.: Faulkner Memorial Art Gallery, Free Public Library, 1934.

Paintings by Guy Rose. Los Angeles: Los Angeles Museum of History, Science and Art, 1916.

Payne, Edgar A. *Composition of Outdoor Painting*. Hollywood: Seward Publishing Company, 1941.

Peixotto, Ernest C. *Romantic California*. New York: Charles Scribner's Sons, 1910.

Petersen, Martin E. *Second Nature: Four Early San Diego Landscape Painters*. Foreword by Everett Gee Jackson. San Diego, Calif.: San Diego Museum of Art; Munich: Prestel-Verlag, 1991.

Pictorial Treasures. San Francisco: California Historical Society, 1956.

Porter, Bruce. "Art and Architecture in California." In *History of California*, edited by Zoeth Skinner Eldredge, vol. 5, pp. 461–84. New York: Century History Company, 1915.

Puthuff, Hanson, and Louise Puthuff. *Hanson Duvall Puthuff: The Artist, the Man, 1875–1972*. Costa Mesa, Calif.: Spencer Printing Service, 1974.

Raassen-Kruimel, Emke. *Joseph Raphael, 1869–1950*. Laren, the Netherlands: Singer Museum, 1982.

Robertson, David. *West of Eden: A History of the Art and Literature of Yosemite*. Yosemite, Calif.: Yosemite Natural History Association, 1984.

St. John, Terry. *Society of Six*. Oakland, Calif.: Oakland Museum, 1972.

———. *Plein Air Paintings: Landscapes and Seascapes from Santa Cruz to the Carmel Highlands, 1898–1940*. Santa Cruz: Mary Porter Sesnon Art Gallery, University of California, 1985.

"Science and Art." In *California Anthology: or, Striking Thoughts on Many Themes, Carefully Selected from California Writers and Speakers*, compiled by Oscar T. Shuck, pp. 9–47. San Francisco: A. J. Leary, 1880.

Seavey, Kent. *Artist-Teachers and Pupils: San Francisco Art Association and California School of Design: The First Fifty Years, 1871–1921*. San Francisco: California Historical Society, 1971.

———. *Monterey: The Artist's View, 1925–45*. Monterey, Calif.: Monterey Peninsula Museum of Art, 1982.

Sellin, David. *Americans in Brittany and Normandy, 1860–1910*. Phoenix: Phoenix Art Museum, 1982.

A Sense of Place: California Landscape Painting, 1870–1930. San Francisco: Transamerica Corporation, 1978.

Seventy-five Works, Seventy-five Years: Collecting the Art of California. Laguna Beach, Calif.: Laguna Art Museum, 1993.

Shere, Charles. *New Deal Art: California*. Santa Clara, Calif.: De Saisset Art Gallery and Museum, University of Santa Clara, 1976.

Silva, Nikki. *Art and Artists in Santa Cruz: A Historic Survey*. Santa Cruz, Calif.: Santa Cruz City Museum, 1973.

Six Early Women Artists: A Diversity of Style: Rowena Meeks Abdy, Jeannette Maxfield Lewis, Eunice Cashion MacLennan, Laura Wasson Maxwell, M. Evelyn McCormick, Mary DeNeale Morgan. Carmel, Calif.: Carmel Art Association, 1991.

Smith, Sarah Bixby. *Adobe Days: Being the Truthful Narrative of the Events in the Life of a California Girl on a Sheep Ranch . . . and the Strange Prophecy of Admiral Thatcher about San Pedro Harbor*. Los Angeles: Jake Zeitlin, 1931.

Snipper, Martin. *A Survey of Art Work in the City and County of San Francisco*. San Francisco: Art Commission, City and County of San Francisco, 1975.

South, Will. *James Taylor Harwood, 1860–1940*. Salt Lake City: Utah Museum of Fine Arts, 1987.

———. *Guy Rose: American Impressionist*. Introduction by William H. Gerdts; essay by Jean Stern. Oakland, Calif.: Oakland Museum; Irvine, Calif.: Irvine Museum, 1995.

South, Will, Iona M. Chelette, and Katherine Plake Hough. *California Grandeur and Genre*. Palm Springs, Calif.: Palm Springs Desert Museum, 1991.

Spangenberg, Helen. *Yesterday's Artists on the Monterey Peninsula*. Monterey, Calif.: Monterey Peninsula Museum of Art, 1976.

Stern, Jean. *The Paintings of Franz A. Bischoff*. Los Angeles: Petersen Publishing Company, 1980.

_____. *Alson S. Clark*. Los Angeles: Petersen Publishing Company, 1983.

_____. *Masterworks of California Impressionism: The FFCA, Morton H. Fleischer Collection*. Foreword by Morton H. Fleischer. Phoenix: Franchise Finance Corporation of America, 1987.

_____. *American Impressionism, California School: Selections from the Permanent Collection and Loans from the Paul and Kathleen Bagley Collection*. Phoenix: FFCA Publishing Company, 1989.

_____. *American Impressionism: A California Collage*. Phoenix: FFCA Publishing Company and the Fleischer Museum, 1991.

Stern, Jean, Janet Blake Dominik, and Harvey L. Jones. *Selections from the Irvine Museum*. Irvine, Calif.: Irvine Museum, 1992.

Stern, Jean, et al. *Romance of the Bells: The California Missions in Art*. Irvine, Calif.: Irvine Museum, 1995.

Stern, Jean, and Joan Irvine Smith. *Reflections of California: The Athalie Richardson Irvine Clarke Memorial Exhibition*. Irvine, Calif.: Irvine Museum, 1994.

Stern, Jean, and Ruth Westphal. *The Paintings of Sam Hyde Harris, 1889–1977: A Retrospective Exhibition*. Los Angeles: Petersen Publishing Company, 1981.

Trenton, Patricia, ed. *California Light, 1900–1930*. Laguna Beach, Calif.: Laguna Art Museum, 1990.

_____. *Independent Spirits: Women Painters of the American West, 1890–1945*. Los Angeles: Autry Museum of Western Heritage; Los Angeles, Berkeley, and London: University of California Press, 1995.

Turnbull, Betty. *California: The State of Landscape, 1872–1981*. Newport, Calif.: Newport Harbor Art Museum, 1981.

Van Nostrand, Jeanne. *A Pictorial and Narrative History of Monterey, Adobe Capital of California, 1770–1847*, pp. 81–95. San Francisco: California Historical Society, 1968.

_____. *San Francisco, 1806–1906, in Contemporary Paintings, Drawings and Watercolors*. San Francisco: Book Club of California, 1975.

_____. *The First Hundred Years of Painting in California, 1775–1875*. San Francisco: J. Howell Books, 1980.

Van Nostrand, Jean, and Edith M. Coulter. *California Pictorial*. Berkeley and Los Angeles: University of California Press, 1948.

Walker, John Alan. *Benjamin Chambers Brown (1865–1942): A Chronological and Descriptive Bibliography*. Big Pine, Calif.: privately printed, 1989.

_____. *Documents on the Life and Art of William Wendt (1865–1946), California's Laureate of the Paysage Moralisé*. Big Pine, Calif.: Privately printed, 1992.

Westphal, Ruth, ed. *Plein Air Painters of California: The Southland*. Essays by Terry DeLapp, Thomas Kenneth Enman, Nancy Dustin Wall Moure, Martin E. Petersen, and Jean Stern. Irvine, Calif.: Westphal Publishing, 1982.

_____. *Plein Air Painters of California: The North*. Essays by Janet Blake Dominik, Harvey L. Jones, Betty Hoag McGlynn, Paul Chadbourne Mills, Martin E. Petersen, Terry St. John, Jean Stern, Jeffrey Stewart, and Raymond L. Wilson. Irvine, Calif.: Westphal Publishing, 1986.

Wilson, Raymond. *A Woman's Vision: California Painting into the Twentieth Century*. San Francisco: Maxwell Galleries, 1983.

Woodward, Arthur. *California Centennial Exhibition of Art*. Los Angeles: Los Angeles County Museum, 1949.

ARTICLES

Abronda, Mildred. "Granville Redmond: California Landscape Painter." *Art and Antiques* 5 (November–December 1982): n.p.

"American Salon Admired in Paris." *New York Times*, February 19, 1911.

Anderson, Antony. "Art and Artists." *Los Angeles Times*, 1906–26. Anderson's columns are an invaluable resource.

"Art in Los Angeles: The Exhibit Now in the Chamber of Commerce." *Los Angeles Express*, June 15, 1895.

"Artistic Career of Guy Rose Remembered." *South Coast News* (Laguna Beach, Calif.), December 4, 1931.

"Artists and Their Work [Armin Hansen]." *San Francisco Chronicle*, October 29, 1916.

"Artists Known Here Exhibit in Pasadena." *Carmel Pine Cone*, April 5, 1924.

"Art Notes." *Carmel Pine Cone*, May 5, 1921; July 21, 1921.

Art Notes: Published in the Interest of American Art and the Macbeth Gallery 48 (April 1913): 761.

Austin, C. P. "The California Art Club." *Out West*, o.s. 19 (December 1911): 3–11.

Austin, Mary. "Art Influence in the West." *Century* 89 (April 1915): 829–33.

Avery, Benjamin Parke. "Art Beginnings on the Pacific." *Overland Monthly* 1 (July 1868): 28–34; (August 1868): 113–19.

_____. "Art in California." *Aldine* 7 (April 1874): 72–73.

Barker, Albert W. "A Painter of Modern Industrialism: The Notable Work of Colin Campbell Cooper." [Appleton's] *Booklover's Magazine* 5 (March 1905): 326–37.

Bartlett, William C. "Literature and Art in California: A Quarter-Centennial Review." *Overland Monthly* 15 (December 1875): 533–46.

Bennet, John. "Some Artists of California." *Art Interchange* 38 (December 1895): 122–26.

Berry, Rose V. S. "California and Some California

Painters." *American Magazine of Art* 15 (June 1924): 279–91.

_____. "A Painter of California [Guy Rose]." *International Studio* 80 (January 1925): 332–34, 336–37.

_____. "A Patriarch of Pasadena [Benjamin Brown]." *International Studio* 81 (May 1925): 123–26.

Blanch, Josephine M. "The Del Monte Art Gallery." *Art and Progress* 5 (September 1914): 387–92.

Boeringer, Pierre N. "Some San Francisco Illustrators: Curbstone Bohemia." *Overland Monthly* 26 (July 1895): 70–90.

Boyer, Hazel. "A Notable San Diego Painter [Maurice Braun]." *California Southland* 6 (April 1924): 12.

Brown, Benjamin Chambers. "The Beginnings of Art in Los Angeles." *California Southland* 6 (January 1924): 7–8.

Brown, Charles Francis. "Some Recent Landscapes by William Wendt." *Brush and Pencil* 6 (September 1900): n.p.

Burlingame, Margaret R. "The Laguna Beach Group." *American Magazine of Art* 24 (April 1932): 259–66.

E.M.C. "Comment on Art Progress: The Art Gallery at the Chamber of Commerce." *Los Angeles Herald*, November 11, 1894.

"California Artists." *Wasp*, December 23, 1911, pp. 21–23.

"Carmel Art Exhibition." *Carmel Pine Cone*, September 9, 1920.

Coan, Helen E. "Art in Southern California: A Few Notes." *News Notes of California Libraries* (California State Library) 3 (January–October 1908): 3–29.

Cole, George Watson. "Missions and Mission Pictures: A Contribution Towards an Iconography of the Franciscan Missions of California." *News Notes of California Libraries* (California State Library) 5 (July 1910): 390–412.

Comstock, Helen. "Painter of East and West

[Maurice Braun]." *International Studio* 80 (March 1925): 485–88.

Cook, Alma May. "Wm. Wendt Called 'Painter Laureate' of California." *Los Angeles Herald-Express*, March 25, 1939.

Crowell, Bertha C. "Granville Redmond: Landscape Painter Who Can Not Hear nor Speak." *Los Angeles Herald*, November 15, 1903.

Culmer, Henry L. A. "The Artist in Monterey." *Overland Monthly* 34 (December 1899): 514–24.

Curtis, Christine Turner. "William Ritschel, California's Painter of the Sea." *California Southland* 8 (August 1926): 10–11.

"Dean of Western Painters [Armin Hansen]." *Western Woman* 7 (1944): 3–4.

"Death Ends Art Career of Guy Rose: World-Famous Painter Is Victim of Long Illness at Pasadena Home." *Los Angeles Daily Times*, November 18, 1925.

"Directory of California Artists, Craftsmen, Designers and Art Teachers." *California Arts and Architecture* 42 (December 1932).

Dominik, Janet. "Guy Rose: American Impressionist." *Antiques and Fine Art* (December 1986): 36–41.

_____. "Artist, William Ritschel, N.A." *Art of California* (February–March 1989): 21–27.

Donovan, Ellen Dwyer. "California Artists and Their Work." *Overland Monthly* 51 (January 1908): 25–33.

Donovan, Percy Vincent. "The Western Ideal." *Sunset* 16 (February 1906): 379–81.

Downes, William Howe. "California for the Landscape Painter." *American Magazine of Art* 11 (December 1920): 491–502.

Dwyer, Eileen. "The Art of Charles Reiffel." *Argus* (April 1929): 20.

"Exhibition of Guy Rose's Pictures at the Ambassador." *Laguna Life*, September 30, 1921, p. 3.

"Experimental Tendencies in Paintings of Clark Hobart." *San Francisco Bulletin*, February 15, 1919.

"Five Exhibitors at the Maryland Hotel." *Los Angeles Times*, June 10, 1923.

"Five Painters at Maryland Galleries." *Los Angeles Times*, May 27, 1923.

"Five Painters at the Maryland Galleries." *Pasadena Evening Post*, May 30, 1923.

Fort, Ilene Susan. "The Figure Paintings of Guy Rose." *Art of California* 4 (January 1991): 46–50.

Frankenstein, Alfred. "An Old Master, a Primitive, and Photographic History [Armin Hansen]." *San Francisco Chronicle*, June 18, 1944.

Frash, Robert M. "Impressionistic Challenge: A Regional Response to the Painters of Laguna Beach, 1900–1940." *California History* (California Historical Society) 63 (summer 1984): 252–55.

Garcia, Monica E. "Jules Pagès." *Art of California* 3 (March 1990): 17–22.

Gearhart, Edna. "Benjamin Brown of Pasadena." *Overland Monthly* 82 (July 1924): 214–16.

Gelber, Steven M. "Working to Prosperity: California's New Deal Murals." *California History* (California Historical Society) 58 (1979): 98–127.

Gittens, Roberta. "Donna Schuster." *Art of California* 4 (May 1991): 16–20.

Gittens, Roberta, and Patricia Trenton. "Donna Norine Schuster: Afloat on Currents of Change." *Southwest Art* 22 (February 1993): 68–74, 132.

Hall, Kate Montague. "The Mark Hopkins Institute of Art." *Overland Monthly* 30 (December 1897): 539–48.

Handley, Marie Louise. "Gardner Symons—Optimist." *Outlook* 105 (December 27, 1913): 881–87.

Hardy, Lowell. "Sculpture and Color at the Panama-Pacific International Exposition." *Out West*, n.s. 8 (December 1914): 321–30.

Hills, Anna A. "The Laguna Beach Art Association." *American Magazine of Art* 10 (October 1919): 458–63.

Hilton, John W. "Artist Who Grinds His Own

Pigments [Paul Lauritz]." *Desert Magazine* 4 (March 1941): n.p.

Hittel, John S. "Art in San Francisco." *Pacific Monthly* 10 (July 1863): 99–111.

_____. "Guy Rose." *Los Angeles Times*, March 7, 1926.

Hogue, Fred. "The Art of Edgar Alwyn [*sic*] Payne." *Los Angeles Times*, May 23, 1926, part 2, p. 4.

_____. "The God of the Mountains [Edgar Payne]." *Los Angeles Times*, May 22, 1927.

_____. "A Hungarian Artist [Joseph Kleitsch]." *Los Angeles Times*, June 25, 1928.

Housh, Henrietta. "California, the Mecca for the Landscapist." *Out West* 41 (March 1915): 119–21.

Hunt, Edwin Arthur. "The Wright Criterion." *Out West* 43 (April 1916): 160–61.

"In Studios and Galleries." *California Southland* (October 1919): 18.

Irwin, E. P. "San Francisco Women Who Have Achieved Success." *Overland Monthly and Out West* 44 (November 1904): 512–20.

"Jack Stark Stages One-Man Exhibit in California Art Show." *Silver City Enterprise*, January 29, 1937.

James, Eleanor Minturn. "Sculptors of Pasadena." *American Magazine of Art* 22 (April 1931): 290–94.

Judson, William L. "Early Art in California," part 3, *Annual Publication of the Historical Society of Southern California and of the Pioneers of Los Angeles County* 5 (1902): 215–16.

Kahn, Gerrie E. "Images of the California Landscape, 1850–1916, Highlighting the Collection of the California Historical Society." *California History* (California Historical Society) 60 (winter 1981–82): 318–31.

Kammerling, Bruce. "Theosophy and Symbolist Art: The Point Loma Art School." *Journal of San Diego History* 26 (fall 1980): 231–55.

_____. "The Start of Professionalism: Three Early San Diego Artists." *Journal of San Diego History* 30 (fall 1984): 241–51.

_____. "Painting Ladies: Some Early San Diego Women Artists." *Journal of San Diego History* 32 (summer 1986): 147–91.

Keeler, Charles. "California's Painters, Poets, Sculptors and Fiction Writers That Have Won for Her Undying World-Wide Fame." *New York World*, March 20, 1904, magazine section, pp. 4–5.

Keyes, Donald D. "California Impressionists, from Giverny to Laguna Beach." *American Art Review* 8 (June–August 1996): 148–55.

Kirk, Chauncey A. "Bohemian Rendezvous: Nineteenth-Century Monterey: Sanctuary and Inspiration for Early Western Artists." *American West* 16 (November–December 1979): 34–44.

Kistler, Aline. "Armin Hansen, Etcher of the Sea." *Prints* 5 (November 1934): 1–9.

Lack-Krombach, Beatric de. "Art." *Graphic* (February 16, 1915): 54.

Landauer, Susan. "The California Art Club: A History (1909–1995)." *American Art Review* 8 (February–March 1996): 144–51.

Larsen, Hanna Astrup, "Jules Pages May Succeed the Late Julian as Head of Art Academy in Paris." *San Francisco Call*, July 22, 1907.

_____. "California Landscapes in Which the Vigor and Wild Beauty of the Golden State Are Manifest." *Craftsman* 16 (September 1909): 630–37.

Latimer, L. P. "The Redwood and the Artist." *Overland Monthly* 32 (October 1898): 354–56.

Laurvik, J. Nilsen. "Evolution of American Painting as Exemplified in the International Exhibition of Fine Arts in the Panama-Pacific International Exposition in San Francisco." *Century* 90 (September 1915): 772–86.

_____. "Art in California: The San Francisco Art Association's Annual Exhibition." *American Magazine of Art* 9 (May 1918): 275–80.

Leeper, John Palmer. "Alson S. Clark, 1876–1949." *Pasadena Art Institute Bulletin* 1 (April 1951): 15–19.

"Loan Exhibit: Paintings at the Art Association Rooms." *Los Angeles Express*, April 20, 1895.

Lytle, Rebecca Elizabeth. "People and Places: Images of Nineteenth-Century San Diego in Lithographs and Paintings." *Journal of San Diego History* 24 (spring 1978): 153–71.

Marquis, Neeta. "Jack Wilkinson Smith, Colourist." *International Studio* 69 (December 1919): 74–76.

_____. "Laguna: Art Colony of the Southwest." *International Studio* 70 (March 1920): xxvi–xxvii.

Maxwell, Everett Carrol. "Development of Landscape Painting in California." *Fine Arts Journal* 34 (March 1916): 138–42.

_____. "Painters of the West: Hanson Puthuff." *Progressive Arizona* 6 (September 1931): 10–11.

_____. "Jack Wilkinson Smith: Constructive Artist." *Overland Monthly* 90 (October 1932): 237–38.

_____. "The Art of Jean Mannheim." *Overland Monthly* 91 (September 1933): 125, 127.

Mechlin, Leila. "William P. Silva—An Appreciation." *American Magazine of Art* 14 (January 1923): 26–28.

Millier, Arthur H. "Our Artists in Person [Benjamin Brown]." *Los Angeles Times*, October 19, 1920.

_____. "California's Etchers." *California Southland* 42 (June 1923): 12–13.

_____. "The Art Temperaments of Northern and Southern California Compared." *Argus* 1 (August 1927): 32.

_____. "Charles Reiffel, American Landscape Painter." *Argus* (July–August 1928): 6.

_____. "Growth of Art in California." In *Land of Homes*, edited by Frank J. Taylor, pp. 311–41. Los Angeles, 1929.

_____. "William Ritschel and Others in the South." *Argus* 4 (March 1929): 5.

_____. "Our Artists in Person [William Wendt]." *Los Angeles Times*, July 6, 1930.

_____. "Our Artists in Person [Hanson Puthuff]." *Los Angeles Times*, September 21, 1930.

_____. "Our Artists in Person [Jack Wilkinson Smith]." *Los Angeles Times*, October 5, 1930.

_____. "Our Artists in Person [Granville Redmond]." *Los Angeles Times*, March 22, 1931.

_____. "Our Artists in Person [Anna Hills]." *Los Angeles Times*, June 7, 1931.

_____. "New Developments in Southern California Painting." *American Magazine of Art* 27 (May 1934): 241–47.

_____. "Our Artists in Person [Charles Reiffel]." *Los Angeles Times*, December 29, 1936.

Miner, Frederick Roland. "California: The Landscapist's Land of Heart's Desire." *Western Art* 1 (June–August 1914): 31–35.

"Miss McCormick Working on a New Picture of La Casa Laritas." *Del Monte Weekly* 1 (November 20, 1909): 7.

Monroe, Harriet. "The Giverny Colony." *Chicago Tribune*, May 28, 1911.

"Mr. and Mrs. Guy Rose Return." *Los Angeles Herald*, February 8, 1895.

Mulford, Henry. "History of the San Francisco Art Institute." Parts 1–7. *San Francisco Art Institute Alumni Newsletter*, May 1978–spring 1980.

"Oakland Sees Interesting Art Group." *San Francisco Chronicle*, August 31, 1930.

Parkhurst, Thomas Shrewsbury. "Gardner Symons: Painter and Philosopher." *Fine Arts Journal* 34 (November 1916): 556–65.

Peters, Mary T. "The Lithographs of California." *Prints* 5 (March 1935): 1–9.

Petersen, Martin E. "Contemporary Artists of San Diego." *Journal of San Diego History* 16 (fall 1970): 3–8.

_____. "Alfred R. Mitchell: Pioneer Artist in San Diego." *Journal of San Diego History* 19 (fall 1973): 42–50.

_____. "Maurice Braun: Master Painter of the California Landscape." *Journal of San Diego History* 23 (summer 1977): 20–33.

_____. "Success at Mid-Life: Charles Reiffel, 1862–1942, San Diego Artist." *Journal of San Diego History* 31 (winter 1985): 25–37.

_____. "Charles Reiffel." *Art of California* 4 (July 1991): 34–39.

"Pine Needles." *Carmel Pine Cone*, August 1, 1918; July 24, 1919; October 23, 1919; October 7, 1920.

Plagens, Peter. "Seventy Years of California Modernism in 340 Works by 200 Artists." *Art in America* 65 (May–June 1977): 63–69.

Powers, Laura Bride. "Art and Artists about the Bay." *Oakland Tribune*, June 12, 1916.

Pratt, Henry Noyes. "The Beginning of Etching in California." *Overland Monthly and Out West* 82 (March 1924): 114.

_____. "Three California Painters." *American Magazine of Art* 16 (April 1925): 199–204.

Pratt Institute Monthly 5 (October 1896): 22; 5 (December 1896): 106; 6 (June 1897): 322.

Reiffel, Charles. "The Modernistic Movement in Art." *Modern Clubwoman* (January 1930): 4.

Robinson, Charles Dorman. "A Revival of Art Interest in California." *Overland Monthly* 18 (June 1891): 52–56.

Robinson, W. W. "The Laguna Art Colony." *California Southland* 6 (July 1924): 10.

Rogers, R. C. "Art Patronage in California." *California Art Gallery* 1 (March 1873): 33.

Roorbach, Eloise J. "The Indigenous Art of California: Its Pioneer Spirit and Vigorous Growth." *Craftsman* 22 (August 1912): 289–496.

Rose, Ethel. "Shooting in France [Normandy]." *Scribner's Magazine* 49 (March 1911): 399–409. Illustrated by Guy Rose and Arthur B. Frost Sr.

_____. "Trout Fishing in Normandy." *Scribner's Magazine* 54 (October 1913): 455–70. Illustrated by Guy Rose and Arthur B. Frost Sr.

_____. [Title obscured; re: First Annual Exhibition of Contemporary American Painters]. *Graphic*, February 26, 1916. In the Scrapbooks of the Los Angeles Museum of History, Science and Art, on file at Los Angeles County Museum of Natural History.

_____. "Among the Pines at Carmel-by-the-Sea." *California Southland* 7 (October–November 1919): 18.

_____. "Honor to a Great Artist of France." Journal article, c. 1920, Rose Family Scrapbooks.

_____. "Coarse Fishing in Normandy." *Scribner's Magazine* 72 (September 1922): 281–92. Illustrated by Guy Rose and Arthur B. Frost Sr.

_____. "Giverny." *For Art's Sake* 1 (November 8, 1923): 4.

Rose, Guy. "At Giverny." *Pratt Institute Monthly* 6 (December 1897): 81.

Ryan, Beatrice Judd. "The Rise of Modern Art in the Bay Area." *California Historical Society Quarterly* 38 (March 1959): 1–5.

"The School of the Music and Art Association." *California Southland* (February–March 1920): 18.

Seares, Mabel Urmy. "The Spirit of California Art." *Sunset* 23 (September 1909): 264–66.

_____. "California as a Sketching Ground." *International Studio* 43 (April 1911): 121–32.

_____. "The Art of Los Angeles." *Western Art* 1 (June–August 1914): 21–23.

_____. "San Francisco's First Half-Century of Art." *Arts and Decoration* 4 (September 1914): 410–13.

_____. "William Wendt." *American Magazine of Art* 7 (April 1916): 232–35.

_____. "Modern Art and Southern California." *American Magazine of Art* 9 (December 1917): 58–64.

_____. "A California School of Painters." *California Southland* 3 (February 1921): 10–11.

_____. "Richard Miller in a California Garden." *California Southland* 5 (February 1923): 10–11.

_____. "California as Presented by Her Artists." *California Southland* 6 (June 1924): 7–13.

Selkinhaus, Jessie A. "The Laguna Beach Art Colony." *Touchstone* 8 (January 1920): 250–55.

_____. "Etchers of California." *International Studio* 78 (February 1924): 383–91.

Semple, Elizabeth Anna. "Successful Californians in New York." *Overland Monthly* 60 (August 1912): 105–16.

Sheldon, Francis E. "Pioneer Illustration in California." *Overland Monthly* 11 (April 1888): 337–55.

Sloane, C. F. "Guy Rose's Work: A Review of the Young Artist's Career." *Los Angeles Herald,* October 4, 1891.

_____. "Mr. Rose's Paintings." *Los Angeles Herald,* October 13, 1891.

South, Will. "Americans in Paris." *Southwest Art* 17 (November 1987): 48–53.

_____. "The Painterly Pen [Guy Rose as Illustrator]." *Antiques and Fine Art* 9 (March–April 1992): 120.

Splitter, Henry Winifred. "Art in Los Angeles before 1900." *Historical Society of Southern California Quarterly* 41 (March 1959): 38–57; (June 1959): 117–38; (September 1959): 247–56.

Stern, Jean. "California Impressionism Chosen for Corporate Offices in Arizona." *Western Art Digest* 12 (November–December 1985): 72–80.

_____. "The Laguna Beach School: California Impressionism, 1900–1930." *Western Art Digest* 13 (September–October 1986): 112–15.

Stevens, Otheman. "Guy Rose Canvases in Notable Display." *Los Angeles Examiner,* August 18, 1931.

"Summer Exhibitions." *Bulletin of the Art Institute of Chicago* (October 1916): 204.

Taber, Louise E. "Jules Pagès." *American Magazine of Art* 31 (July 1914): 511–12.

_____. "Jules Pagès: An American Artist." *Fine Arts Journal* 5 (September 1914): 385–87.

Tilden, Douglas. "Art, and What California Should Do about Her." *Overland Monthly* 19 (May 1892): 509–15.

Titus, Aime Baxter. "Artists of San Diego County." *San Diego Magazine* 3 (September 1927): 11–12, 30.

Ussher, B. D. "California Art Exhibit." *Holly Leaves,* April 26, 1919.

Vreeland, Francis William. "A New Art Centre for the Pacific Coast." *Arts and Decoration* 28 (November 1927): 64–65.

Walker, John Alan. "William Wendt, 1865–1946." *Southwest Art* 4 (June 1974): 42–45.

Warren, Marjorie. "Armin Hansen: Painter of the Sea." *What's Doing Magazine* 1 (September 1946): 22–23, 49.

Whiting, Elizabeth. "Painting in the Far West: Alson Clark, Artist." *California Southland* 5 (February 1922): 8–9.

"Wild Gardens of California Interpreted by John M. Gamble." *California Southland* 10 (March 1928): 12–13.

Wilkinson, J. Warring. "Our Art Possibilities." *Overland Monthly* 2 (March 1869): 248–54.

Williams, Michael. "A Pageant of American Art." *Art and Progress* 6 [Special Exposition Number, 1915]: 337–53.

_____. "Western Art at the Exposition." *Sunset* 35 (August 1915): 317–26.

Wilson, L. W. "Santa Barbara's Art Colony." *American Magazine of Art* 12 (December 1921): 411–14.

Wilson, Raymond L. "The First Art School in the West: The San Francisco Art Association's California School of Design." *American Art Journal* 14 (winter 1982): 42–55.

_____. *A Woman's Vision: California Painting into the Twentieth Century.* San Francisco: Maxwell Galleries, 1983.

_____. "Painters of California's Silver Era." *American Art Journal* 16 (autumn 1984): 71–92.

Winchell, Anna Cora. "Artists and Their Work [Clark Hobart]." *San Francisco Chronicle,* December 19, 1915.

_____. "Artists and Their Work [Clark Hobart]." *San Francisco Chronicle,* July 22, 1917.

Wortz, Melinda. "Celebrating the Feminine Palette [Anna Hills]." *Los Angeles Times,* January 31, 1977.

Zehnder, Gladys. "Armin Hansen Exhibit of Much Interest." *San Francisco Chronicle,* February 7, 1926.

Index

(Page numbers in **boldface** refer to biographies for specific artists. Page numbers in *italic* refer to illustrations.)